# ANGELS

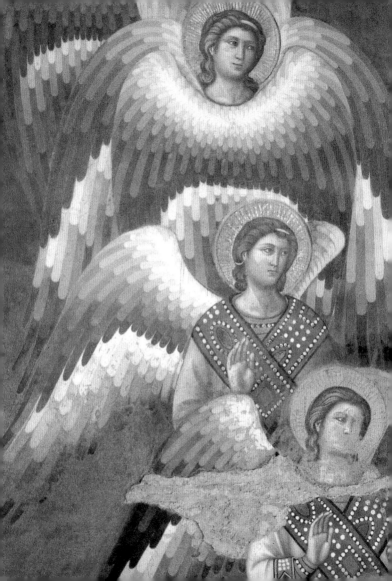

# ANGELS

MARCO BUSSAGLI

ABRAMS, NEW YORK

*Art Director*
Giorgio Seppi

*Editorial direction*
Lidia Maurizi

*Editors*
Veronica Buzzano, Lucia Moretti

*Graphic design*
Chiara Forte

*Picture research*
Daniela Teggi con Matteo Penati

*Editing and layouts*
Studio Bolduri, Milano

*English translation*
Rosanna M. Giammanco Frongia, Ph.D.

*English-language typesetting*
William Schultz

*Cover illustration:*
Domenico Zampieri,
known as Domenichino
*The Guardian Angel*, (detail)
1615
Museo Nazionale di Capodimonte, Naples

*On page 2:*
Pietro Cavallini
*Judgment Day*, (detail)
c. 1293
Santa Cecilia in Trastevere, Rome

Library of Congress Cataloging-in-Publication Data

Bussagli, Marco, 1957–
[Angeli. English]
Angels / by Marco Bussagli.
  p. cm.
Includes index.
ISBN 978-0-8109-9436-2

1. Angels in art. 2. Bible—Illustrations. I. Title.
N8090.B8813 2007
704.9'4864—dc22
                          2007010749

Printed and bound in Italy
10 9 8 7 6 5

Abrams books are available at special discounts when purchased in
quantity for premiums and promotions as well as fundraising or
educational use. Special editions can also be created to specification.
For details, contact specialmarkets@abramsbooks.com or the
address below.

# ABRAMS

THE ART OF BOOKS SINCE 1949

115 West 18th Street
New York, NY 10011
www.abramsbooks.com

# Contents

# Introduction

Page after page, this book explores biblical verse that discusses angels, from Genesis to Revelation. It is a journey that moves between faith, history, and art, because every passage cited is accompanied by a work of art that represents the scene or episode being narrated. The art does not merely illustrate the passages, however, because the images selected, in addition to illuminating the text, also highlight aspects that would otherwise be left unnoticed. The images that accompany these passages complement them; together with the texts, they offer the reader a much more fulfilling view of the subject than would otherwise be possible. An analysis of the images allows us to understand the weight of the artistic representation in developing the figure of the angel in the collective imagination, which often has been influenced more by visual tradition than by the Scriptures themselves.

The theoretical principle underpinning this book is that each human artifact, especially works of art, must be considered the mirror and the synthesis of an age, of its technical and cultural evolution. In the case of the representation of angels, the subject takes on a different complexity, given the determining role that theological thought plays in it.

An important aspect in studying angelic figures is the fact that, unlike other texts to which the iconographic tradition refers—such as the writings of the Fathers of the Church or the apocryphal Gospels—only in rare cases does the Bible give us a satisfying description. The established image of the angel with large wings, blond hair, delicate features, and blue eyes is not

only the result of the interaction of all these writings, but also of different historical, religious (i.e., linked to popular devotion), and theological (i.e., doctrinal) factors. For example, in the Scriptures it is often asserted, either directly or indirectly, that the angel is a winged being. However, in the first three hundred years of Christianity, when many patristic writers were active (including Tertullian, who stated that "all spirits have wings"), angels were depicted without wings. The reason for this was probably linked to the need to differentiate God's messengers from the winged divinities of the pagan world. Therefore, in an age when Christianity had not yet fully come into its own, in order to avoid confusion between sacred and profane, the iconographic tradition was inspired by those writings that spoke of angels as simply "men" appearing to other men. An episode such as that of Balaam's ass even highlighted the paradox that the animal sees and recognizes the angel of God, while the prophet, who should be learned about divine matters, does not see the angel until the humble animal tells him (miraculously) with words.

In other cases, the image underscores and bares a controversial tradition. Such is the case of the cherubim, who were canonized by the apparition to Ezekiel during the Jewish exile in Babylonia. In fact, although the prophet described them as being equipped with four wings full of eyes, strange wheels, on which they moved, and four "faces" (the faces of a man, an eagle, a lion, and a bull), the previous biblical tradition had described them as having only two wings; in Exodus, the wings were meant to protect the Ark of the Covenant. These two textual sources resulted in different iconographic solutions: The first produced the cherubim of the theophanies; in the second, the cherubim were depicted as "ordinary" angels, recognizable only from the context in which they appeared—for example, guarding the Ark of the Covenant or protecting Christ (in this case assimilated to the Ark).

Clearly, this difference stands out only when the image is juxtaposed with the scriptural passage; for this reason, the images are the main reference points in this book. When it comes to angels, in fact, art is much richer than the written word, often adding them to episodes in which the Scriptures do not mention them, such as the baptism of Christ or the Crucifixion. Often, however, text and image coincide. When this is not the case, the comments of the author—who has been writing about this subject for more than twenty years—help to explain.

Chronologically, the art included in this book spans the period from the ninth century BCE to the middle of the twentieth century, from the ivory sculptures of Megiddo to the watercolors and oils of Marc Chagall. This broad historical span allows the reader to appreciate the many changes that affected the representation of angels over the centuries, and that reflect the changing "metatraditions"—the iconic traditions that are built on the texts. See, for example, how the Renaissance angels whose bouffant dress (the *guarnello*[1]) is pulled in at the waist were adapted from classical images of the goddess Nike (Victory). This is an example of "metatradition" in that the initial representational parameters did not change, although a new line was added, dictated by new, nontheological, historical–cultural requirements. The presupposition for this change lies in the rediscovery—through the cultural phenomenon of humanism—of classicism as a living reality, close to the feelings of the people of the Renaissance.

Such a broad historical perspective also allows us to reconstruct the development of the iconography of each subject. Thus, for example, we follow the Annunciation from its earliest surviving example on the vault of Priscilla's catacomb (second to third century CE) to the late nineteenth-century version by James Tissot, thus offering the reader, in addition to a pano-

ramic view of the main iconic transitions that marked the history of this subject, more occasions for reflection. For all of these reasons, the presentation of each theme in this book is strictly chronological, except for images that illustrate, step-by-step, the various phases of an episode, such as the expulsion from the Garden of Eden.

One final comment: The broad time period we have explored allowed us to assess the contribution of each single artist in developing a line that was not always part of tradition, but sometimes modified it, as in the case of Andrea del Verrocchio who, more than any other artist, contributed to popularizing the image of angels dressed in their new Renaissance clothes.

[1] "*Guarnello* (M/F). Both a kind of linen or cotton textile, and the feminine garment constructed from such a fabric, the *guarnello* probably has the same significance as a *rascia*. It is a simple, reasonably loose-fitting dress, similar to the *cotta*, but sometimes worn without sleeves. [. . .] The *guarnello, rascia,* or *saia* is the standard form of dress for angels. It is worn by children as a simple, washable garment, and possibly also by pregnant women. There are also examples of *guarnelli* listed under items of male clothing." (From "Glossary of Terms in Italian Clothing, 1400–1500," in *Dress in Renaissance Italy, 1400–1500.* Jacqueline Herald. New Jersey: Humanities Press, 1981.)

# The First Day

▶▶

> In the beginning God created the heaven and the earth. And the earth was without form, and void; and darkness was upon the face of the deep. And the Spirit of God moved upon the face of the waters. And God said, Let there be light: and there was light. And God saw the light, that it was good: and God divided the light from the darkness. And God called the light Day, and the darkness he called Night. And the evening and the morning were the first day.

Previati's painting unknowingly offers a solution to a problem that theologians have long grappled with—the question of when angels were created. Certainly, this painting by the Ferrarese artist seems to illustrate a celebrated passage from Saint Augustine's *De Civitate Dei* [*The City of God*] (XI, 9), which reads:

> For in fact when "God said 'Let there be light!' And there was light," if by this light is meant the creation of the angels, this means that they were created as participating in the eternal light, which is the very same immutable Wisdom of God, through which everything was created, what we call the only begotten Son of God. Thus, illuminated by the light from which they were created, they became light and were called day because they participate in the immutable light and day . . .

For this reason, Previati painted the angels as clouds filled with the light that sprang forth from the Word of God.

CREATION OF LIGHT
Gaetano Previati
1913
Galleria Nazionale d'Arte Moderna, Rome

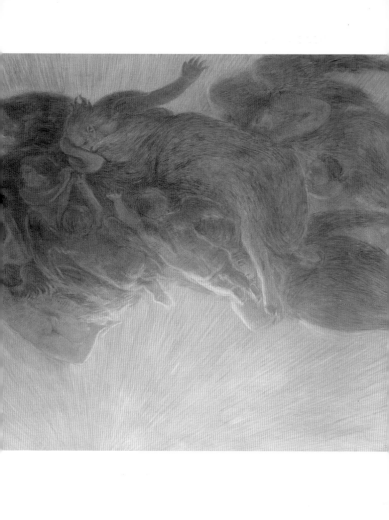

◀◀ ◀───────────────────────────────────

# *The First Day*

───────────────────────────────── ▶▶ ▶

This scene represents the creation of the world with the Christ-Logos that, as we shall see later on, symbolizes in Christian theology the creating aspect of God. This fresco may be considered a "summary" of the primordial week, with the earth at the center supported by the winds (we can identify the shapes of Italy and the Mediterranean basin, Europe, Africa, and Asia), the seven planetary spheres, and the zodiacal band, in accordance with the Ptolemaic tradition.

The gold background represents the empyrean, and the outer band the eternal paradise. The creating Christ-Logos is depicted as he sets the world into motion. To do so, he appears in glory—that is, seated among the angels that form his throne, as sung in Psalm 80:2. Therefore, these angels are cherubim, although the painter has differentiated them as red seraphim and blue cherubim. The angels on the right, wearing white garments, are instead an extension of the creative power of God, as further illustrated in this book.

THE CREATION OF THE WORLD
Giusto de' Menabuoi
1370–78
Baptistery, Padua

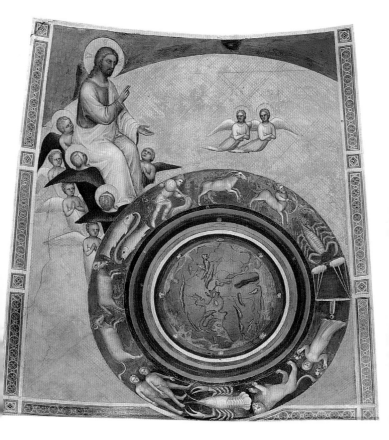

◄◄

# *The First Day*

Located in the narthex of Saint Mark's Basilica in Venice, this small cupola, known as the "Genesis mosaics," illustrates the biblical text up to the expulsion of our progenitors from the Garden of Eden. This mosaic draws its inspiration from a codex known as the Cotton Bible (see page 96). This is the second scene: the creation of light and its separation from darkness. It includes the creation of the angels who, according to Irenaeus (second century CE), are not gods but spiritual creatures that God created out of Time (John Damascene, seventh century CE). In fact, Time had yet to be created. The fact that this particular angel is half red (good) and half blue (evil) recalls the reflections of Saint Augustine (fourth to fifth century CE), according to whom the name "angel" refers not to the nature (which is not always good) but to the function of messenger.

GENESIS MOSAIC
(detail)
13th century
Basilica di San Marco, Venice

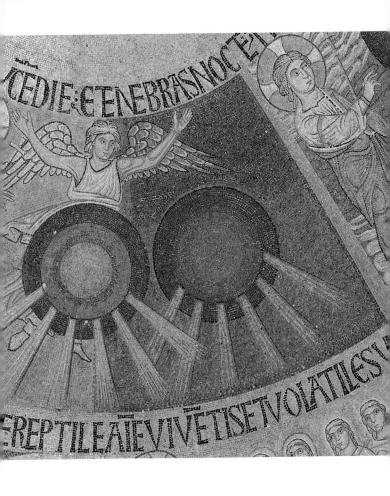

## *The Second Day*

> And God said, Let there be a firmament in the midst of the waters, and let it divide the waters from the waters. And God made the firmament, and divided the waters which were under the firmament from the waters which were above the firmament: and it was so. And God called the firmament heaven. And the evening and the morning were the second day.

The second day shows the separation of the waters, which, it is important to note, are neither the sea nor the rain, but the cosmic waters in which floats the sphere of the firmament. "Firmament" is the meaning of the Greek term *steréoma* in the version of the Bible known as the Septuagint—that is, "what is steady, unmoving," corresponding to the Latin *firmamentum*, and it is where God is to place the earth, the sun, the moon, and the stars. All the phases of Creation illustrated in this cupola include an increasing number of angels, according to the sequence of Creation. There is one angel on the first day, and now, on the second day, two.

GENESIS MOSAIC
(detail)
13th century
Basilica di San Marco, Venice

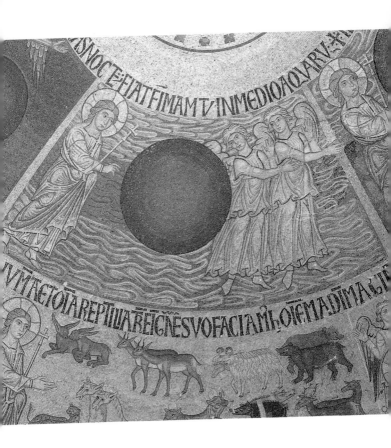

# The Third Day

"And God said, Let the waters under the heaven be gathered together unto one place, and let the dry land appear: and it was so. And God called the dry land earth; and the gathering together of the waters called he Seas: and God saw that it was good. And God said, Let the earth bring forth grass, the herb yielding seed, and the fruit tree yielding fruit after his kind, whose seed is in itself, upon the earth: and it was so. [. . .] and God saw that it was good. And the evening and the morning were the third day."

In the vision of Pseudo-Dionysius (fifth century CE), which draws on the philosophy of Proclus (fifth century CE) and adapts it to Judeo–Christian thought, the angels are intermediate beings who proceed from God and to him return. They are *dunámeis*, that is, "powers," a sort of personification of the creative power of God. We should also stress another aspect: According to the Ptolemaic universe and to Gnostic thought, each of the powers of the celestial spheres (the angels) is attributed one of the seven vowels of the Greek alphabet. Nichomacus of Gerasa (second century CE) called these *storichéia*, "letters," but another translation is "elements." It is an additional consonance with the scenes from this Venetian mosaic, where the angels are signs of the creative power of God.

GENESIS MOSAIC
(detail)
13th century
Basilica di San Marco, Venice

18

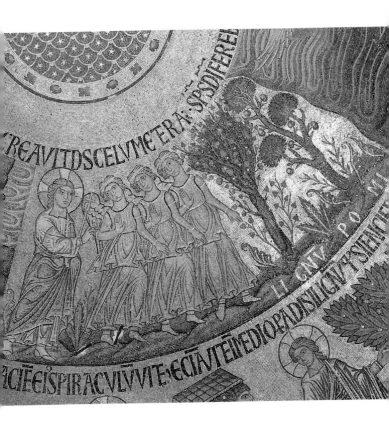

# *The Fourth Day*

> And God said, Let there be lights in the firmament of the heaven to divide the day from the night; and let them be for signs, and for seasons, and for days, and years: And let them be for lights in the firmament of the heaven to give light upon the earth: and it was so. And God made two great lights; the greater light to rule the day, and the lesser light to rule the night: he made the stars also. And God set them in the firmament of the heaven to give light upon the earth, and to rule over the day and over the night, and to divide the light from the darkness: and God saw that it was good. And the evening and the morning were the fourth day.

Christ is the Word, the Logos, the Son who is also the Father, but also the Word of the Father; hence, he is God's declension in act. For this reason, the Christ-Logos appears in this Venetian mosaic. Interestingly, he is not represented in a blessing posture: His hand is in the *adlocutio* gesture, typical of someone speaking. It is not by coincidence that the text begins with "And God said . . ."

At this point, the function of the angels who increase day by day is made clear: They are the words of God which, pronounced by the Christ-Logos, become creative power, and in the Gnostic vision, they are the *protoktístoi*, the seven angels who were created first. On the fourth day, Time is created, along with the sun, the moon, and the stars.

GENESIS MOSAIC
(detail)
13th century
Basilica di San Marco, Venice

20

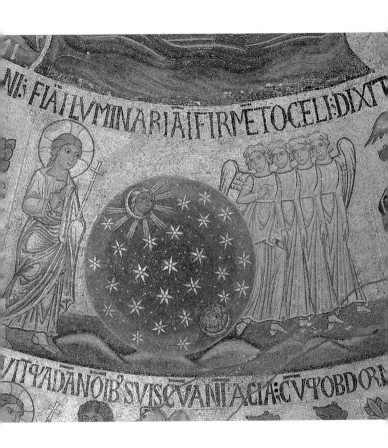

# *The Fifth Day*

> And God said, Let the waters bring forth abundantly the moving creature that hath life, and fowl that may fly above the earth in the open firmament of heaven. And God created great whales, and every living creature that moveth, which the waters brought forth abundantly, after their kind, and every winged fowl after his kind: and God saw that it was good. And God blessed them, saying, Be fruitful, and multiply, and fill the waters in the seas, and let fowl multiply in the earth. And the evening and the morning were the fifth day.

The beauty of the creation of the animals, the fishes, the birds, even the "great whales" cited in the text is visible in the three sections of the mosaic cycle of Saint Mark's Basilic. Interestingly, the birds are set next to the five angels who, in the middle frame, refer to the fifth day of the primordial biblical week. We also note that a number of texts liken birds to angels, since both "inhabit" the sky and the air. In one passage, Philo Judaeus (first century CE) explains how the air is filled with visible beings (the birds) and spiritual beings (the souls). The latter are divided into two classes: those that fly at a low level and become incarnated in bodies, and those that have a more divine nature—the angels.

GENESIS MOSAIC
(detail)
13th century
Basilica di San Marco, Venice

22

# The Sixth Day

> And God said, Let us make man in our image, after our likeness: and let them have dominion over the fish of the sea, and over the fowl of the air, and over the cattle, and over all the earth, and over every creeping thing that creepeth upon the earth. So God created man in his own image, in the image of God created he him; male and female created he them. And God blessed them, and God said unto them, Be fruitful, and multiply, and replenish the earth, and subdue it: and have dominion over the fish of the sea, and over the fowl of the air, and over every living thing that moveth upon the earth. [. . .] And it was so. And God saw every thing that he had made, and, behold, it was very good. And the evening and the morning were the sixth day.

In order to describe the phases of the creation of man, the cupola was divided into two sections, separated by the scene of the seventh day. The larger section (see opposite page) shows the Christ-Logos fashioning a puppet from brown clay, with the sixth angel, corresponding to the sixth day, next to him. In the second section, the Christ-Logos speaks, or rather breathes into the soul, repre-sented as a classic *éidolon* (a symbol of Psyche, the soul), complete with butterfly's wings, in what has now become Adam. This scene evokes a reflection on the difference between the Hebrew term *ruah*, "spirit," what God breathed into Adam, and *nephesh*, "the vital soul." With that breath, therefore, the clay doll became akin to the spirit of the angels.

GENESIS MOSAIC
(detail)
13th century
Basilica di San Marco, Venice

24

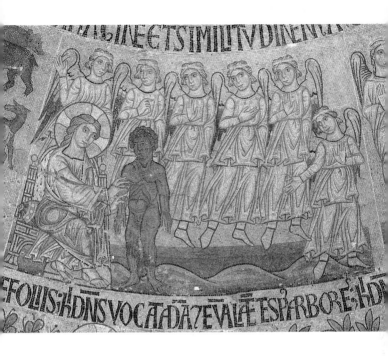

…AGINE ET SIMILITVDINE NR…

EFOLIIS · ADNS VOCATA DA ZEVLA Æ ESP ARBORE · HDN

# The Seventh Day

> Thus the heavens and the earth were finished, and all the host of them. And on the seventh day God ended his work which he had made; and he rested on the seventh day from all his work which he had made. And God blessed the seventh day, and sanctified it: because that in it he had rested from all his work which God created and made. These are the generations of the heavens and of the earth when they were created.

In the last scene of this Venetian mosaic cycle, the correspondence between angels and days is an intimate one, leading some scholars to rashly suggest a personification of the Hours, or merely temporal allegories. At the center, dressed in a sumptuous gold pallium (a large, rectangular mantle), the Christ-Logos is now seated on the throne, in achievement and crowning of the primordial week. Around him, like a royal retinue, are six angels arranged symmetrically from left to right. In front, kneeling, the seventh angel, corresponding to the seventh day, receives God's blessing. Now the work is completed, and its creator consecrates it through the seventh day.

GENESIS MOSAIC
(detail)
13th century
Basilica di San Marco, Venice

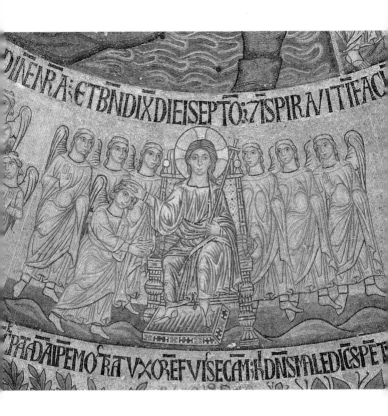

# The Creation of Adam and Eve

▶▶

" And the LORD God formed man of the dust of the ground, and breathed into his nostrils the breath of life; and man became a living soul. [. . .]And the LORD God said, It is not good that the man should be alone; I will make him an help meet for him. [. . .] And the LORD God caused a deep sleep to fall upon Adam and he slept: and he took one of his ribs, and closed up the flesh instead thereof; And the rib, which the LORD God had taken from man, made he a woman, and brought her unto the man. And Adam said, This is now bone of my bones, and flesh of my flesh: she shall be called Woman, because she was taken out of Man. Therefore shall a man leave his father and his mother, and shall cleave unto his wife: and they shall be one flesh. "

The uniqueness of Lorenzo Maitani's relief is due not only to the inclusion of the angels watching the scene and expressing sorrow for the destiny of this new creature, but also to the replacement of the image of the creator God with the Christ-Logos, identified by the short beard and the long hair falling on his shoulders. A third important element is the likeness between Christ and Adam, created on purpose as homage to the biblical text, which says "God created man in his own image."

STORIES OF GENESIS
(detail)
Lorenzo Maitani
1320
Cathedral, Orvieto

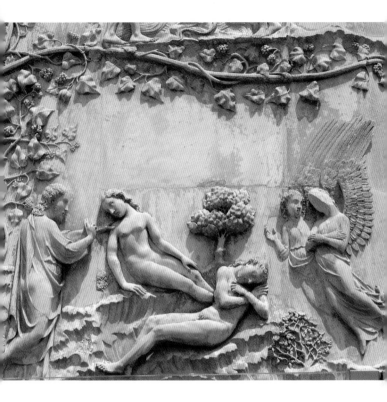

◀◀

# *The Creation of Adam and Eve*

▶▶

The presence of musical angels on the upper section of the panel, part of an altarpiece dedicated to Saint Peter, alludes to the achievement of cosmic harmony. The two small angels in the upper corners, in fact, are playing two stringed instruments—a *lira da braccio* and a cittern—for these, unlike pipes, were believed to more aptly reproduce the rhythms of the music of the universe, which,

according to Plato, was a sort of immense "cosmic music box" where the celestial spheres played sublime music. Yet this was still an imperfect mirror of the unreachable divine harmony. The instant when God created Eve, thereby completing the human world by creating the female half, is seen as the concrete application of this concept of the harmony that pervades the world.

GRABOWER ALTAR
(detail)
Master Bertram von Minden
*c.* 1379
Kunsthalle, Hamburg

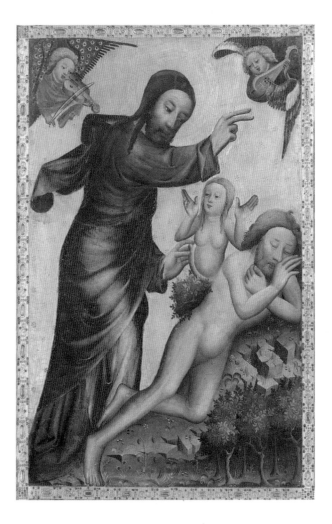

Genesis 2:7 and 18–24

◄◄

# The Creation of Adam and Eve

►►

In his *Gates of Paradise*, Ghiberti
sculpted various scenes inside each
panel; this particular panel is
dedicated to Adam and Eve and
depicts the creation of Adam in
the lower left corner, as well as
the expulsion from paradise.
Interestingly, the artist placed the
creation of Eve at the center of the
panel, thus conferring an unusual
importance to the episode, further
heightened by the presence of the
angels, who help Eve extricate
herself from the side of the first
man, as if she were Adam's better
half, the one through whom life is
transmitted.

GATES OF PARADISE
Lorenzo Ghiberti
1425–52
Museo dell'Opera
di Santa Maria del Fiore, Florence

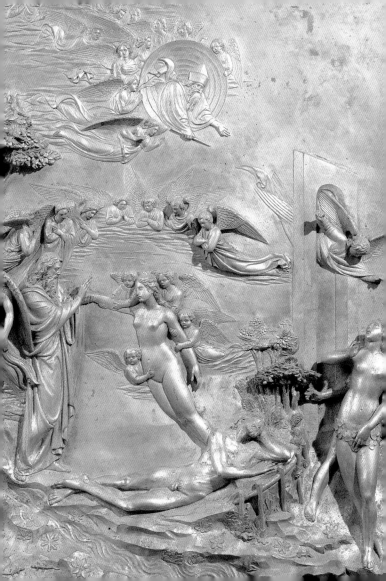

◄◄

# The Creation of Adam and Eve

►►

Undoubtedly one of the most celebrated images in the history of art, this scene has become part of the collective imagination, and is considered the creation of Adam par excellence. It is interesting to note that in Michelangelo's fresco the angels supporting God have often been interpreted to represent the souls of those who are to be born in the millennia to come. Much more likely, though, it is the Renaissance-style transposition of the concept of divine retinue and the epiphany of God in glory who, in all his might (and angels are *dunámeis*, or "powers"), creates man.

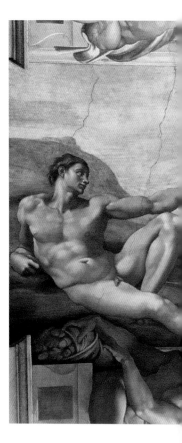

THE CREATION OF ADAM
(detail)
Michelangelo Buonarroti
1508–12
Sistine Chapel,
Vatican Palace, Vatican City

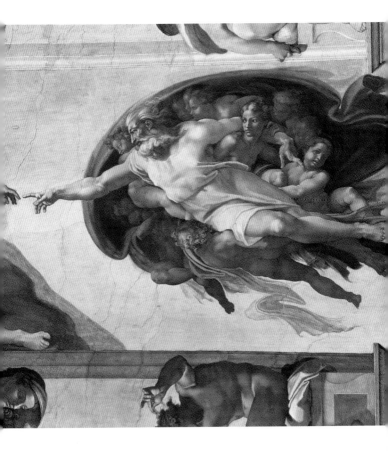

◄◄◄

# *The Creation of Adam and Eve*

The figure of God the creator is here replaced by an angel with outspread wings: the angel of God, who, in the biblical conception, must be always identified with God himself. The Lord uses this personification when he appears before the eyes of men and comes into contact with the material world. In Genesis, no angels are mentioned; in order to safeguard the Hebrew conception of monotheism, it is God who creates all things. The presence of the angel in this painting is part of Marc Chagall's dreamlike approach to the biblical tale. However, this scene is also a sort of "summary" of what shall be man's destiny. On top, as if in a vortex, we see the Tables of the Law, Jacob's Ladder, and, highly unusual in a Jewish context, the crucified Christ.

THE CREATION OF MAN
Marc Chagall
1956–58
Message Biblique Marc Chagall,
Musée National, Nice

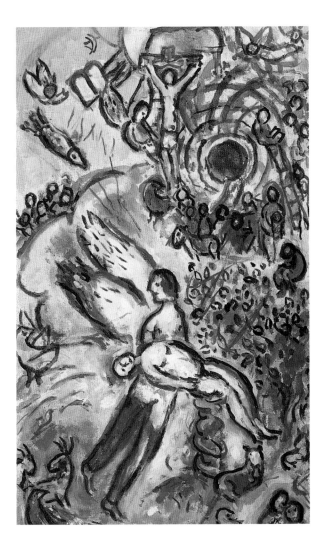

# The Original Sin

> And when the woman saw that the tree was good for food, and that it was pleasant to the eyes, and a tree to be desired to make one wise, she took of the fruit thereof, and did eat, and gave also unto her husband with her; and he did eat.

Just before the creation of Adam scene, Michelangelo places the original sin scene next to the expulsion from paradise. It is interesting to note how the artist positioned the angel banishing our progenitors next to the tempting serpent, as if they were two faces of the same coin—that of God's design for redemption. It is not by coincidence that in the *exultet*—the rolls on which the liturgical chant sung during the Good Saturday rituals was transcribed and illustrated—the original sin is called *felix culpa*, or the "happy fault." According to a specific iconographic tradition, the serpent resembles a woman, with blond hair and breasts. At the center of this scene is the tree of the knowledge of good and evil, a fig tree that separates the blessedness now lost on the left from the impending punishment on the right, the direction in which they are being forcefully driven by the angel.

THE FALL AND EXPULSION
FROM THE GARDEN OF EDEN
(detail)
Michelangelo Buonarroti
1508–12
Sistine Chapel,
Vatican Palace, Vatican City

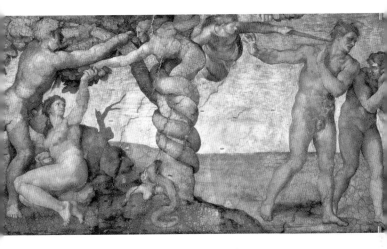

# The Original Sin

This painting by Cranach has a clearly apocalyptic air, as shown by the presence of Christ, recalling Saint John's vision of the Son of Man who appears at the end of time (Revelation 1:12–16). The text describes a man with white hair and a sword coming out of his mouth; the artist has interpreted it as a flowering branch and placed it next to Christ, who fully embodies John's vision. On top, angels are blowing the trumpets of the Last Judgment. The presence in the painting of two scenes—that of the original sin in the lower left corner, and the scene from Revelation—is intentional: They symbolize the Alpha and the Omega of human history, the closing of the circle and the full revelation of God's design. For this reason, the presence of the bronze serpent on the right (Numbers 21:8–9) recalls Christ's act of salvation.

FALL AND REDEMPTION OF MAN
(detail)
Lucas Cranach the Elder
1529
Schloss Friedenstein Museum, Gotha

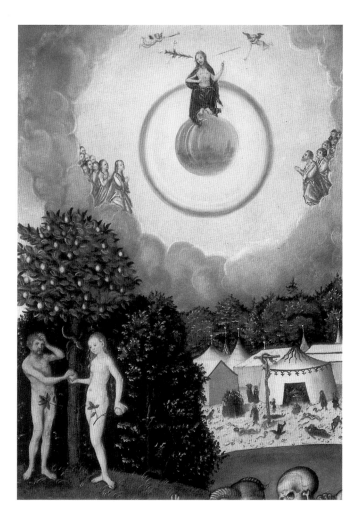

◀◀ ◀

# *The Original Sin*

The central scene in Tintoretto's work is the one described in the Bible: Eve has taken a bite of the apple and, finding it tasty, offers it to Adam. The identification of the tree of the knowledge of good and evil with an apple tree is the result of an improper linguistic transfer: In Latin, *malum* means both "apple tree" and "evil." Therefore, in the Garden of Eden, it is the tree of evil that causes Adam and Eve to fall from the level of wisdom to that of mere knowledge. An interesting detail is the presence of the angel in the specific role of executor of God's will. For this reason, it is the only point of light in a scene that has otherwise been deliberately painted with earthen tones, a chromatic metaphor for the darkness of sin that Adam and Eve are about to enter.

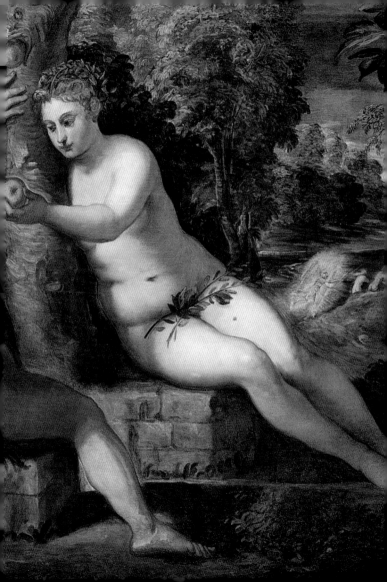

# Adam and Eve Rebuked

▶▶

"And the eyes of them both were opened, and they knew that they were naked; and they sewed fig leaves together [. . .] And the LORD God called unto Adam, and said unto him, Where art thou? And he said, I heard thy voice in the garden, and I was afraid, because I was naked; and I hid myself. And he said, Who told thee that thou wast naked? Hast thou eaten of the tree, whereof I commanded thee that thou shouldest not eat? And the man said, The woman whom thou gavest to be with me, she gave me of the tree, and I did eat. [. . .] Unto the woman he said, I will greatly multiply thy sorrow and thy conception; in sorrow thou shalt bring forth children [. . .]. And unto Adam he said, Because thou hast hearkened unto the voice of thy wife, and hast eaten of the tree, [. . .] cursed is the ground for thy sake."

Wiligelm has placed the scene in which the Lord reproaches Adam and Eve right next to the expulsion from the Garden of Eden, a narrative choice that stresses God's will as, on the left, he turns to our progenitors with a questioning gesture while, on the right, his shoulders to the Omnipotent, the angel who is acting as his emissary expels them. The contiguity of the two scenes suggests a close relationship between God and the angel, similar to that of judge and bailiff.

ADAM AND EVE REPROACHED
(detail)
Wiligelm
1099–1106
Cathedral, Modena

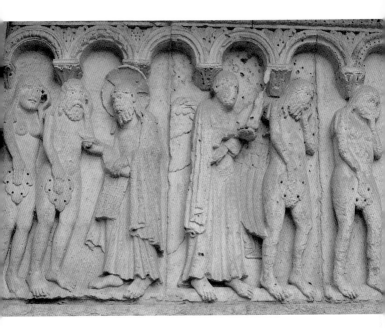

◀◀ ◀━━━━━━━━━━━━━━━━━━━━━━━━━━━━━━━━━━━━━━━━━━━━━

# *Adam and Eve Rebuked*

It is not difficult to understand which model inspired Domenichino. The *Creation of Adam* that Michelangelo painted on the Sistine Chapel suggested to the Bolognese artist the figure of the Lord supported by angels arrayed inside a wide mantle blown by the wind. The painter has used the gesture of God the creator as a gesture of reproach to our progenitors. We see them on the lower left awkwardly trying to find excuses. Adam, already wearing a girdle made of leaves, points to Eve as the sole culprit; in turn, she points to the serpent, while covering herself with her hand. In the upper part of the painting are the heads of the cherubim and a pair of angels peacefully commenting on the episode: One of them points to the scene, while the other invites him to be quiet.

ADAM AND EVE
(detail)
Domenico Zampieri, known as Domenichino
1623–25
Musée des Beaux-Arts, Grenoble

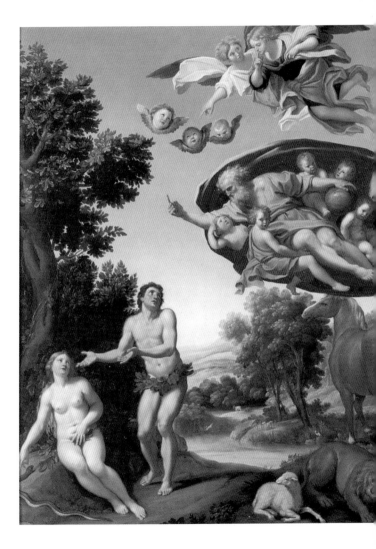

# The Expulsion from the Garden of Eden

> Therefore the LORD God sent him forth from the garden of Eden, to till the ground from whence he was taken. So he drove out the man; and he placed at the east of the garden of Eden Cherubims, and a flaming sword which turned every way, to keep the way of the tree of life.

The sculptor of the doors of the cathedral of Hildesheim created an image that is not faithful to the biblical text, though it has achieved great popularity. Here, an angel expels our progenitors from Eden, whereas the Scriptures attribute this action to the Lord. In the upper panel of this three-part narrative, God, a Bible in hand, imperiously turns to Adam and Eve, who have repented and are embarrassed by their nakedness. The presence of the angel is perhaps due to the artist's intention to keep God away from direct action: The angel interprets visually both God's act and his role of watchman, usually attributed to a cherub, who does not appear in this relief.

EXPULSION FROM THE GARDEN OF EDEN
(detail)
1015
Cathedral, Hildesheim

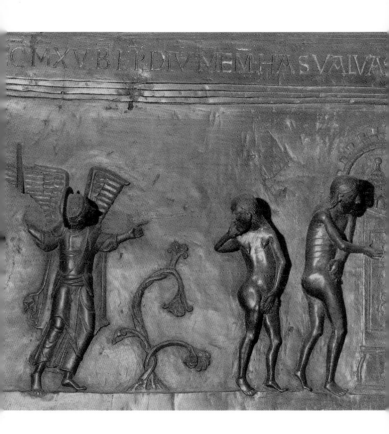

# The Expulsion from the Garden of Eden

This lovely miniature from a copy of *De Rerum Naturis* [*On Nature*] by Rabanus Maurus (d. 856)—bishop of Mainz and a theologian—shows the real intent of the author of the biblical text. Here, as in all medieval iconographic tradition, we find in the center the door to earthly paradise, likened simply to paradise, with its four rivers. Apparently above, but in reality behind, is the tree of life, which in this case is a fig tree. Next to the door, almost like sentries, are the cherubim (their identity is clear, though their imagery has been mixed with the seraphim's) with flaming swords that, for symmetrical reasons, have been placed in each hand. Many scholars have argued that this image is inspired by the well-known images found on Mesopotamian seals, which are contemporaneous with the Bible and depict griffins, here transformed into the cherubim that protect the tree of life.

THE CHERUBIM GUARD THE
TREE OF LIFE
1022–35
Archives of the Abbazia di Montecassino,
Montecassino

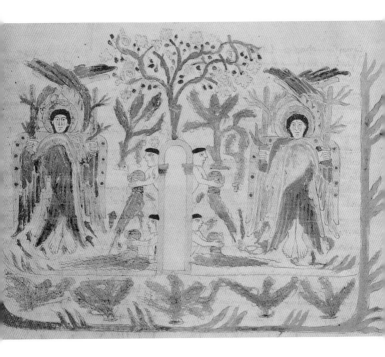

◄◄

# The Expulsion from the Garden of Eden

►►

This scene sculpted by Wiligelm for the Modena Cathedral is part of a series of friezes, the so-called "Genesis friezes," that decorates the facade of the building. In this case, the sculptor has begun the narrative by depicting the Lord as he points an accusing finger against our progenitors, who cover themselves, in shame, with a fig leaf (see pages 44–45). It is an appropriate scene, because the Lord, who is also the Christ-Logos, seems to visibly turn into the angel who expels the first couple. Christ and the angel are shoulder to shoulder, like the open pages of the same ideal book. Recently restored, the relief shows an angel brandishing a sword, dressed in tunic and mantle. The arches in the background that run along the length of the slab suggest the walls of the paradise that Adam and Eve are leaving behind.

THE EXPULSION FROM THE GARDEN OF EDEN
(detail)
Wiligelm
1099–1106
Cathedral, Modena

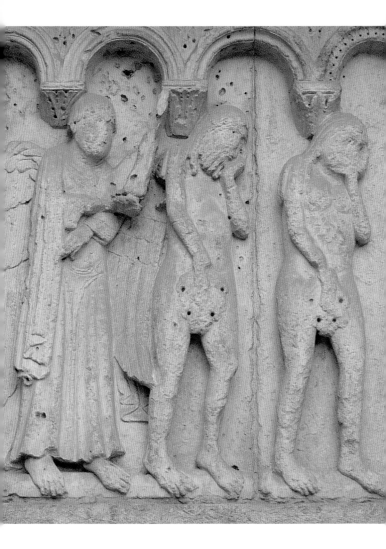

# The Expulsion from the Garden of Eden

This scene, part of a mosaic narrating the episodes from Genesis that runs along the lateral walls of the large central nave of the Monreale cathedral, follows an iconography that in some ways is more faithful to the text than the examples we have seen so far. The artist has distinguished two moments of the expulsion: At the center is the angel dressed in snow-white robes doing the Lord's bidding by forcefully driving Adam and Eve out of paradise. The first couple is wearing skins instead of the traditional fig leaf, a sign that they have become part of history and are ready to "labor in sweat and give birth in sorrow." To the left, a turreted building marks the entrance to paradise, now inexorably shut; it is guarded by a red cherub; the color has crossed over from the imagery and color of the seraphim. Note the hand that is expected to hold the flaming sword, never completed. At the top is an inscription, a quotation from the Vulgate version of the Bible.

EXPULSION FROM PARADISE
12th–13th century
Cathedral, Monreale

HIC · EXPVLIT · ADÃ · 7 · EVÃ · DE ·
DISO · DS · 7 · POSVIT · CHERVBIN ·
TODE · CV · FLAMEO · GLADIO ·

# The Expulsion from the Garden of Eden

This mosaic from the Florence Baptistery follows the traditional iconography that attributes the task of expelling our progenitors to a cherub. It is a deviation from the biblical narrative, however, where it is God who drives Adam and Eve from the Garden of Eden and the cherubim's only task is to stand guard at the entrance to this place, now lost. Here the situation is mixed, though the result is highly effective and very suggestive. The image of the cherub brandishing a sword (another difference, though understandable) has in turn been contaminated by the imagery of the seraphim; hence, he has six wings instead of four, and his color, traditionally blue, is now red.

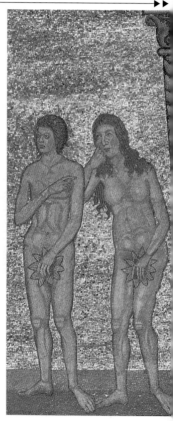

THE EXPULSION FROM THE GARDEN OF EDEN
(detail)
13th–14th century
Baptistery, Florence

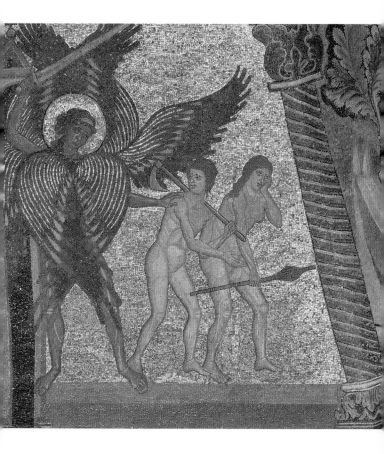

# The Expulsion from the Garden of Eden

Designed as a sort of aquatic orb, the paradise painted on this panel has a round shape sealed by the door, against which the red outline of the cherub stands out. The surrounding trees form a kind of fortified wall, inside which we can observe the first stages of the creation of man. The composition is dominated by the presence of angels: An angel helps the Lord create Adam from clay, and later, after Adam has sinned, another angel with a sword metes out God's punishment. This work has other interesting details: Our progenitors are half-naked only when they are expelled. They were formerly dressed in glory robes; now they sit frightened on the ground, far from paradise, dressed in simple tunics that symbolize the misery of their earthly condition.

CREATION OF ADAM AND EXPULSION
FROM THE GARDEN OF EDEN
(detail)
14th century
Museum of History and Art, Solvychegodsk

# The Expulsion from the Garden of Eden

The great novelty in the solution devised by Giusto de' Menabuoi in this fresco is the militaristic interpretation of the angel who banishes Adam and Eve. If on one hand this interpretation, contaminated by apocryphal versions, strains the biblical tale, on the other hand, the idea of Michael as the executive arm of divine justice was growing in the popular imagination.

Certainly, the artist was thinking about the archangel Michael, and eloquently surrounded his head with a halo. The angel's garb is also telling: a compromise between the military dress of the time of the artist (complete with iron shoes, shin guards, and knee pieces) and the classical uniform of ancient Roman soldiers with the *lorica* (a leather cuirass), which appears often in angelic images. Note that our progenitors have already been sentenced to farm labor (Adam holds a hoe) and household chores (Eve holds a spinning distaff).

ADAM AND EVE
(detail)
Giusto de' Menabuoi
1370–78
Baptistery, Padua

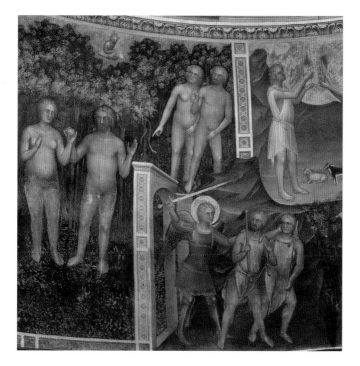

# The Expulsion from the Garden of Eden

In the Guimerà retable, characterized by the typical calligraphic text of the international Gothic style, master Ramon de Mur has pictured the earthly paradise as an immense, precious garden, rich with wonderful plants and flowers, and enclosed by high, turreted walls. This detail narrates one crucial element of the episode—the banishment: An angel with red wings (identifying him as a cherub), forcefully escorts our progenitors outside the walls.

Their dejected expression is arresting; they cover their naked parts with their hands and a fig leaf in a spontaneous gesture of modesty.

Finally, the ecclesiastical flavor of the angel's garb is interesting: He is wearing a hood and an *amitto* (a broad stole). In the artist's interpretation, the angel's task is clear: escort Adam and Eve, and afterward guard Eden's door to prevent anyone from entering.

ADAM AND EVE EXPELLED
FROM THE GARDEN OF EDEN
(detail)
Ramon de Mur
1402–12
Museu Episcopal de Vic, Barcelona

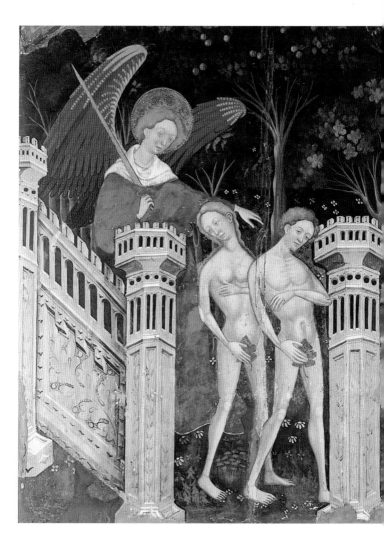

# The Expulsion from the Garden of Eden

The sense of completeness in the scene of the deacon's door of the cathedral of Solvychegodsk (see pages 58–59) returns, albeit in a different artistic medium: this miniature from the *Très Riches Heures du Duc de Berry* by the Limbourg brothers. The circular layout of the composition, the round mountain range, and the encircling walls that "float" on an intensely blue sea, attempt to represent the cosmic dimension of the scenes occurring in the Garden of Eden around the fountain of paradise. Not by coincidence, the viewer's eye is drawn to the final scenes of the episode. The chronological sequence moves from left to right: We see Eve allowing herself to be tempted by the serpent (who, not by chance, has a woman's face similar to Eve's), Adam being tempted, God's reproach and, finally, the banishment beyond the door of paradise where, in full biblical tradition, an elegant red cherub then takes up guard duty.

EXPULSION FROM PARADISE
Limbourg brothers
*c.* 1416
Musée Condé, Chantilly

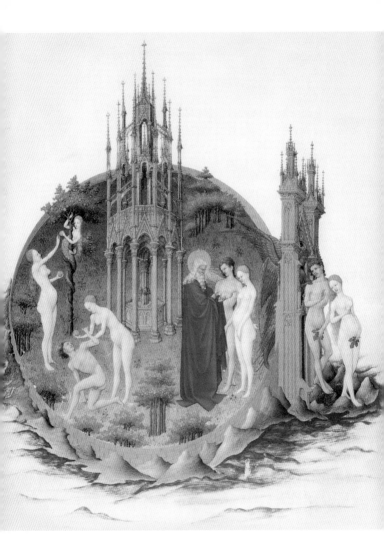

# The Expulsion from the Garden of Eden

Undoubtedly, the most celebrated scene illustrating the expulsion from paradise is that of Masaccio, which was recently restored. This work has several peculiarities, starting from the angel's red figure: Because of the color used, the angel is the meeting point between the traditional imagery of the angel and the literary tradition of the biblical text, which speaks only of a cherub. Tall and majestic, dressed in a *guarnello*—as was typical of Quattrocento angels—he brandishes a dark sword, the threatening shape of which recalls the flaming sword mentioned in the Bible text. The fact that the angel is on a cloud as red as his dress is explained, as we can see from other examples in the following pages, by his aerial, spiritual nature. To the left, we glimpse the door of the paradise that our progenitors are leaving behind. The composition contrasts the whiteness of the gate with the barren rocks of an arid, hostile world.

THE EXPULSION FROM THE GARDEN OF EDEN
(detail)
Masaccio
1424–25
Brancacci Chapel,
Santa Maria del Carmine,
Florence

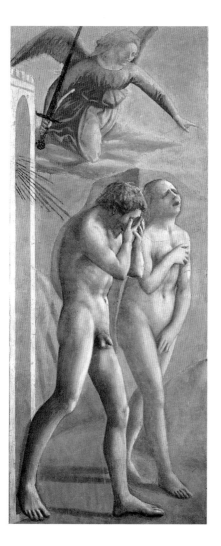

# The Expulsion from the Garden of Eden

The peculiarity of Giovanni di Paolo's rendering is his portrayal of the angel who banishes Adam and Eve as naked. Undoubtedly an unusual image, it is difficult to identify both the iconographic source and the theological rationale for it. It is important, however, to note the different value attributed to the nakedness of Adam and Eve and that of the angel, highlighted by the fact that the artist has covered the latter's private parts with a white flower to signify purity, like the nearby lily branch. On the other hand, the human couple is next to a hare, a symbol of lust. This painting is filled with allegories, especially of paradise (note, at the bottom right, the four rivers: Pison, Gihon, Tigris, and Euphrates). Other angels in the picture are the group of blue seraphim supporting the figure of God the creator.

THE CREATION AND THE EXPULSION
FROM PARADISE
Giovanni di Paolo
*c.* 1445
Metropolitan Museum of Art, New York

# The Expulsion from the Garden of Eden

The left panel of Bosch's famous *Haywain* triptych is dedicated to Adam and Eve and ends with a close-up of the first couple being banished from paradise. The main scene takes place before the bare, rocky opening of a cave, a natural ravine that serves as an entrance and evokes bleak architectural forms. All around are thorny bushes. The angel, dressed in a cassock, his mantle swept by the wind, raises his sword with a threatening gesture, while our two progenitors try to fight fate. Eve touches her cheek in a sign of regret, while Adam seems to be asking the angel, "Why?" In the garden beyond the door is the original sin scene (the serpent has the same face as Eve), while the creation of Eve is glimpsed in the background, a distant memory of happiness now lost.

HAYWAIN
(detail)
Hieronymus Bosch
1485–90
70  Museo del Prado, Madrid

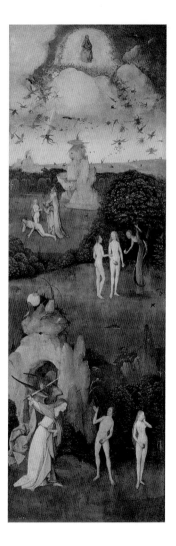

# The Expulsion from the Garden of Eden

Hieronymus Bosch painted the creation of Eve in the foreground of the left panel of this triptych, the *Last Judgment*, but without details. We see the Christ-Logos acting as creator, caught in the simple gesture of lifting Eve from a kneeling position, a gallant sort of act. The episodes of the sin and the expulsion follow: The angel who banishes our progenitors, unlike in other representations, does not drive them from the scene; rather, he guides them to a Dante-esque forest, which symbolizes the darkness of sin and is understood as a lack of divine grace. The colors notwithstanding, the panel projects a disturbing atmosphere, reinforced by the cloud of insects and diabolical beings that some angels are causing to fall to earth.

THE LAST JUDGMENT
(detail)
Hieronymus Bosch
*c.* 1482
Akademie der Bildenden Künste, Vienna

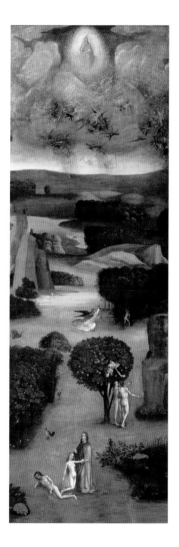

# The Expulsion from the Garden of Eden

The composition of this miniature, taken from an antiphonary, is characterized by the presence, on top, of the allegory of justice that is purposely identified with the biblical image of the angel with the sword. Inside the decorated frame are the various phases of our progenitors' history, which revolves around the sinful moment when Eve offered Adam the fatal fruit, here rendered as a fig in the central scene that is painted on a larger scale. In the background on the left, we see the creation of Adam, and below that, Eve born from one of his ribs; on the right is a scene capturing a moment of quiet, serene joy; in the background, our progenitors are banished, a scene that recalls Masaccio's (see pages 66–67) in their attitude and in the color and style of the robe that the angel is wearing.

THE STORY OF ADAM AND EVE
Monte di Giovanni
1516–28
Museo dell'Opera di Santa Maria del Fiore, Florence

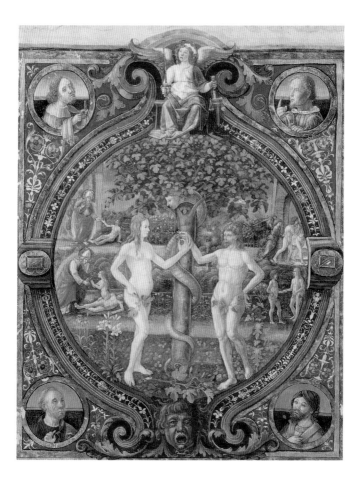

◄◄

# The Expulsion from the Garden of Eden

►►

This work by Raffaello—who was aided by his best assistants, including Giulio Romano and Giovan Francesco Penni (known as il Fattore) for the frescoes and Giovanni da Udine for stucco work—marks an important moment in the development of religious iconography that transcends the Renaissance period. Still, although this work was executed by Raphael's workshop (using his cartoons), it must be treated as the Master's version of the banishment from paradise. His inventive addition to the scene is the set of stairs, here used as an architectural element as well as an easy reading device, since it explains visually the couple's situation: As they leave Eden, they are walking downward to an undoubtedly inferior condition. Adam's figure recalls that of Masaccio; the angel increasingly resembles a winged Victory, partly due to similarities between the classical *chiton* and the bouffant *guarnello*.

THE EXPULSION FROM THE GARDEN OF EDEN
Workshop of Raphael
1518–19
Logge del Palazzo Apostolico, Vatican City

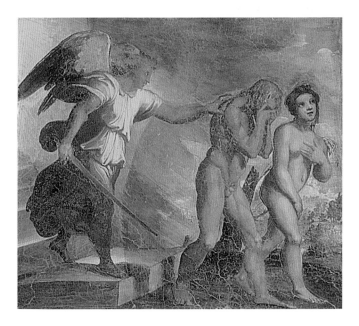

# The Expulsion from the Garden of Eden

This drawing, executed with mixed media (black pencil over water-colored sepia), superbly reproduces the livid, ashen atmosphere of the moment of banishment from paradise. The angel, by now rendered in classical form with a large pair of wings and wearing a sort of *chiton*, expresses the fullness of God's rage falling on the disobedient couple. Although he brandishes a sword (we only see the hilt's pommel), the angel seems to be whipping them, as a peasant does with a stubborn ass. This strong comparison clarifies the artist's intent in creating this type of composition: Adam and Eve try to avoid the blows and flee, frightened and ashamed, covering their heads against the force of the angel's blows and seeking comfort in each other's frightened looks. This drawing, probably part of Villa Pelucca's decorations (the frescoes are now conserved at the Accademia di Brera), is certainly the work of artists from Bernardino Luini's circle, and was possibly done by the master himself.

THE EXPULSION FROM THE GARDEN OF EDEN
Bernardino Luini (attr.)
1520–23
Gallerie dell'Accademia, Venice

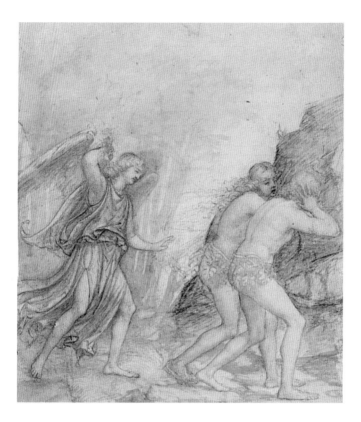

# The Expulsion from the Garden of Eden

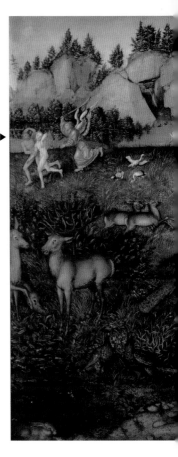

In the foreground scene, the Lord entrusts our progenitors with the care of the earthly paradise and the task of naming all the animals. The dog curled up next to Eve is a dark omen, however, since he is in the *circulo mortis* ("circle of death") position, suggesting the impending tragedy. In the background are scattered scenes of Adam's creation, the original sin, the creation of Eve, and God's rebuke. To the left is the banishment scene where an angel, now wearing the typical red garment, runs after the couple like a herdsman with his cows, adding to the painting an amusing, folkloric touch.

THE PARADISE
Lucas Cranach the Elder
1530
Gemäldegalerie,
Kunsthistorisches Museum, Vienna

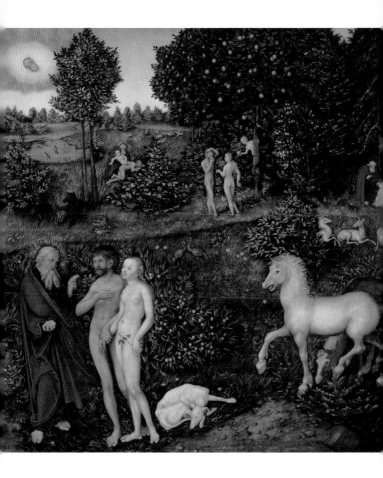

# The Expulsion from the Garden of Eden

The theme of the expulsion was adapted to the stylistic evolutions of art history, to be sure. This seventeenth-century painting by an anonymous artist from Emilia follows the canons of the new trend that, beneath an already stale Mannerism, hints at the luministic contrasts that would come to be typical of the mature Caravaggio school. In this painting as well, the presence of the angels is stressed: Divine heralds appear from the clouds, flanking the angel, who energetically pushes our progenitors out of Eden. This angel stands out for his deacon's habit, complete with a stole crossed over the chest. After all, even the priests may be considered a *militia Christi*, an army of Christ that can be symbolically compared to the heavenly army. From above, the Eternal opens his arms in a gesture of resignation that is also one of mercy. Realizing his fault, Adam hides his face in a fit of shame.

THE EXPULSION FROM THE GARDEN OF EDEN
Emilian school
17th century
Pinacoteca, Civiche Raccolte d'Arte Antica
del Castello Sforzesco, Milan

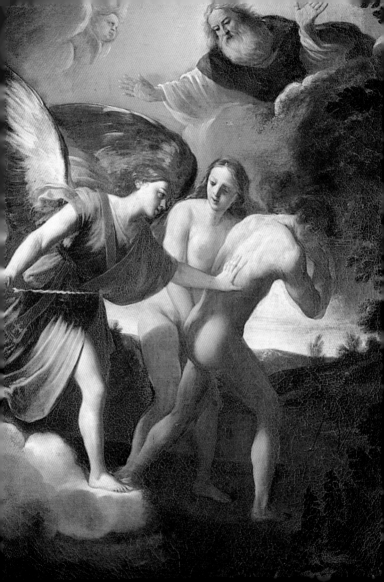

# The Expulsion from the Garden of Eden

It is not difficult to see, in this fresh painting by Amigoni, a Neapolitan artist who matured in the Venetian artistic milieu, an echo of Tiepolo's teaching, especially in the gauzy, atmospheric clouds and the slightly foreshortened perspective. The angel's image follows an iconography that by then tended to coincide with the models from pagan antiquity. In fact, the artist seems to antici-pate the future choices of a ripe Neoclassicism, when there would be no more formal differences between angels and winged genies. The angel who drives out the first couple is here totally naked, and only the presence of a cloud saves him from what could be an unusual and embar-rassing situation. On the other hand, the leafy wreaths covering Adam and Eve's private parts follow tradition.

THE EXPULSION FROM THE GARDEN OF EDEN
Jacopo Amigoni
18th century
Benedictine Abbey, Ottobeuren

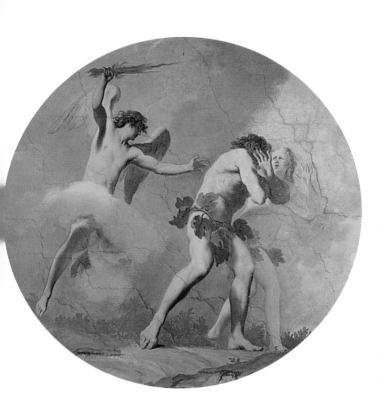

◄◄ ◄ ─────────────────────────────────────────

# The Expulsion from the Garden of Eden

──────────────────────────────────────────── ►►

This etching is part of a rich series created by John Martin, a visionary and inventive painter, to illustrate *Paradise Lost*, John Milton's 1667 poetic masterpiece. Hence, strictly speaking, this mezzotint (the technique used on copper plates) should not be included in this book; however, the subject is derived from the biblical text, even if Milton's imagination and poetry describe Adam and Eve's state of blessedness as they contemplated the angels, conversed with Raphael, and met Gabriel. It was the archangel Michael who expelled them after they sinned, but he does not appear directly here: His implacable presence is suggested only by a blinding radiance. The glare of Michael's light filters through the opening in the rocks surrounding Eden. It is from here that Adam and Eve will exit, then entering the darkness of sin to which they now inexorably belong.

ADAM AND EVE EXPELLED
FROM THE GARDEN OF EDEN
John Martin
1827
British Library, London

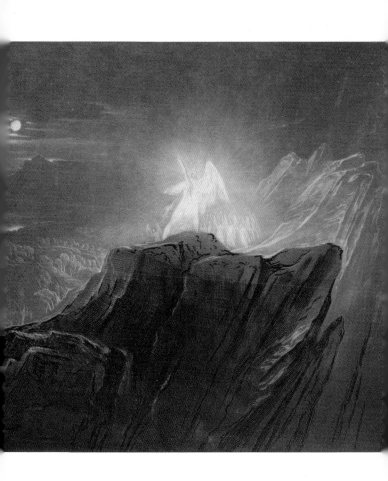

◀◀ ●————————————————————————————

# *The Expulsion from the Garden of Eden*

————————————————————————————————▶▶

The composition of this painting by a
member of the American Hudson
River School (which advocated paint-
ing landscapes on site to re-create
the suggestive, naturalistic scenery
of the Hudson River), revolves around
the contrast of light and shadow. The
scene is separated by a diagonal line
running downward from left to right
and separating grace from sin. In the
middle is the gate of paradise that
resembles the opening of an under-
ground cave, through which filters
the powerful glare of the divine light.
This dazzling light, which is the
angel (according to *Paradise Lost*,
the literary source for this painting,
it is the archangel Michael), drives out
our progenitors, whose spirits have
now been dimmed by disobedience.
Indeed, the two protagonists have
become insignificant figures who
bartered away eternity for death.

EXPULSION FROM THE GARDEN OF EDEN
Thomas Cole
1828
Museum of Fine Arts, Boston

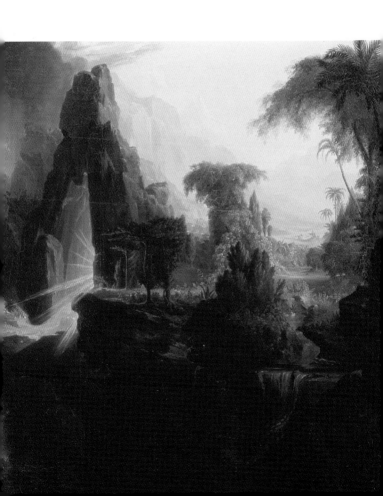

# The Expulsion from the Garden of Eden

Doré's etching is highly suggestive: The angel is the focus of the scene where Adam and Eve are banished from paradise. The iconography has become established by now, and the French artist has exploited with great skill the power of the etching technique to create strong contrasts. For this reason, instead of endowing the angel with a supernatural light, he uses natural lighting conditions, such as a forest at twilight, to evoke a different dimension; the light in the forest is God's light, a metaphor for the grace with which Adam and Eve were born, and which now they fear exceedingly. In fact, it is the light that drives the couple away, setting them off on a road that leads to the world of darkness. The angel is merely a sign that allows us to understand the real nature of that immense light.

THE EXPULSION
Gustave Doré
1866
Granger Collection, New York

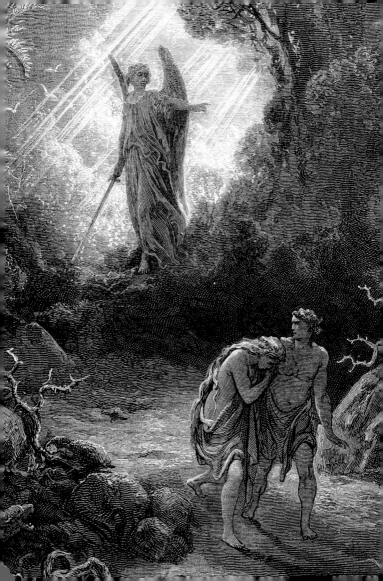

# Noah Builds the Ark

> And God said unto Noah, The end of all flesh is come before me; for the earth is filled with violence through them; and, behold, I will destroy them with the earth. Make thee an ark of gopher wood [. . .]. And this is the fashion which thou shalt make it of: The length of the ark shall be three hundred cubits, the breadth of it fifty cubits, and the height of it thirty cubits. A window shalt thou make to the ark, and in a cubit shalt thou finish it above; and the door of the ark shalt thou set in the side thereof; with lower, second, and third stories shalt thou make it.

The angel sitting on the edge of the ark under construction signifies that all this intense human activity is blessed by God. Noah's children, Shem, Ham, and Japheth; their wives; and the patriarch towering at the center of this tapestry are busy carrying wood, cutting logs, hammering nails, and gluing, thus fulfilling God's command. But the angel's presence is required for another reason as well: The building of the ark is tantamount to refounding the universe, one where iniquity and malice will be removed and where God's covenant with man will be saved and made stronger. The ark's measurements too, are symbolic, the three-level division corresponding to the three cosmic kingdoms: heavenly, human, and chthonic—i.e., underground.

NOAH BUILDS THE ARK
(detail)
Brussels manufactory
*c.* 1550
Wawel Castle, Krakow

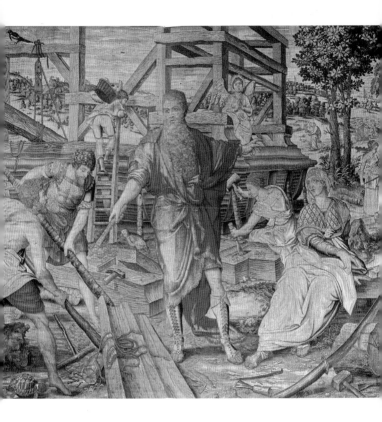

# Genesis 9:9–13

## *The Covenant Between God and Man*

> And I [God], behold, I establish my covenant with you, and with your seed after you; And with every living creature that is with you, of the fowl, of the cattle, and of every beast of the earth with you; from all that go out of the ark, to every beast of the earth. And I will establish my covenant with you; neither shall all flesh be cut off any more by the waters of a flood; neither shall there any more be a flood to destroy the earth. And God said, This is the token of the covenant which I make between me and you [. . .]. I do set my bow in the cloud, and it shall be for a token of a covenant between me and the earth.

The universe has been cleansed by the deluge. God appears before Noah to subscribe a new covenant between God and humankind; hence, naturally, the rendering of the scene is one where he appears in glory with his angels. In this Brussels tapestry, the Lord is seated on a rainbow; his open arms are a gesture of welcome and of future forgiveness as well. The escorting angels highlight this moment of harmony between heaven and earth, between man—an earthly creature—and God, who is absolute light.

THE COVENANT BETWEEN GOD AND NOAH
Brussels manufactory
1567
Rijksmuseum, Amsterdam

94

# *Hagar and the Angel*

> But Abram said unto Sarai, Behold, thy maid is in thy hand;
> do to her as it pleaseth thee. And when Sarai dealt hardly with
> her, she fled from her face. And the angel of the LORD found
> her by a fountain of water in the wilderness, by the fountain
> in the way to Shur. And he said, Hagar, Sarai's maid, whence
> camest thou? and whither wilt thou go? And she said, I flee
> from the face of my mistress Sarai. And the angel of the LORD
> said unto her, Return to thy mistress, and submit thyself under
> her hands. [. . .] And the angel of the LORD said unto her,
> Behold, thou art with child, and shalt bear a son, and shalt call
> his name Ishmael; because the LORD hath heard thy affliction.
> And he will be a wild man; his hand will be against every
> man, and every man's hand against him; and he shall dwell in
> the presence of all his brethren.

This illumination decorates the manuscript known as the Cotton Bible. Damaged by fire in 1731, only a few fragments survive today, all iconographically precious. It is said that to ensure descendants to her husband, Sarah had allowed Abraham (Sarai and Abram in Aramaic, in the biblical passage) to know Hagar, a slave woman.

After becoming pregnant, Hagar no longer respected the older woman, who banished her. In this scene, Hagar lies on the desert ground; an angel dressed in white is sent by God to appear before her and point to a well where she might quench her thirst. This image was later reproduced in a mosaic in Saint Mark's Basilica (see pages 98–99).

HAGAR AND THE ANGEL
5th–6th century
British Library, London

# *Hagar and the Angel*

This scene from the mosaic decorating Saint Mark's little cupola is based on an image from the Cotton Bible (see pages 96–97) and allows us to see the details of the model lost when the book burned, such as the flowing ribbons behind the head, a symbol of royalty. The characters are dressed in the fashion of the time of the mosaic: the dalmatic and the pallium. The angel, however, is God's angel, God himself appearing in this guise; were that not the case, he could not have ordered Hagar to return to Abraham and Sarah and announce to them the birth of her son, Ishmael, with the words used in the Scriptures.

GENESIS MOSAIC
(detail)
13th century
Basilica di San Marco, Venice

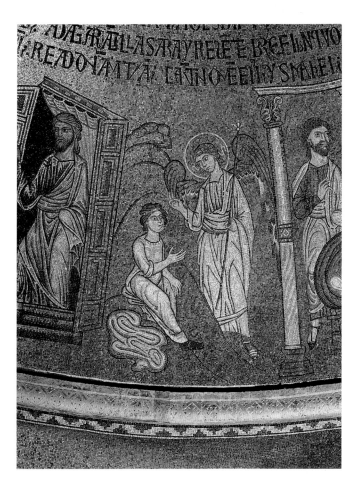

# *Hagar and the Angel*

In this work, the sky is darkened by clouds, though they recede into the distance. The drama is all played out between Hagar and the angel, whose appearance differs from that of previous iconographies, in that he is seminude. Neither scandalous nor an anticipation of Neoclassicism, the angel's nakedness applies the exact ecclesiastical instructions of Cardinal Federico Borromeo. An intellectual and an avid art lover and patron, in 1624 the cardinal published a work, *De pictura sacra* [*On Sacred Painting*], which gave instructions and guidelines on how sacred figures and scenes ought to be rendered. He preferred that angels be depicted naked—because the human form is the height of creation, and therefore the most appropriate for representing pure spirits—and young, because their age and beauty would show that they are immune from the degradation caused by sin.

HAGAR AND THE ANGEL
(detail)
Simone Cantarini
1630
Fondazione Cassa di Risparmio di Fano, Fano

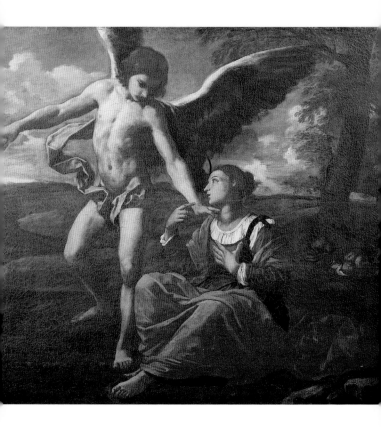

## Genesis 16:6–12

◄◄

*Hagar and
the Angel*

►►

This version of the biblical tale by
the Genoese painter Gioacchino
Assereto diverges from the text
in several details, such as the
presence, on the right, of the baby
Ishmael, an inconsistency that recurs
often in traditional iconography,
even in the nineteenth century.
The divine herald wears an unusual
hairstyle and dress: Blown by the
wind, he is almost a *genius loci.*
The ample, snow-white robe, close
to the style favored by Bernini,
accentuates the classical component
of this work. The flashes of light
also add mystery and tension to
the episode.

HAGAR AND THE ANGEL
Gioacchino Assereto
*c.* 1640
Palazzo Rosso, Genoa

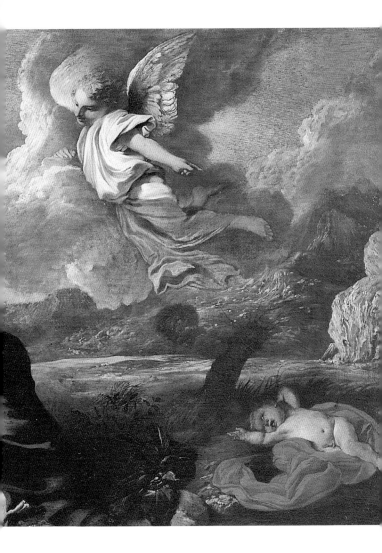

◄◄ ─────────────────────────────────────

# *Hagar and the Angel*

───────────────────────────────────── ►►

As was often the case at the time of Lorrain, artists frequently returned to the same subject over and over again. This is the first of a long series of canvases that Lorrain devoted to the Hagar and the angel scene. Here, the divine herald warns the slave, who instinctively tries to justify herself and tell her own story, though the angel's straight-pointing index finger leaves no space for replies. We almost hear him admonish: "Return to your mistress and be submissive to her." He would then reassure the woman that her progeny would multiply and announce that she was pregnant and would give birth to Ishmael. Hagar's condition was the occasion for Saint Paul's reflections on the different nature of Abraham's children, which in turn become an allegory of the tribes of Israel: Hagar's progeny would be considered the prototype of humanity born of the flesh, while Sarah's would be the archetype of the descendants born as a result of the promise God made to the patriarch (Galateans 4:23).

LANDSCAPE WITH HAGAR AND THE ANGEL
Claude Lorrain
*c.* 1646
National Gallery, London

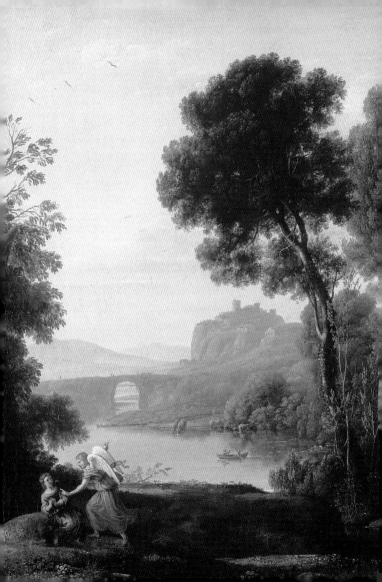

# *Hagar and the Angel*

The slightly foreshortened view is very appropriate to render the moral and narrative meaning of the biblical story of Abraham's concubine crossing her own "wilderness" (concretely represented by the rocks in this painting) in order to recapture God's favor, though God has already granted it by sending the angel who will save her from dying of thirst—a metaphor for the human longing to drink at the source of spirituality, which comes from God alone. After directing Hagar to the water spring, the divine messenger explains that she must return to her mistress and humbly accept her role. The lighting of the scene is telling as well, for it comes from above, meaning that it is not only the light of the sky, but also of God's grace.

HAGAR AND THE ANGEL
Gian Domenico Cerrini,
known as il Cavaliere Perugino
*c.* 1650
Fondazione Cassa di Risparmio
di Perugia, Perugia

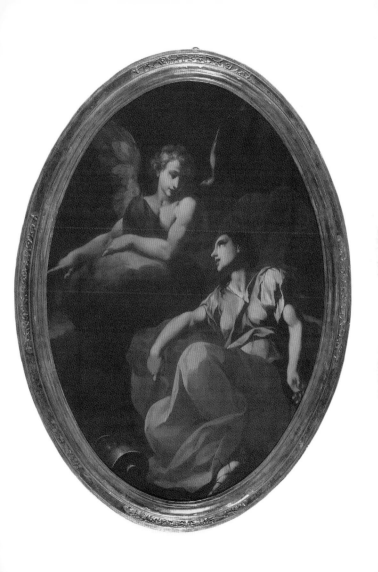

## Genesis 16:6–12

# *Hagar and the Angel*

In this canvas, Poussin, a French painter who spent several years in Rome, forces us to stay on the side of the angel, for Hagar is portrayed as very small—literally and metaphorically—lost as she is in a desolate land where the clouds of destiny loom. The threatening sky is above, and in the distance, behind the angel, the viewer sees the light in his direct line of perspective. Poussin was not the first to infuse moralizing tones into landscapes (Carracci had already done so), but surely he was the most fertile and skilled interpreter of this way of juxtaposing the biblical tale (or profane ones) with the landscape. Usually, as it is in this case, there is a correspondence between the story's atmosphere and the weather depicted in the work of art.

HAGAR AND THE ANGEL
(detail)
Nicolas Poussin
1660–64
Galleria Nazionale d'Arte Antica, Rome

# Hagar and the Angel

Lorrain was a great friend of Poussin's and here applied the latter's always-fascinating landscapist solution. Here the landscape is the protagonist, and it is totally indifferent to Hagar's anguish. Works of this type suggest man's real significance vis-à-vis nature and how the actions of human history are lost in the immensity of the universe. We hardly recognize the subject: Only the angel, silhouetted against the indifferent green of the trees, allows us to understand that on this vast stage an important event in human history is unfolding, a story that is explicitly concerned with God, who came down to earth in the form of an angel to look man in the eye.

HAGAR AND ISHMAEL IN THE DESERT
Claude Lorrain
1668
Alte Pinakothek, Munich

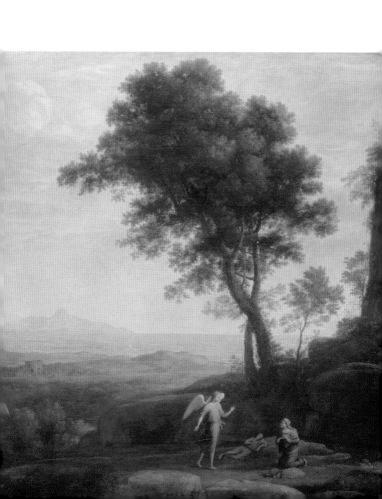

# *Hagar and the Angel*

Unlike the literal account in Genesis, in the iconographic tradition we often meet the figure of Ishmael in this episode. It is undoubtedly an error, because the text is exceedingly clear and specifies that Hagar was pregnant but had not yet given birth; there was no child at this point. But the visual narrative follows different paths, and the presence of the child completes and clarifies Hagar's destiny. Thus Tiepolo adds Ishmael, enfeebled by thirst, in the foreground. Gustave Doré falls into the same mistake, and much later, the film director John Huston does as well in his 1966 blockbuster *The Bible*. In this case also, the angel points Hagar in the direction of humility and salvation.

HAGAR IN THE WILDERNESS
Giambattista Tiepolo
1727–28
Palazzo Patriarcale, Udine

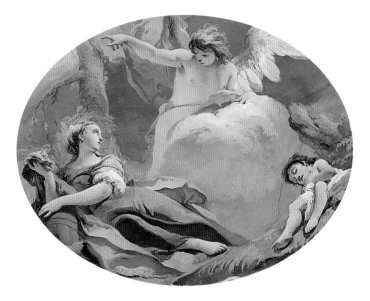

# Hagar and the Angel

This painting offers an intimist version of the biblical tale, creating the impression of a sacred conversation. Tiepolo has removed all traces of the desert, leaving only a leafy tree to suggest the landscape. The close-up framing of the composition concentrates the viewer's attention on the faces of the protagonists, starting with Ishmael, whose presence we find in the iconographic tradition but not, as previously mentioned, in the biblical source. The child is resting on his mother's lap; Hagar gazes into the angel's eyes and explains her reasons to him. The angel is attentive, all the while pointing with his finger to the direction in which she must go and telling her what she must do to find God's grace again: return to her mistress and comport herself humbly.

APPARITION OF THE ANGEL TO HAGAR
AND ISHMAEL
Giandomenico Tiepolo
c. 1780
The Nelson-Atkins Museum of Art,
Kansas City, Missouri

# *Hagar and the Angel*

By including Ishmael, Corot's painting also follows a popular iconographic tradition that deviates from the biblical source text. The artist's careful historical reconstruction has replaced Lorrain's lush glade in the forest (see pages 110–11) with a barren landscape evocative of the desert (though the American agave is totally out of place with the biblical locale). The artist is pulling at our emotions: In this inhospitable landscape, Hagar cries out to her son in vain for help. She is in despair and pulls her hair, not realizing that salvation comes from afar. High up in the sky, like an immense white dove with outspread wings, the angel is about to glide down. It is a sign of God's benevolence that will soon be expressed in words of comfort to the woman and her progeny.

HAGAR IN THE WILDERNESS
Camille Corot
1835
The Metropolitan Museum of Art, New York

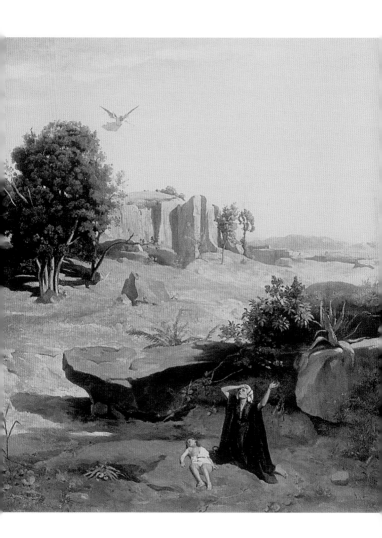

# Hagar and the Angel

This drawing is a study for a canvas conserved at the Museum of Villa Belgiojoso Bonaparte in Milan. The padded atmosphere one perceives in this sketch on paper suggests the gentle touch of the finished work. The composition is entirely new, compared to the images of the previous pages. Here, redemption is suggested in a different manner: No longer gliding from above or appearing at her side, the angel comes upon the woman from behind. He is evoked by Hagar's conscience, and as soon as he is beside her, he supports her. On the other hand, this artist's wilderness is purely metaphorical, its final version fresh with blues and greens. The angel's dress is Manneristic and unlike the traditional garb: It is simply a slightly exotic tunic tied at the waist.

HAGAR WITH HER SON IN THE DESERT
COMFORTED BY THE ANGEL
Giovanni Carnovali, known as il Piccio
1860–62
Private collection, Bergamo

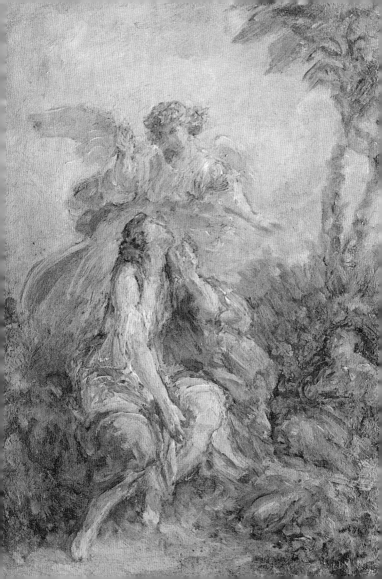

# Hagar and the Angel

The almost ethnographic style of James Tissot was the result of a sudden, violent, mystical crisis that he experienced after he had become successful, leading him to spend ten years in Palestine to study, understand, and re-create (in highly refined watercolors such as this one) the world of the Gospels and, later, the Old Testament. Here the angel is a Palestinian youth dressed in linen and leather straps.

Hagar, barely a young girl, as she must have truly been, is caught in the desperate act of lowering a jar into the well to look for the much-needed water. Warned by a presence and more worried than reassured, she pauses and is about to turn. The angel on the other hand, does not move: He appeared at the site instead of flying there, just as the Fathers of the Church explain.

HAGAR AND THE ANGEL IN THE DESERT
James Tissot
1896–1900
The Jewish Museum, New York

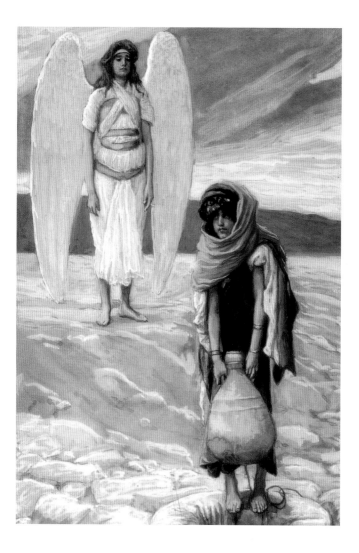

## *Hagar Returns to Abraham*

> And Hagar bare Abram a son: and Abram called his son's name, which Hagar bare, Ishmael. And Abram was fourscore and six years old, when Hagar bare Ishmael to Abram.

There is no biblical passage that recounts Hagar's return to Abraham, but from the story we can surmise what happened: Hagar was readmitted into the presence of Sarah and from that time forward the roles were respected, aided in part by the fact that a while later Isaac would be born to Sarah. The scene as imagined by Pietro da Cortona, therefore, takes this happy conclusion into account and offers a somewhat rare image of this tale. The angel's role here is to harmonize this episode with what happened in the desert; for this reason, his gesture, though light, is commanding. Hagar moves forward with a humble, sincere demeanor, touching her heart; Abraham opens his arms to welcome her, and Sarah, in the background, waits inside the house for the slave to apologize.

THE RETURN OF HAGAR
Pietro da Cortona
1637
Gemäldegalerie,
Kunsthistorisches Museum, Vienna

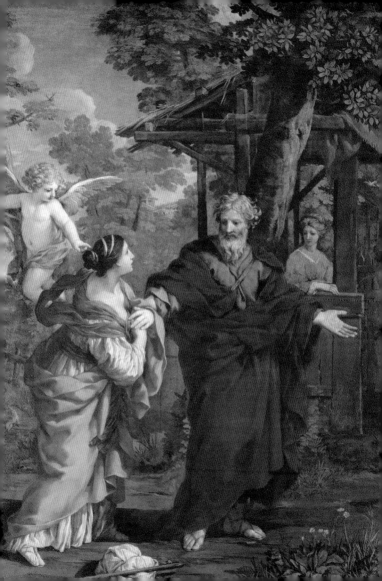

## *Abraham's Hospitality*

> And the LORD appeared unto him in the plains of Mamre [. . .]. And he lift up his eyes and looked, and, lo, three men stood by him: and when he saw them, he ran to meet them from the tent door, and bowed himself toward the ground, And said, My Lord, if now I have found favour in thy sight, pass not away, I pray thee, from thy servant: Let a little water, I pray you, be fetched, and wash your feet, and rest yourselves under the tree. [. . .] And he stood by them under the tree, and they did eat.

This mural depicts the moment when Abraham sees the "three men" in the opening part of the biblical tale. A careful reading of the text tells us that there is no distance between the presence of the Lord and that of the three men, who must therefore be understood to be an emanation of God. It is not carelessness on the part of the author, but a clear intent to superimpose the role of the three men on that of God. Indeed, there is a doctrinal reason for this: To safeguard the most absolute monotheism, one must assume that the Lord's emissaries are in actuality his extensions. A careful analysis of this image allows us to note that the angels are literally represented as three men, without wings. The wings are an attribute that will only appear in later angelic iconography, and their absence does correspond exactly to the text.

THE THREE ANGELS APPEAR TO ABRAHAM
4th century
Via Latina catacomb,
known as Ferrua, Rome

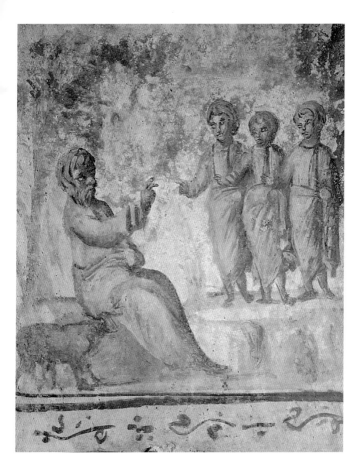

# *Abraham's Hospitality*

This mosaic decorates the central nave of the Church of Santa Maria Maggiore in Rome. The two salient points of the episode are arranged one below the other to render the spatial and temporal sequence. In the top scene, Abraham kneels before the three men. The scene includes a telling detail about the interpretation of this passage: The central figure is enveloped in a halo of light, a true nimbus, which was added to conform to the patristic interpretation that treated the three men as a prefiguration of the Trinity—hence the "man" at the center is considered Christ. In the scene below, we see Abraham doubled: One turns to Sarah, asking her to prepare the cakes of bread, while the other gets ready to serve the tender veal to his guests.

SCENES FROM THE STORY OF ABRAHAM:
ABRAHAM AND THE ANGELS
(detail)
432–40
Santa Maria Maggiore, Rome

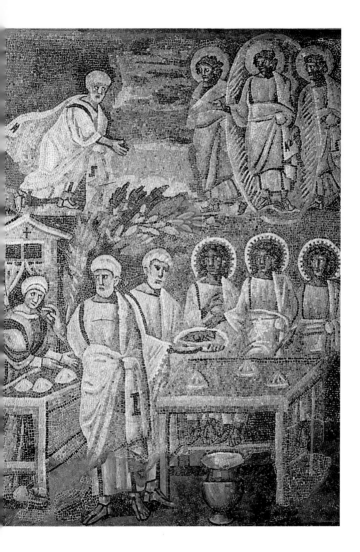

# Genesis: 18:1–8

◄◄

## *Abraham's Hospitality*

►►

This mosaic in the presbytery of the Church of San Vitale in Ravenna illustrates a different moment of the biblical episode, when Abraham invites the three men to sit under the oak trees at Mamre. To the right of the tree is a table with the guests seated; to the left, Sarah comes out of the tent, while Abraham deferentially approaches the dining table, carrying the veal on a platter. Thus, the artist has highlighted one of the many theological interpretations of the scene, one that sees in it a prefiguration of the Last Supper, and thus of the Eucharist. On the table—an altar of the period—are three loaves marked with the cross; this Eucharistic bread would be called "the bread of angels" in Christian symbolism.

ABRAHAM'S VISION AND HOSPITALITY
AT THE OAKS OF MAMRE
(detail)
546–47

San Vitale, Ravenna

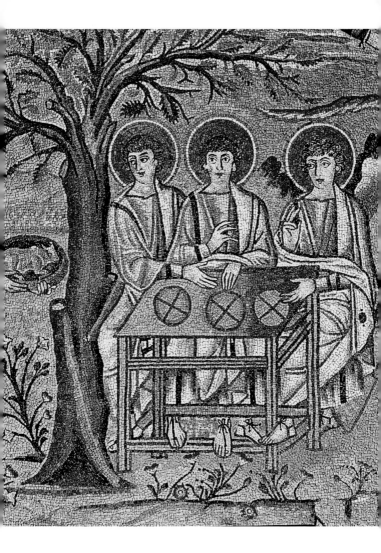

# Abraham's Hospitality

This scene is part of a larger fresco that includes illustrations of the Old Testament and runs along the walls of the three-nave church. Dated to the Romanesque period and uncovered during recent restoration work, this register has its own artistic dignity. Executed with great restraint, the image shows us only the essential elements—including the oak tree, slightly higher than Abraham kneeling—and resembles a miniature insert of the codices of the time. The figures stand out against a cobalt blue sky; interestingly, the angels, who are wingless, are dressed in white, red, and green, the colors of the Trinity, which they prefigure in the Old Testament.

ABRAHAM'S HOSPITALITY
(detail)
12th century
San Pietro, Galtellì (Nuoro)

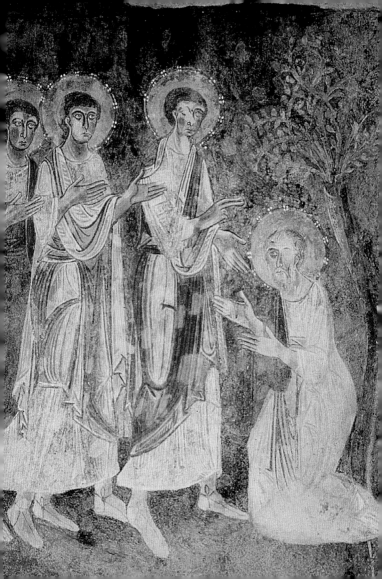

# Abraham's Hospitality

The first detail to be noticed in this icon is that the three men have wings, by this point a traditional attribute of angels, first acquired in the fifth century. The fact that they were not included in the San Vitale mosaic (see pages 128–29) means that that artist chose to follow the biblical text literally. On the contrary, this icon by Andrei Rublëv shows that the accepted and shared exegetic interpretation of the passage considered the three men to be angels, and their image immediately evokes the Trinity. The spare setting drawn by the Russian artist, with the subdued presence of the tree and the house, raises the icon above the level of a mere illustrative work, and transforms it into an occasion to meditate on the mystery of the Trinity and its role in the plan of man's salvation willed by God.

THE HOLY TRINITY
Andrei Rublëv
*c.* 1411
Tretyakov Gallery, Moscow

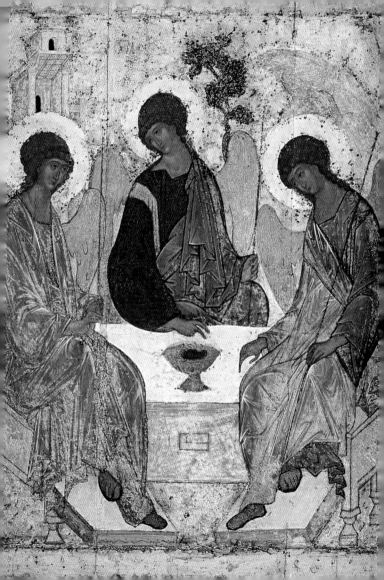

# *Abraham's Hospitality*

The loss of Abraham's figure, which completed the panel (only the edge of his robe has survived), is deplorable, though undeniably these isolated, diaphanous angels are truly beautiful. This work, possibly part of a banner of one of the many sacred brotherhoods for which Antonello da Messina worked, revives the theme according to the canons of a Flemish-inspired Renaissance. We see it in the robes, the *alba tunica* (white tunic) with collar worn by the deacons and preferred by the Northern European dioceses. Next to the angels is the table where they are about to sit. Certainly, it is the type of outdoor table likely to be found in or near the threshing yards of the farmhouses in fifteenth-century Messina.

ABRAHAM SERVED BY THE ANGELS
Antonello da Messina
*c.* 1465
Museo Nazionale, Reggio Calabria

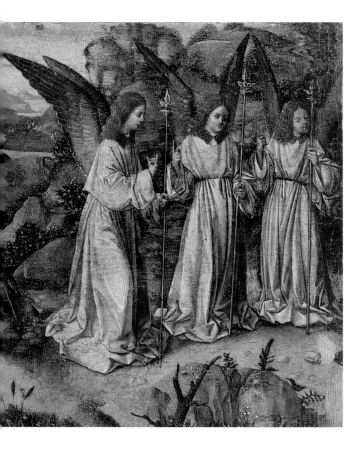

# Abraham's Hospitality

Ludovico Carracci has prepared a true open-air banquet for Abraham's guests. Tableware and victuals are on the table, and on the ground are the remains of the repast; the atmosphere is convivial. This impression is reinforced by observing the attitude of the three angels, who are wingless and behave as if they were discussing the latest edition of the *Book of Etiquette* of Monsignor della Casa. There is no mystical solemnity. Only the clothes, inspired by ancient fashion, tell us that this is a historical (actually, biblical) scene. The immense oak tree is extraordinary; it occupies the right half of the canvas, its leafy branches offering shade and cool. Before the table, standing, is Abraham, on whom everyone's gazes converge.

ABRAHAM AND THE ANGELS
Ludovico Carracci
*c.* 1590
Pinacoteca Nazionale, Bologna

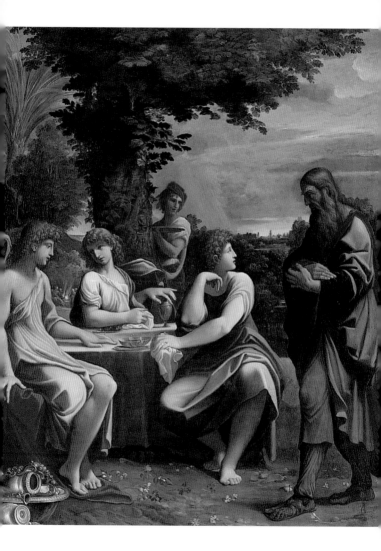

◄◄ ◄

# *Abraham's Hospitality*

► ►►

Although this is an outdoor scene, the warm colors, which echo Caravaggio's work, evoke the intimacy of a scene indoors. The story's characters are all here: Sarah and her maidservant are on the threshold, while another servant carries a basket. The three angels are already seated at the table and look at Abraham, who deferentially invites them to a repast. An angel, turning his back to Abraham, points to a faraway place, toward Sodom and Gomorrah. The angel in the foreground is barefoot; probably the patriarch washed his feet with great devotion. On the table is a loaf of bread, but nothing hints at a prefiguration of the Eucharist. With the exception of the angelic wings, nothing in this work suggests a transcendental dimension.

ABRAHAM AND THE ANGELS
Francesco Solimena
1701
Pinacoteca di Brera, Milan

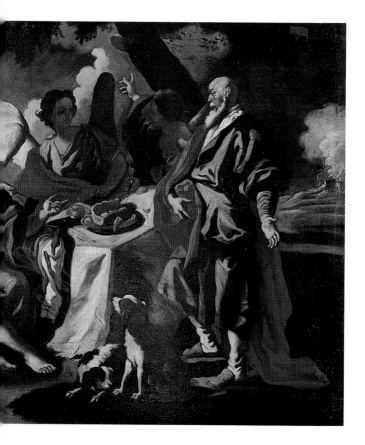

## Genesis 18:1–8

◂◂

*Abraham's
Hospitality*

▸▸

The passage that inspired this canvas
by Tiepolo is the first part of the
biblical episode, when the patriarch
becomes aware that three men stand
before him and he addresses them
with great deference, inviting them
to stay. The master painted Abraham
kneeling, with open arms, in a
gesture of prayer and submission.
The work stresses and emphasizes
the extraordinary nature of the event:
The artist had no desire to feign
normality; actually, he intended to
show every exceptional aspect of
this episode, so the three angels,
who are practically naked and
display immense wings, appear on
a cloud that grows pale in the
empyrean light, surrounded by a
few winged cherubim.

ABRAHAM AND THE THREE ANGELS
Giandomenico Tiepolo
1773–74
Gallerie dell'Accademia, Venice

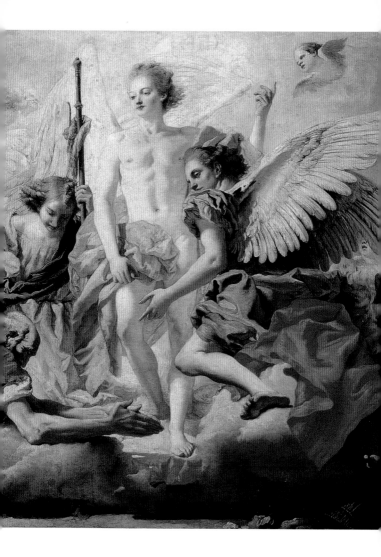

◄◄◄

# *Abraham's Hospitality*

Chagall's poetic world reveals unusual aspects: This time he explores the angels who are Abraham's guests. The wings become the protagonists, introducing as they do a different dimension whereby the sacred enters into everyday life. The angels are sitting on a bench around the table, as if it were the most natural thing in the world, as if they had always been there. But Chagall's skill lies in the fact that this easiness resembles the simplicity that allows the sun to shine or the wind to blow: It is an extraordinary unfussiness, from a time long gone. Abraham is standing and wears a sort of overcoat.

ABRAHAM RECEIVES THE THREE ANGELS
Marc Chagall
1931
Message Biblique Marc Chagall,
Musée National, Nice

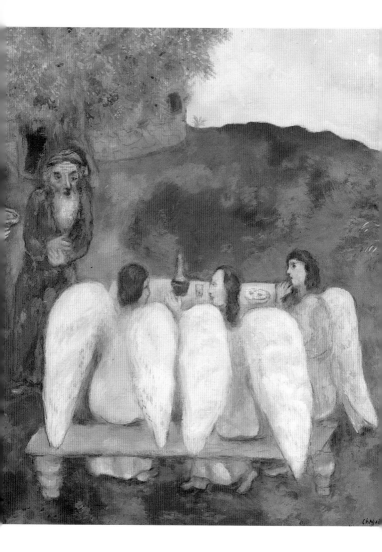

Chagal

# The Angel and Sarah

> And the LORD visited Sarah as he had said, and the LORD did unto Sarah as he had spoken. For Sarah conceived, and bare Abraham a son in his old age, at the set time of which God had spoken to him.

Tiepolo's visual interpretation in this fresco of the biblical episode is masterly. The angel appears like a knight in fancy dress, and knocks on the door of an elderly woman who could be a Venetian old lady, like those who lived in Ponte delle Ostreghe or in the brightly colored alleys of Torcello, although she is portrayed as a lady with a lace collar and a satin gown. The unusual figure of the angel, so unlike the traditional images in his dress, is the artist's way of stressing that he belongs to another dimension. The angel has just arrived, his wings are still aquiver, and his clothes have just been rearranged from the wind. His gesture is commanding, as if he had said, "You . . . !" The woman's instinctive, disbelieving reaction is to touch her breast as if to say, "Who, me? Is it possible?" Then the angel seems to remind her that "God's spirit blows where it will" (John 3:8).

SARAH AND THE ANGEL
Giambattista Tiepolo
1727–28
Palazzo Arcivescovile, Udine

144

# The Angels of Sodom

> And there came two angels to Sodom at even; and Lot sat in the gate of Sodom: and Lot seeing them rose up to meet them; and he bowed himself with his face toward the ground; And he said, Behold now, my lords, turn in, I pray you, into your servant's house, and tarry all night, and wash your feet, and ye shall rise up early, and go on your ways. And they said, Nay; but we will abide in the street all night. And he pressed upon them greatly; and they turned in unto him, and entered into his house.

The interpretation that Gustave Moreau, a master of symbolism, gives to this episode is truly artful. The foggy atmosphere, rendered with a skillful use of whites and grays that leaves nothing to naturalism, well depicts the suspended time, when the air is still, that we sense just before a catastrophe. Moreau's angels are thickenings of sky, or perhaps color. They take shape like diaphanous outlines that move toward the city to be destroyed or toward the house of Lot. In fact, the Bible first mentions the angels, then attributes the city's destruction directly to God. The French painter added red flashes of color to the landscape, either a sinister omen or the presence of fire.

THE ANGELS OF SODOM
Gustave Moreau
1872–75
Musée National Gustave Moreau, Paris

# The Destruction of Sodom

> And when the morning arose, then the angels hastened Lot, saying, Arise, take thy wife, and thy two daughters, which are here; lest thou be consumed in the iniquity of the city. And while he lingered, the men laid hold upon his hand, and upon the hand of his wife, and upon the hand of his two daughters; the LORD being merciful unto him: and they brought him forth, and set him without the city. [. . .] Then the LORD rained upon Sodom and upon Gomorrah brimstone and fire from the LORD out of heaven; And he overthrew those cities, and all the plain, and all the inhabitants of the cities [. . .]. But his wife looked back from behind him, and she became a pillar of salt.

With the theatrical sumptuousness typical of his art, Rubens illustrates the first part of the biblical tale, where contrasting feelings dominate and are visible in the faces of the protagonists. The angel, shrouded in a red mantle, moves with elegance as he urges the family to leave their home. He walks with them toward salvation and points out the road to them. Lot turns around while his wife wipes away the tears. Rubens has caught fully their inner conflict: to leave their home and all their possessions and memories, and thus be saved from disaster? The smile of the second angel is the reply, inviting him to take his daughters and some provisions with him.

THE DEPARTURE OF LOT AND HIS FAMILY FROM SODOM
Pieter Paul Rubens
*c.* 1614
The John and Mable Ringling
Museum of Art, Sarasota, Florida

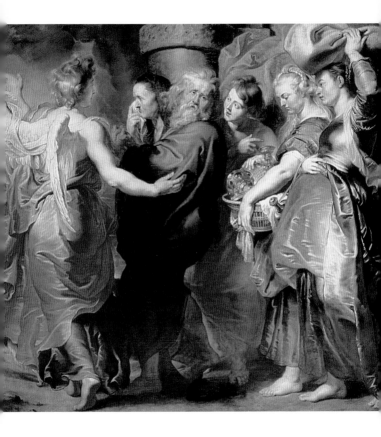

◄◄

# *The Destruction of Sodom*

Big, rich, and, according to Guariento's interpretation, with crenellated towers, the city of sin was to be destroyed with all its inhabitants. The authors of this punishing action are angels dressed in snow-white robes and luminous halos, executing God's will. Actually, the text does not mention angels, but instead the Lord, a fact explained by the theological role that God's angel plays in the Old Testament, appearing and withdrawing to save the monotheistic quality of the God of the Jewish faith. Therefore, the inclusion of angels in this work is arbitrary, albeit justified by the iconographic tradition. Note, on the right, Lot's wife, who has been turned into a statue of salt.

THE DESTRUCTION OF SODOM
(detail)
Guariento di Arpo
1349–54
Private Carraresi Chapel
(now Accademia Galileiana), Padua

# The Sacrifice of Isaac

> And it came to pass after these things, that God did tempt Abraham, and said unto him, Abraham: and he said, Behold, here I am. And he said, Take now thy son, thine only son Isaac, whom thou lovest, and get thee into the land of Moriah; and offer him there for a burnt offering upon one of the mountains which I will tell thee of. And Abraham [. . .] took [. . .] Isaac his son [. . .] and rose up, and went unto the place of which God had told him. [. . .] And Abraham built an altar there [. . .]. And Abraham stretched forth his hand, and took the knife to slay his son. And the angel of the LORD called unto him out of heaven, and said, Abraham, Abraham: and he said, Here am I. And he said, Lay not thine hand upon the lad, neither do thou any thing unto him: for now I know that thou fearest God, seeing thou hast not withheld thy son, thine only son from me. And Abraham lifted up his eyes, and looked, and behold behind him a ram caught in a thicket by his horns: and Abraham went and took the ram, and offered him up for a burnt offering in the stead of his son.

This precious Rhenish plaque testifies to the synthetic qualities of medieval culture. Here the elements of the composition, although reduced to a minimum, still allow for an unmistakable reading: Abraham, who splits the scene in half, holds Isaac with one hand and a knife with the other. The angel who appears behind him forces him to turn as he holds the weapon. With the other hand, the angel points to the ram that sits like a faithful dog, waiting to be sacrificed.

THE SACRIFICE OF ISAAC
13th century
Museo Nazionale del Bargello, Florence

# The Sacrifice of Isaac

This scene by Guariento di Arpo is particularly dramatic even in the absence of cruel visual elements. The artist's interpretation (shared by his patrons in Padua) is to stress the reaction of little Isaac, who instinctively pulls back from a father visibly determined to act, as we can see in his stance, with wide-spaced, firmly planted legs. In his rush to do God's bidding, Abraham raises his arm to create more momentum and ensure that his helpless son will not pull back. It is in this exact moment that the angel, with lightning speed, stops Abraham's arm. In the background we see a ram, the animal that will enable Abraham to pay his debt to the Lord, who no longer has any doubts about the patriarch's devotion and the greatness of his spirit.

THE SACRIFICE OF ISAAC
Guariento di Arpo
1349–54
Private Carraresi Chapel
(now Accademia Galileiana), Padua

154

# The Sacrifice of Isaac

Ghiberti's *Sacrifice of Isaac*, together with Brunelleschi's (see pages 158–59), marks an epochal transition between two different modes of expression, and it is rightly deemed to mark the beginning of Renaissance art. In this transition, the angel takes on an expressive, meaningful role. His figure in foreshortened view, in the upper right corner of the panel, adds depth to the scene and suggests the idea of the sacred suddenly erupting into the human world to carry out the Lord's plan of salvation. In fact, though the angel does not even graze Abraham's arm, the patriarch seems already stopped in his tracks. Note the exact contrast between the curve formed by Abraham's body and the straight line of the angel who blocks his movement. Isaac, on the other hand, looks to the angel as his only chance of escape.

THE SACRIFICE OF ISAAC
Lorenzo Ghiberti
1401

Museo Nazionale del Bargello, Florence

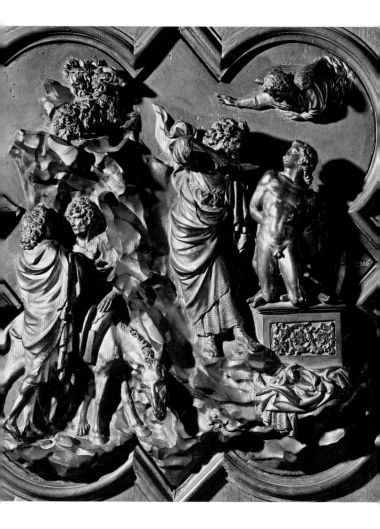

# The Sacrifice of Isaac

Although the solution devised by Brunelleschi is simpler than Ghiberti's (see pages 156–57), the angel's role is still pivotal. Here the angel's and Abraham's respective positions are clearly contrasted, even though, paradoxically, they are both an expression of God's will. The patriarch is passionately throwing himself, almost with the weight of his whole body, onto his son, and he lifts the boy's head, exposing the throat so that the deadly knife will more smoothly do its job. But the angel rushes to block the patriarch's arm; given his resolution, it is not a moment too soon. Now Abraham is petrified; he raises his eyes and cannot believe what he sees. He still does not know if he can save his son, the most precious of his affections. Erupting from the clouds, the angel follows the shape of the panel's compass frame. Below the divine herald, we see the ram, ready to be sacrificed in Isaac's stead.

THE SACRIFICE OF ISAAC
Filippo Brunelleschi
1401
Museo Nazionale del Bargello, Florence

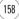

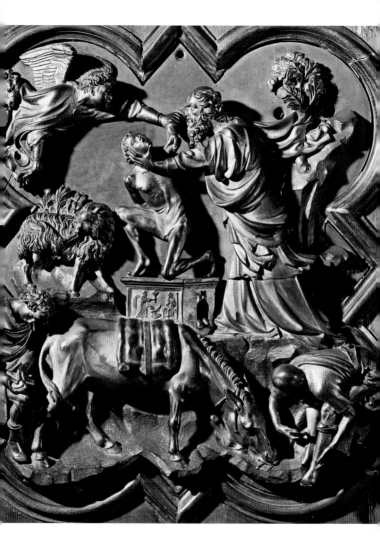

◄◄ ◄

# *The Sacrifice of Isaac*

►► ►

The narrative solution offered by Raphael lies outside of any iconographic tradition on this subject. The novelty is in the presence of two angels: One is the angel of the biblical tale who, in Raphael's version, pounces on Abraham's outstretched arm to block it, preventing him from going through with his excruciating task and making him turn his eyes to heaven, as if looking for hope. The presence of the second angel is a poetic license, for it does not exist in the text, which reads: "And Abraham lifted up his eyes, and looked, and behold behind him a ram caught in a thicket by his horns." But this second angel has a role in the episode as well, for he explains its meaning: His sudden headlong descent with the ram in his arms seems the very personification of divine providence, which supports us even in our darkest moments.

THE SACRIFICE OF ISAAC
(detail)
Raffaello Sanzio, known as Raphael
1511
Vatican Palace, Vatican City

# The Sacrifice of Isaac

The great polychrome marble intarsia executed by Domenico Beccafumi on the floor of the Siena cathedral is located before the altar, to express that the sacrifice of Isaac is the prefiguration of that of Christ, as sixteenth-century theologians claimed, and as the Fathers of the Church had also asserted. Although the dramatic climax of the episode—the angel commanding Abraham to drop his murderous hand—is set at the center of the scene, the artist has also illustrated two other moments of the story: The first, on the left, shows the angel calling to Abraham; the second, on the right, depicts the divine herald commanding the patriarch to leave for the sacrifice.

SACRIFICE OF ISAAC
(detail)
Domenico Beccafumi
1546
Cathedral, Siena

◄◄

# The Sacrifice of Isaac

►►

Each artist and each epoch catches a specific aspect of the sacred story. Caravaggio, for example, has stressed in this painting the human dimension of the angel, whose wings can barely be glimpsed— indeed, only a faint sign behind his shoulder blade hints that this is a divine messenger. What does it mean? That anyone could be our angel; that God's help comes from our neighbor, and that all we have to do is recognize it. Here everything is human; the angel, who could be a passerby, blocks Abraham's hand and points to the ram, which spontaneously offers itself.

THE SACRIFICE OF ISAAC
Michelangelo Merisi da Caravaggio
1603
Galleria degli Uffizi, Florence

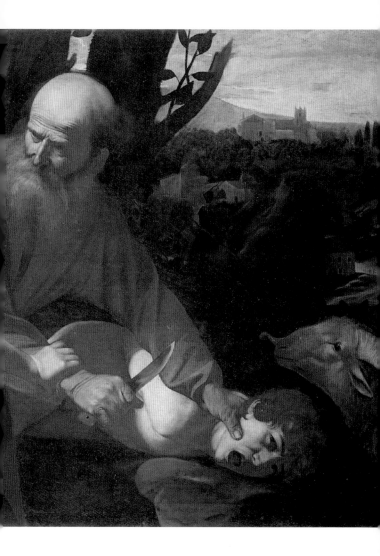

# The Sacrifice of Isaac

Rembrandt has a preference for the extraordinary nature of the sacred, here mixed with violence and the attempt, in the intentions of the Dutch artist, to effect a philological reconstruction that is, in fact, a visionary one. Note the shape of the knife and the scabbard and their precious manufacture; we immediately understand that the artist intends to transport the viewer into an Oriental atmosphere. Abraham's act is a violent one: He rudely covers his son's face, forcing him to expose his throat; he holds him forcefully, not wanting him to struggle, he raises his arm and is about to strike, but is blocked. He turns. The angel irrupts into his life, as had been the case with God's tremendous command. Abraham's look is one of incredulity, full of tension and gratitude for his Lord who, as the Bible says, giveth and taketh away.

THE SACRIFICE OF ISAAC
Rembrandt von Rijn
1635
The Hermitage, Saint Petersburg

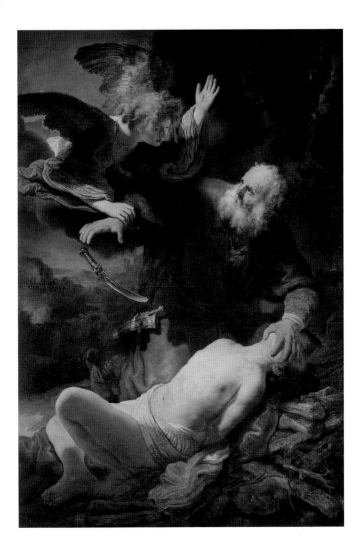

# The Sacrifice of Isaac

Abraham patiently builds the sacrificial altar, first laying the wood, then the stones. Isaac asks him, "Behold the fire and the wood: but where is the lamb for a burnt offering?" And his father replies: "My son, God will provide himself a lamb for a burnt offering." Isaac is satisfied with the answer, and the meekness with which the artist depicts the youth lying on the cold altar stone shows that he understands the deepest meaning of his father's words. At the risk of sounding blasphemous, if there is a biblical episode that, more than any other, expresses the deepest sense of the word *islam*, which means "to submit, to abandon oneself," it is this one. The French artist has fully grasped this essential nuance: Abraham and Isaac, in their respective roles, give themselves up to God, without the slightest doubt, because the angel is with them and they are aware of his presence.

THE SACRIFICE OF ISAAC
Laurent de La Hire
1650
Musée Saint-Remy, Rheims

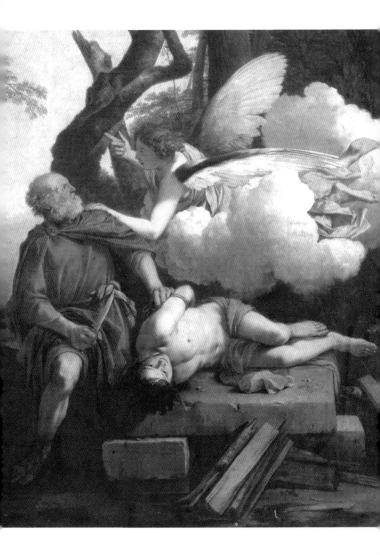

◄◄

# *The Sacrifice of Isaac*

The dreamlike quality of this work is in sharp contrast with the cruelty of the episode, but is justified by the hope and benevolence shown by God. In the foreground lies Isaac's helpless and naked body, a total offering. He is truly the prefiguration of Christ, the Lamb given in sacrifice for man's sins. His body has been drawn with the lightness of a leaf blown by the wind, a reflection of his real condition. Next to him, his father, his potential executioner, brandishes a knife bigger than he is. Abraham looks disbelieving at the angel, who is both the salvation and the end of a nightmare, an angel who resembles a cloud with a head: a breath of God.

ABRAHAM PREPARING
TO SACRIFICE HIS SON
Marc Chagall
1931
Message Biblique Marc Chagall,
Musée National, Nice

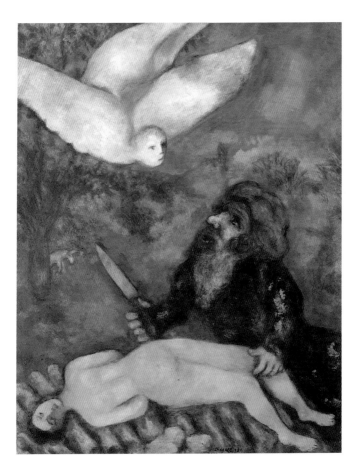

# *Jacob's Ladder*

> And [Jacob] dreamed, and behold a ladder set up on the earth, and the top of it reached to heaven: and behold the angels of God ascending and descending on it. And, behold, the LORD stood above it, and said, I am the LORD God of Abraham thy father, and the God of Isaac: the land whereon thou liest, to thee will I give it, and to thy seed. [. . .] And, behold, I am with thee, and will keep thee in all places whither thou goest, and will bring thee again into this land; for I will not leave thee, until I have done that which I have spoken to thee of. And Jacob awaked out of his sleep, and he said [. . .], How dreadful is this place! this is none other but the house of God, and this is the gate of heaven.

The angels of the Via Latina catacomb look like proper gentlemen who enjoy climbing up and down the ladder. There are several reasons for this interpretation in the earliest Christian images of angels. First, it is a literal adherence to the Bible that, as we see in several instances (for example, Genesis 18:1–8 and Tobit 5–6), refers to as men the beings who will reveal themselves to be angels. The other reason is to avoid confusion with winged pagan deities such as Aion, Iris, or Nike, though the latter would soon be totally absorbed into the rising Christian iconography.

JACOB'S LADDER
4th century
Via Latina catacomb,
known as Ferrua, Rome

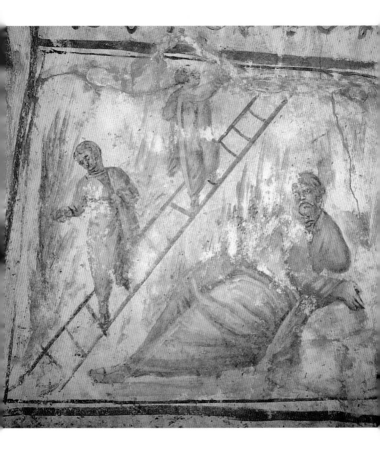

# *Jacob's Ladder*

This mosaic from the Monreale cathedral also includes the scene when Jacob wakes up and builds an altar on the stone he has used as bed, calling it Bethel (Genesis 27:18). The reason is simple: That place has become sacred because of the angelic vision he just had, and he believes that angels lead to God. In any case, this is the meaning of Jacob's ladder: The man who takes the straight road, if he can see with loving eyes, can arrive before God. The ascending and descending angels, their wings outspread, demonstrate this. The final reflection that Jacob cannot make on the dreadfulness of the place is based on the fact that God is unknowable, and only with the help of the ladder (the future Christ) can man approach him.

JACOB'S LADDER
1174–86
Cathedral, Monreale

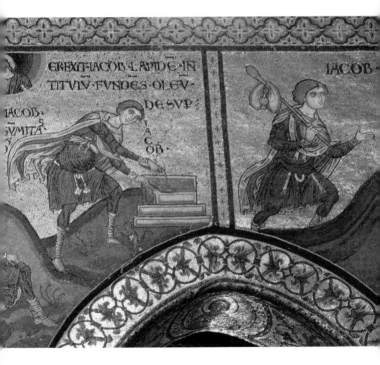

ERENTIACOB LAPIDE·IN
TITVLV·FVNDES·OLEV·
DESVP·

IACOB·

IACOB·
GVMITA·

IACOB

# Jacob's Ladder

Although the artist used rather simple expressive devices because of the spare colors, which still provide strong chromatic contrasts, and the purity of the lines, this panel is highly suggestive. White is the dominant color, appearing on Jacob's robe, those of the angels, and the clouds that lead up to God. It is almost an ode to purity. Heaven opens its gates to the pure of heart, those whom Christ loves. The identification of Jacob's ladder with Christ is stated unequivocally in the Gospel of John (1:51), where we read: "Verily, verily, I say unto you, Hereafter ye shall see heaven open, and the angels of God ascending and descending upon the Son of man." Thus Christ is the true ladder, because it is through him, and his sacrifice, that men can achieve redemption and reach God. The angels simply reiterate the concept of an intermediary between the high and the low.

JACOB'S LADDER
Nicolas Dipre
*c.* 1500
Musée du Petit Palais, Avignon

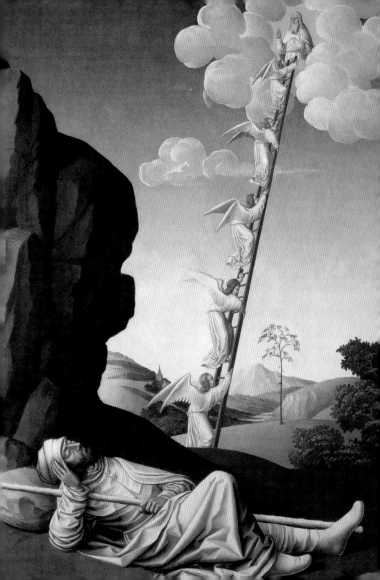

◄◄ ───────────────────

# Jacob's Ladder

───────────────────── ►►

Raphael's fresco keenly illustrates the biblical passage, since Jacob sleeps on a stone that is already in the shape of an altar. The ladder is a true staircase that descends from heaven, and the angels climbing up and down have the Renaissance form of elegantly attired, winged beings; they no longer wear the tunic and pallium of the Monreale mosaic (see pages 174–75) or the spare deacon's tunic of the Avignon panel (see pages 176–77). These are angels from a Renaissance court that takes its inspiration from the models of classical antiquity, such as the winged Victories. The Eternal, who opens his golden palace, recalls Michelangelo's God.

JACOB'S LADDER
(detail)
Raffaello Sanzio, known as Raphael
1511
Vatican Palace, Vatican City

178

# Jacob's Ladder

If there is a figure in the Scriptures that acts as a channel between God and men, it is the angel. It is not by chance that the word, derived from the Latin *angelus*, which is itself a transliteration of the Greek *ángelos*, ultimately finds its root in the Hebrew *malak*, which means "messenger." This meaning has been retained in all three languages. The messenger is one who carries messages; however, in the Judeo–Christian context, more than in other religions that believe in intermediary beings (and all religions do), this messenger has a double meaning: He carries God's orders and precepts to men but, above all, transmits the latter's prayers to Christ, to the Virgin, to the saints, and to God. Jacob's ladder is also a visual metaphor for all of this: For this reason, the angels climb up and down.

JACOB'S LADDER
(detail)
Workshop of Raphael
1518–19
Vatican Palace, Vatican City

# Jacob's Ladder

The ladder imagined by William Blake, the eighteenth-century visionary poet and painter, to visualize Jacob's dream is a spiraling one. We see the main character lying under the starry vault, as was certainly the case for biblical characters, dreaming the dream that would reveal God's design to him: to make that particular spot sacred. Blake's angels are very unlike those of earlier iconography. Their features, already gentler after the Middle Ages—a change influenced, in part, by the concept introduced by the Dolce Stil Novo of woman as an angelic creature—are now clearly feminine. Furthermore, neither Christ nor God appear. Yet the ladder—no longer a rung ladder or a sumptuous architectural staircase, but a spiraling flight of steps—is bathed in warm, reddish glares that lead to the empyrean.

JACOB'S LADDER
William Blake
*c.* 1790
British Museum, London

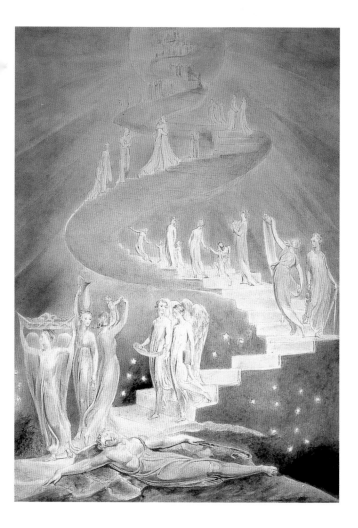

# *Jacob's Ladder*

Gustave Doré was attracted by the play of contrasts. An engraver must always wrestle with the raw material. Painters can freely use colors and change their arrangements; not so engravers. Theirs is a constant dialogue with the white of the paper and the black of the ink, light and darkness. This is the challenge and also the reality of the metaphor that fits the biblical subjects of Doré's work. In fact, the ladder imagined by the French artist is a stream of light, a swollen river, and the angels the brightest waves. Jacob lies in a corner in the shade, lapped by this divine vehemence that seemingly shakes him even as he sleeps. The diaphanous angels climb up and down, moving near and away from the most intense brightness, which is unbearably white. The angelic task, then, is to bring to men a spark of that impossible light.

JACOB'S LADDER
Gustave Doré
1866
Granger Collection, New York

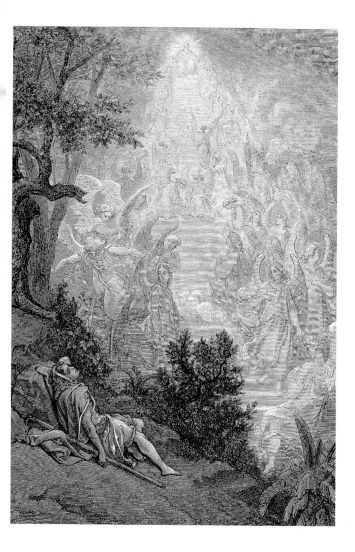

◀◀

# *Jacob's Ladder*

Chagall's interpretation of this biblical episode is quite unusual: Unlike the earlier iconography, the artist has made a radical change by placing the ladder to one side of the composition. In any case, the dream is interspersed with a number of references to Exodus and the conquest of the Promised Land, which are perfectly compatible with the dream episode. As a matter of fact, they add one more reading key to the text. The presence of the angels dominates the scene: We see the three large figures that recall Abraham's angels, and the angel with yellow wings, who is Christ embracing humankind. To the left, the artist stands before his easel, waiting to fix this vision on the white canvas. He is, in fact, the true Jacob.

JACOB'S DREAM
Marc Chagall
1960-66
Message Biblique Marc Chagall,
Musée National, Nice

# Jacob Wrestles with the Angel

> And Jacob was left alone; and there wrestled a man with him until the breaking of the day. And when he saw that he prevailed not against him, he touched the hollow of his thigh; and the hollow of Jacob's thigh was out of joint, as he wrestled with him. And he said, Let me go, for the day breaketh. And he said, I will not let thee go, except thou bless me. And he said unto him, What is thy name? And he said, Jacob. And he said, Thy name shall be called no more Jacob, but Israel: for as a prince hast thou power with God and with men, and hast prevailed. And Jacob asked him, and said, Tell me, I pray thee, thy name. And he said, Wherefore is it that thou dost ask after my name? And he blessed him there. And Jacob called the name of the place Peniel: For I have seen God face to face, and my life is preserved.

This is a crucial episode for trying to understand both the role of God's angel, whom Jacob's deep spirituality leads to reveal himself, and the reason why the first angels depicted had no wings. Delacroix depicts Jacob's adversary as an angel based on an iconographic tradition that had become firmly set by then; still, the biblical text speaks of a man. The interpretation that it is an angel is justified by the fact that he will reveal himself, but since God cannot compete with man, it is God's angel who appears.

JACOB WRESTLING WITH THE ANGEL
Eugène Delacroix
1850
Saint-Sulpice, Paris

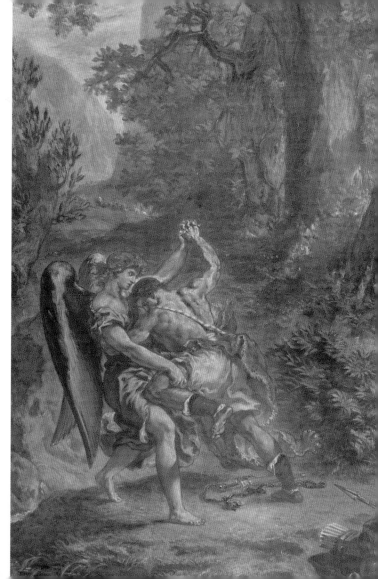

# Jacob Wrestles with the Angel

Doré's etching is much closer to the substance of the episode than the painting by Delacroix (see pages 188–89). The difference lies in a small yet significant nuance: The angel of Delacroix suffers Jacob's strength, though he contains it, while Doré's does not—he is not even grazed by Jacob's vehemence. Not only is this angel unmovable, he is also touched by the fire of this man, who is unaware of the adversary he has dared to measure himself against. Hence, the meaning of the new name that the angel will give him: Israel. Composed of the Hebrew words *isar*, "just" and *El*, "Lord," it means "the Lord is just." This meaning is well expressed in Wisdom (10:12), which states: "[In] a sore conflict she gave him the victory; that he might know that goodness is stronger than all." Here lie the biblical roots of Christianity's understanding of the seed of justice.

JACOB WRESTLING WITH THE ANGEL
Gustave Doré
1866
Granger Collection, New York

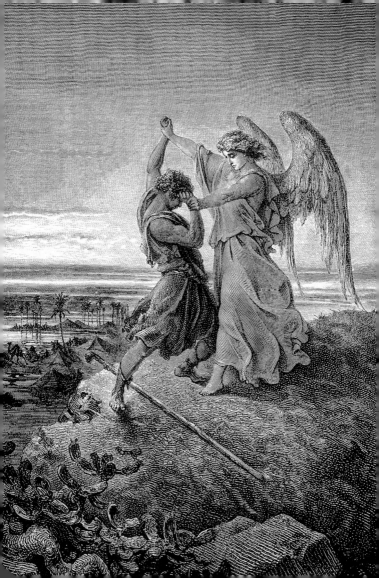

# Genesis 32:24–30

◄◄

## *Jacob Wrestles with the Angel*

Gauguin's interpretation is based on the idea that the biblical message is always relevant. Here the praying Brittany women have just listened to the priest evoke from the altar the images from the Scriptures that they now believe they are seeing in the meadow. Each one of us re-creates in his heart and mind his own Bible, mixing it with his own everyday reality. The two wrestling figures in the background do not exist except in the soul, and every man is called to wrestle with the angel who represents him. God will allow himself to be defeated because he will then be the victor and can change everyone internally, just as he did with Israel.

THE VISION AFTER THE SERMON
Paul Gauguin
1888
The National Gallery of Scotland, Edinburgh

# *The Burning Bush*

> And the angel of the LORD appeared unto him in a flame of fire out of the midst of a bush: and he looked, and, behold, the bush burned with fire, and the bush was not consumed. And Moses said, I will now turn aside, and see this great sight, why the bush is not burnt. And when the LORD saw that he turned aside to see, God called unto him out of the midst of the bush, and said, Moses, Moses. And he said, Here am I. And he said, Draw not nigh hither: put off thy shoes from off thy feet, for the place whereon thou standest is holy ground. Moreover he said, I am the God of thy father, the God of Abraham, the God of Isaac, and the God of Jacob. And Moses hid his face; for he was afraid to look upon God.

The interpretation given to this biblical episode by Nicolas Froment and the patrons who commissioned his work is a Christian one. The presence of the Virgin and Child in the bush is an allusion to the Immaculate Conception, which, though not yet a dogma (it became one only in 1854), already enjoyed great popular favor. In this sense, the fact that the Lord's angel appears in clerical robes is of even greater consequence; his splendid cape fastened by the rich necklace and the white tunic denote his position of deacon. Before him, Moses removes his sandals and shields his face from the unbearable light of the Lord.

THE BURNING BUSH
Nicolas Froment
1475–76
Saint-Sauveur, Aix-en-Provence

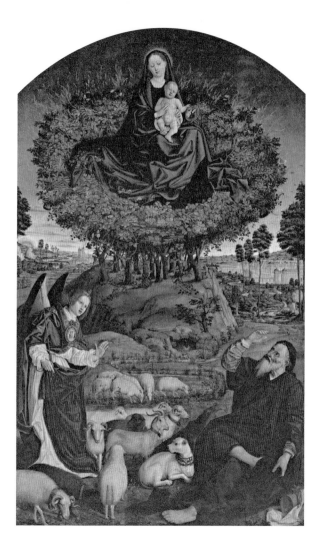

◄◄

# *The Burning Bush*

Surely the ambiguity of the biblical
text could not escape Raphael's
creative genius, for the function
of God's angel is extremely clear:
He appears to Moses "in a flame of
fire out of the midst of a bush" and
says to him, "I am the God of thy
father, the God of Abraham, the God
of Isaac, and the God of Jacob."
For this reason, Raphael paints both
the figure of the Lord and that of his
angel. Having understood that the
entire bush is God's image, he turns
the fire sparks into flaming seraphim
with blazing wings around their
heads. It is a very apt choice,
because the name *seraphim* means
"those who burn." Thus, Raphael's
fresco is indeed a figural theology.

THE BURNING BUSH
(detail)
Raffaello Sanzio, known as Raphael
1511
Vatican Palace, Vatican City

# *Passover*

❝In the tenth day of this month they shall take to them every man a lamb, according to the house of their fathers, a lamb for an house [. . .]. Your lamb shall be without blemish, a male of the first year: ye shall take it out from the sheep, or from the goats: And ye shall keep it up until the fourteenth day of the same month: and the whole assembly of the congregation of Israel shall kill it in the evening. And they shall take of the blood, and strike it on the two side posts and on the upper door post of the houses, wherein they shall eat it. [. . .] And thus shall ye eat it; with your loins girded, your shoes on your feet, and your staff in your hand; and ye shall eat it in haste: it is the LORD'S passover.❞

Despite its dreamlike quality, a characteristic of Chagall's art, this scene is perfectly faithful to the text. The guests are gathered around a table for Passover, as God commanded, and he has given them precepts and rules, that everything might be pleasing to him—including the hasty meal, for Passover is not a leisurely dinner, but an expiation rite in which tribute is paid to God. The only addition to the text worthy of note is the presence of the angel with a sword, circling above God's chosen to protect them. The angel will carry out God's will against the Egyptians.

THE ISRAELIS EAT THE PASSOVER LAMB
Marc Chagall
1931
Message Biblique Marc Chagall,
Musée National, Nice

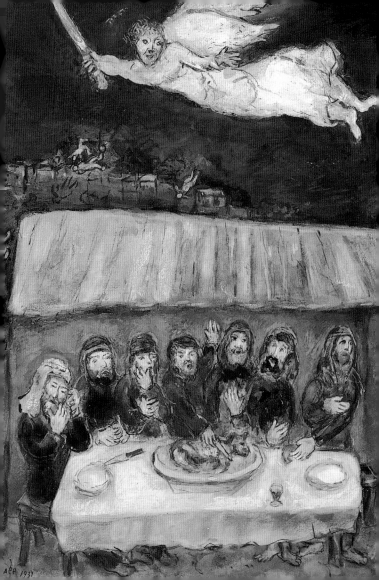

# The Sacrifice of the Firstborn

> For I will pass through the land of Egypt this night, and will smite all the firstborn in the land of Egypt, both man and beast; and against all the gods of Egypt I will execute judgment: I am the LORD. [. . .] And it came to pass, that at midnight the LORD smote all the firstborn in the land of Egypt, from the firstborn of Pharaoh that sat on his throne unto the firstborn of the captive that was in the dungeon; and all the firstborn of cattle.

There is an anachronism in this splendid Doré print, and it is meant to illustrate and provide meaning: The frieze on the lintel is the winged head of a cherub. Although it is a contemporary iconography, this image, skillfully placed as if it were an image of Horus (the biblical episode takes place in Egypt), stresses that God's actions are written in history. The angel with the sword, on the other hand, walks away with great strides, uncaring about the death he has sowed, certain that he has accomplished God's will. In this case also, although the text mentions God, the iconographic tradition shows the angel. The choice is widely supported by all the passages, such as that of the burning bush (Exodus 3:2), in which there is a superimposition of the Lord and his angel, who is his personification.

THE SACRIFICE OF THE FIRSTBORN
Gustave Doré
1866
Granger Collection, New York

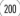

# The Pillar of Fire and Smoke

> And they took their journey from Succoth, and encamped in Etham, in the edge of the wilderness. And the LORD went before them by day in a pillar of a cloud, to lead them the way; and by night in a pillar of fire, to give them light; to go by day and night: he took not away the pillar of the cloud by day, nor the pillar of fire by night, from before the people.

There is a long written tradition (though perhaps not well-known) of writings such as those of the Syriac Pseudo-Berossos and the Renaissance Neoplatonist Marsilio Ficino (1433–99), according to whom the pillar of fire and smoke was none other than an angel. Chagall grasped at once this possibility and executed several paintings on this theme, as well as drawings, lithographs, and even a monumental ceramic version. In the foreground to the left is Moses, though the undisputed protagonist of this watercolor is the angel leading the throng of Jews. Placed above, like the ogive of a rocket shot into the sky, the angel is moving his arms as if to say, "Come on, let's go!" Below, the blue of the sea completes the scene.

THE PARTING OF THE RED SEA
Marc Chagall
1931
Notre-Dame de Toute Grâce, Plateau d'Assy

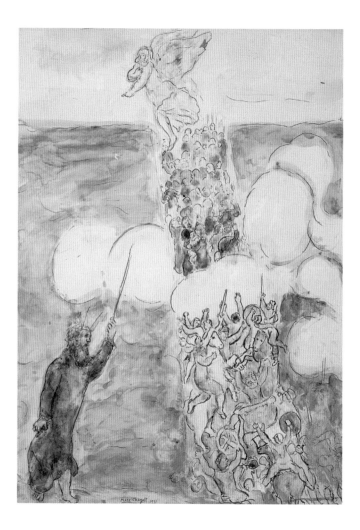

# The Cherubim of the Ark of the Covenant

> And make one cherub on the one end, and the other cherub on the other end: even of the mercy seat shall ye make the cherubims on the two ends thereof. And the cherubims shall stretch forth their wings on high, covering the mercy seat with their wings, and their faces shall look one to another; toward the mercy seat shall the faces of the cherubims be.

The mosaic decorating the apse of the church of Germigny-des-Près was commissioned by Theodulf, archbishop of Orléans. The cherubim depicted follow the specific interpretation that has its roots in the above passage from Exodus and would later evolve. As a matter of fact, the biblical source speaks of two cherubim, each with one wing facing upward and the other spread over the Ark. The artist has depicted the two large cherubim, along with their reproductions in smaller scale, on the cover of the Ark; the latter are yellow because, according to the text, they were made of gold. With this expedient, the artist ensured correspondence between human artifacts and God's model.

THE ARK OF THE COVENANT
SUPPORTED BY CHERUBIM
5th century
Germigny-des-Prés

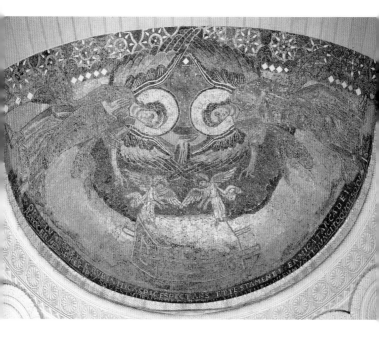

# Transporting the Ark

> And thou shalt make staves for the altar, staves of shittim wood, and overlay them with brass. And the staves shall be put into the rings, and the staves shall be upon the two sides of the altar, to bear it.

The description given in Exodus is evidence that the Ark and the altar could and ought to be moved. The system was a simple one: two rings on each side, and staves to lift them. In other passages, it is reported that a cloud followed the journey of this divine testimony man had built under dictation.

This painting by Nicola Malinconico depicts the Ark as described, adding the presence of the Lord surrounded in the clouds by an array of angels, who bless the journey of his chosen people. The artist has carefully respected the biblical passage, even down to the staves of the Ark.

TRANSPORTING THE ARK
Nicola Malinconico
18th century
Pinacoteca di Brera, Milan

# The Cherubim on the Mercy Seat

And he made the mercy seat of pure gold: two cubits and a half was the length thereof, and one cubit and a half the breadth thereof. And he made two cherubims of gold, beaten out of one piece made he them, on the two ends of the mercy seat; One cherub on the end on this side, and another cherub on the other end on that side: out of the mercy seat made he the cherubims on the two ends thereof. And the cherubims spread out their wings on high, and covered with their wings over the mercy seat, with their faces one to another; even to the mercy seatward were the faces of the cherubims.

The decoration of the synagogue of Dura Europos, interrupted in 256 CE by the Sassanid invasion that sacked and destroyed the city, is an extraordinary piece of archaeological evidence. Arranged on three registers, the images narrate the history of the Jewish people and the design of the salvation promised to them. The scene we are interested in involves Aaron, the priest of the temple, inside which one can see the Ark and in front of it, the Candelabrum. Observing carefully, one detects at the corners of the temple's roof two winged creatures, placed there as acroteria. It is an interesting image because it plays on the ambiguous location of these ornaments—which surely represent winged cherubim—about whom no iconography yet existed.

AARON'S TEMPLE AND THE
CONSECRATION OF THE TABERNACLE
*c.* 239 CE
National Museum, Damascus

# *Balaam's Ass*

> And God's anger was kindled because [Balaam] went: and the angel of the LORD stood in the way for an adversary against him. Now he was riding upon his ass, and his two servants were with him. And the ass saw the angel of the LORD standing in the way, and his sword drawn in his hand: and the ass turned aside out of the way, and went into the field: and Balaam smote the ass, to turn her into the way. [. . .] And when the ass saw the angel of the LORD, she fell down under Balaam: and Balaam's anger was kindled, and he smote the ass with a staff.

This episode is well-known: The prophet Balaam was tricked by Balak, the king of Moab, into going to curse the Jews, who were preparing to make war against the Moabites. The Lord appeared to the prophet in a dream to dissuade him from the task, but since the king's emissaries insisted, he agreed, warning them that only the words that God wanted would come out of his mouth. This is the scene describing Balaam's journey on his ass to go and curse Israel. On the road, however, he meets God's angel. The image of the divine herald is quite different from the iconography that would evolve in later centuries. This painting on the wall of the Via Latina catacomb shows a bearded angel, confirming the fact that angels were considered to be men.

BALAAM STOPPED BY THE ANGEL
4th century
Via Latina catacomb,
known as Ferrua, Rome

# *Balaam's Ass*

This early painting by Rembrandt illustrates the stormy encounter between Balaam and God's angel. The hot-tempered prophet struck three times the ass that stopped at the sight of the Lord's angel. The third time, the animal, to whom God had given the gift of speech, said, "What have I done unto thee, that thou hast smitten me these three times?" Then Balaam understood, saw the angel, and cast himself down on the ground, begging forgiveness. The artist here has immortalized the instant when the prophet, still deaf to God's word and blind to his sight, violently strikes the ass, which opens its mouth not to rail, but to speak. Next to them stands the angel in a bright white robe and with wings outspread; with the sword, he is trying to soothe Balaam's anger, while in the distance two servants (also part of the biblical tale) look on in disbelief.

BALAAM'S ASS
Rembrandt von Rijn
1626
Musée Cognacq-Jay, Paris

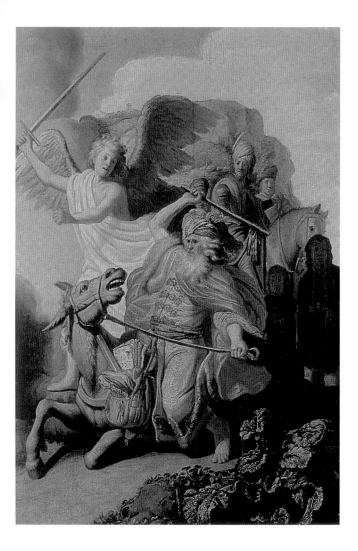

# *Balaam's Ass*

Cecco Bravo's canvas draws its inspiration from the same part of Balaam's tale that Rembrandt illustrated (see pages 212–13). The reason is simple: This is the heart of the prodigy, when God's presence becomes even more manifest. On one side is God's messenger, who appears repeatedly; on the other, the ass that, paradoxically, is more perceptive than the prophet, since it is able to see the divine envoy while the man is unaware of it. Furthermore, Balaam is the stubborn one here, because he cannot grasp the situation, even after the ass stops. He thinks about the stubbornness of the animal, which at this point becomes a tool of God's manifestation and speaks. The animal turns to its obstinate master, its mouth open; here, the prophet is more hardheaded than an ass.

BALAAM'S ASS
Francesco Montelatici, known as Cecco Bravo
17th century
Staatsgalerie, Stuttgart

# Balaam's Ass

Doré's etching portrays the first encounter between Balaam and God's angel, or rather, between the latter and the ass, because at first only the animal can see the divine messenger. The artist has chosen the perspective from behind the prophet: This allows him to be along the same axis as the protagonist's path. The ass swerves upon seeing the angel, and Doré has skillfully rendered the animal's movement, which the servant is in vain trying to correct. Actually, it is clear that Balaam is about to be run over, as the ass is slipping from him, although he is pulling the halter tightly in his hand. In all this brouhaha, the angel remains unmoved and regal, the sword drawn, enjoining the animal to stop. The order is given from above, from the light that breaks through the clouds.

THE ANGEL APPEARS TO BALAAM
Gustave Doré
1866
Granger Collection, New York

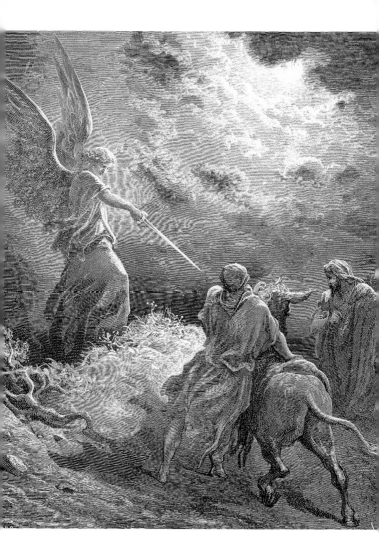

# *The Herald of the Host of the Lord*

And it came to pass, when Joshua was by Jericho, that he lifted up his eyes and looked, and, behold, there stood a man over against him with his sword drawn in his hand: and Joshua went unto him, and said unto him, Art thou for us, or for our adversaries? And he said, Nay; but as captain of the host of the LORD am I now come. And Joshua fell on his face to the earth, and did worship, and said unto him, What saith my lord unto his servant? And the captain of the LORD'S host said unto Joshua, Loose thy shoe from off thy foot; for the place whereon thou standest is holy. And Joshua did so.

There is no real connection between the above passage from Joshua's story and this painting by Hans Memling, but the Flemish painter has correctly interpreted the spirit in which the angel manifests himself to Joshua: The open hand shows that the archangel is speaking, just like the "man" of the biblical account. Memling's angel looks calm, in contrast with the sword he holds in the other hand, which justifies the calmness. The fifteenth-century white robe, symbol of purity, with the stole crossed on the chest, is that of a deacon. Here Michael is *miles Christi* (Christ's soldier), just like the man in the above passage is "the captain of the host of the Lord." The sword is the cross—the weapon against evil and the symbol of victory.

THE ARCHANGEL MICHAEL
Hans Memling
*c.* 1480
The Wallace Collection, London

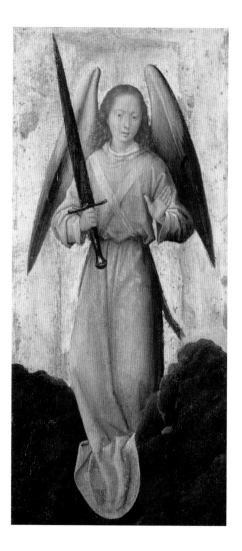

# *The Herald of the Host of the Lord*

In all likelihood, Joshua was one of Moses' many soldiers who had distinguished himself for his valor and courage, so much so that when the first great Jewish legislator died, he took over the command of the army with the latter's full legitimation. After a series of vicissitudes recounted in the Bible, the Israelites found themselves fighting in the shadow of the walls of the Palestinian town of Jericho, whose fortifications crumbled at the sound of the Jewish army's trumpets led by God's will. Doré here describes the moment when the "man with his sword drawn" appears to Joshua, who asks the man whether he is friend or foe. Then he manifests himself for what he really is—the Lord's angel—although he does not say so explicitly. At this revelation, everything stops on the plain below before the walls of Jericho; everyone turns to Joshua, who, as the Bible says, "fell on his face to the earth" in a sign of devotion.

THE ANGEL APPEARS TO JOSHUA
Gustave Doré
1866
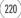 Granger Collection, New York

# Joshua Makes the Sun and the Moon Stand Still

> Then spake Joshua to the LORD in the day when the LORD delivered up the Amorites before the children of Israel, and he said in the sight of Israel, sun, stand thou still upon Gibeon; and thou, moon, in the valley of Ajalon. And the sun stood still, and the moon stayed, until the people had avenged themselves upon their enemies.

The reason why Joshua decided to stop the sun must be sought in the fact that the custom of the time dictated that all battles cease at sunset. By stopping the course of the sun and the moon, Joshua offered to the Israelites the possibility of continuing to fight without breaking a custom observed almost unanimously in antiquity. This work by Nicola Malinconico, full of lighting contrasts, highlights this astronomical miracle. The presence of the angels, although not reported in the text, is quite appropriate since, according to Christian belief, they moved the sun, the moon, and the stars. However, we note that in the eighteenth century, scientific research had rendered these beliefs obsolete; undoubtedly, the artist included the angels to underscore the prodigious nature of the event.

JOSHUA STOPS THE SUN
Nicola Malinconico
18th century

Pinacoteca di Brera, Milan

# The Angel of the Lord Appears to Gideon

> And there came an angel of the LORD, and sat under an oak which was in Ophrah; [. . .] and [Joash's] son Gideon threshed wheat by the winepress, to hide it from the Midianites. And the angel of the LORD appeared unto him, and said unto him, The LORD is with thee, thou mighty man of valour. And Gideon said unto him, Oh my Lord, if the LORD be with us, why then is all this befallen us? and where be all his miracles which our fathers told us of, saying, Did not the LORD bring us up from Egypt? but now the LORD hath forsaken us, and delivered us into the hands of the Midianites.

Before Israel developed a solid judicial system, something it would receive under Solomon, it was ruled by leaders who filled both civilian and military functions. Gideon was one of these leaders, and, when the angel of the Lord appeared to him, he took the opportunity to point out the unhappy state of the Jewish people at the time. This woodcut from the *Biblia Pauperum* [*Poor Man's Bible*], refers to such an episode: Gideon, dressed in armor as tradition depicts him in certain situations, begs the angel under a terebinth, a resinous tree very common on the Mediterranean shores.

GIDEON AND THE ANGEL
15th century
Bibliothèque Nationale de France, Paris

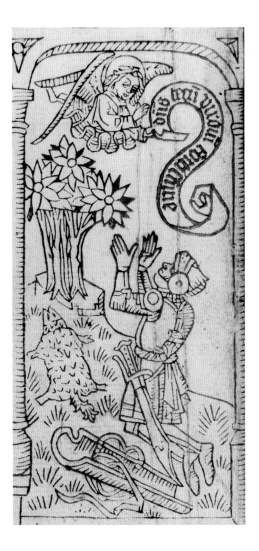

# Judges 6:16–21

## The Sacrifice of Gideon

> And the LORD said unto [Gideon], Surely I will be with thee, and thou shalt smite the Midianites as one man. And he said unto him, If now I have found grace in thy sight, then shew me a sign that thou talkest with me. [. . .] And Gideon went in, and made ready a kid, and unleavened cakes of an ephah of flour. [. . .] And the angel of God said unto him, Take the flesh and the unleavened cakes, and lay them upon this rock, and pour out the broth. And he did so. Then the angel of the LORD put forth the end of the staff that was in his hand, and touched the flesh and the unleavened cakes; and there rose up fire out of the rock, and consumed the flesh and the unleavened cakes.

Gideon is unhappy about the state in which Israel finds itself, and he questions the angel, who reassures him, but it is not enough: Gideon wants a sign. This etching by Francesco Berardi illustrates the passage. On the left is Gideon, wearing vaguely priestly robes; the divine messenger places the staff on the altar, and, as if by magic, a fire rises up that consumes the sacrifice, a sign that God was pleased. The angel's function is to make manifest God's will, allowing man to dialogue with him who would otherwise be unreachable. It is a suggestive etching that accentuates the lighting effect of the flames.

THE SACRIFICE OF GIDEON
Francesco Berardi
18th century
Biblioteca Marciana, Venice

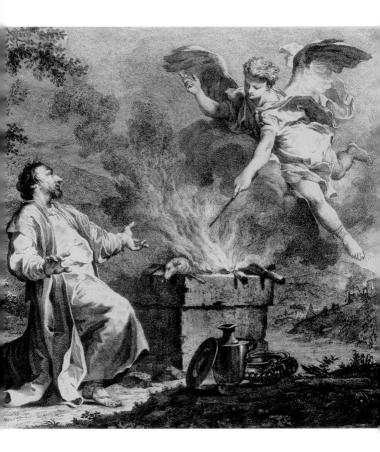

# The Ark of the Lord of Hosts Which Dwelleth Between the Cherubim

" So the people sent to Shiloh, that they might bring from thence the Ark of the Covenant of the LORD of hosts, which dwelleth between the cherubims: and the two sons of Eli, Hophni and Phinehas, were there with the Ark of the Covenant of God. "

Some Quattrocento marble sculptures are based on verses such as these. Of course, the biblical ark does not appear, and the cherubim of which the Bible speaks do not have this appearance; however, this image is indeed based on literary evidence: God in glory, holding in his arms the soul of Mary, is transported by a cloud of angels. The passage from one artistic medium to another and from one age to another carries with it deep changes in meaning and context, because the ark to which the passage refers is transported by the cherubim, the ones sculpted here that decorate it. This sacred object is a seat for God, who sits on it as if on a cloud, as we clearly read in Exodus (40:34–38). Here the Ark of the Covenant is Mary, and she represents the glory of God.

CHRIST, SURROUNDED BY CHERUBIM,
CARRIES THE SOUL OF THE MADONNA
Berry master sculptor
15th century
Musée du Louvre, Paris

◄◄

# The Ark of the Lord of Hosts Which Dwelleth Between the Cherubim

A comparison of the biblical text with this work by Pordenone helps us to understand how angelic iconography evolved over time. The point of departure is the passage in Samuel describing God sitting on an ark protected by the cherubim (see pages 228–29). Here God is Sabaoth, the "Lord of hosts," which is to say, "God the military leader." The interpretation offered by the Berry master's relief on the preceding page grasps, in the Bible's literary image, the aspect of glory, with the lovely garland of four-winged cherubim. In this case, the artist is once more moving the center of gravity, transforming God's glory in a God who, no longer unreachable, is sweet and kindhearted and stretches toward man. In Cinquecento iconography, the cherubim have taken on the new appearance of little boys with wings (even if the wings are not visible here), and nothing has survived of the ancient warlike vision.

GOD THE FATHER SUPPORTED BY ANGELS
Giovan Antonio Pordenone
1530
San Francesco, Cortemaggiore

230

# The Lord of Hosts Dwelleth Between the Cherubim

►►

" And David arose, and went with all the people that were with him from Baale of Judah, to bring up from thence the ark of God, whose name is called by the name of the LORD of hosts that dwelleth between the cherubims. "

This intriguing archeological artifact helps explain, even if only approximately, why the men of the Bible pictured a God seated on an ark. This figure, whom the scholars have identified as a female centaur, is very similar to the Babylonian *lamassu* after which the cherubim were fashioned (see pages 322–23): In reality, it is the armrest of a throne. The idea of God in glory that Samuel must have formed in his mind was that of a judge—as was Samuel himself—seated on a throne. The logical transition is due to the fact that the Ark has two cherubim on each side in the position of armrests; therefore, they serve in that role when God, in the form of a cloud, sits on the Ark.

FIGURE OF FEMALE CENTAUR
7th century BCE
British Museum, London

# The Lord of Hosts Dwelleth Between the Cherubim

The triumphant Christ illustrated on the opposite page is part of a panel that also reproduces the suffering Christ. The artist painted the blessed and the damned under Christ triumphant, with a small Saint Michael positioned in the center, arranging the entire scene as a Last Judgment. The gigantic Christ in glory is seated on an interlacement of red cherubim, with the ones at each side blowing trumpets. Of course, their iconography follows that of the times; in the Quattrocento, they were pictured as small winged heads, their large wings strewn with black dots recalling the eyes of Ezekiel's vision (Ezekiel 1:1–28). In this case as well, the image painted by the Sienese artist is quite different from what Samuel was trying to evoke, but the meaning is so similar that here we also have the military element included in the meaning of Christ the Judge.

CHRISTUS PATIENS AND
CHRISTUS TRIUMPHANS
(detail)
Giovanni di Paolo
c. 1425
Pinacoteca Nazionale, Siena

# The Angel of the Plague

> And when the angel stretched out his hand upon Jerusalem to destroy it, the LORD repented him of the evil, and said to the angel that destroyed the people, It is enough: stay now thine hand. And the angel of the LORD was by the threshing place of Araunah the Jebusite. And David spake unto the LORD when he saw the angel that smote the people, and said, Lo, I have sinned, and I have done wickedly: but these sheep, what have they done? let thine hand, I pray thee, be against me, and against my father's house! And Gad came that day to David, and said unto him, Go up, rear an altar unto the LORD in the threshing floor of Araunah the Jebusite.

There is no real connection between the above biblical passage and this disturbing painting, but this work lends itself to a reflection on the suffering of men throughout history; in imagining this scene, Böcklin must have also remembered the biblical account. As represented here, the plague is a cross between a demon, the beast of the Apocalypse, and the angel of death, reaping as many lives as he can with his scythe, cutting blindly without regard for age or the value of the individuals. It is a violence that carries everything away as in a storm, that of the biblical angel, and leaves one speechless.

THE PLAGUE
Arnold Böcklin
1898
Kunstmuseum, Basel

# *The Cherubim*

"And within the oracle cell he made two cherubims of olive tree, each ten cubits high. And five cubits was the one wing of the cherub, and five cubits the other wing of the cherub: from the uttermost part of the one wing unto the uttermost part of the other were ten cubits. And the other cherub was ten cubits: both the cherubims were of one measure and one size. The height of the one cherub was ten cubits, and so was it of the other cherub. And he set the cherubims within the inner house: and they stretched forth the wings of the cherubims, so that the wing of the one touched the one wall, and the wing of the other cherub touched the other wall; and their wings touched one another in the midst of the house. And he overlaid the cherubims with gold."

The image of the sphinx, one of many mythical beings composed of parts of different animals and a human head, must have influenced the appearance of the cherubim. In the case of this ivory artifact, we have an idea of how the external decoration of the Temple of Solomon must have looked, with carved figures of cherubim, palm trees, and open flowers (1 Kings 6:29). This artifact was found in Megiddo, which is a few miles from Nazareth, where Solomon probably had horse stables built (1 Kings 10:26 ff.), and is a clear example of cultural crossbreeding.

SPHINX WITH WINGS
2nd–1st millennium BCE
Israel Museum, Jerusalem

◀◀—————————————————————————————

# *The Cherubim*

Scholars of Oriental art and culture have highlighted the relationship between the biblical conception of the cherubim and the cultural context where it originated. There is a relationship between them and the winged griffins that were found on ivory carvings such as this one and on Assyrian seals as mythical beings guarding the tree of life. Thus we must look at the cherubim as the result of religious and artistic exchanges between neighboring cultures, as was probably the case in eastern Anatolia (modern Turkey), where this Urartu ivory artifact, similar to Nimrud's Assyrian figures, was found.

GRIFFIN
8th–7th century BCE
British Museum, London

# Elijah's Dream

> And as he lay and slept under a juniper tree, behold, then an angel touched him, and said unto him, Arise and eat. And he looked, and, behold, there was a cake baken on the coals, and a cruse of water at his head. And he did eat and drink, and laid him down again. And the angel of the LORD came again the second time, and touched him, and said, Arise and eat; because the journey is too great for thee. And he arose, and did eat and drink, and went in the strength of that meat forty days and forty nights unto Horeb the mount of God.

After reproaching the Israelite king Ahab for reintroducing the worship of Baal, Elijah suggested that sacrifices be made to both Baal and Yahweh. The first did not respond to the offering, while Yahweh devoured the holocaust with fire; therefore Elijah believed it just to slay all the priests of the pagan god (1 Kings 18). Then, to escape the rage of Queen Jezebel, he fled into the desert, where he begged God to let him die, since he did not believe that after this deed he was any better than his fathers. His heart was tried by his own deeds. But God saved the prophet and sent him an angel who fed him bread and water in the desert.

ELIJAH'S DREAM
(ELIJAH AND THE ANGEL)
Bernardino Luini
1521
Museo della Scienza e della Tecnica, Milan

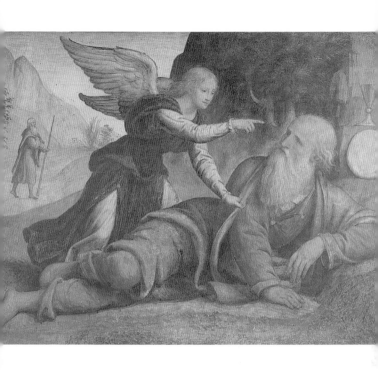

# Elijah's Dream

According to a well-known metaphor, a barren landscape represents the arduous path toward Truth and Salvation. The road we see in the background reinforces this symbolic meaning. The Fathers of the Church and the biblical literature hold it to be a forerunner of John the Baptist and, at bottom, of the Savior. The prophet Elijah does not flee from his duties, but punishes himself, sentencing himself to a life in the wilderness. This sixteenth-century artist has skillfully rendered the prophet's physicality, marked by a lean, muscled body also typical of the image of John the Baptist. Elijah falls into a deep sleep, from which the angel, God's messenger—a concrete sign of his favor—awakens him.

ELIJAH COMFORTED BY THE ANGEL
Alessandro Bonvicino,
known as Moretto da Brescia
early 16th century
San Giovanni, Brescia

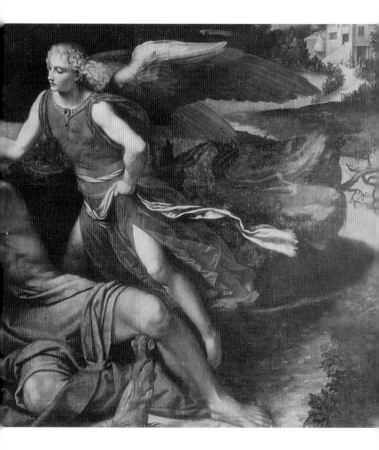

◀◀

# *Elijah's Dream*

▶▶

In this painting by Morazzone, the light is coming from the left because that is where the angel is, and it takes on a redemptive aspect. In the fifth century CE, Elijah became a favorite subject in the writings of Pelagius and his followers—Christian heretics who saw in him an example of the man in need of grace, understood as an aid to free will. As long as Elijah sleeps, he knows not whether God will grant him this grace, and his ability to do either good or evil is suspended. After the angel awakens him and feeds him, the divine grace, which will help the prophet choose the best course of action and reach the spiritual heights to which the biblical passage alludes with the assumption of Elijah into heaven, is made explicit (2 Kings 2:11).

ELIJAH'S DREAM
Pier Francesco Mazzucchelli, known as Morazzone
1616–18
San Raffaele, Milan

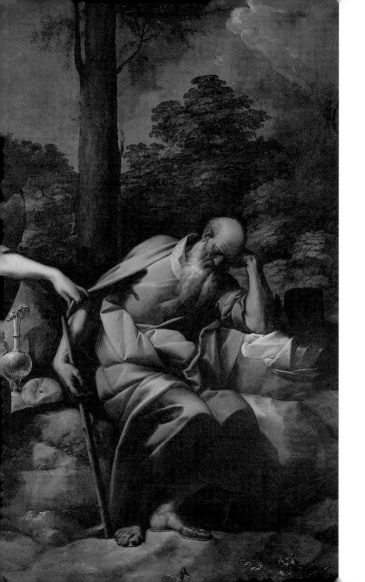

◄ ◄

## *Elijah's Dream*

The angel's touch gives Elijah the strength to carry on. A master of seventeenth-century French painting, Philippe de Champaigne began practicing the Jansenist spirituality of Port-Royal in 1640, condemned by the Catholic Church in 1641. According to this doctrine, redemption from sin could only come about through God's grace. Here, the artist has taken the episode of Elijah and the angel to show, paradoxically, the opposite of what the heretic Pelagius had claimed in the fifth century (see pages 246–47). For this reason, a jug of water and some bread are nearby—symbols of the Eucharist (metaphorically administered by the angel), the true sign of grace. Indeed, this painting had been commissioned to hang in the refectory room of the Val-de-Grâce convent. The angel, therefore, personifies grace, and in awakening the prophet, he points to the right path, which leads to Val-de-Grâce.

THE DREAM OF ELIJAH
Philippe de Champaigne
1650–55
Musée de Tessé, Le Mans

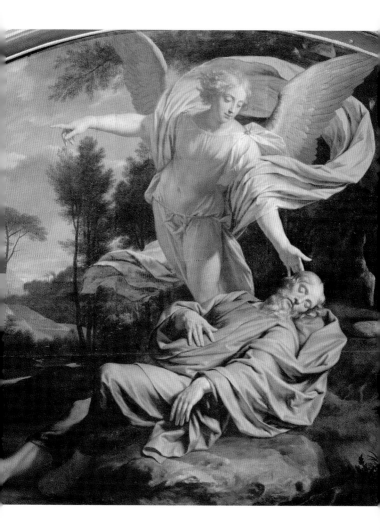

# Elijah's Dream

Here Rubens shows us Elijah, now awake, conversing with the angel. The divine messenger has just stepped off a staircase, which the viewer glimpses behind him, and which evokes the ladder of Jacob's vision (Genesis 28:12–17). He offers the prophet a glass of water and a small loaf of bread. The angel's clothes reveal a breast: The painter deliberately did not hide it, because offering the breast is a sign of mercy, even if the angel has androgynous features, both male and female. The composition shows the columns of the Temple of Solomon enclosing the scene on each side, a warning to return to the worship of Yahweh.

THE PROPHET ELIJAH RECEIVING
BREAD AND WATER FROM AN ANGEL
Pieter Paul Rubens
1626–28
Musée Bonnat, Bayonne

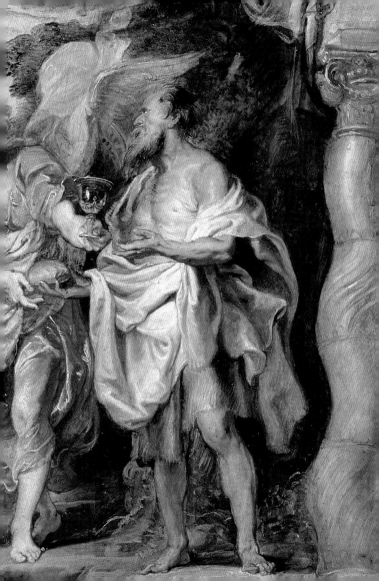

◄◄

# Elijah's Dream

The prophet is sleeping soundly in the shade, while the angel is kissed by the divine light. This is a humble angel, satin sash notwithstanding, for the sleeves rolled up to his elbows give him a peasant's air that is at home with the rustic environment (not a desert) where the scene unfolds. In fact, unlike Luini (see pages 242–43) or Moretto da Brescia (see pages 244–45), this painter did not follow the text blindly and did not paint a desert. Similarly, he did not follow the description in the biblical passage that places the prophet under a juniper tree. Escalante's use of poetic license, without betraying the spirit of the Scriptures, has created his own personal version.

THE ANGEL AWAKENING THE PROPHET ELIJAH
IN THE DESERT
Juan Antonio Escalante
1667
Gemäldegalerie, Staatliches Museen, Berlin

# Elijah's Dream

In interpreting this episode, Francesco Maggiotto decided to set on canvas the moment when the angel actually looks after the prophet, telling him, "Arise and eat, because the journey is too great for thee." Indeed, the two figures painted by the Venetian artist are having a discussion, and the angel, still hovering in the air, makes a clearly theatrical, oratorical gesture as he points to the water and the bread, which is fully in keeping with the contents of the discussion. Like many angelic figures we have already seen, this one, scantily dressed in fluttering garments, resembles the classical model of the winged Victory. The reference to classicism must be seen as a more or less evident and learned gloss that heightens the dignity of the biblical tale.

ELIJAH AND THE ANGEL
Francesco Maggiotto
early 18th century
San Giovanni in Bragora, Venice

# The Heavenly Host

> And [Micaiah] said, Hear thou therefore the word of the LORD:
> I saw the LORD sitting on his throne, and all the host of
> heaven standing by him on his right hand and on his left.

Biblical passages such as this one shaped the iconography adopted by artists such as Tzanes. The *synáxis* (Greek for "religious gathering") of the angels is their communion with the ruler of the heavens, a popular subject of Byzantine iconography, here rendered harmoniously by the Greek painter Emmanuel Tzanes—a native of Crete who had moved to Corfu and from there to Venice after the island was invaded by the Turks. This scene represents the angelic army under the command of the archangels Gabriel and Michael, who lead them holding the icon of the Savior, present in effigy as befits a ruler. A study of the angels' garments reveals interesting details, reflecting as they do the iconographic tradition of the time, but not in contemporary military attire: The angel on the left is wearing the ancient Roman *lorica*, while others wear the *chlamys*, the typical short mantle of the Byzantine soldier.

THE SYNAXIS OF THE ANGELS
Emmanuel Tzanes
1666
Byzantine and Christian Museum, Athens

# Elijah and the Angel

> And the angel of the LORD said unto Elijah, Go down with him: be not afraid of him. And he arose, and went down with him unto the king. And he said unto him, Thus saith the LORD, Forasmuch as thou hast sent messengers to enquire of Baal-zebub the god of Ekron, is it not because there is no God in Israel to enquire of his word? therefore thou shalt not come down off that bed on which thou art gone up, but shalt surely die.

Only rarely has this biblical passage been represented in art, although it is part of the cycle dedicated to Elijah. This episode refers to the messenger from Ahaziah, king of Israel from 852 to 851 BCE. This king, wounded and ill, had sent his messengers to enquire of Baal-zebub about his fate. Elijah had cautioned them, reminding them that Yahweh was the only God of Israel. Then the king had resolved to speak with Elijah, sending another messenger to search for him. This is the scene where the angel (the winged figure; the putto next to him is the personification of foresight) counsels Elijah to accept the invitation and follow the king's herald (who is in front of him and points to Israel) and to tell Ahaziah that he will soon die. The flaming sword under the prophet's feet and the pillar of smoke in the horizon recall earlier parts of this episode, when the fifty soldiers who had followed the previous messengers were devoured by Yahweh's fire.

ELIJAH AND THE ANGEL
Antonio Cavallucci
18th century
San Martino ai Monti, Rome

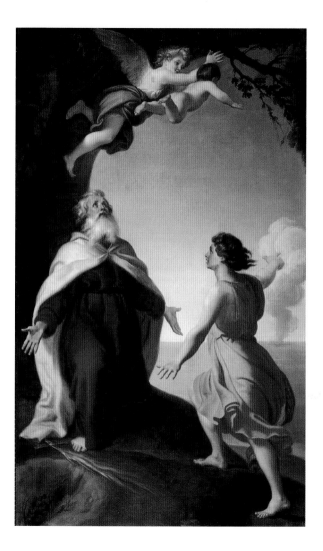

# *Elijah Is Taken Up to Heaven*

"And it came to pass, as they still went on, and talked, that, behold, there appeared a chariot of fire, and horses of fire, and parted them both asunder; and Elijah went up by a whirlwind into heaven. And Elisha saw it, and he cried, My father, my father, the chariot of Israel, and the horsemen thereof. And he saw him no more: and he took hold of his own clothes, and rent them in two pieces. He took up also the mantle of Elijah that fell from him, and went back, and stood by the bank of Jordan; And he took the mantle of Elijah that fell from him, and smote the waters, and said, Where is the LORD God of Elijah? and when he also had smitten the waters, they parted hither and thither: and Elisha went over."

This fresco by Guariento di Arpo brings a meaningful addition to the biblical text; the two angels depicted on the opposite page, standing guard by the chariot of fire, are not in the passage, but their presence is not illogical, for it completes the scene and confers a sense of prodigiousness to the event. Thus the artist seems to allude to the wheels that in the vision of Ezekiel (Ezekiel 1:1–28)—which Guariento must have known, since he painted the entire series of angelic hierarchies—appear below the feet of the cherubim.

ELIJAH IS TAKEN UP TO HEAVEN
Guariento di Arpo
1349–54
Private Carraresi Chapel
(now Accademia Galileiana), Padua

# *Elijah Is Taken Up to Heaven*

This icon, which summarizes the story of Elijah, includes all the episodes in which the prophet gives his difficult testimony about worshipping Yahweh as the only God, in antithesis to the idol worship of King Ahaziah. In it, we see the initial scene, where the prophet is being fed by the ravens (1 Kings 17:2–6), tangible proof of divine providence, and the scene where the angel wakes the prophet. The icon also includes the detail reproduced on the opposite page, the apex of the story: Elijah is raised to heaven in a red chariot that moves like a novel seraph, while Elisha pulls him by the mantle (2 Kings 2:14). The iconographic novelty introduced here is the presence of the angel pulling the chariot and leading it toward the small figure of God, leaning out of the empyrean, in the upper right corner. This is a meaningful presence, because it attributes to the angel the role of executor of God's will, thus safeguarding the distance between man and God. Besides, the fact that the angel waking up Elijah is the same one that leads him to heaven on the chariot underscores the unity of God's plan.

ELIJAH'S ASSUMPTION TO HEAVEN
(detail)
School of Pskov
15th century
Museum of the History of Religion,
Saint Petersburg

# *The Archangel Raphael*

> Then [his father] said unto him, Seek thee a man which may go with thee [to Media], whiles I yet live [. . .]. Therefore when [Tobias] went to seek a man, he found Raphael that was an angel. But he knew not.

The artist has chosen to illustrate the initial moment of the tale of Tobias and the angel, something quite rare in art, since this story is usually represented synthetically in one atemporal scene that includes the salient points. Tobias, whose name means "God is good," leaves for Media with the task of collecting an old debt from a distant relative. His family needs money because his father, Tobit, has become blind. Tobias, represented in other works of art as a child, is inexperienced, and finds as fellow traveler another wayfarer, who will turn out to be the archangel Raphael.

THE DEPARTURE OF TOBIAS
Giovanni Antonio Guardi
1749–50
San Raffaele Arcangelo, Venice

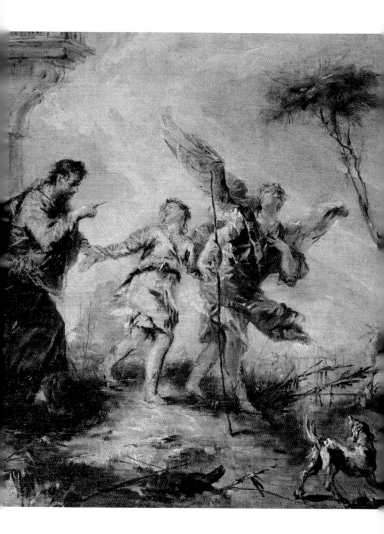

# *Tobias and the Fish*

> And as they went on their journey, they came in the evening to the river Tigris, and they lodged there. And when the young man went down to wash himself, a fish leaped out of the river, and would have devoured him. Then the angel said unto him, Take the fish. And the young man laid hold of the fish, and drew it to land. To whom the angel said, Open the fish, and take the heart and the liver and the gall, and put them up safely.

This mural is the earliest surviving image of Tobias and the angel. Since we are used to imagining angels as chubby children, we might be tempted to consider the half-naked young man as an angel, but it is in fact Tobias, holding a fish in one hand and a fishing rod in the other. The angel is the other figure, unexpectedly (for us) dressed in a dalmatic and pallium. The iconography is typical of the early Christian angels, who were represented as men. On the other hand, the Tobias story does not attribute wings or unusual details to the angel.

RAPHAEL, TOBIAS, AND THE FISH
4th century
Trasone Catacombs, Rome

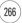

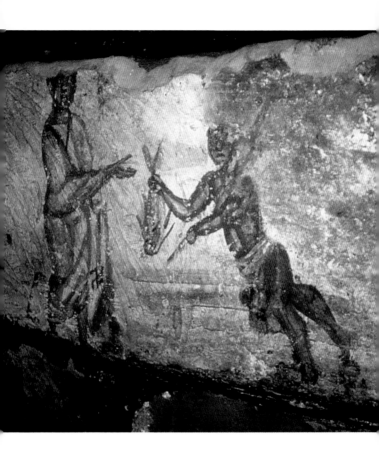

# *Tobias and the Fish*

The story of Tobias introduces into the Scriptures the figure of Raphael, the angel sent by God to cure Tobit's eyes, which had been harmed by bird excrement. This deeply symbolic episode explains how faith in God is the only way to remove the darkness from the eyes and drive back evil. In the course of the story, Raphael will chain "the evil spirit Asmodeus," thus appearing as the prototype of the angelic choir known as the Powers, and he is depicted here as an angel escorting a young boy. In fact, the figure of Raphael is easily recognizable because he is usually in the company of the child Tobias (sometimes referred to by the diminutive "Tobiel") carrying a fish; however, the story shows that, through his angels, God follows and protects each one of us.

TOBIAS AND THE ANGEL
Giovanni Santi
1460
Galleria Nazionale delle Marche, Urbino

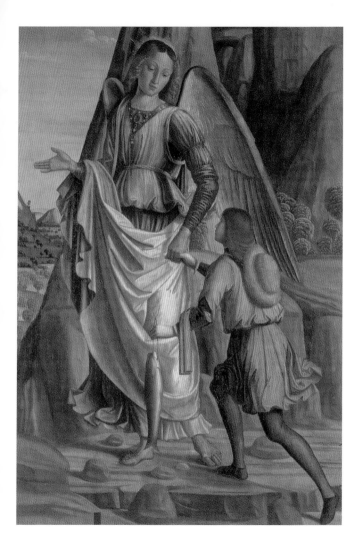

◄◄

# *Tobias and the Fish*

►►

This panel, attributed to Francesco Botticini and his teacher, Andrea del Verrocchio, was commissioned by the Archangel Raphael Society of Florence. This explains the central position of Tobias and the archangel, who appears here with all the iconographic attributes that are in the story: in addition to the boy holding the fish, the divine messenger holds a small box containing the medicaments and is followed by a small dog—a symbol of faithfulness—also mentioned in the Bible. The angel's wings are peacock feathers, a detail that signifies immortality. Commonly used by medieval as well as Renaissance artists, the peacock feathers are also an attribute of foresight.

THE THREE ARCHANGELS WITH TOBIAS (detail)
Francesco Botticini and Andrea del Verrocchio (attr.)
*c.* 1467
Galleria degli Uffizi, Florence

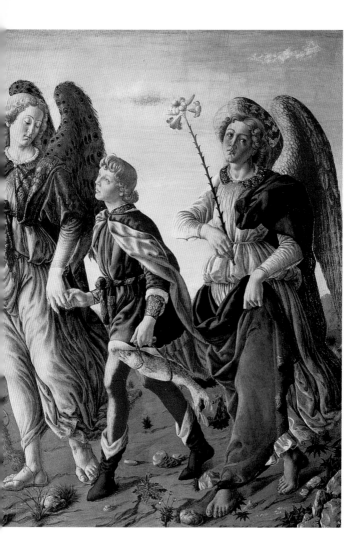

# Tobias and the Fish

Young Tobias and the archangel Raphael look like two friends out on a stroll. Antonio Pollaiuolo and his brother Piero created this painting by taking the entire story into account and condensing it into this rich, and by now famous, image, although the point of departure seems to be the line that reads: "Then they both went on their way, till they drew near to Ecbatane" (Tobit 6:6). Indeed, the two figures look like wayfarers, except for Raphael's large wings. Tobias is wearing a smart hat, which costume historians have called "a captain's hat," that beautifully evokes the atmosphere of the journey. The landscape, with the river in the background (from which the fish was taken), confirms this impression. Clearly, the artists were trying to build an image that was tied to the then-current iconography, with all the elements of the story, to explicate the meaning as clearly as possible. The result, however, does not follow the chronology of the story, and all the elements in it end up as symbols and marks of recognition. In fact, the fish could not coexist with the small round box that held the medicaments extracted from its innards, just like the journey is incompatible with the complete fish, because it was cut up and cooked right after being caught.

TOBIAS AND THE ANGEL
Antonio and Piero Pollaiuolo
*c.* 1460
Galleria Sabauda, Turin

◄◄

# *Tobias and the Fish*

►►

One unusual detail of this panel pertains to Tobias's smart figure, here with his head surrounded by a halo. This is not the first time he has been so represented, but it was not as noticeable before. In actuality, there is a cult of Saint Tobias, but it is directed more toward his father, Tobit. Filippino Lippi's work draws on the imagery of the panel in the Uffizi as an iconographic *topos*; the reason for the fact that here also the archangel Gabriel is at the center of the composition must be sought in the patron who commissioned this work— perhaps a religious brotherhood dedicated to the archangel. On the popularity of Tobias's image there are many theories, among them that the paintings were offerings for protection for a safe journey or, more probably, for children, before the cult of the guardian angel became popular.

THE THREE ARCHANGELS AND TOBIEL
Filippino Lippi
*c.* 1480–85
Galleria Sabauda, Turin

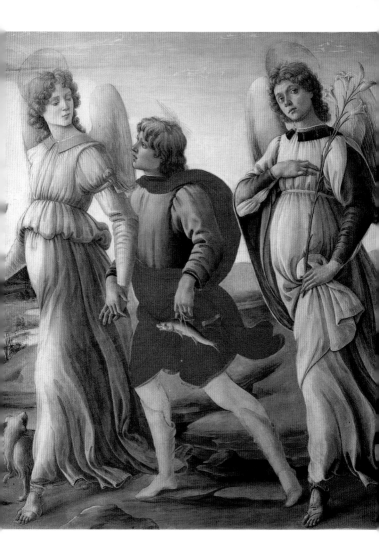

◀◀ ─────────────────────────────────────────── 

# *Tobias and the Fish*

─────────────────────────────────────────── ▶▶

Completed two years before Botticini's death, this panel was painted for the son of Raffaele Doni, who commissioned the work. The destination of the work reveals another important aspect of the image of Raphael, specifically as guardian angel; in fact, he is the prototype of the healing, and therefore protecting, spirit. It is not by coincidence that the child for whom this work was created figures in the foreground, in a smaller scale, as was the custom, and that he bears a certain resemblance to the representation of Tobias. The image of Raphael follows the customary Renaissance iconography that, as in the case of the archangel painted by Giovanni Santi (father of Raffaello Sanzio, known as Raphael), evokes the classical winged Victory. Here the artist has added a deacon's mantle and stole. Botticini paid special attention to the figure of Raphael (he painted other versions of him), perhaps out of personal devotion: In fact, the artist gave to his son, who also became a painter, the name "Raphael."

TOBIAS AND THE ARCHANGEL RAPHAEL
Francesco Botticini
1495
Santa Maria del Fiore, Florence

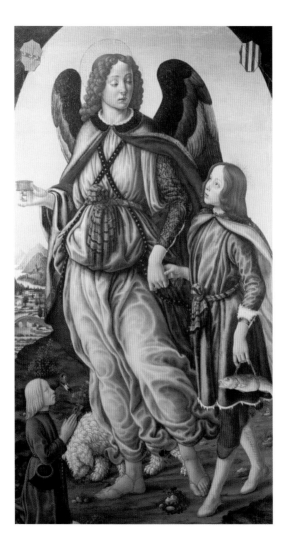

◄◄ ◄─────────────────────────────────────────

# *Tobias and the Fish*

─────────────────────────────────────────► ►►

Like Filippino Lippi's panel, this one by Giacomo Pacchiarotti, which is almost folkloric in flavor, also depicts Tobias with a halo. This work by the Sienese artist is the last panel of a now-lost predella that shows, at the beginning and the end, the same figure wearing a red toque and carrying a small box with the medicaments (the same box that Raphael is holding), and that perhaps refers to Saints Cosmas and Damian, the Arab twins who were medical scholars and reputed healers. The choice would be totally consistent with the scene of Tobias and the angel, also because the same figure (the other brother) appears in the first panel of the predella next to Saint Michael, driving away the devil, i.e., afflictions. The image of Raphael is still flavored by Quattrocento iconography: He wears a mantle and the typical *guarnello* that recalls the winged Victory of classical antiquity.

TOBIEL AND THE ANGEL
Giacomo Pacchiarotti
*c.* 1510
Pinacoteca Nazionale, Siena

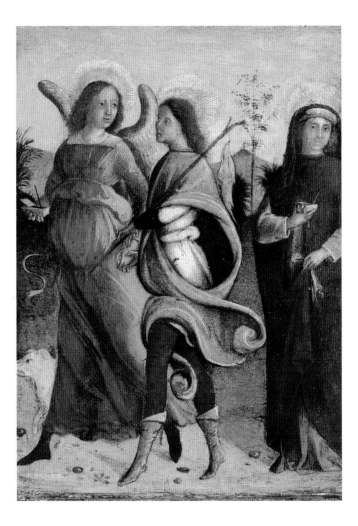

# Tobias and the Fish

———————————————————► ►

If there is one work where the iconography of Tobias and the angel was renewed, it is undoubtedly this splendid canvas by Savoldo. The scene no longer depicts the meeting of the boy and the angel outside Tobit's house (Tobit 5:4–8), but the moment when the angel commands him to grab the fish and not let go (Tobit 6:3). Tobias looks perplexed, like someone who is not expecting this sort of request. Savoldo has constructed a "film frame," as we would call it today, of the biblical story. Here the small medicine box is missing, and the presence of the dog is functional to the scene; he is curled up, waiting to jump into action. The artist's intention to follow closely the biblical text is also clear in Tobias's features, no longer those of a young boy, but of a young man, in keeping with the description in the Scriptures.

TOBIAS AND THE ANGEL
Giovanni Gerolamo Savoldo
c. 1530
Galleria Borghese, Rome

◄◄

# *Tobias and the Fish*

Although faithful to the traditional scenes, this panel by Raffaellino da Reggio renews angelic iconography by attributing to Raphael markedly feminine features, even if the more visible sexual attributes are missing. This is the result of a long process that affected angel figures from the time that the literary theme of the angelic woman became widespread. The bases for attributing feminine features to the images of angels are to be found in the meditations developed by all the Fathers of the Church, Pseudo-Dionysius in particular, about God's beauty. In this painting, the angel is escorting Tobias and pointing out the road to him. The artist has highlighted the ample robes, a reference to classical antiquity, which was understood to be a mythical time.

TOBIAS AND THE ANGEL
Raffaello Motta,
known as Raffaellino da Reggio
*c.* 1580
Galleria Borghese, Rome

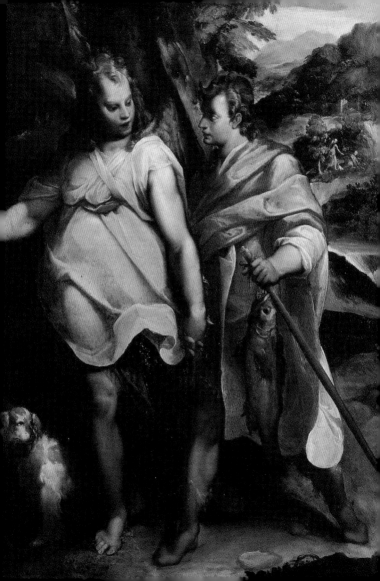

# *Tobias and the Fish*

Almost lost in the immensity of this luscious woodland setting, Tobias and his companion, who will reveal himself as Raphael only at the end, follow the path in the trees. A curious detail in this painting is the pilgrim's hat worn by the archangel; it is an intelligent humanization of the divine herald, who folds his wings in the back as if to hide them. The two are dressed as wayfarers and even carry a walking stick. The ever-present little dog follows them; running, he seems to frighten the deer and cause the rabbit hiding in the bushes to lift its ears. Of course, beyond being a representation of the biblical story, the journey is also a metaphor for life, through which Raphael, the prototype of the guardian angel, accompanies us.

LANDSCAPE WITH RAPHAEL, TOBIAS, AND THE FISH
Workshop of Gillis van Coninxloo
*c.* 1600
Pinacoteca Nazionale, Siena

◄◄ ◄────────────────────────────────────────────

# *Tobias and the Fish*

─────────────────────────────────────────────────

This painting by Battistello Caracciolo offers a moving, pathos-filled interpretation of Tobias and the archangel Raphael. Like Savoldo's painting, it captures the moment when the angel orders the boy to grab the fish and not let go (Tobit 6:3). However, here Tobias is forced to throw himself with all his weight on the fish so it will not escape, thus suggesting the idea of an extraordinary event. The artist has skillfully concealed Raphael's real nature—the wings are carefully hidden by the shadow, and he wears a hat, typical accessory of the wayfarer. Consistent with his role, the angel is leaning on a walking stick. Finally, but no less important, the light that pools around Tobias's seminude body is a tangible sign of divine benevolence.

TOBIAS AND THE ANGEL
Battistello Caracciolo
1615
Private collection

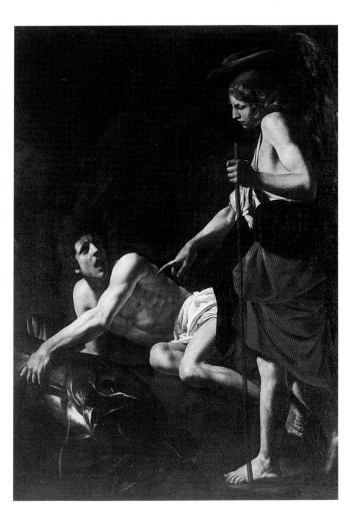

# Tobias Heals His Father Tobit

"[Said Raphael to Tobias], And take in thine hand the gall of the fish. So they went their way, and the dog went after them. [. . .] Then said Raphael, I know, Tobias, that thy father will open his eyes. Therefore anoint thou his eyes with the gall, and being pricked therewith, he shall rub, and the whiteness shall fall away, and he shall see thee. [. . .] And [Tobias] took hold of his father: and he strake of the gall on his fathers' eyes [. . .] And when his eyes began to smart, he rubbed them; And the whiteness pilled away from the corners of his eyes: and when [Tobit] saw his son, he fell upon his neck. And he wept, and said, Blessed art thou, O God, and blessed is thy name for ever; and blessed are all thine holy angels!"

The name Raphael is of Hebrew origin; it means "God has healed me," and therefore it already contains the destiny of his mission. Raphael explains to Tobias how he should use the fish's entrails and how he should process them into effective ointments. The return home, after the long mishaps of the journey during which Raphael was a watchful, unobtrusive companion, marks the fulfillment of the divine messenger's mission. Thanks to the cure, Tobit regains his sight. Materially, it is Tobias who cured his father, but in reality it was God acting through Raphael.

TOBIAS HEALING HIS FATHER TOBIT
Giovanni Battista Carloni
17th century
Private collection

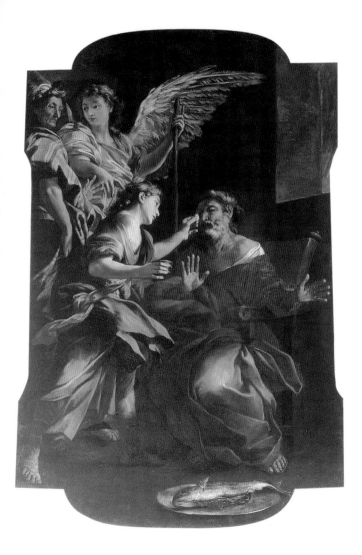

# Tobias Heals His Father Tobit

This version of the episode, also created by Carloni, sets the scene on a horizontal register, giving it the intimate atmosphere of a family gathering. Tobit, his beard white, lets his son Tobias treat his eyes, which must also cause him pain. His white sleeve exposed fully to the light, Tobias looks like a real physician. He holds in his hands the container with the ointment extracted from the fish's gall and entrails; with the other hand, he gently wipes the eye. Behind him is the angel, the true artificer of the miracle, since he is an agent of God's will, overseeing unobtrusively to ensure that all proceeds well. The wings almost disappear in the shadow, while his face is flooded with the light of God's benevolence, which the divine envoy represents.

TOBIAS HEALS HIS FATHER
Giovanni Battista Carloni
17th century
Private collection

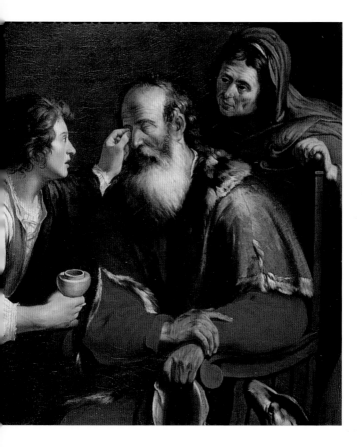

◄◄

# *Tobias Heals His Father Tobit*

►►

This work by Bernardo Strozzi intentionally strays into a genre theme. The family is again reunited. To the left we see Anna, Tobit's wife and Tobias's mother; in the center is the father, undergoing his son's treatment; behind is the angel, who looks like a shop apprentice, though his wings cover all the characters, who are thus placed under his protection. To the extreme right, bloodied belly upturned, is the fish, almost part of a still-life. One trend of Seicento iconography was to render biblical scenes as scenes from quotidian life, a trend that was warmly encouraged by the Catholic Church.

THE HEALING OF TOBIT
Bernardo Strozzi
*c.* 1635
The Hermitage, Saint Petersburg

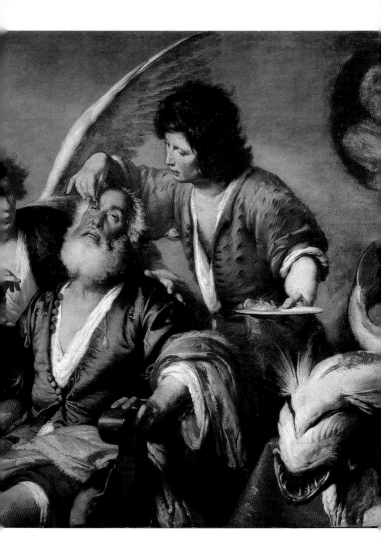

◀◀ ◀

# *Tobias Heals His Father Tobit*

▶▶ ▶

One common trait of paintings of Tobias healing his father is the intent to stress the angel's unobtrusiveness. The meaning is this: God acts through things, and one must be able to discover God's actions in quotidian life. Thus Filippo Abbiati portrays Tobias like a physician and Tobit like a model patient who trusts the doctor and submits to the treatment. The old father throws back his head and opens his arms, a somewhat instinctive reaction to the uncomfortable treatment, and also as if to say: I am in your hands. In reality, the hands of Tobias are those of the angel standing behind him in the shadows, a hand on his chest, as if promising that the treatment will be successful. It will succeed, of course, since it is God's will, done through his faithful envoy.

TOBIAS HEALS HIS FATHER
Filippo Abbiati
*c.* 1670

Archbishop's Palace, Milan

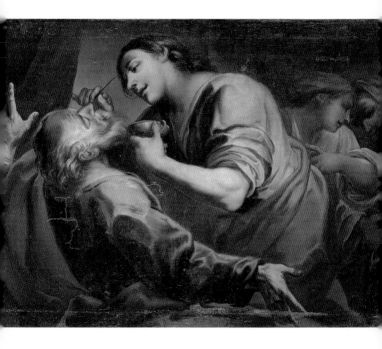

◄◄

# *Tobias Heals His Father Tobit*

This monumental canvas by the Varese painter Pietro Antonio Magatti, one of the more representative Settecento painters from Lombardy, depicts the famous moment when Tobit regains his sight. His open arms and his head tilted forward well render the jubilant exclamation that ends the story: "Blessed art Thou, O God!" Next to him is Tobias, who witnesses the miracle of the father regaining his sight with great wonder. He has not yet finished spreading the ointment; the effect has been instantaneous. Is it the medicament? True, the ointment is the tool, but the substance of the miracle is the work of the angel, who towers on the right side of the painting in a pose that could not be more Mannerist, the period of this work notwithstanding. His slow, commanding gesture aptly interprets the passage where the divine messenger says, "I know, that thou shalt see." And so, to mark the extraordinary nature of the situation, two more angels appear in the background; one holds the curtain that opens on the house door, the other materializes from the shadow. Everything in this canvas is grandiose, from Tobit's house, which recalls a temple, to the majesty of the figures.

THE ANGEL HEALS TOBIT
Pietro Antonio Magatti
1732
San Michele Arcangelo, Busto Arsizio

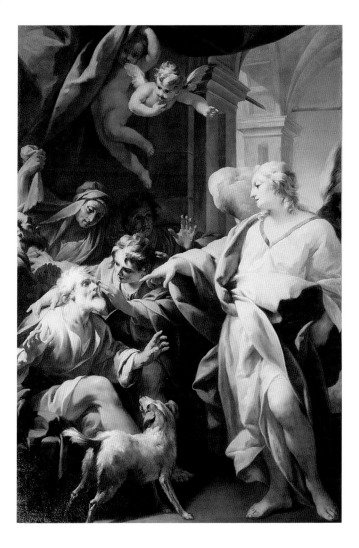

# *Raphael Reveals Himself*

▶▶

> I am Raphael, one of the seven holy angels, which present the prayers of the saints, and which go in and out before the glory of the Holy One. [. . .] But he said unto them, Fear not, for it shall go well with you; praise God therefore. For not of any favour of mine, but by the will of our God I came; wherefore praise him for ever.

At the end of Tobias's story, Raphael reveals his true nature: He is an angel, whom men have always imagined as a dignitary of God's court. Every age has adapted the image to its own customs and parameters. The Byzantine culture, here represented in the mosaic of the Palatine Chapel in Palermo, portrays him like a prince in martial dress; he is covered by a large *chlamys*, and a military-style mantle is fastened on the right shoulder, freeing the right arm to maneuver with the sword. He is wearing rich clothes, the mantle decorated by *tablia* inserts—precious fabrics of gold thread, marking the angel's elevated rank. Below the mantle is a *stricta* tunic (with close-fitting sleeves) covered by a *tunicella* (short tunic) fastened at the waist; the legs are covered by stockings derived from *anaxírides*—wide pants of Persian origin—popular in the late Byzantine empire.

THE ARCHANGEL RAPHAEL
(detail)
1130–43
Cappella Palatina, Palermo

# *Raphael Reveals Himself*

As we already noted, every epoch has imagined Raphael according to the sensitivity of the time. This polychrome statue of the archangel stands out for its rich vestments, intentionally and freely inspired by classical tradition but softened by the influence of contemporary ecclesiastical garb. In fact, Raphael is wearing an unusually soft sort of dalmatic (as we can see from the collar), opened on each side, and fastened at the waist by an elaborate belt that recalls the lower border of a Roman *loric*. The tunic reaches down to the heels and has buttons on the upper and lower legs. Finally, a sash fastened with a buckle on the left shoulder crosses his chest. Naturally, the use of gilding confers a sumptuous quality to this sculpture.

THE ARCHANGEL RAPHAEL
Neapolitan sculptor
16th century
Los Angeles County Museum of Art,
Los Angeles

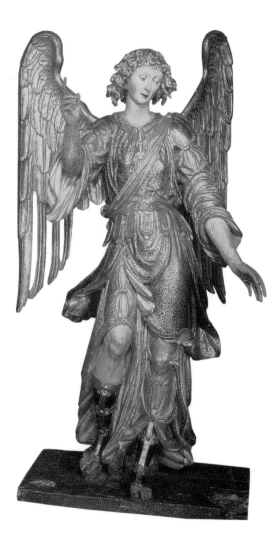

# *Raphael Reveals Himself*

Raphael's revelation, "I am one of the Lord's seven holy angels," should be read next to the passage from Revelation (8:1–13), which refers to the angels of the seven churches, as it is one of the texts that gave rise to speculations about the nature of the angels, positing the existence of seven special angels who have a preferential relationship with God. Clement of Alexandria (*c.* 150–215 CE), one of the major theologians of Hellenized Egypt, had posited the presence of *protoktístoi*, seven angels "created first," who had flanked God in creating the world, as illustrated in the Genesis mosaic in Saint Mark's cupola (see pages 14–26). Such speculation later led to the creation of works such as this one, linked to the cult of the seven archangels, which found new appreciation thanks to Antonio Del Duca, a priest and music teacher at Palermo Cathedral who had the idea of transforming the ruins of the Diocletian Baths in Rome into a church (Santa Maria degli Angeli). The plan was executed by Michelangelo, and the angels to whom the church is dedicated were surely the seven archangels: Michael, Gabriel, Raphael, Uriel, Jegudiel, Selaphiel, and Barachiel. Only the first three are recognized by the Roman Catholic Church and the Eastern Orthodox Church (the latter also recognizes Uriel).

THE SEVEN ARCHANGELS
Michele Ragolia (attr.)
17th century
Ex-Convento di Santa Chiara,
Solfora (Avellino)

◀◀◀

# Raphael Reveals Himself

The scene painted by Giovanni Bilivert is inspired directly by the biblical passage where Raphael refuses the reward offered by Tobias and reveals his true nature as a messenger of God. The reaction is immediate and instinctive: All kneel before him. The artist has focused on the context, depicting jewelry, pearls, and all sorts of precious items contained in a shining gold pyx. As such, the scene takes on a didactic quality: a sort of renunciation of wealth. In this case, it is Raphael who refuses, though the warning is directed more generally to humankind, for no amount of riches can repay God's grace, metaphorically represented by Tobit regaining his sight. Furthermore, the angel makes explicit gestures: Touching his chest with his left hand, he moves his right away from him, as if to say, with a clearly resigned air, "Of course, I cannot be paid." Therefore, God's favor can be ours only through our prayers and our conduct.

TOBIAS'S FAREWELL TO THE ANGEL
Giovanni Bilivert
17th century
The Hermitage, Saint Petersburg

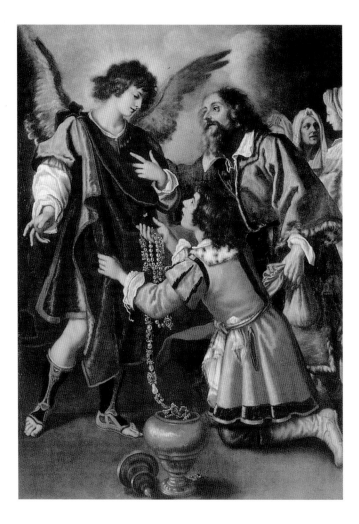

# Raphael Flies Away

> "Now therefore give God thanks: for I [Raphael] go up to
> him that sent me [. . .] And when they arose, they saw him
> no more."

His mission accomplished, Raphael flies away from Tobit's house. The Bible does not use the verb "fly," but the sequence of events does not leave any doubt as to what happened. To "go up" means to "fly off." It is an important meaning because it confirms that the apterous (from the Greek for "without wings") images of angels in Paleochristian iconography were intentional artistic choices. In Rembrandt's time, on the other hand, the passage constituted an attractive occasion to paint, in foreshortened view from behind, the angel taking flight. In any case, the entire scene is well designed.

The light flooding the angel is that of the divine grace, and the decisive air with which the angel flies off aptly illustrates his words: "For I go up to him that sent me." Each participant in the scene is painted with great psychological insight. Tobit kneels, full of gratitude; Tobias opens his hands as if to say: "Look who was beside me all this time"; Anna, Tobit's wife, leans on Sara, trying to be comforted in all these emotions; and Sara is the only one who looks directly at the angel in silent thanks. The dog, frightened by all the commotion, barks.

THE ARCHANGEL LEAVING
THE FAMILY OF TOBIAS
Rembrandt von Rijn
1637
Musée du Louvre, Paris

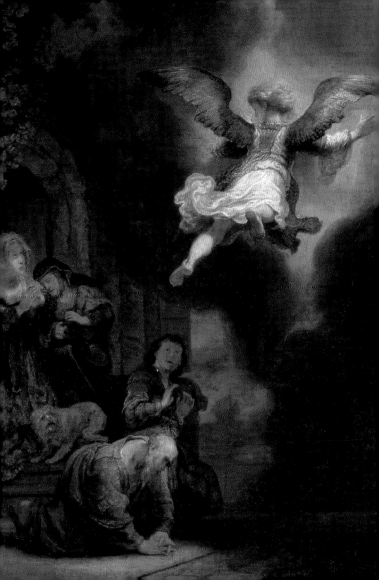

## Judith Takes the Scimitar

> "And Judith was left along in the tent, and Holofernes lying along upon his bed: for he was filled with wine. [. . .] Then she came to the pillar of the bed, which was at Holofernes' head, and took down his fauchion from thence."

This is a rare scene; the details are not corroborated by the biblical passage, which does not speak of angels. Jacques Stella's intention is entirely hagiographic and stresses how Judith's action was pleasing to God. Indeed, the Hebrew heroine is praying that God may give her the strength to carry out her mission (see Judith 13:7). However, the artist has translated the episode into terms that are closer to Christian sensitivity and has included child cherubim, who are busy readying the sword for her; the presence of the angels is meant to reassure the viewer of the goodness of Judith's decision, but also adds, somewhat inappropriately, a playful element that is not suitable to the event and contrasts with the kneeling figure of Judith praying before a lit candlestick like the most pious of women. Of course, one must understand the intrinsic value of the biblical episode metaphorically, insofar as Holofernes represents evil, and Judith good.

JUDITH PRAYING
Jacques Stella
17th century
Galleria Borghese, Rome

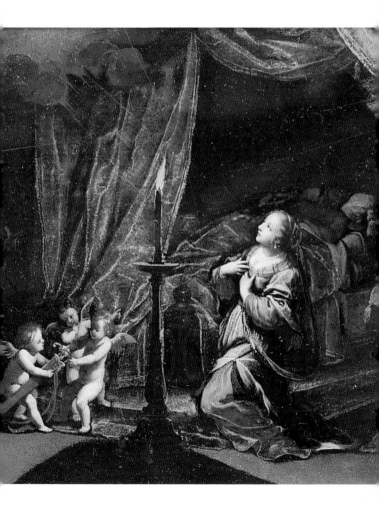

# Judith and the People Give Thanks to God

> And Judith said, Begin unto my God with timbrels, Sing unto my Lord with cymbals: tune unto him a new psalm: exalt him, and call upon his name. [. . .] Woe to the nations that rise up against my kindred! the Lord Almighty will take vengeance of them in the day of judgment.

There is no biblical passage that directly inspired the theatrical setting invented by Luca Giordano to glorify the Hebrew heroine in this fresco. In any case, the artist and his patrons did take their inspiration loosely from a number of passages in Judith, such as the one quoted above, to conceive this fresco. The accent is on the bellicose virtues of Judith and of Sabaoth, the Lord of Hosts, since the angels pictured in the center of the vault all carry swords. All around, the painter has illustrated Judith's historical episode.

TRIUMPH OF JUDITH
Luca Giordano
1704
Certosa di San Martino, Naples

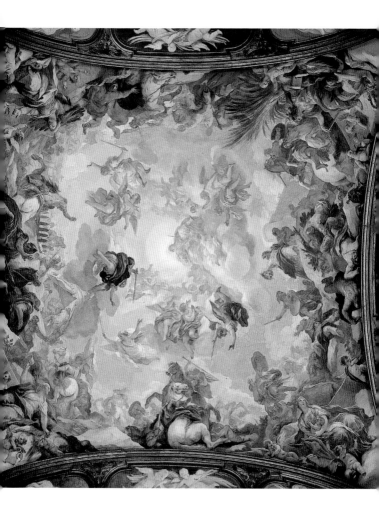

# Punishment and Repentance of Heliodorus

"For there appeared unto them an horse with a terrible rider upon him, and adorned with a very fair covering, and he ran fiercely, and smote at Heliodorus with his forefeet, and it seemed that he that sat upon the horse had complete harness of gold. Moreover two other young men appeared before him, notable in strength, excellent in beauty, and comely in apparel, who stood by him on either side; and scourged him continually, and gave him many sore stripes."

From 187 to 175 BCE Heliodorus was minister and treasurer to Seleucus IV, ruler of the Hellenistic Seleucid Empire, who had asked him to seize the treasure of the temple of Jerusalem; Heliodorus decided to do this personally. The scene painted by Raphael refers to the above biblical passage, which describes God's reaction to the offense. Of course, the warrior in the resplendent armor and the two young men who scourge Heliodorus, although not made explicit, are angels. In this scene, Raphael sensibly depicted them without wings to remain faithful to the biblical text.

THE EXPULSION OF HELIODORUS
FROM THE TEMPLE
(detail)
Raffaello Sanzio, known as Raphael
1511–12
Vatican Palace, Vatican City

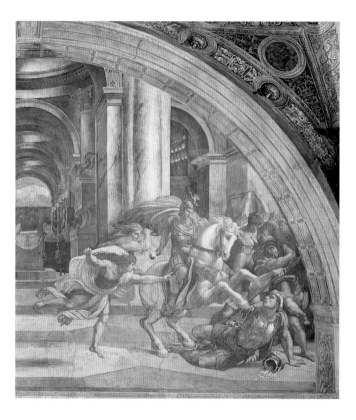

# The Guardian Angel

> If there be a messenger with him, an interpreter, one among a thousand, to shew unto man his uprightness: Then he is gracious unto him, and saith, Deliver him from going down to the pit: I have found a ransom.

Biblical passages such as this contributed to create the image and iconography of the guardian angel, which became popular especially after the Counter-Reformation. The figure of Raphael, whom we met earlier in the book of Tobit, is important in helping to define the role of the guardian angel. Sixteenth-century theologians described the importance of angels, experienced through prayer and meditation. In his poetic *Spiritual Canticle*, Saint John of the Cross (1542–91) explained their role, confirming their function as custodians and intermediaries between man and God: "to him our prayers ascend, offered by the angels" (*Spiritual Canticle* 2:3). This painting by Borroni illustrates this role; the angel's gesture is one of intercession on behalf of man, to protect him from contact with evil, here represented by the devil subdued by Saint Michael.

SAINT MICHAEL THE ARCHANGEL
AND THE GUARDIAN ANGEL
Giovan Angelo Borroni
17th century
Santuario della Madonna di Caravaggio,
Codogno

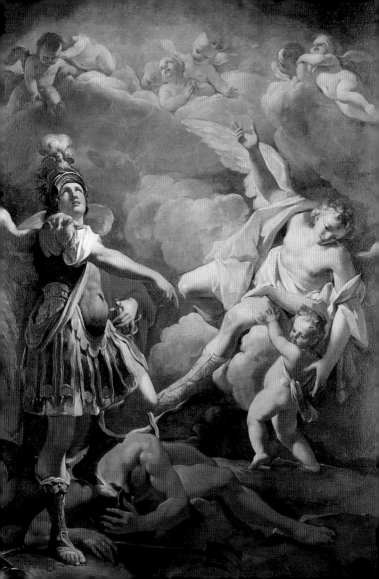

# The Guardian Angel

Sometimes it is the guardian angel's role to arrive at the very last minute to resolve facts and situations, as is the case here, where the angel holds a child who was about to fall off a steep cliff. The Spanish theologian Franciscus Suárez (1548–1617), a Jesuit, described such actions in his book *De angelis* [*On Angels*]. According to him, it is the angel's task to defend man from material and spiritual dangers that could harm his soul and body, direct him to the Good and away from Evil, contribute to drive demons away from men, see that men's prayers to God reach their destination, pray for men, and, finally, try to correct mankind's errors, by punishing them if necessary to promote their final conversion. The theme developed by Suárez is illustrated in this canvas by Piazzetta, who seems to outline the guardian angel's task, along with that of the friar and the priest, vis-à-vis the child: The angel not only protects children, but is an example of spirituality for God's ministers, and carries man's prayers to the Most High.

THE GUARDIAN ANGEL WITH SAINTS
ANTHONY OF PADUA AND GAETANO THIENE
Giovan Battista Piazzetta
*c.* 1729
San Vitale, Venice

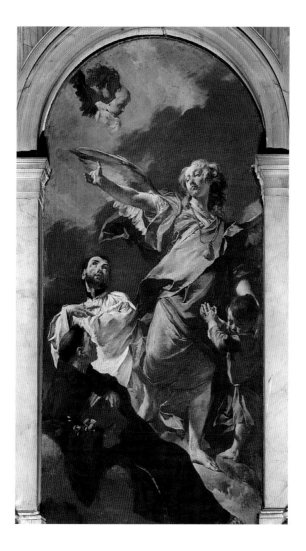

# The Guardian Angel

Starting with the Counter-Reformation, the figure of the guardian angel became so strong that the theologian Franciscus Suárez deemed failure to recognize the angel's educational role a serious error. In particular, he argued that the mission of the guardian angels had to be treated as a truth to be accepted without reservation by all, and that denying it was a serious sin. The existence of angelic hierarchies as well was to be held as a truth of faith, since it was recognized by the Scriptures and hinted at in several passages of both the Old and the New Testaments.

All of this created the premises for the diffusion, at the grassroots level, of the cult of the guardian angel, which continued to grow until the twentieth century. This splendid canvas by Tiepolo was created in such a cultural climate, at a time when the existence of the angel had been taken for granted in the popular imagination. The large winged figure towering above the sleeping child well summarizes the deep sense of connection between man and angel, and the feeling of protection derived from it. The stick the angel is holding points to the straight path.

THE GUARDIAN ANGEL
Giambattista Tiepolo
1737
Museo Civico, Udine

318

# The Guardian Angel

On this and on the opposite page are reproduced three examples of popular devotion to the guardian angel—a phenomenon that should not be underestimated, as it is deeply linked to the cultural value and deep significance of such a figure. These small holy pictures are genuine documents of faith, although they were often also exploited commercially. This was especially true when the subject was the guardian angel, who may be considered the first step of a long, steep ladder that leads, on one side, to the empyrean of theological knowledge and, on the other, to the undemonstrable truths of faith.

S. ANGELO CVSTODE

THE GUARDIAN ANGEL
18th and 19th centuries
Fototeca Storica Nazionale Ando Gilardi

*Angelo Santo, nel mio cammino*
*siami Duce e Guida*

SERZ & CÆEDIT CHUR ORERG.

IN PACE IN. IDIPSUM DORMIAM ET REQUIESCAM.
Ps 4.8.

# And He Rode Upon a Cherub, and Did Fly

> And he rode upon a cherub, and did fly: yea, he did fly upon the wings of the wind.

The text of this psalm, almost identical to a verse from Samuel (2 Samuel 22:11), is one of the literary sources that enabled scholars to trace back the image of the cherubim—born when the Hebrew book traditionally attributed to King David was first composed—to the contemporaneous cultural and religious environment of the ancient Near East. We cannot here retrace the age-old dispute about dates; however, we will mention that the most recent scholarship tends to date these texts to the age of the kings, therefore before the exile—between the tenth and seventh centuries BCE. The fact that God is riding a cherub shows that the image to which the psalmist referred was that of the *lamassu* or *karibu* from Babylonian culture. These were beneficent demons with a man's head, eagle's wings, and a bull's or a lion's body, placed outside the gates of cities and vast palaces as guardians. In this respect, we should not overlook the play on words between the Hebrew words *kerub*, "cherub," and *rakab*, which means "to ride." The *lamassu* were intermediate beings between the supreme triad Ea-Enlil-Enu (of the Assyro–Babylonian pantheon) and men. Later modifications and interpolations would lead to the iconography of the cherub with which we are familiar.

WINGED BULL WITH A MAN'S HEAD (*LAMASSU*)
(from Khorsabad)
late 8th century BCE
Musée du Louvre, Paris

# *The Guardian Angel*

> "The angel of the LORD encampeth round about them that fear him, and delivereth them."

Antonio Franchi's image is particularly striking: Here the angel intercedes for men, even to the point of opposing God, sheltering them from his wrath when they sin, just as a mother or father would when the other parent gets upset. Thus, the angel becomes a protective shield behind which to seek shelter, like the small child hiding behind the mother's skirts when the father wants to scold him. It is a folk interpretation of the angel's role, therefore close to people's sensitivity and easy to understand, because it is based upon everyday experience. This is one more reason for the success of the guardian angel, whose figure, in most cases, enters our lives from the youngest age, and memories from that time are among those we cherish most. Here the angel is using the shield to defend his protégé from the divine reproach; this, too, is a form of intercession.

THE GUARDIAN ANGEL
Antonio Franchi, known as il Lucchese
1653
Museo Civico, Riva del Garda

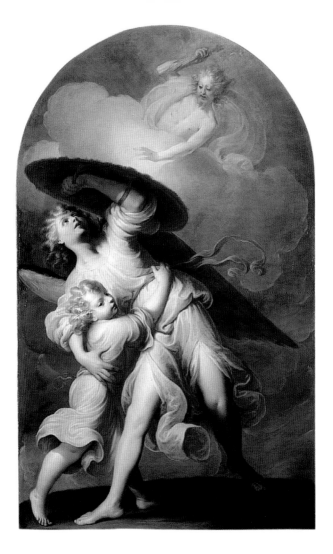

# *The Guardian Angel*

The Catholic conception of the guardian angel treats this figure as a constant in the life of the faithful, irrespective of their age. It is only with death that the angel's task ends. This altarpiece, which stood in the Church of Sant'Andrea in Ferrara, shows an angel of statuesque beauty pointing the way to a man who is in trouble: Half-naked, he hugs himself to keep away the cold. He was wise enough to pray, so that immediately the angel appeared to show him that God is close; the only way to save oneself is through prayer, which acts as a bulwark against evil. The carrier of these prayers is the guardian angel, who takes it upon himself to deliver them to the Highest. Prayer will save this man, and the devil's temptation will have no power over him. Although the devil has his hand on the man's shoulder to drag him into the darkness, the path of his salvation has been marked, for the guardian angel is pointing the way of light, away from the darkness of sin.

THE GUARDIAN ANGEL
Carlo Bonomi
mid-17th century
Pinacoteca Nazionale, Ferrara

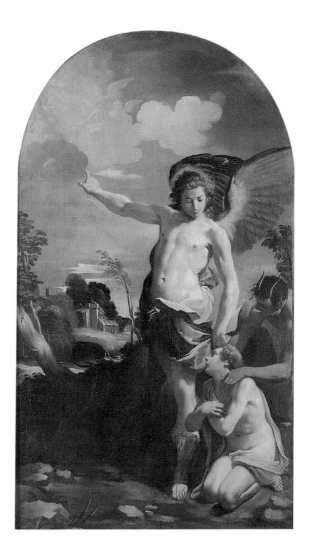

# The Guardian Angel

The doctrine of the guardian angel became definitive under Pope Clement X (1670–76), who authorized it and set the feast day on October 2. From then on, there was a proliferation of images that took on their own characteristics and were worshipped at altars, deviating from the prototype of Raphael and Tobias (Tobit 5–12). Often these guardian angels are portrayed watching over a child, or guiding him by the hand (evoking the link to the Tobias story) or again, as in this case, pointing the way and hugging him in a protective gesture. However, the guardian angel's task is one of teaching, in addition to guiding. The angel that the divine Providence assigns to each human being, in fact, helps us to recognize good and evil, embracing the former and rejecting the latter. It is not by coincidence that immediately after Pope Clement X's authorization, prayers began to be written asking precisely this, to be guided: "Hold me and guide me," says the Angel of God prayer.

THE GUARDIAN ANGEL
Matteo Loves
c. 1660
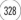
Chiesa dei Santi Sebastiano e Rocco, Cento

# The Guardian Angel

The "domestic" quality of the guardian angel, i.e., his propensity to handle man's everyday problems—such as in this example where the two angels, like a sweet family, watch over two babes asleep—fostered an altered vision of their transcendental dimension. The Lutheran philosopher Emanuel Swedenborg (1688–1772) posited a natural world that interlaced with the spiritual one, giving life to a universe where the distinction between man and angel was blurred. Thus, the angels were sexual beings and lived in a sort of community formed of real family units. Their activity as guardians, messengers, and defenders of the world from the evil demons was rounded out by their family task of raising their own children. These children, according to Swedenborg, even used a handwriting that men could not understand. Although this painting does not directly derive from Swedenborg's theories, it effectively suggests the risks inherent in such ideas.

THE GUARDIAN ANGELS
Joshua Hargrave Sams Mann
1849–84
Haynes Fine Art at the Bindery Galleries,
Broadway

# God Shines Forth Dwelling Between the Cherubim

> Give ear, O Shepherd of Israel, thou that leadest Joseph like a flock; thou that dwellest between the cherubims, shine forth.

This miniature by Belbello da Pavia, created for a manuscript that was originally a psalter for Caterina Visconti and later became the office of her son Filippo Maria, looked to passages such as these for inspiration. God is enthroned; the cherubim and the other angelic hosts (the red seraphim stand out among them) float around him on golden clouds from which scrolls with hymns of glory flutter. All the celestial court is arrayed around its Lord, who sits on a throne adorned with statues of saints and prophets. He holds the earth in his hand and opens the apocalyptic book of the seven seals. It is a different image from that of the psalm in that it is much richer in detail, though the root is the same. Although he is not seated on the cherubim, he is at the center of the angelic hosts, like a shepherd among his flock. In both cases, God is surrounded by the angelic powers and is resplendent with glory.

INITIAL "D" WITH GOD THE FATHER IN GLORY
Belbello da Pavia
15th century

Biblioteca Nazionale, Florence

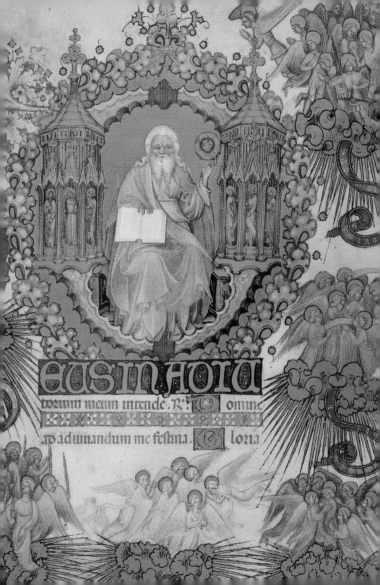

◄◄

# God Shines Forth Dwelling Between the Cherubim

The reference to the flock and to shepherding fostered the assimilation between God and Jesus, which, in images such as these, is at least partially faithful to the words of the psalm. The art reproduced on the opposite page is suggestive because it is a detail from *The Annunciation* of Jan van Eyck (see pages 572–73). What is interesting is the fact that this scene—painted by the Flemish artist on a stained glass window in the background of the main scene—was probably inspired by

this passage or similar ones. True, in the mandorla Christ stands below the cherubim, but the spirit is the same one we find in the words of the psalm: the glory of God. Christ in the mandorla, with the scepter in his hand and the open Gospel, comes to men in glory, escorted by the cherubim who are his evident sign. Interestingly, although they are painted red, the typical color of the seraphim, these angels are truly cherubim; they even have the wheels of Ezekiel's vision (1:16–21).

THE ANNUNCIATION
(detail)
Jan van Eyck
1435
National Gallery, Washington

# *The Heavenly Praise Thy Wonders*

> And the heavens shall praise thy wonders, O LORD: thy faithfulness also in the congregation of the saints.

If there is an image that, more than any other, illustrates the idea expressed in this verse, it is this illumination from the Vatican edition of the manuscript by Cosmas Indicopleustes. A traveler from the time of Emperor Justinian (527–65 CE), Cosmas prefaces the narrative of his exploratory journeys, which took him as far as India, with an interpretation of the structure of the cosmos, seen as a sort of immense Ark of the Covenant at whose center, on a flat Earth, rises Mount Tabor. Around the mountain, which constitutes the navel of the world, rotate the heavens and is found the zodiac band of the fixed stars. In Cosmas's vision, however, planets and stars are actually angels, according to a belief that had been formalized by Origen (185–254 CE) but had its roots in the biblical texts that describe the heavens and sing the wonders of the Creator. The Vatican edition of Cosmas's text made symbolic use of perspective as an aid in reading the structure of the cosmos. In effect, we see Mount Tabor in profile, while the band of fixed stars and the planetary orbits, with the two principal luminaries being pushed by angels, are seen from above, though transposed to a vertical plane.

CHRISTIAN TOPOGRAPHY
Cosma Indicopleustes
9th century
Biblioteca Apostolica Vaticana,
Vatican City

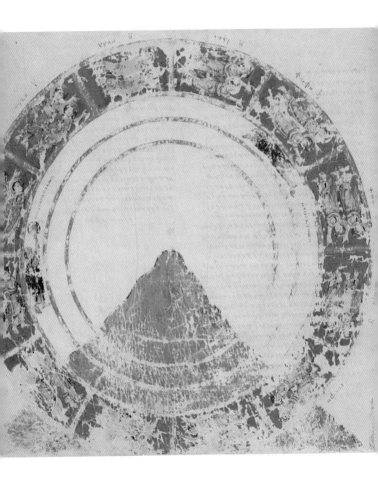

# The Guardian Angel

> For he shall give his angels charge over thee,
> to keep thee in all thy ways.

Domenichino made this cartoon as a study for a large canvas now conserved at the Museo di Capodimonte in Naples (see pages 508–509), which had probably been commissioned by the Vanni family of Palermo. The attention is directed to the figure of the angel, who appears in rustling, classical garments, as was the style already for some time in angelic iconography. The gesture is typical of the guardian angel who guides his protégé to God. And, truly, it is to God that we must turn our prayers, which the angel takes upon himself to deliver, and it is from the Lord that we must receive comfort. The angel is only a messenger, though an important one. The attitude of Domenichino's angel is a gestural translation of this concept, as if he had said: "Not to me, but to him."

THE GUARDIAN ANGEL
(preparatory cartoon)
Domenico Zampieri, known as Domenichino
1615
Istituto Nazionale per la Grafica, Rome

# The Guardian Angel

The figure of the guardian angel was deeply felt in the seventeenth century. When Carlo Francesco and Giuseppe Nuvolone painted this image, its theological connotation was imbued with a deeply felt devotional reality. In fact, from the middle of the sixteenth century on, there was a growing request from the masses to the Curia for a feast day in which to give proper homage to this figure. However, the Church's attitude in matters such as these has always been one of caution, since there was a risk, if not of a latent polytheism, then at least of a sort of "fetishism of the sacred" to be avoided at all costs. For this reason, the feast of the guardian angel was added to the liturgical calendar only in 1615 by decision of Pope Paul V. In 1670, Pope Clement X moved the feast to October 2.

THE GUARDIAN ANGEL
Carlo Francesco and Giuseppe Nuvolone
c. 1650
Cathedral, Monza

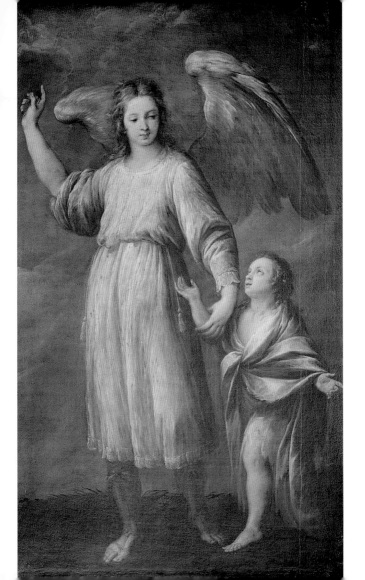

# The Guardian Angel

This image, created by Pietro da Cortona and commissioned by Pope Alexander VII, seems to have been literally inspired by the verse from Psalm 91. Included in this large canvas, in addition to the angel holding the child by the hand in the foreground, is another angel, in the shadow in the bottom left corner, who flies to take a man by the hand and lead him on the right path—the same one on which the child walks with a sure step, thanks to the presence of his own angel custodian. The cloud-filled landscape does not have a meteorological meaning, but a symbolic one, for it represents sin and the danger from which the angel must keep us. The proof is in the central scene, where the two figures walk safely and serenely in the light of grace.

THE GUARDIAN ANGEL
Pietro Berrettini, known as Pietro da Cortona
1656

Galleria Nazionale d'Arte Antica, Rome

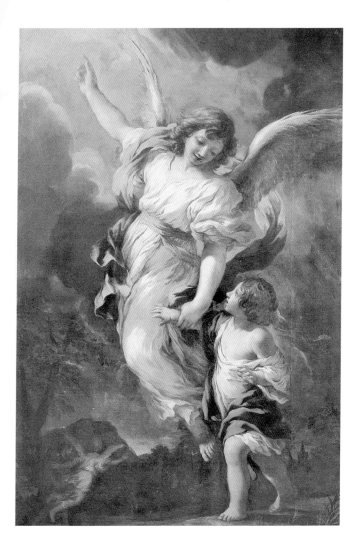

◀◀

# *The Guardian Angel*

The idea of the continuous presence of an angel guiding man's choices and trying to right his mistakes is confirmed in the Gospel of Matthew (18:10), where Christ compares the innocence of children to the wisdom of the angels who protect them. This deep connection between the guardian and the children is the primary reason for the longevity of this cult, which has survived all historical periods. Even during the French Revolution and under the Enlightenment, when Reason was the only deity to which one could and ought to refer, the figure of the angel custodian remained alive in man's consciousness. Still, it was just this tendency to consider the angel in general as a guardian and a "fellow traveler" that gave rise to interpretations such as Swedenborg's (see pages 330–31), namely that angels were men and women who had reached a state of perfection. Here the angel, dressed like a classical divinity, firmly seizes the child's hand. Note, in fact, the difference between the child's hesitant steps and the sure gait of his heavenly escort.

THE GUARDIAN ANGEL
Antonio Zucchi
18th century
Museo Civico Ala Ponzone, Cremona

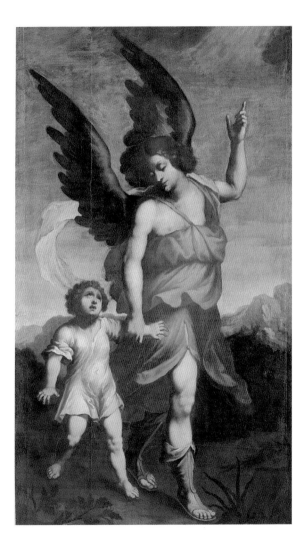

# The Lord Sits Between the Cherubim

> The LORD reigneth; let the people tremble: he sitteth between the cherubims; let the earth be moved.

On the altar of Ratchis, a Longobard duke, Christ is shown in all his glory. The Savior is at the center of a mandorla carried in flight by four angels (perhaps also a reference to the four winds that support the world). In it, he is seated on a throne and flanked (almost supported) by two cherubim. These angels exhibit peacock wings, a solution that seems to interpret in a naturalistic manner the image of Ezekiel's vision (1:4–28), where the cherubim's wings are described as being strewn with eyes—a formula that will be very successful. In this way, Christ is assimilated to the Ark of the Covenant.

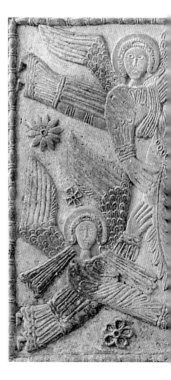

CHRIST IN GLORY BETWEEN THE CHERUBIM
737–744
Museo Cristiano, Cividale del Friuli

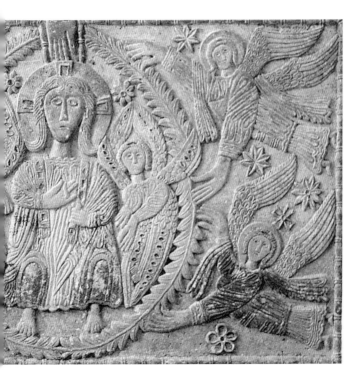

# Who Appoints the Winds His Messengers

> Who maketh his angels spirits; his ministers a flaming fire.

This is not the venue to analyze the complex issue of the syntactic relationship between the Hebrew words *malak* ("messenger, angel") and *ruah* ("wind"), where the latter can be either a complement or a predicate. Although the rabbinical version ("uses the winds as his messengers") differs from the more recent Christian Vulgate ("turns angels into winds"), certainly this verse is responsible for the super-imposition of the angel's image with that of the winds, as we can see in this illumination. In fact, the supple representation of the wind turned out to be the most appropriate to convey the spiritual nature of angels, whose representation changed drastically when, at the end of the fourth and beginning of the fifth century CE, angels began to be portrayed with wings that were conceived as the wings of the wind. This image, drawn with bistre on parchment, shows Adam inside a shield, sitting on a throne like nature's ruler, together with other elements of creation. Around him are the figures of the winds, who blow into their horns according to a popular tradition of the time. This is the only detail that distinguishes them from the angels, since, like them, they have wings and are dressed with the dalmatic and the pallium.

THE WIND ROSE
11th century
Biblioteca Apostolica Vaticana,
Vatican City

# Who Appoints the Winds His Messengers

At first reading, it is difficult to understand whether the small enamel figures on the four corners of this evangelistary are angels or winds, but the scrolls they hold in their hands erase any doubt, since they identify them as Auster, Oriens, Aquilo, and Favonius, which are the names of winds. Still, they have the same iconography as angels. This total superimposition, though justified by the psalm verse, should also be seen in a wider cultural context since, as a result of a number of philosophical reflections, the angels' spiritual dimension has been placed in the air, which is one of Nature's four elements. Precisely because they are spiritual beings, the angels are made of air—a metaphor for the spirit. This would be corroborated in the iconography of the subsequent centuries, when the divine messengers would be represented emerging from the clouds. Here, the blessing Christ, enthroned, holds the Gospel in his hands and appears surrounded by the symbols of the four Evangelists; because of their number and position, they are arranged as analogues of the winds.

EVANGELISTARY COVER
1170
Museum Schnütgen, Cologne

# The Angels' Praise

> Praise ye him, all his angels:
> praise ye him, all his hosts.

Donatello's inventiveness and that of his patrons consists in super-imposing the songs of the choristers who performed regularly at liturgical solemnities, with the angels. The latter, in marble, are warm and strong like all the figures created by Donatello, who humanizes them by portraying them shouting loudly in a lively dance. One may consider this the image of enthusiasm in the literal sense of the word, which comes from the Greek *én theó istemi*, "I am inside God," or *entheázo*, "I am inspired by God"—just as the angels singing the glory of the Most High stand inside his grace. Donatello's vision kindles a joy that spreads contagiously to all and to everything; it is the force of life and of creation that God has spread to all beings, both visible and invisible. Thus, to praise him, for the angels, means to recognize his creating, unrestrain-able force: love.

CANTORIA
(detail)
Donato di Niccolò di Betto Bardi,
known as Donatello
1433–39
 Museo dell'Opera del Duomo, Florence

◄◄

# *The Angels' Praise*

These kneeling angels, which we find on the western wall of the rectangular apse of the Magi Chapel in the Palazzo Medici Riccardi in Florence, have inscribed around their halos *Adoramus Te, glorificamus [Te]* ("We worship thee, we glorify thee"), while those standing in the last row have inscribed *Gloria in excelsis Deo* ("Glory to God in the highest"). These quotations from the liturgy complement the reference to Psalm 148. The reason for this glorification, in the case of the birth of Jesus, is to be found in the joy for the union of the divine with the human; in the psalm, on the other hand, the praise of God refers to the angels' intention to give thanks and witness for the wonder of creation.

ANGELS WORSHIPPING
(detail)
Benozzo Gozzoli
1459–61
Magi Chapel, western wall
Palazzo Medici Riccardi, Florence

## Musical Angels

> Praise ye the LORD. Praise God in his sanctuary:
>     praise him in the firmament of his power.
> Praise him for his mighty acts:
>     praise him according to his excellent greatness.
> Praise him with the sound of the trumpet:
>     praise him with the psaltery and harp.
> Praise him with the timbrel and dance:
>     praise him with stringed instruments and organs.
> Praise him upon the loud cymbals:
>     praise him upon the high sounding cymbals.
> Let every thing that hath breath praise the LORD.
>     Praise ye the LORD.

This panel, conserved in Berlin, is the earliest known work of Gentile da Fabriano, and exhibits a very interesting iconography of the angels in that the divine messengers are likened to birds. The painter has arranged the angelic choirs and their musical instruments in the two trees in the background, as if they were singing birds. The connection between these winged beings is based on a shared singing ability; of course, the song and the music of the angels have the cosmic value of universal harmony, here inspired by the birth of Jesus.

MADONNA AND CHILD WITH
SAINTS NICHOLAS AND CATHERINE
Gentile da Fabriano
*c.* 1405
Gemäldegalerie,
Staatliches Museen, Berlin

# *Musical Angels*

In this polyptych, the two groups of angels singing psalms and playing music stand to the side of the Virgin Mary and Saint John the Baptist; at each end are Adam and Eve; in the lower register is the Adoration of the Mystical Lamb, an arrangement that aptly explains the role of these images. On one hand, they complete the glory of the heavenly court, for like any king worthy of his name, Christian God appears with his glorifying choirs, except that in this case, the song of praise that rises heavenward is that of all created creatures.

The angels have no wings, which revives an earlier iconography. An important element of this work is the carving on the furniture, which the artist used to decorate the scene. In particular, the lectern of the singing angels is decorated with important figures such as Moses and Elijah. Below is Michael the archangel defeating the dragon, intended to be read as a victory of harmony (cosmic song and music) over chaos. The carvings on the base of the furniture recalls the material world and sin: The monkeys allude to false appearances of reality, while the fruits are, like the one that Eve is holding, those of the tree of knowledge. The lion in the center is the devil. Even the floor tiles have meaning, as they carry the design of the resurrected Lamb and *IHS*, Christ's monogram.

THE GHENT ALTARPIECE: SINGING ANGELS
AND ANGELS PLAYING MUSIC
Jan van Eyck
1426–27
Cathedral of St. Bavo, Ghent

# Musical Angels

The Roverella Polyptych, now in pieces and conserved in different museums, was probably made on the occasion of the death of Lorenzo Roverella, bishop of Ferrara, who is depicted, as we know from a description (the original was lost), knocking on the door of paradise. This gesture reveals the final meaning of the central panel (illustrated on the opposite page), now at the National Gallery in London, clearly portraying the paradise that the bishop so yearned to enter. Characterizing paradise, next to the Virgin Mary and the Child, are musical angels playing typical fifteenth-century instruments, including two lutes and two citterns, medieval chord instruments that were still used in the Renaissance until they were replaced by the *lira da braccio*. In the foreground is the organ in profile.

MADONNA WITH THE CHILD ENTHRONED
Cosmè Tura
*c.* 1474
National Gallery, London

# *Musical Angels*

The musical angels now held at the Pinacoteca Vaticana were part of an *Ascension of Christ*, now on loan to the Quirinale Palace in Rome, that originally decorated the apse of the church of the Santi Apostoli in Rome, which was destroyed during eighteenth-century reconstruction work that was undertaken first by Francesco Fontana (1702–1708) and later by his father Carlo (until 1714). Identifying this work of art is important because it justifies the daring perspective that Melozzo da Forlì successfully achieved without affecting the feminine beauty of the angelic figures. Surviving are fourteen fragments, with as many angels playing stringed instruments such as the *lira da braccio* and the lute. In this case, their function is to highlight the moment of harmony when the Son rejoins the Father.

MUSIC-MAKING ANGEL
(fragment)
Melozzo da Forlì
1480

Pinacoteca Vaticana, Vatican City

# Musical Angels

Psalm 150 names several instruments played by the angels, including the trumpet (the Jewish *shofar*, a ram's horn) and the *nebel*, which was a horizontal lyre or zither that would become a psaltery in the eleventh century and was similar to the ancient Persian *santur*. The kithara (*kinnòr* in Hebrew) is the vertical lyre, a popular instrument throughout the Mediterranean and an ancestor of the Greek and Sumerian harp, with gut strings stretched across a horizontal axis. Other instruments are the tympans (*top* in Hebrew), similar to the tambourine, the cymbal (*selslim*), a double bronze percussion plate, and finally, the *ugab* or flute. All the classes of instruments are included. The Vulgate mistakenly translated the flute as an *organum*, thus authorizing the presence of the organs in Christian iconography.

ANGEL MUSICIANS
(detail)
Hans Memling
1485
Koninklijk Museum voor Schone Kunsten,
Antwerp

# Musical Angels

This intense work by the young Flemish artist, who by the time of his death at the age of twenty-eight had completed a dozen masterpieces, renders beautifully the concept of cosmic harmony, a Platonic idea to which the images of musical angels inevitably refer. The reference to cosmic harmony here is made clear by a surprising detail highlighted in the scholarly studies on the subject: The infant Jesus is excitedly playing sleigh bells and assumes a dancing pose. The angels, whose concentric arrangement evokes that of the celestial spheres, play instruments of various kinds, some the lute, some the *lira da braccio*, the twisted trumpet, the double flute, and the portable organ, to name a few. Only one angel holds the same bells that Jesus is playing; they exchange looks, and the angel immediately perceives the rhythm that the Savior wants to impress upon the cosmos to express his glory. Another interesting detail is that Mary has the same iconographic features as the woman of Revelation (12) dressed with the sun.

VIRGIN AND CHILD
Geertgen tot Sint Jans
*c.* 1485
Boijmans Van Beuningen Museum,
Rotterdam

# *Musical Angels*

The panel reproduced on the opposite page and attributed to one of Leonardo da Vinci's two assistants who worked on the *Virgin of the Rocks* polyptych (Evangelista created the wooden structure of the polyptych and decorated it in gilded wood relief, and Ambrogio De Predis painted the two angels) should be viewed in its general context. The theme of Leonardo's masterpiece is the immaculate conception which, though not yet a dogma (it would become one only in 1854), was already an official belief of the Church, thanks to the power of popular credence and the actions of Pope Sixtus IV. Often confused with the dogma of Mary's virginity, the immaculate conception dogma considers the mother of Jesus the only human being born free of original sin, at a time when baptism did not yet exist. The complex symbology of Leonardo's work, which cannot be reproduced here, was meant to illustrate this most unique, special condition. Therefore, the musical angels, who must have stood originally on each side of the Virgin Mary, heighten with their presence the wonder of this harmonious agreement of the human dimension with the divine one.

ANGEL WITH *LIRA DA BRACCIO*
Ambrogio De Predis (attr.)
*c.* 1506
National Gallery, London

# Psalm 150

◄◄

## *Musical Angels*

The cupola decorated by Gaudenzio
Ferrari is an immense fresco with
God the Father in the center,
surrounded by flaming seraphim.
All around are the cherubim, little
blue-winged putti. The rest of the
angels reproduced in this detail are
playing the music of the cosmos.
The Platonic concept of the harmony
of the spheres, conceived as sirens
that each sing one tone on the
planetary orbits, was adapted to
Christian thought, which replaced
the sirens with angels, who now
sing the harmony of the universe for
God's glory. It is a heavenly music
that has nothing in common with
human music; for this reason, Ferrari
has added to real instruments purely
fanciful ones that cannot be played.

GLORY OF ANGELS
(detail)
Gaudenzio Ferrari
1535
Santa Maria dei Miracoli, Saronno

# The Creation of Wisdom

" I wisdom dwell with prudence, and find out knowledge of witty inventions. The fear of the LORD is to hate evil [. . .] I am understanding; I have strength [. . .] The LORD possessed me in the beginning of his way, before his works of old. I was set up from everlasting, from the beginning, or ever the earth was. "

The Biccherna tablets are small works of art, and were once covers of the Siena treasury registers kept in the Exchequer's Office, which was called Biccherna (perhaps to recall the Blacherne Palace in the district of Constantinople by the same name). This tablet illustrates to perfection the above passage from Proverbs: The artist has highlighted the relationship between Christ enthroned in majesty and seated on the seraphim, and the image of Wisdom, which seems to leave eternal heaven to enter into the material dimension, to whose creation it will also contribute. The verse "I have strength [power]" is an allusion to the angels who help Wisdom carry out the Creation, for we recall that the angels are also called "powers"; they are the premise of what will become act, the act that unfolds instantaneously as God thinks it, since in him there is no difference between thought and action.

WISDOM EMANATING FROM GOD
(detail)
Sano di Pietro
1471
Archivio di Stato, Siena

SAPIENTIA

KAMARLENGO · E · EXECVTORI · dELA · GENERALE
KABELLA · MCCCCLXX · E · FINITO · MCCCCLXXI ·
ANdREA · dI · MISXPbANO · CAPACCI · K · dIRICARdO · SARA
dIMISERE · AGVSTINO · dIMIS       CINI · dIVANNI · dISGIOVAN
NICOLO · dATI · dIVANOCIO · dI      NI · dICATERINO · dINANI · d
PAVOLO · dIGORO · dIBENEdETO · d    INERI · dICONPANGNIO ·
IbIAGI O · dIRVbERTO · dIdOME      dIbARTALOMEO · dELAG
NICO · dIPANTA · bVNSIGNIORI ·      ACAIA · dISANGN
dANGNIOLO · dILANdO           IOLO · dIMEO · dIGA
SCRITORE · dISPRIAMO          NO · NOTAIO
dANbRVOGIO · NOTAIO ·

# The Creation of Wisdom

This tablet, which has Wisdom at the center as an emanation of the Redeemer, who stands over it, was part of the upper decoration of a *kibotos*, a wardrobe where church vestments were stored. On each side of the Savior is an array of angels who unfold the heavens as if they were a wide tent, the opposite of the representations of the Last Judgment (especially those in the Byzantine tradition), where the angels are seen rolling them up like a carpet (a solution that was also adopted by Giotto in the *Last Judgment* that he painted in the Scrovegni Chapel in Padua). Here, therefore, the angels unfold the heavens, as one does with freshly laundered sheets, since creation has just taken place. In Russian orthodoxy, Wisdom has its own iconographic autonomy. Here the angels represent the heavenly spheres, for if we include the seraph placed at the top center, there are seven divine heralds, representing the seven planets of the Ptolemaic system—the only one recognized by Christian philosophy at the time. The image of the cherub and the seraph standing on each side of Wisdom (so identified by the inscription) is the same, thus solidifying a process of identification for the two angelic choirs already under way since the Middle Ages.

DIVINE WISDOM
School of Novgorod
17th century
Ecclesiastical Academy, Moscow

# *Wisdom Creates the World*

> Yea, and without these might they have fallen down with one blast, being persecuted of vengeance, and scattered abroad through the breath of thy power: but thou hast ordered all things in measure and number and weight.

The opening miniature of this codex is a stylistic updating of the illustrations that prefaced the moralizing medieval Bibles, where Christ was represented with the compass in hand, about to organize the freshly created world. The presence of the compass is a specific reference that Wisdom makes to the Intelligence with which God "has ordered all things in measure and number and weight." The Christ-Logos is here surrounded by an array of seraphim; the blue sky in the background is none other than a mass of cherubim that make up the true essence of heaven. The reference is to the idea of angels as powers emanated by God in a flow of creation, which returns to him. This is the vision of Plotinus, appropriated by Christian philosopher and theologian Dionysius the Areopagite.

GOD, THE GREAT ARCHITECT
OF THE UNIVERSE
15th century
British Library, London

# *Wisdom Creates the World*

The reaction to the unusual views of the philosopher Emanuel Swedenborg, who introduced the humanization of the angels, was swift. Although Immanuel Kant (1724–1804) branded Swedenborg a visionary, the Catholic theologian Antonio Rosmini (1797–1855) returned the angels to their spiritual dimension. Born from God's will, and therefore creatures just like men and women, the angels form the structure or "skeleton" of that invisible universe that is the complement of the material world. In his *Psychology*, the Italian thinker explained that all material bodies (composed of atoms) follow a passive organizing principle, while the active element is intelligent and spiritual and is identified with the angelic presence that organizes the world. This suggestive painting by George Frederich Watts seems to express such a concept: The "dweller in the innermost" seems to be the essence of things (or the "noumenon," as theorized by Kant). In fact, if we analyze the world scientifically, today more than ever we realize that matter is organized according to measure and number and weight. In Rosmini's thought, the capacity of matter to react and organize itself according to an exact design is the mark of a supreme intelligence that reaches matter through the angels. The pensive attitude of this quiet angel, having laid down his trumpet, renders the idea effectively.

THE DWELLER IN THE INNERMOST
George Frederich Watts
1885–86
Tate Gallery, London

# The Seraphim and the Vision of Isaiah

" In the year that king Uzziah died I saw also the Lord sitting upon a throne, high and lifted up, and his train filled the temple. Above it stood the seraphims: each one had six wings; with twain he covered his face, and with twain he covered his feet, and with twain he did fly. And one cried unto another, and said, Holy, holy, holy, is the LORD of hosts: the whole earth is full of his glory. "

This illumination from a manuscript of Saint Gregory's *Moralia* is one example of the great confusion that marked the iconography of cherubim and seraphim. In the top left we read the words *duo cerubin sex ale uni et sex ale alteri*, which means "there are two cherubim, each with six wings," as if implying that seraphim are six-winged cherubim.

This illumination shows two angels on top holding the fixed stars and the moon, symbols of the cosmos. Below are the symbols of the four Evangelists. In the center is Christ enthroned with the two seraphim supporting him and acting as cherubim, since their wings, with the peacocklike eyes, cover him like the new Ark of the Covenant.

ISAIAH'S VISION
945
Biblioteca Nacional, Madrid

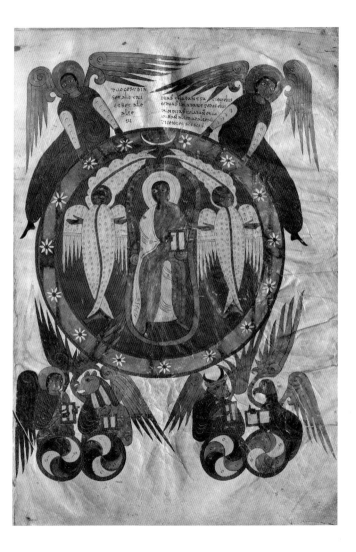

# The Seraphim and the Vision of Isaiah

This illumination, which had belonged to Henry II, the Germanic ruler of the Holy Roman Empire, offers a very original image of the vision of Isaiah. The prophet is enclosed in a mandorla and waits for two seraphim to approach. One of them collects a piece of burning wood with a long pair of tongs; he will place it on the prophet's mouth to purify it. Thus Isaiah's words will have been purified by fire, something that only one who speaks through the mouth of God can suffer. The scene is a visual transposition of the etymological meaning of the term "seraph," which, appropriately, means "the burning one." Here also the iconography paints the angels with six wings, but without eyes. Note the miniaturist's skill in blending the image of the angel wearing dalmatic, pallium, and halo with that of the six-winged seraphim.

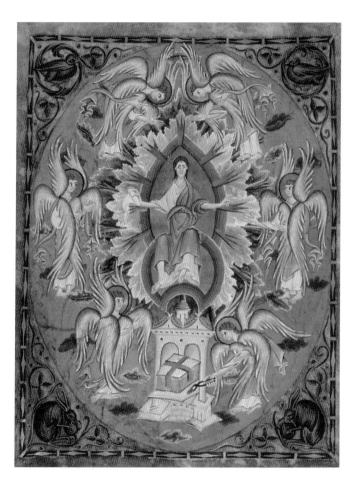

# The Seraphim and the Vision of Isaiah

This mosaic is one of the more majestic medieval interpretations of angelic choirs. Arranged in the transept of the cathedral's presbytery, the seraphim, flanked by the Greek inscription *ó ághios seráphem* ("the holy seraph"), are escorted by cherubim (arranged in the opposite section). They are the highest angelic orders, who alternate in giving homage to God; however, the iconography is confused here and it would not be possible to differentiate them without the inscription. In fact, both cherubim and seraphim appear with their six wings strewn with eyes, and even with the same standard: the *labarum* that, for the seraphim, should bear the motto "Holy, Holy, Holy," as written in the book of Isaiah.

THE SERAPHIM
1148
Cathedral, Cefalù

# The Seraphim and the Vision of Isaiah

Arranged above the immense Christ inside the shield and seated upon the spheres of the seven heavens, in this Florentine mosaic the red seraphim hover over the blue cherubim, who stand on each side of another figure of Christ, represented standing—a clear reference to the New Testament interpretation of the Ark of the Covenant. The blessing Savior holds in his left hand the open Gospel, the book of life. The seraphim are at the summit of the long series of images that illustrates all the choirs of the heavenly hierarchies according to the dictates of Pseudo-Dionysius and the guidelines of the medieval encyclopedists. In this case, however, custom takes over, and the images of the seraphim are totally given over to the cherubim, who in this mosaic have neither eyes on the wings nor wings proper. It is interesting to note how the scenes arranged along the registers of this immense mosaic do not take into account the iconography of the mirroring sections, which didactically illustrate the hierarchies. Thus, the cherub of the expulsion from earthly paradise is red, but is contaminated by the flaming sword mentioned in Genesis, while here the next-to-last angelic choir is blue.

CHRIST IN MAJESTY AND SERAPHIM
13th–14th century
Baptistery, Florence

# The Seraphim and the Vision of Isaiah

The moment when Christ crowns Mary, who, as Dante sings (*Paradiso*, XXXIII, 1–6), is at once the mother and the daughter of the Savior and also (in a link to the Song of Songs) the bride of Jesus, is one of those rare instants when the entire universe reaches the apex of its own harmony. For this reason, all the medieval tradition represents this episode, which does not appear in the Scriptures, with musical angels playing the harmony of the cosmos and celebrating this meeting of the human and the divine. In this panel, Spinello Aretino added the presence of a garland of red seraphim, who surround the throne on which the two protagonists are seated. These are the angels who raise Jesus and Mary to the empyrean with the powerful beating of their wings. Note also how they alternate with the cherubim and how the artist used biblical passages from the many prophetic visions, including Isaiah's, for new iconographies, such as this coronation of the Virgin Mary.

CORONATION OF THE VIRGIN
Spinello Aretino
*c.* 1385
Pinacoteca Nazionale, Siena

# The Seraphim and the Vision of Isaiah

In the garden that he painted on the eastern wall of the rectangular apse of the Magi Chapel in the Palazzo Medici Riccardi in Florence, Benozzo Gozzoli also took as his model the original interpretation of the angels as "birds" that was given by Gentile da Fabriano in his panel conserved in Berlin (see pages 356–57) and imagined a red seraph perching on a tree like a nightingale. On the western wall of this precious room, the artist arranged among the clouds other red seraphim, above whom hover small heads adorned with four wings, while blue cherubim flit around in the crystal-clear sky.

In any case, the conflation of angels and birds was also a favorite of Dante, who called them "divine birds." Furthermore, especially for the cherubim, the English and German art milieu developed an iconography where the bodies of these heavenly messengers are covered with feathers.

ANGELS WORSHIPPING
(detail)
Benozzo Gozzoli
1459–60

Palazzo Medici Riccardi, Florence

# The Seraphim and the Vision of Isaiah

Seraphim are at the top of the ladder of angelic hierarchies, and therefore only they have the privilege of gazing directly into the face of God. This is the reason why Sano di Pietro placed a seraph at the top of an ideal ladder starting from the saints John the Baptist (below left), Jerome (below right), and Bernadino of Siena (above Jerome), continuing with the angels and ending with the red seraph, whose iconography by now has blended with the new one of the cherubim, who are depicted as small putti with wings or, in this case, with winged heads. Often it is the color that differentiates them, as it does here, or the number of wings which does not always follow the textual sources. Here the red seraph has the compositional value of an uppermost seal that acts as a keystone in the harmonious arch of purity that begins with the saints and rises toward the angels and the seraphim.

MADONNA AND CHILD WITH
SAINTS ANTHONY ABBOTT AND BERNAR-
DINO OF SIENA
Sano di Pietro
c. 1460–65
 Pinacoteca Nazionale, Siena

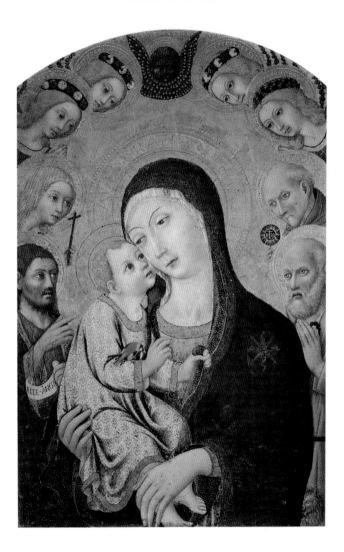

# The Seraphim and the Vision of Isaiah

The prevailing color of this painting is red, and it is dominated by the six-winged seraph. The face of the prophet, on the other hand, is green, a color complementary to red. With this chromatic language, Chagall is telling us that the seraph and Isaiah are two sides of the same coin. The seraph touches the prophet's face, and it is as if he had found a friend or, better, a part of himself: his human dimension complementing the divine one. Chagall completes the composition by depicting Isaiah as he is about to kneel, with the text of the vision in hand; the seraph's gesture expresses affection, and seems to ask him: "What are you doing? You kneel before your divine self? Let me embrace you, for you have seen me and you have recognized me."

THE PROPHET ISAIAH
Marc Chagall
1968
Message Biblique Marc Chagall,
Musée National, Nice

# *The Vision of Ezekiel*

"As I was among the captives by the river of Chebar, [. . .] the heavens were opened, and I saw visions of God. [. . .] And I looked, and, behold, a whirlwind came out of the north [. . .]. Also out of the midst thereof came the likeness of four living creatures. And this was their appearance; they had the likeness of a man. And every one had four faces, and every one had four wings. And their feet were straight feet; and the sole of their feet was like the sole of a calf's foot. [. . .] And they had the hands of a man under their wings on their four sides; and they four had their faces and their wings. [. . .] As for the likeness of their faces, they four had the face of a man, and the face of a lion, on the right side: and they four had the face of an ox on the left side; they four also had the face of an eagle. [. . .] And the living creatures ran and returned as the appearance of a flash of lightning."

On the left side of one of the earliest surviving Byzantine mosaics, we see the prophet Ezekiel watching the divine vision, admiring and frightened at the same time. Below we see a watercourse, the "river of Chebar." On the right, Ezekiel is seated holding his book. In the center is Christ with the cross halo, replacing God, seated on top of the world and surrounded by the Tetramorph—the four beings of the vision: the bull, the lion, the eagle, and the man, symbols of the four Evangelists.

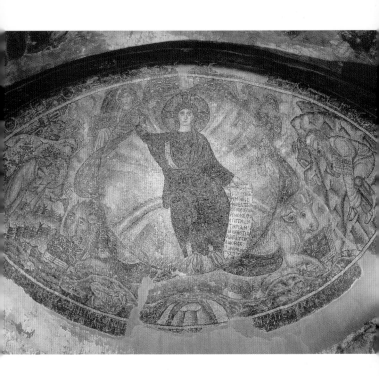

# The Vision of Ezekiel

The layout of the funerary chapels of Bawit and Saqqara is more or less the same; in the bow-shaped vault of the apse is Christ in Majesty with the four symbols of the Tetramorph from the vision of Ezekiel. Below, among a group of apostles, sit the Virgin and Child. In chapel 6 (reproduced on the opposite page) are all the elements of the prophet's vision, though they are "arranged" differently: The four wings strewn with eyes have become appendages that support the enthroned Christ, who has taken the place of the Eternal. On each of these wings is an aspect of the Tetramorph—that is, the heads of a man, a lion, a bull, and an eagle. Under the nimbus that holds Christ, we see the wheels of the vision. Finally, in a total deviation from the text, we find two large angels at each side and above them two heads on a shield, probably the personification of the sun and the moon, the major luminaries, as the different colors (yellow for the sun, blue for the moon) seem to confirm.

EZEKIEL'S VISION
(detail)
6th century
Copt Museum, Cairo

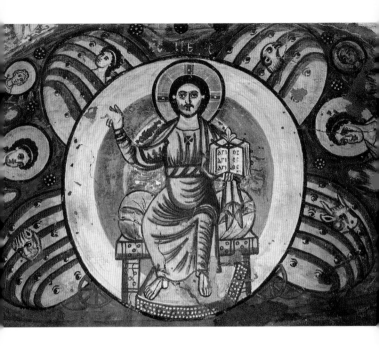

# The Vision of Ezekiel

In the bottom register of this illumination we see the Holy Roman Emperor Charles II with soldiers in formation appearing before God the Father with the Virgin's intercession; in the central register is the array of the blessed, and in the topmost register the vision of the prophet. Dressed in white like the Father (depicted in the lower right), Christ is seated on a sort of figure-eight-shaped mandorla inscribed in a circle. Next to Christ is the Tetramorph, with the symbols of the four Evangelists, while in the upper section, two angels coming out of the clouds seem to move the heavenly spheres, thus conferring a cosmic quality to the scene. On each side, the cherubim have six wings, like the seraphim, and they are strewn with eyes. Contrary to what Ezekiel wrote, the cherubim here have human feet, not calves' hooves, for at this point it was taken for granted that angels are men and so, therefore, are the cherubim.

CHRIST IN MAJESTY WITH THE TETRA-
MORPH (EZEKIEL'S VISION)
9th century
San Paolo fuori le Mura, Rome

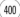

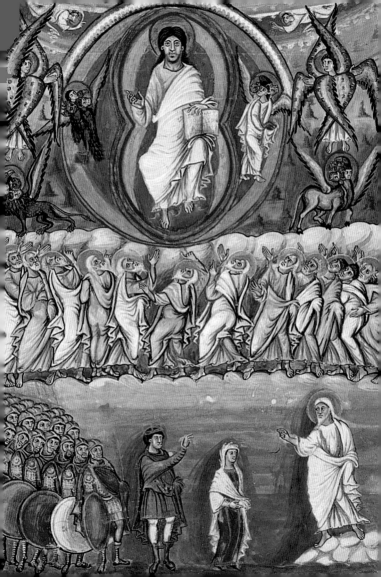

# The Vision of Ezekiel

This fresco in the Collegiate Church of León follows the consolidated iconographic tradition of the vision of Ezekiel where God has been replaced by Christ. Here, the Savior in majesty—or, to be more exact, Christ of the Last Judgment with the Alpha and the Omega next to him—is depicted seated inside the mandorla and surrounded by the symbols of the four Evangelists, derived from the figure of the Tetramorph. The Evangelists play the same role as the cherubim, but the iconographic novelty is that each one of them has the symbolic head instead of the human one, except Matthew, for whom the two aspects coincide. Each Evangelist holds his own Gospel, displaying it like an offering or a trophy to be carried triumphantly. Next to the four figures are inscriptions that clarify their respective identities. They read: *Mateus omo, Lucas vitulo, Marcus leo, Ioannis aquila* ("Matthew man, Luke calf, Mark lion, John eagle").

CHRIST IN MAJESTY (EZEKIEL'S VISION)
1164–75
Panteón de los Reyes,
San Isidoro, León

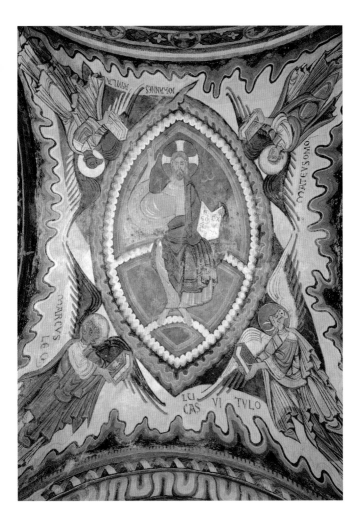

# The Vision of Ezekiel

The novelty of this vision of Ezekiel painted by Raphael is the inclusion of the figure of God at the center of the scene; until this point, the traditional iconography had replaced God with Christ. After the extraordinary "revolution" wrought by Michelangelo's Sistine Chapel masterpiece, which he painted between 1508 and 1512, it would have been unthinkable to return to traditional solutions, for Michelangelo's powerful images of the creator God had conferred full dignity to an image that previously had appeared only rarely in Christian iconography, depicting instead the Christ-Logos.

Therefore, Raphael was somehow "forced" to change the traditional line, and he conceived of this Father God with hair and beard blown by the wind, in Michelangelo's style. Still, the Umbrian artist followed tradition in painting the Tetramorph that represents the symbols of the Evangelists, without using Ezekiel's text. In fact, in a sense he dismantled the prophet's vision by transforming the Tetramorph into the Evangelists, and the cherubim into two child-angels supporting God the Father by his arms. Here we have clear proof that, at this point in history, the winged putti are not generic angels, but cherubim.

THE VISION OF EZEKIEL
Raffaello Sanzio, known as Raphael
1518
Galleria Palatina,
Palazzo Pitti, Florence

# *The Cherubim*

▶▶

> " Then I looked [. . .]. Now the cherubims stood on the right side of the house, when the man went in; and the cloud filled the inner court. [. . .] And the sound of the cherubims' wings was heard even to the outer court, as the voice of the Almighty God when he speaketh. [. . .] And there appeared in the cherubims the form of a man's hand under their wings. [. . .] And their whole body, and their backs, and their hands, and their wings, and the wheels, were full of eyes round about, even the wheels that they four had. "

According to the scholarship on the subject, this passage from the vision of Ezekiel is an interpolation, meaning that it was added shortly after the text was drafted. Indeed, the wings strewn with eyes are not part of the iconographic and religious tradition of Mesopotamia, where Ezekiel was in exile. On the contrary, they are found in the culture of ancient Egypt contemporaneous with the prophet. The detail of the eyes was probably drawn from the representation of the Egyptian deity Bes. The guardian of women in childbirth and of sleep, during the Saitic age (664–525 BCE) Bes underwent a transformation and became Bes Pantheos; he had four wings filled with eyes, a number of animal heads around his head, and a wheel under his feet—all elements that went into the final text of Ezekiel, which thus mixed the Assyro–Babylonian tradition of the *lamassu* with that of Bes Pantheos.

THE GOD BES
7th century BCE
Musée du Louvre, Paris

# The Cherubim

The issues surrounding these figures are some of the most complex in the iconography of angels. After all, the cherubim were not imagined entirely by Ezekiel, because the entire previous written tradition, from Genesis (3:24) to Exodus (25:18 ff.) refers to these beings. In Exodus we have a description significantly different from that of Ezekiel's, though just as authoritative, since only two wings are described. This discrepancy between the two narratives gave rise to two different artistic traditions. This illumination from Gundoin's Gospel is one of the earliest surviving examples of an iconography that was inspired by the Exodus narrative. The inscription *Cyrubim*, next to what appear to be simple angels, removes all doubt about their real identity: They are the cherubim who watch over the Ark of the Covenant, here replaced by the figure of Christ enthroned. The chief evidence is the raised wing that covers Christ, the new Ark. From this time forward, next to the iconography derived from the vision of Ezekiel, a new representational parameter was born, one that shows the cherubim as angels.

CHRIST IN MAJESTY BETWEEN TWO CHE-
RUBIM
754
Bibliothèque Municipale, Autun

# *The Cherubim*

The Byzantine composition of this Universal Judgment (based on the vision of Daniel) was adopted in Italy as well, and may be read along its horizontal registers. On top is the divine court of the King of Kings, with Christ enthroned and flanked by the Virgin Mary and John the Baptist, the apostles on each side, and behind them the sword-bearing angels (the heavenly host). In the register below is the array of cherubim and seraphim, differentiated according to the correct iconography; the seraphim, in fact, have six wings and the cherubim four, although the wings of both are covered with eyes.

Under the feet of the cherubim are the wheels that, in this interpretation, fill the role of court chamberlains, for it is not by coincidence that they are next to Daniel's "great river of fire," and stand over the shield containing the Etimasia (the throne with the Gospel), a symbol of Christ. Other angels are also present: One rolls up the sky, one blows the trumpet to resuscitate the dead, one drives away the wicked, and one weighs the souls for their judgment. A final interesting detail is the presence of a cherub who holds shut the door of earthly paradise.

THE CHERUBIM AND THE LAST JUDGMENT
(DANIEL'S VISION)
11th century
Bibliothèque Nationale de France, Paris

τὸ τ᾽ ἂν ἀπεκρίθησαν ται ἡμῖν αὐτοῖς κἀκεῖνα τὰ
κε. πότε σε ἰδομεν πεινῶν τα ἢ διὲν ἢ τὰ
ἢ ξένον ἢ γυμνὸν ἢ ἀσθενῆ ἢ ἐν φυλακῆ. ∴
οὐ διηκονήσαμεν σοι ☩ τότε ἂν ἀποκριθῇ
σει αὐτοῖς λέγων ☩ ἀμὴν λέγω ὑμῖν ☩ ἐφ᾽
ὅσον οὐκ ἐποιήσατε ἑνὶ τούτων τῶν ἐλαχίστων
οὐδὲ ἐμοὶ ἐποιήσατε ☩ καὶ ἀπελεύσονται
οὗτοι εἰς κόλασιν αἰώνιον· οἱ δὲ δίκαιοι. εἰς
ζωὴν αἰώνιον ✛

# The Cherubim

The iconography of the cherubim differing from that of the prophet Ezekiel and based instead on passages from Exodus became official in German theologian Rabanus Maurus's (*c.* 780–856) work, *De Cherubim et Seraphim circa crucem scriptis et significatione eorum* [*On Cherubim and Seraphim Concerning the Writings on the Cross and Their Meaning*], dedicated to the long medieval dispute. He had found a new representational method to educate the faithful: He had illustrations made of the concepts he wanted to express and placed a current explanatory text inside the illustration. This elegant miniature, from a later manuscript, elucidated the double iconography of the cherubim, derived from both traditions, and officialized the new image of the cherub that from that time forward took its place in twelfth-century art and illuminated books. The miniature, divided into four sections by the cross, and with a crimson background (the imperial color par excellence), shows the seraphim on top and the cherubim at the bottom. The yellow alludes to gold, which, like crimson, was a sign of spiritual wealth and nobility.

CARMEN FIGURATUM
12th century
Biblioteca Apostolica Vaticana,
Vatican City

CHERVBIM SERAPHIMD
ALTATE IGNIS NAMHI
MDIVINA CRVCIS VERA
RVCT LVCIS CHRIST VE
CITTRIS TIA TVNCRE
ERA SERAPHIN CAROK
ELESTIA MONSTRAN
VMEST PENNARVMA
CRAT MATQ EDE CVS
ONSVLT VHAC RISTVS
NPASSV SCVNCTOS GEP
RDISTRICTA RVPIT EX
VETERE SACTVS TORS
SSTE ERAT ADAMSON
ASORO THORVNT VIRE
IXILIA INTENEBRIS I
SCRVCE ACTOREM CON

CAELO NOMEN IESVS TA
CVES TERRA MINE LVCE
EST LAVS HAEC QVIAVIT
VS QI ET SOCIAE ST LAVS
NVNC QESC SVLTAT VBIQ
FIANT CELE BRANDO BIC
TA FINC LAVE SVPERM
AVS VNAM CONCLAMAT
RAC FIRANT QVSO QVOTO
BONA QVAE TRIBVITRE
ECVM CONBVSS IT INIGS
CAVTICAL CEP OTENTES
VSI CLAVS TRA CELVDRE
TDEDIT IPSA BENIGNVS
REGNA SABE VICI INARCO
TNVMENVICIT VIFERRI
CARCEREIVS SABE ATVC
IXVM INSTIPITE REGE

IXILLVM FRAMEA SORS
ROTERI THOC HOSTES SA
IBLEVAT ATQVE CONS
MHIN CELSVLIGNIS SS
ANDCHERVBIN HAE CO
CHAECLABRARADANT
NCTARASAPLVNTVN
CTATHRIVMPHVNQ CO
AETA GEDISTENSIS DV
NALISSENS MT RADVN
ENNIS OS QVI SVVMGER
IOCARNALIS EAT LVXV
ENSA CRA BRACHI ASALV
SGTRAHI AQVE HICE
MDIS PENSANS NS TVT
AEIAM NOTA ANTE AVO
CRVCE IVSTI TVBANT
CRVCE NON FALLVNTI

ELLIINSIGNE DECORV
MAQ CONFRINGIT INIQVA
RTVTIS PROEMIA DONAT
ITO QLAETE ALATEREN
RA MASIS SVNTARSAG
IGNORITQ ET SATISORA
QVOQES CITATE QVEHIC
AT PERQ LACOONDVNT
VNTHAE CLACTABEANDO
ALMAALTA QVE PANDAN
FIMVTIA PROPETEMPVS
DICANTVLTIA QVEHINO
NTISHICOFFE CIODANT
SOQVVDI CLOIPSEHINC
MLECETIPSA PROBANDO
ET CARAPRO BATVRVBIQ
VS TORVM VNTIA VATVR
TORVMSIGNANI MANTVM

# The Cherubim

Placed next to the seraphim, whom we admired earlier (see pages 384–85), the enormous cherubim that fill the two other vaulting cells of the presbytery of the Cefalù cathedral are as large and majestic as their cousins the seraphim, from whom, as was often the case, they arbitrarily borrow six wings, though strewn with eyes. Next to each cherub are two figures that could be half-length angels coming down from the clouds; they, too, are cherubim, identified by the inscription *ó ághios chéroubim* ("the holy cherubim") skillfully placed so as to denote all three characters. These two-winged cherubim hold the *labarum* (standard) in their hands, a concept borrowed from the images of seraphim, further identifying them as high-ranking angels. This is an important mosaic because it offers supporting evidence in the arts of the iconographic line sanctioned by Rabanus Maurus (see pages 412–13).

CHERUB
(detail)
1148
Cathedral, Cefalù

ΘΑΘΟΣ    ΧΕΡδΕΜ

REDEMPT R + IVDICO

# The Cherubim

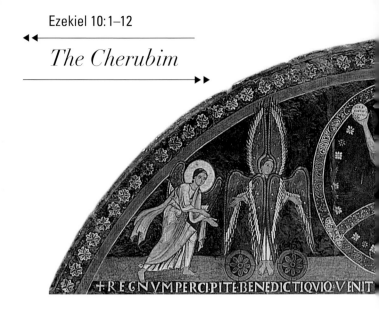

+REGNVMPERCIPITE BENEDICTIQVIQVENIT

This panel, in an unusual omega shape, is arranged with super-imposed registers: On the lowest is the sentencing to hell of the wicked, next to the City of God, over which towers the figure of the Virgin Mary. Above is another register with angels playing trumpets to call the dead from their graves while fishes and wild beasts regurgitate the bodies of men they had devoured. The central register illustrates episodes from the life of Saint Stephen, while the uppermost register contains Christ before the altar, flanked by two angels and the

THE LAST JUDGMENT
(detail)
Niccolò di Giovanni
c. 1180
Pinacoteca Vaticana, Vatican City

OBISPARATVM·PERSECIACVNCTADONATVM·

apostles. Above the composition towers a central shield with Christ in majesty (shown on this page) or more exactly, Christ Pantocrator—the creator king of the universe—with an angel and a splendid cherub at each side; the latter reveal contamination with the iconography of the seraphim, for they have six wings, although they have retained other distinguishing features such as the eyes on the wings and the wheels described by Ezekiel. The rosette decoration all around suggests the stars of the universe.

# *The Cherubim*

Recent research has dated the frescoes of Anagni to the middle of the thirteenth century. The fresco of the third vault, representing the Tetramorph derived from Ezekiel's vision, was designed in relation to primordial and individual causes, the former based on the theories of Honorius Augustodunensis (*c.* 1151), the latter on those of Rabanus Maurus. This superimposition is possible because man is a miniature cosmos, and because the universe and man and his soul are all based on the number four. In fact, the key point of this design lies in the quadripartite arrangement of the vault, so that on one hand, the image recalls the cross of the elements (earth, water, air, fire) corresponding to the four aspects of the Tetramorph, and on the other hand, it recalls the canonical subdivision of the soul. As a matter of fact, Rabanus Maurus developed Plato's concepts by identifying a rational soul, an irrational one, and a concupiscent soul. To these three, a fourth must be added, according to Rabanus Maurus, that corresponds to the eagle of the Tetramorph, and it is the part called *syntéresis*, the noblest part of our incorporeal dimension: It is the spirit, through which we are made in the image of God. The Greek term means "conservation" and points to the ultimate source of the divine dimension of the soul.

TETRAMORPH OR SERAPH
(detail)
Second Master, Hand A
1231–50
Cripta di San Magno, Anagni

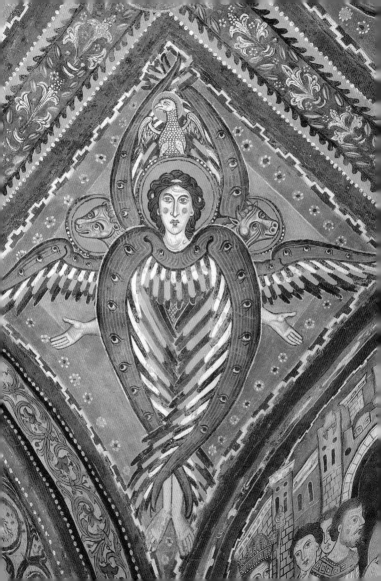

# The Cherubim

Following the teachings of Fra Angelico, Benozzo Gozzoli perfected a new iconography of the angelic choir. The artist portrays the cherubim as "adult" angels, but with four wings. He used this imagery in several other paintings as well. The musical angels, however, do not fall into this new category, although the ones in the background do, and their four wings are all of different colors. Below the clouds, almost hidden by Mary's blue mantle, are two small red heads; these are the seraphim, and we see nothing else of them. Interestingly, for the garments, Benozzo reproduced the multicolored tunics of Fra Angelico in addition to introducing the more recent *guarnello*.

MADONNA DELLA CINTOLA
Benozzo Gozzoli
1450
Pinacoteca Vaticana, Vatican City

◂◂ ——————————————————————————————

# *The Cherubim*

—————————————————————————————— ▸▸

This fresco, created by Piero della Francesca for the Monterchi cemetery, shows two angelic cherubim on each side of the Virgin; they are the cherubim who watch over the Ark of the Covenant, here replaced by the figure of Mary, guardian of the even higher covenant for the redemption of man, of which Jesus is the witness. The word "witness," in addition to the current general meaning, also acquires the nuances of the Greek language, where the word *martyr* refers to the witness. Identifying the two angels as cherubim is not a forced interpretation; the artist was very careful to position two of the four wings of each cherub as if they were cabinet doors that, when closed, cover the Virgin, who is made equivalent to the Ark, homage to an established tradition derived from an interpretation of the Exodus passage (25:18 ff.). To reinforce the idea of the couple, the artist created inverted chromatic correspondences between the color of the wings, the garments, and the stockings of the two cherubim.

MADONNA DEL PARTO
Piero della Francesca
1460
Cemetery chapel, Monterchi

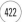

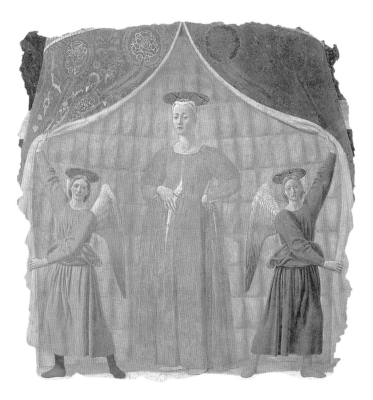

# The Cherubim

The varied cherubim iconography offers different solutions that captivated Renaissance artists such as Andrea Mantegna, who chose to render these angels as young children's heads with wings for this, one of his more delicate and refined works. Here the artist has skillfully and gently combined the angels' musical attitude with the very idea of the harmony of the heavens, translating it into singing cherubim. God has become man, Jesus is in the arms of the Virgin Mary, and the cherubim in the clouds sing their glory. Here the artist has stressed the painterly aspects by diversifying the features of the putti, their expressions and attitudes, even using different and sometimes daring foreshortening angles.

THE MADONNA OF THE CHERUBIM
Andrea Mantegna
*c.* 1485
Pinacoteca di Brera, Milan

◀◀◀

# The Cherubim

The attention given to the many solutions in the representation of cherubim allows us to identify some unusual meanings, as wish some of the preceding examples. Thus we may dare to hypothesize that the four angels arranged at the top of the spiral columns of the monumental baldacchino (canopy) in Saint Peter's Basilica in the Vatican are cherubim who refer specifically to the Ark of the Covenant. Besides, the meaning of Bernini's monumental bronze sculpture is clear. The traditional meaning assigned to the four spiral columns is the Temple of Solomon where, as narrated in 1 Kings (6:1-30), the Ark of the Covenant was kept—a covenant that, in the Christian religion, is renewed each time Mass is celebrated. Therefore, the "Holy of Holies" where the covenant between God and man is renewed is the very altar, at once an ark and a temple. And so, the cherubs placed at the very top of this immense, theatrical creation are none other than the Ark cherubim.

THE BALDACCHINO
(detail)
Giovanni Lorenzo Bernini and
Francesco Borromini
1624, 1633
Basilica di San Pietro, Vatican City

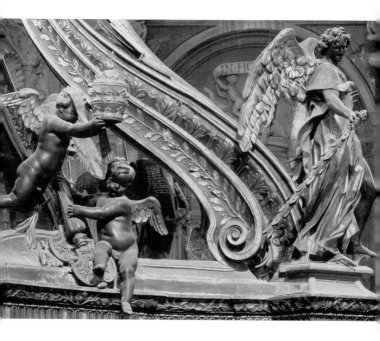

## The Three Jews Thrown Into the Furnace

> And the king's servants, that put them in, ceased not to make the oven hot with rosin, pitch, tow, and small wood; So that the flame streamed forth above the furnace forty and nine cubits. And it passed through, and burned those Chaldaeans it found about the furnace. But the angel of the Lord came down into the oven together with Azarias and his fellows, and smote the flame of the fire out of the oven; And made the midst of the furnace as it had been a moist whistling wind, so that the fire touched them not at all, neither hurt nor troubled them.

This is one of the episodes believed to prefigure the coming of Jesus and one that suggests the salvation of the soul for the believer. This relief from the sarcophagus of Publia Florentia is one of the earliest examples where the angel appears, as early Christian art often replaced it with a dove bearing an olive branch in its beak (a prefiguration of Christ). In the first centuries of Christianity, the figure of the angel was not as widespread. In fact, there was an unwillingness to represent them, hence the importance of this work. However, this angel is still quite removed from the iconography of later centuries, because he is depicted wearing the dalmatic and pallium and even has a beard.

THE ANGEL SAVES THE THREE JEWISH
BOYS FROM THE FURNACE
(detail)
4th century
Musei Capitolini, Rome

◀◀ ——————————————————————————

# The Three Jews Thrown Into the Furnace

————————————————————————— ▶▶

The mosaic of Óssios Lukas in Phocis, a region in Greece, well exemplifies the evolution in representing this biblical episode, compared to the Paleochristian model (see pages 428–29). No longer absent, or so discreet as to be unrecognizable, we now see the angel returned to his leading role. Dressed in a dalmatic and a pallium, in keeping with the earlier tradition, he now flaunts a splendid pair of wings. His ample gesture, embracing the three miraculously saved boys, harmonizes with and is amplified by the curvilinear shape of the lunette. An important detail is the ribbon in the angel's hair, an ornament that appeared for the first time in the sixth century and was subsequently adopted until the fourteenth century to signify the angel's royal status (see pages 416–17).

THE ANGEL SAVES THE THREE JEWISH BOYS FROM THE FURNACE
11th century
Monastery Church, Óssios Lukas

430

# The Three Jews Thrown Into the Furnace

Guariento di Arpo's fresco revives the general design of this scene, which in previous instances had been reduced to its essential components: the angel, the furnace, and the Jewish boys. Here the artist has amplified the view to include the effects of the episode, depicting the king's astonishment before the extraordinary nature of the event. Convinced that he was inflicting a deadly punishment, Nebuchadnezzar had ordered the three boys to be thrown into the furnace like fire logs, but the angel upset his plans. As a matter of fact, as the Bible says, the fire turned against the the king's subjects who were standing by and watching. Guariento masterfully contrasts the angel's seraphic calm, clear from the detail reproduced here, not only with the turmoil of the executioners, who cannot explain the phenomenon, but also with the excited anxiety of the boys: Their expressions are a mixture of shock and disbelief. In this instance, the angel has executed God's will.

THE STORY OF THE THREE BOYS
(detail)
Guariento di Arpo
1349–54
Private Carraresi Chapel
(now Accademia Galileiana), Padua

432

# The Angel Feeds Daniel in the Lions' Den

> Then the king commanded, and they brought Daniel, and cast him into the den of lions. Now the king spake and said unto Daniel, Thy God whom thou servest continually, he will deliver thee. [. . .] Then the king arose very early in the morning, and went in haste unto the den of lions. And when he came to the den, he cried with a lamentable voice unto Daniel: [. . .] O Daniel, servant of the living God, is thy God, whom thou servest continually, able to deliver thee from the lions? Then said Daniel unto the king, O king, live for ever. My God hath sent his angel, and hath shut the lions mouths, that they have not hurt me: forasmuch as before him innocency was found in me.

Nebuchadnezzar had hired Daniel, who had the power to interpret the dreams that the court wizards could not understand, because, worshipping as they did false and mendacious gods, the wizards could not interpret the will of the one true God. Now the wizards, jealous of Daniel, accused him, and he was thrown into the lion's pit that he might prove his innocence. The artist has relegated the angel's miraculous action to the background; he appears in the top right corner, carrying the prophet Habbacuc, who had come from Judea to Babylon to feed Daniel.

DANIEL IN THE LIONS' DEN
16th century
Museum, Novgorod

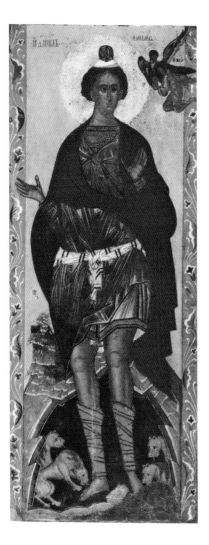

# Thousands of Angels Serve the Ancient Before the River of Fire (Last Judgment)

> I beheld till the thrones were cast down, and the Ancient of days did sit, whose garment was white as snow, and the hair of his head like the pure wool: his throne was like the fiery flame, and his wheels as burning fire. A fiery stream issued and came forth from before him: thousand thousands ministered unto him, and ten thousand times ten thousand [angels] stood before him: the judgment was set, and the books were opened.

The book of Daniel is one literary source that helped shape the iconography of the Last Judgment, which began to appear in Byzantium around the tenth century and drew inspiration from various canonical texts. It is not by coincidence that the iconography of this ivory carving in the Victoria and Albert Museum is identical to that of the evangelistary on which we commented earlier (see pages 410–11). But there is one important difference: While in the miniature the Christ-Logos appears, here we really find the "Ancient of Days," and before him a true river of fire traversed by an angel driving demons and sinners into hell.

THE LAST JUDGMENT
(DANIEL'S VISION)
10th century
Victoria and Albert Museum, London

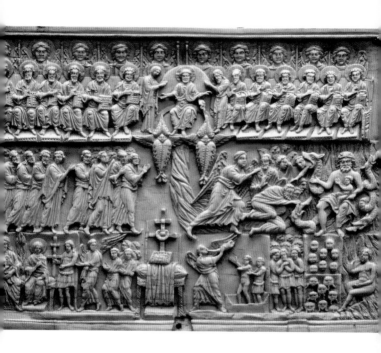

# The Vision of Daniel

> And as I was considering, behold, an he goat came from the west on the face of the whole earth, and touched not the ground: and the goat had a notable horn between his eyes. [. . .] And whiles I was speaking, and praying, and confessing my sin and the sin of my people Israel, and presenting my supplication before the LORD my God for the holy mountain of my God; Yea, whiles I was speaking in prayer, even the man Gabriel, whom I had seen in the vision at the beginning, being caused to fly swiftly, touched me about the time of the evening oblation.

We must turn to the above passages from the prophet Daniel to explain this painting by Willem Drost, one of Rembrandt's best students. It is a formally arbitrary arrangement, since it does not follow the text, yet is perfectly consistent with the substance of the vision, since the archangel Gabriel guides the prophet to the discovery of the meaning of his visions. The artist's solution is an interesting one; he portrays a gentle, very young Gabriel, but dressed in the garments that Daniel attributes to Michael—that is, "a man clothed in linen, whose loins were girded with fine gold of Uphaz" (Daniel 1:5). The text has been adapted to the artist's sensitivity and the tastes of the time, creating a highly suggestive scene marked by flashes both visionary and naturalistic.

DANIEL'S VISION
Willem Drost
1650
Gemäldegalerie,
Staatliches Museen, Berlin

# The Archangel Gabriel Reveals the Vision

> And it came to pass, when I, even I Daniel, had seen the vision, and sought for the meaning, then, behold, there stood before me as the appearance of a man. And I heard a man's voice between the banks of Ulai, which called, and said, Gabriel, make this man to understand the vision.

Even though this splendid mosaic, which decorates the sides of the apse in the Church of Sant'Apollinare in Classe, does not specifically narrate the preceding passage from Daniel, it still provides a very suitable interpretation. Indeed, this image of Gabriel is not only decidedly unusual; it is also the earliest to follow this particular iconography. The divine messenger appears as a high-ranking court dignitary dressed in military attire, complete with *chlamys* and standard, on which *ághios* ("Holy") is inscribed three times, recalling the adoration of the seraphim. Gabriel has nothing of the gentle presence that is typical of the Annunciation; according to Daniel's words, "[he] stood [. . .] as the appearance of a man"—a man of the court of God.

THE ARCHANGEL GABRIEL
6th century
Sant'Apollinare in Classe, Ravenna

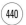

# The Angel Leads Habbacuc to Daniel in the Lions' Den

> But the angel of the Lord said unto Habbacuc, Go, carry the dinner that thou hast into Babylon unto Daniel, who is in the lions' den. And Habbacuc said, Lord, I never saw Babylon; neither do I know where the den is. Then the angel of the Lord took him by the crown, and bare him by the hair of his head, and through the vehemency of his spirit set him in Babylon over the den.

The misfortunes that history meted out to the Israelites in the biblical age have always been interpreted by them as a punishment for their hesitation to unreservedly embrace monotheism. Thus the prophet Habbacuc admonished them, fearing that the Chaldaeans might come to punish them, which in fact happened. It then becomes clear why the Lord sent Habbacuc to bring food to Daniel (see pages 434–35), for both had understood that it was Yahweh's hand that had guided the Babylonians against Israel and used them to convert Nebuchadnezzar, who would later free the chosen people. Once more, the angel is an instrument for fulfilling God's will.

AN ANGEL CARRIES HABBACUC
TO FEED DANIEL IN THE LIONS' DEN
(detail)
late 13th century
Santa Margherita,
Laggio di Cadore (Belluno)

# The Angel Leads Habbacuc to Daniel in the Lions' Den

Jacopo Guarana chose a foreshortened view from below to highlight the extraordinary and grandiose nature of the event in this large canvas, conserved in the Udine Castle Museum. In the foreground, a lion is curled up like a puppy and seems frightened. Above him, the prophet is seated and looks upward as if witnessing a miracle. Habbacuc comes down from the sky, pulled by the hair by the angel, who lifts him up without effort, but the prophet is not in pain. The angel's large wings spread out like those of a heron about to land. Habbacuc lands softly and Daniel thanks the divine Providence that he never doubted. The prophet was kept six days in the lions' den. On the seventh, seeing that the lions pretended not to notice him, he was released and Nebuchadnezzar proclaimed the greatness of the God of Israel.

THE ANGEL CARRIES HABBACUC
TO DANIEL IN THE LIONS' DEN
Jacopo Guarana
18th century
Civici Musei di Storia e Arte, Castello di Udine

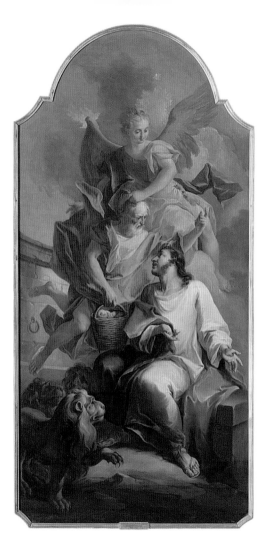

# The Angel of the Lord and the Candlestick

> And the angel that talked with me came again, and waked me, as a man that is wakened out of his sleep, And said unto me, What seest thou? And I said, I have looked, and behold a candlestick all of gold, with a bowl upon the top of it, and his seven lamps thereon, and seven pipes to the seven lamps, which are upon the top thereof: And two olive trees by it, one upon the right side of the bowl, and the other upon the left side thereof. So I answered and spake to the angel that talked with me, saying, What are these, my lord? Then the angel that talked with me answered and said unto me, Knowest thou not what these be? And I said, No, my lord. Then he answered and spake unto me, saying, [. . .] [The seven lamps] are the eyes of the LORD, which run to and fro through the whole earth. [. . .] These [two olive trees] are the two anointed ones, that stand by the LORD of the whole earth.

This painting captures the prophet Zechariah who, thanks to the presence of the angel of the Lord, sees the sign after the Babylonian captivity that would portend good omens for the future: the "seven lamps" of the seven-armed candelabrum that appears in the painting. This scene restores the formal neatness and simplicity of the Quattrocento, also reflected on the angel, who is dressed with an ample robe puffed up at the waist in the fashion of Quattrocento angelic iconography.

THE VISION OF ZECHARIAH
Riccardo Cessi
1892
Chiesa Parrocchiale, Pincara (Rovigo)

# Joseph's Dream

> Now the birth of Jesus Christ was on this wise: When as his mother Mary was espoused to Joseph, before they came together, she was found with child of the Holy Ghost. Then Joseph her husband, being a just man, and not willing to make her a publick example, was minded to put her away privily. But while he thought on these things, behold, the angel of the Lord appeared unto him in a dream, saying, Joseph, thou son of David, fear not to take unto thee Mary thy wife: for that which is conceived in her is of the Holy Ghost. And she shall bring forth a son, and thou shalt call his name JESUS: for he shall save his people from their sins.

This is Joseph's first dream, a prelude to the other well-known dream of the flight into Egypt, and one that justifies the choice of Jesus' putative father. The artist has captured Joseph as he sleeps on a bench in his carpenter's shop. The angel who appears to him is dressed in a style resembling fifteenth-century fashion, with the *guarnello* and the balloon sleeves. The words of the divine messenger tranquilize him and suggest a reassuring vision; in fact, the scene that apparently takes place in the distant background is actually Joseph's dream, which prefigures Mary reading with Jesus next to her.

JOSEPH'S DREAM
Master of Dinteville,
known as Pseudo-Félix Chrétien
1541
Musée de Vauluisant, Troyes

448

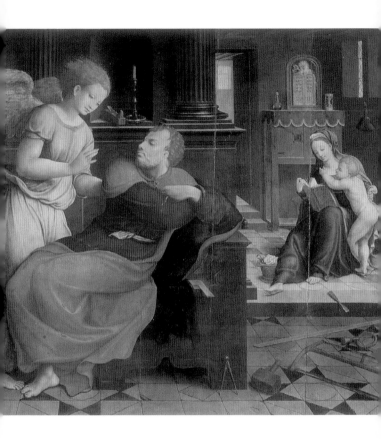

# Joseph's Dream

This is an unusually busy scene: Joseph is asleep in his workshop on a bench when suddenly an angel appears from behind, breaking through the wall and letting a glory of angels through. Next to Joseph, the Virgin rocks baby Jesus with two angels. In this painting by Michele Desubleo, though the iconography is traditional, the manner of presentation is more detailed and grandiose than similar scenes from the previous century. Here Joseph's dream is like an immense fresco in which angels come and go and Mary retires to a sweet family scene. The Virgin stops reading (a symbol of Wisdom) to gaze at the sweet blond head of Jesus. Next to the cradle, an angel is busy trying to get the Redeemer to fall asleep. The sky in the background and the clouds suggest that the dimension that Joseph is perceiving is a transcendental one that is not only very close to his fears and perplexity, but also signifies that he will be able to find a solution.

JOSEPH'S DREAM
Michele Desubleo
*c.* 1650
Chiesa del Paradisino, Modena

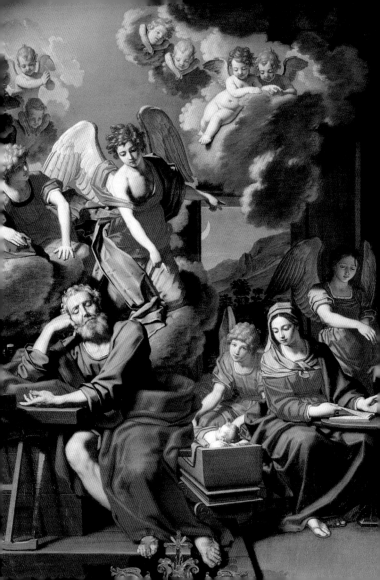

# Joseph's Dream

Scholars have extensively debated the meaning of this painting, because they are unable to fit it smoothly into the context of the iconography for the passage in Matthew (2:13) about Joseph's second dream of the flight with his family into Egypt. This scene refers to Joseph's dream before Jesus was born. Worried and full of concerns, Joseph has fallen asleep. An angel sent by God appears, reassuring him and confirming to him the goodness of his choice to take Mary as his bride. Thus we can explain the presence of the open book that alludes to the passage in Isaiah (7:14) quoted in the Gospel: "Behold, a virgin shall be with child, and shall bring forth a son, and they shall call his name Emmanuel, which being interpreted is, God with us." In this painting by Georges de La Tour, the figure of the angel plays a large narrative role. The masterfully measured light from the candle confers to the scene the quality of a superhuman apparition without forcing the overall naturalness of the lighting. In other words, the transcendental is merely one aspect of the natural. Thus the angel is Joseph's dream; he appears before Joseph and everything becomes clear. The angel's apparition, with the palm of his hand turned upward as if in a demonstrative gesture, explains everything to Joseph, and he thus comes to understand God's grand plan.

THE DREAM OF JOSEPH
Georges de La Tour
*c.* 1640
Musée des Beaux-Arts, Nantes

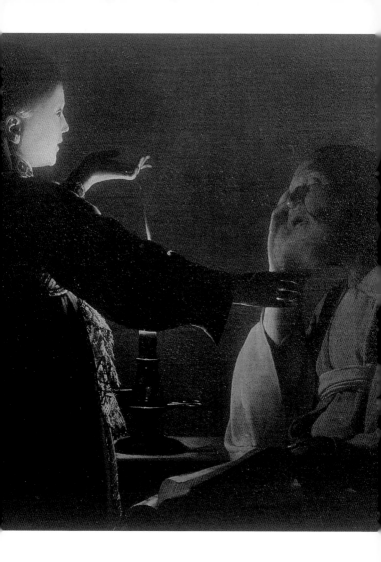

◄◄

# *Joseph's Dream*

The scene in this painting by Legnanino is simple and clear. Joseph has fallen asleep at his workbench; leaning on the wall, he supports his head with his folded hand, the other hand dropped on his knees. He is in a deep sleep when a classically drawn angel appears to him. The divine herald approaches, lips to Joseph's ear, moving as if to avoid being noticed. He counsels Joseph to marry Mary, to whom his gesture with the right arm seems to point, almost as if to say: "Marry the woman you are dreaming about, because you will then be part of God's plan for the redemption of humankind." The tender, nuanced colors offer a calm image that effectively renders Joseph's feelings after hearing the angel's comforting words. The presence of the large carpenter's saw in the foreground chases away any doubt as to the identification of this episode.

SAINT JOSEPH'S DREAM
Stefano Maria Legnani, known as Legnanino
1708
Museo Civico, Novara

454

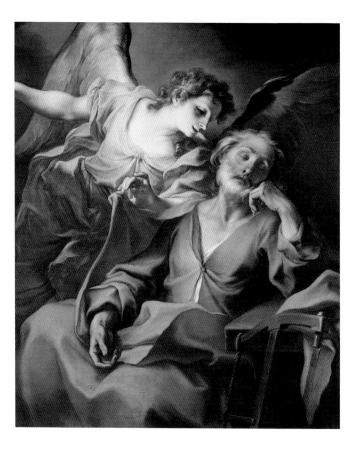

# *The Magi*

> Now when Jesus was born in Bethlehem of Judaea in the days of Herod the king, behold, there came wise men from the east to Jerusalem, Saying, Where is he that is born King of the Jews? for we have seen his star in the east, and are come to worship him. [. . .] And, lo, the star, which they saw in the east, went before them, till it came and stood over where the young child was. When they saw the star, they rejoiced with exceeding great joy. And when they were come into the house, they saw the young child with Mary his mother, and fell down, and worshipped him: and when they had opened their treasures, they presented unto him gifts; gold, and frankincense, and myrrh.

The sarcophagus of Boville Ernica offers one of the earliest, if not the first, image of the adoration of the Magi where the star is accompanied by the presence of the angel who represents it. Later tradition will consolidate both presences in the iconography with written passages that, still later, will become a solid belief, identifying the angel with the star. Thus this sarcophagus relief is a rare document of a tradition that at the time was still only oral. In this scene, Joseph acts as witness; he is seated behind the hut, while the angel is the bearded figure who appears before the Magi and the Child.

THE ADORATION OF THE MAGI
4th century
San Pietro Ispano,
Boville Ernica

# The Magi

The unusual nature of this fresco, in which lime was used, following the classical technique, is due to the presence of an angel with large outspread wings hovering over the group of the Madonna and Child with the adoring Magi. The presence of the divine messenger, dressed with the usual fluttering dalmatic and pallium, floating like a large bird in the air, evokes the tradition of the star-angel and the arguments about angelic nature as a "power." According to Christian exegesis, the Greek word *dynamis* (which means "power") refers to all the classes of angels. It is for this reason Saint John Chrysostom (347–407 CE), a Father of the Church, referred to the Magi star as a "most intelligent power" and an "invisible power." Behind the Virgin, almost lying down, is Joseph. The Magi are dressed in the Persian style.

THE ADORATION OF THE MAGI
7th–8th century

Santa Maria Foris Portas, Castelseprio

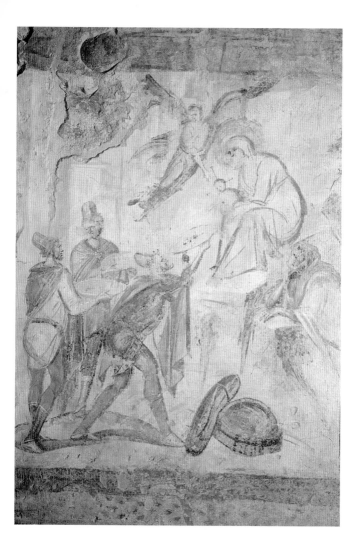

# *The Magi*

The slab on the right side of the Ratchis altar is dedicated to the Magi theme, in this case highly appropriate for illustrating the desire of Ratchis, a Longobard duke. The duke must have undoubtedly wanted to appear like the kings of the Gospel, in a double homage to Christ, whom he recognizes as the Savior and Son of God, while at the same time, he (and the Magi) are receiving from him a clear testimonial of nobility. Over the head of the three kings floats an angel occupying the scene's upper register. In this case also it is a star-angel, which therefore appears as a double-faced figure, meaning that the angel is seen as a star by the men who turn to look at the sky, but in fact his innermost nature is that of an angel, brighter than the sun. Scholars have tended to identify the figure behind Mary as Balaam. The rosettes in the backdrop are stars.

THE ADORATION OF THE MAGI
744–749
Museo Cristiano, Cividale del Friuli

# The Magi

This mural painting in the church of Toqali Kilisse shows, among other things, one of the Magi holding a large scroll whose writing has been almost erased by time. The differing attitudes of the three kings may be explained by the chronological succession of the episode pertaining to the search for the Child (as skillfully suggested by the inscriptions above the Magi), here illustrated in two distinct sequential moments. Hence, in the group before the Virgin, the king who is closest to Jesus bows his head in homage, having found him (and the Greek inscription underscores this with the word *proskynesis*, "adoration"). However, the Magi behind him are in the earlier temporal sequence, because they are still "scanning the skies" (*astrologoúntes*, as the inscription says). One of them holds a cross that recalls a deep-rooted tradition, according to which the Magi had left in search of Jesus based on the prediction of the prophet Balaam, who had said: "I shall see him, but not now: I shall behold him, but not nigh: there shall come a Star out of Jacob, and shall smite the corners of Moab, and destroy all the children of Sheth" (Numbers 24:17). These premonitory words about Jesus and the star were inscribed on the scroll, and it is the star prophesied by Balaam, in the form of an angel, that floats over the Virgin, Joseph, and the Child.

THE ADORATION OF THE MAGI
10th century
Rock Church of Toqali Kilisse,
Cappadocia (now in Turkey)

# The Magi

This miniature from Basil II's *Menologium* is an important document that proves how the tradition of the star-angel spread and was modified. A key contribution to this development was given by the great Byzantine poet and composer of religious hymns Romanos the Melodist, who lived in the sixth century under Emperor Justinian. In his *kontákion* (the name given to a short poetic composition written on a scroll and wound around a small stick) dedicated to the Nativity, the poet is extremely clear; he explains that, in reality, the star was an angel: "It is a star in appearance, it is a power by its intelligence, it came with the Magi to serve me, it stands still fulfilling its office showing with its rays the place were I was generated a just-born babe, God before the centuries." The verse "it is a power by its intelligence" means that the star is an angel, i.e., a heavenly intelligence, but also a source of light for those who can intelligently understand what they see. This hymn was later adapted for the theater where, in all likelihood, an actor dressed as an angel preceded the Magi in the procession that went to pay homage to Jesus, much in the way it is depicted in the miniature.

THE ADORATION OF THE MAGI
985
Biblioteca Apostolica Vaticana,
Vatican City

◄◄

# *The Magi*

►►

A small, but not to be dismissed, iconographic tradition adds to the Magi star mentioned by Matthew an angel, sometimes even replacing it. First identified by Origen, one of the great Christian theologians and philosophers, with a comet, several exegetes treated the star as an angel. Based on Platonic and Aristotelian texts, Origen considered the stars as animated, intelligent beings, whom he referred to as *empsychoús*, or "filled with soul." This philosophical premise is

necessary to understand why a century and a half later, in 397, the theologian John Chrysostom, in commenting on the passage from Matthew, wrote that the Magi saw the star turn into an angel before Christ: "No longer a star, an angel welcomes them." As a result of these reflections, we have the representation of the Magi train escorted by an angel who, in this case, is even preceded by a personified star, the rays evoking the wings of a seraph.

ADORATION OF THE MAGI
Giovanni Pisano
1297–1301
Sant'Andrea, Pistoia

INI DECOLLATON COMPDOIA ZCURS PRESENTIS SIB PRIMO MILLE TRECENTIS

◄◄ ◄ ─────────────────────────────

# *The Magi*

───────────────────────────── ►►

This diptych evenly divides the scene of the adoration of the Magi in half on each of the two doors. On the left are the three kings paying homage; on the right, the Virgin with Child surrounded by an array of angels. It is an unusual interpretation of the event, characterized by the presence of John the Baptist and the absence of gifts. In keeping with a tradition from the tenth century, the Magi were given the features of real kings; indeed, we see King Richard II of England (1377–99) as the young Magus next to the other Anglo-Saxon kings Edmund of East Anglia (*c.* 840–70) as the adult Magus and Edward the Confessor (*c.* 1004–66) as the elderly Magus, the latter of whom are both saints. The decision to be portrayed thus, as a clear allusion to the Gospel episode, reflects the genuine religious devotion of King Richard. On the opposite door, the Virgin enthroned in majesty holds the Child and is surrounded by angels (no longer star-angels) arrayed like court dignitaries, in a generally decorative intent devoid of metaphysical significance.

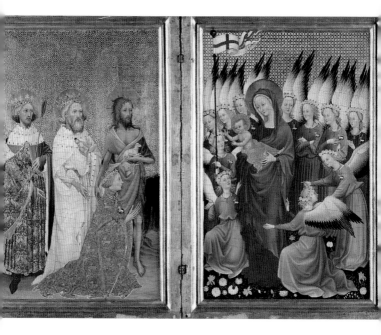

# The Magi

This fascinating and unusual image of the star-angel is not limited to Byzantine art. Images such as this lovely fifteenth-century French miniature from the Lyons Sainte-Chappelle Missal, made when the flowery Gothic style had become established, show that the idea of the star-angel accompanying the Magi had become quite popular. Even though the more common version has only the star, there are notable examples that feature the star-angel and form a solid chain that reached Europe and captivated miniaturists, sculptors, and painters. In this work, the miniaturist plays on the formal ambiguity that likens the typical stylization of the star to the representation of the four-winged cherub. Furthermore, this angel easily lends himself to represent the image of the shining star because he belongs to the highest hierarchy and, as such, receives light directly from God. The blue of the wings confirms that the star is a shining, resplendent cherub whose clear intellect reveals the truth of Christ.

ADORATION OF THE MAGI
15th century
Bibliothèque Municipale, Lyons

◄◄

# *The Magi*

The large number of angels in this lovely triptych by Andrea Mantegna was dictated by different super-imposing iconographic and textual traditions, primarily Byzantine, which preferred to arrange the angels on the eaves of the hut's roof, and a variant, linked to the *Zuqnin Chronicle* and the *Cave of Treasures* (sixth- and seventh-century, respectively) that instead suggested that the angels were placed at the cave entrance, as in this example. Mantegna adopted the idea of the star-angel, which had reached Renaissance Europe also through the philosopher Marsilio Ficino, who, adapting the philosophy of Saint Thomas Aquinas, in his *De stella magorum* [*About the Magi Star*] identified the shepherds' angel with the star of the Magi. In Ficino's words, "The angel of the Lord flooded the shepherds with light and announced his great joy to them [. . .]. Then the angel immediately moved eastward to Persia, whence he would lead the Magi toward Christ [. . .]. Therefore, as this comet was the same angel that had announced the great joy to the shepherds and since the Magi saw the path of the same star, they also rejoiced for this same great joy [. . .], just as the shepherds had rejoiced."

ADORATION OF THE MAGI
Andrea Mantegna
1462
Galleria degli Uffizi, Florence

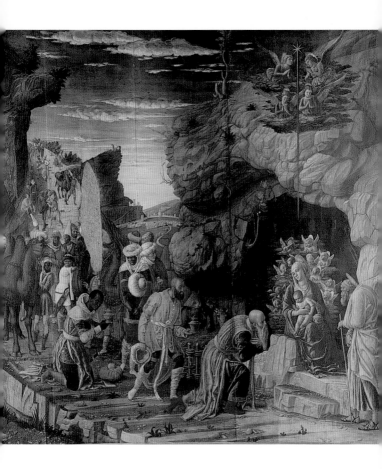

# The Dream of the Magi

> And being warned of God in a dream that they should not return to Herod, they departed into their own country another way.

The sculptor of this capital from Saint-Lazare's Cathedral has skillfully contained the entire scene in a very small space. The three kings are sleeping one next to the other, and an angel approaches to warn them. It is a strained interpretation of the Gospel, where the angel is not mentioned; however, if one believes that dreams are sent by God, one must conclude that an angel had warned the Magi. In this case, however, the angel has nothing in common with the comet that, in this capital, is positioned on the abacus molding like a decoration, facilitating our recognition of this scene. The severe, simplified style tends to take any detail, such as the blanket's folds, and transform it into an elegant and decorative motif.

THE MAGI'S DREAM
Gislebertus (attr.)
early 12th century
Musée Rolin, Autun

# Joseph's Dream

> The angel of the Lord appeareth to Joseph in a dream, saying, Arise, and take the young child and his mother, and flee into Egypt, and be thou there until I bring thee word: for Herod will seek the young child to destroy him.

This small ivory plaque in the Museum of Antiquities in Rouen captures the moment when the angel appears to Joseph. It is a conventional representation, since it is not easy for an artist to create a dreamlike atmosphere, especially when this work was carved. The dreamlike dimension is communicated by the position of the angel, behind the sleeping saint; it means that he is dreaming. According to some scholars, the scene refers to Joseph's first dream (Matthew 1:20), but the absence of any reference to Mary and the presence instead of the building in the background that could represent Bethlehem raise the likelihood that the reference is to the episode in the second chapter of the Gospel of Matthew. This theory is confirmed by the angel's imperious gesture: He stretches his hand to exhort Joseph, or as if to say: "Arise [. . .] and flee into Egypt." An order, rather than advice.

JOSEPH'S DREAM
Salerno manufactory
11th century
Museum of Antiquities, Rouen

# *Joseph's Dream*

The surroundings depicted in this mosaic, which decorates the cupola of the Florence Baptistery, are naturalistic. Joseph is sleeping on bare rock, rendered in accordance with a stylization, by then codified, of Byzantine and Russian derivation. In the background, stylized plants soften the landscape. The angel is flying excitedly toward Joseph, holding a scroll on which God's command to flee into Egypt is inscribed. The angel's elegant figure and the moving fabric of his tunic contribute to convey the impression of his glide. However, in this case as well, the angel is neither flying nor gliding; his presence is merely the outward projection (thus helping the faithful to understand) of Joseph's dream as the latter quietly continues to sleep.

JOSEPH'S DREAM
(detail)
13th–14th century
Baptistery, Florence

◄◄

# *Joseph's Dream*

►►

The composition of this painting by Rembrandt is highly original. The atmosphere is warm and intimate, like a poor man's hut filled with love. The Virgin and Child sleep leaning on a mound of straw, the most comfortable place. Jesus, all bundled up, is laid gently on top of the straw. Joseph sits on the floor next to his family, with a walking stick between his legs like someone who knows that he must leave momentarily. The angel has just alit from an opening that formed in the roof; he approaches Joseph as if to awaken him. The angel seems to shine of his own light, immersed as he is in the whiteness of his garment, but we know that his beauty comes only from God. But how can we be sure that Rembrandt was thinking about this specific episode, and that the Virgin is not an apparition, a dream, as in so many previous examples? The accurate composition of the Dutch master averts this risk by placing Mary and Jesus in the foreground, not behind Joseph, as in other works, and illuminating them with the same light of the angel. Mary and Jesus are as real as Joseph, and the angel here has really appeared, even though Joseph will remember him only as a dream.

JOSEPH'S DREAM
Rembrandt von Rijn
1645
Gemäldegalerie,
Staatliches Museen, Berlin

◄◄

# *Joseph's Dream*

The composition in this painting by Goya is agitated; the stormy light conveys Joseph's worries, for indeed Jesus' putative father has sunk, all curled up, into a restless sleep, in his dark workshop. The angel appears suddenly, as shown by the long, curved line of the shoulder, arm, and hand. He places a hand on Joseph's shoulder to awaken him and call his attention to the fact that he must leave, for that place has become dangerous to him and his family. Mary is in the background with the barely visible Jesus; seated on the floor, she is the Madonna of humility. The painter intelligently exploits Mary's absence/presence, which complements Joseph's dream state. Note in the foreground at bottom right the walking stick, and behind Joseph the stylobate of a temple column.

SAINT JOSEPH'S DREAM
Francisco Goya
1771
Museo de Bellas Artes, Zaragoza

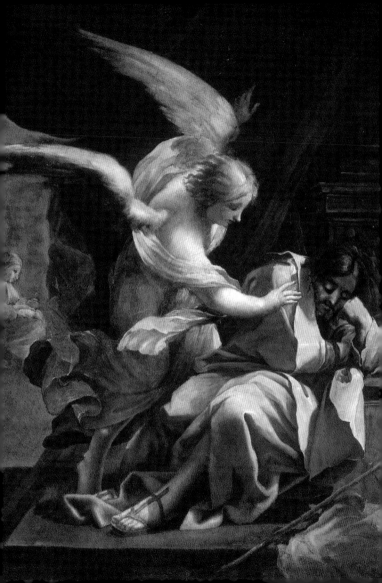

# The Flight into Egypt

> When [Joseph] arose, he took the young child and his mother by night, and departed into Egypt: And was there until the death of Herod: that it might be fulfilled which was spoken of the Lord by the prophet, saying, Out of Egypt have I called my son.

The text reported by Matthew is from the prophet Hosea (11:1) who was referring to the return of the Israelites from Egypt; here, however, it is used auspiciously for Christ. Some consider it a forced comparison, but the profound meaning is that the body of Christ and that of the tribes of Israel are one and the same. The scene imagined by Giotto, however, not only takes Matthew's text into account, but is also inspired by the apocryphal Gospels, as shown by the presence of the angel guiding the small group. Indeed, in Matthew there is no mention of angels (although it might be a logical development of Joseph's dream), while the apocryphal Gospels often tended to emphasize the evangelical episodes to stress even more the divinity of the Child. Thus, for example, they spoke of plants that bowed in homage to the Holy Family passing by and clouds of angels who sang God's praise.

NO. 20 SCENES FROM THE LIFE OF CHRIST:
4. FLIGHT INTO EGYPT
Giotto di Bondone, known as Giotto
1304–1306
Cappella degli Scrovegni, Padua

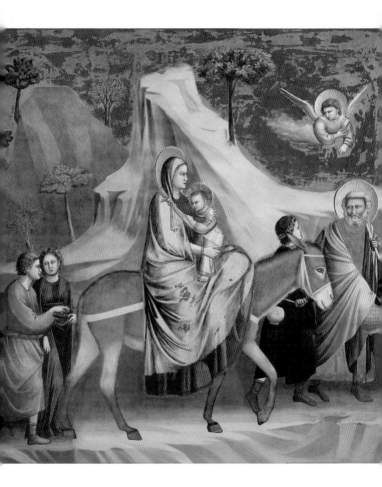

# The Flight into Egypt

If there is a depiction of the rest during the flight into Egypt that everyone knows, it is this one by Caravaggio, created the day after the opening of the tomb of Saint Cecilia, patroness of music, whose body was found in a perfect state of preservation (the sculptor Carlo Maderno later translated the saint's body to marble with exceptional synthetic virtuosity). The focus of this canvas, which evokes the saint, is music, worthily represented by the angel playing the violin. The choice of this instrument, one that may seem obvious today, was at the time a gauge of a painter's skill also with reference to the world of sound: The violin had only recently replaced the *viola da braccio*. Not only that, but the angel of God is playing from a real musical composition. Indeed, on the score that Joseph is holding like a lectern are the notes of a lullaby by the Flemish composer Noel Bauldeweyn: music perfectly attuned to the circumstance. Thus, the profound meaning of this moment, a tender human touch underscored by the angel's wings that resemble a nightingale's, lies in the achieved harmony between the human and the divine.

REST ON THE FLIGHT INTO EGYPT
Michelangelo Merisi da Caravaggio
1596–97
Galleria Doria Pamphili, Rome

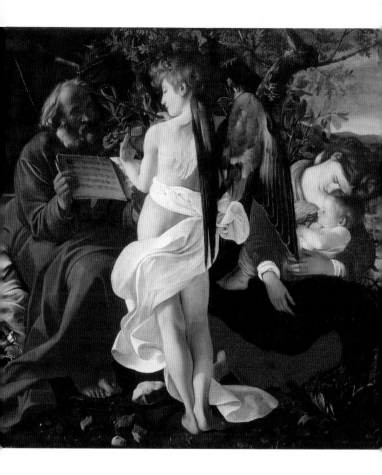

# The Flight into Egypt

Completed at the turn of the century, Reni's *Rest During the Flight into Egypt* takes on an immediate symbolic connotation because of the visible presence of the temple. Considered as a Christian element, it suggests that the Holy Family is the very foundation of the Church; considered in a pagan context, it suggests that the Holy Family rebuilds the very idea of religion. In both cases, Christian faith finds in this image a poster for its own reason for being. The angel's role, as in Caravaggio's painting (see pages 486–87), is that of the servant, but also a presence that qualifies the event as prodigious, in the best apocryphal tradition. The fact that the angel is offering fruit to Mary who accepts, suggests that divine Providence abandons no one. In the foreground is Joseph, leaning on the travel sack; Jesus' putative father is lost in contemplation while John the Baptist stands nearby.

REST DURING THE FLIGHT INTO EGYPT
Guido Reni
1599–1600
Combs Collection, London

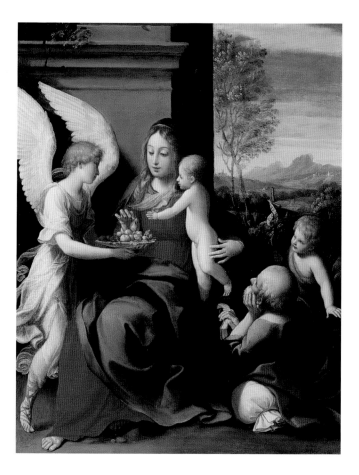

# The Flight into Egypt

The scene imagined by this artist totally renews the classical iconography of the flight into Egypt with the donkey, Joseph, and, sometimes, the angel. Here, the artist must have drawn inspiration from his life near the Po River, probably taking as a model the wide barges that ferried passengers across. However, it is not an entirely fanciful idea, because one could also reach Egypt from Bethlehem by sea. For this reason, the boat has a sail, even if the boatman's movement is the typical one of pushing a barge down a river with the long oar used for river or lake boats. In all this, we should not forget the angel's role; he symbolically stands near the mainmast and the sail, watching over the boat and holding up the mainmast. He also ensures that the wind that fills the sail is blowing.

THE FLIGHT INTO EGYPT
Ludovico Carracci (attr.)
1600
Private collection

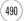

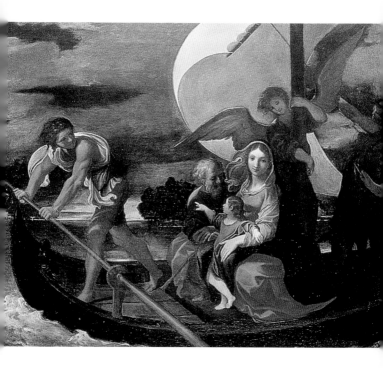

# The Flight into Egypt

This is a complex scene, almost a stage setting: The large ruined building in the background must be interpreted as the pagan temple destroyed and refounded by rising Christendom. Mary is seated in the foreground (the Madonna of Humility); she lovingly holds the Child in her lap and, like every mother, worries about his well-being. Joseph is seated nearby, attentive to the needs of his loved ones. This is the human element. The divine is represented by the angels everywhere, animating the landscape, almost like *genii loci* paying homage to the infant Jesus; still, from a narrative point of view they underscore the prodigious quality of this scene. Far away, we intuit the tragedy of the slaughter of the innocents, which contrasts with the idyllic scene in the foreground. But the angels are also in the background; flying amid the clouds, they watch horrified the crowd of power-hungry men who trample on all feelings and insult newborn life.

REST DURING THE FLIGHT INTO EGYPT
AND THE SLAUGHTER OF THE INNOCENTS
Luigi Miradori, known as il Genovesino
17th century
Sant'Imerio, Cremona

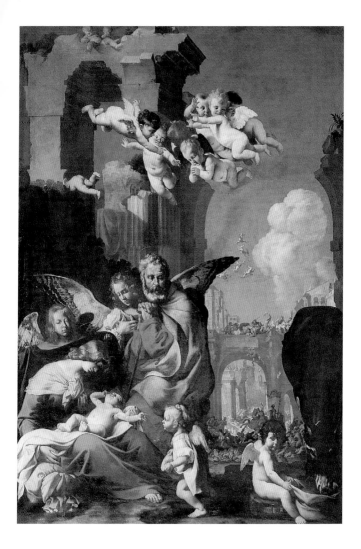

# The Flight into Egypt

After finishing his studies at the Accademia degli Incamminati, founded and directed by the Carraccis, Mastelletta created this grandiose scene where the Holy Family moves in a lush, natural landscape that is itself prodigious, highlighted by the presence of the angels descending from heaven and escorting on foot the three protagonists. Mary and the Child ride the donkey while Joseph, on foot, clears the way. All of nature celebrates the passage of the Child Savior, Joseph, and Mary, and the colors confirm this. The sky sheds its clouds, perhaps an allusion to the escaped danger and an omen for Jesus of calm and joy in Mary's arms and under Joseph's loving, paternal protection. The majestic, triumphant angels line the way. Above, a flying group of three angels follows and shields the Holy Family; two more escort them on foot.

THE FLIGHT INTO EGYPT
Giovanni Andrea Donducci,
known as Mastelletta
1616–1620
Santa Maria della Pietà
o dei Mendicanti, Bologna

◀◀

# The Flight into Egypt

The great French painter François Boucher, a leading exponent of Rococo, arranged this scene like a theatrical setting. The elements are all here; the theater wing is formed by the curtain and the palm tree on the right, the backdrop has the landscape, and in the foreground are the leading characters—Mary is absorbed in reading, Joseph turns around as if asking himself whether it will rain, or else he is puzzled at the small creatures that fly low in the sky. But what could be little more than a common scene is enriched by specific meanings linked to the Wisdom symbolism that seems to pervade this canvas: Mary's reading evokes the symbolism of the Virgin as the seat of divine Wisdom; next to her is the Lamb, a representation of Christ; and in the foreground at the center, little Jesus plays with another child—John the Baptist. Behind them is an upturned column, which is a symbol of Mary and the temple of Solomon, the latter also linked to Wisdom. Joseph sits on a squared-off stone, emblem of Wisdom and solidity. Finally, cherubim fly in and out of the low-lying clouds with their little winged heads; if on one hand they mark the transcendental and extraordinary nature of the event, on the other, as "clear intelligences," they are part of the symbolism of Wisdom.

THE REST ON THE FLIGHT INTO EGYPT
François Boucher
1737
The Hermitage, Saint Petersburg

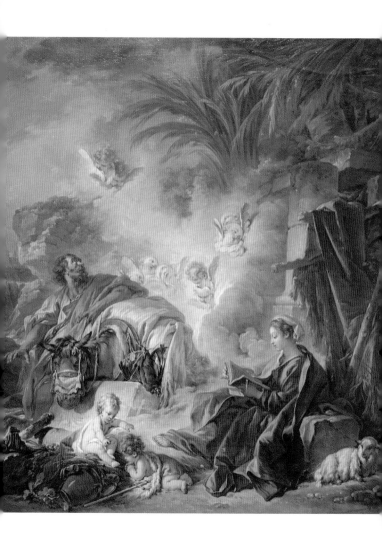

# *The Slaughter of the Innocents*

> Then Herod, when he saw that he was mocked of the wise men, was exceeding wroth, and sent forth, and slew all the children that were in Bethlehem, and in all the coasts thereof, from two years old and under, according to the time which he had diligently enquired of the wise men.

This canvas, commissioned for the Berò Chapel in the Church of San Domenico in Bologna, is one of Guido Reni's masterpieces. He created it upon his return to Bologna from Rome, and it is a cornerstone of the new Baroque style founded by the Bolognese master, where the classical elements are clearer than ever, as is its power of moving the faithful. The presence of the cherubim, palm fronds in their hands, compares the children slaughtered by Herod's blind wickedness to Christian martyrs who will soon enter heaven in the glory of the Father. For this reason, Guido Reni stresses the contrast between the hectic shouting of the human scene, where calls and cries mix with the tangled mass of bodies, against the unreal calm of the divine plane; here the cherubim, who intentionally have the same features as the slain children, as if in a mirror, look with pity on their human "brothers," who will soon join them in heaven—unknowing martyrs for the love of Jesus.

MASSACRE OF THE INNOCENTS
Guido Reni
1611
Pinacoteca Nazionale, Bologna

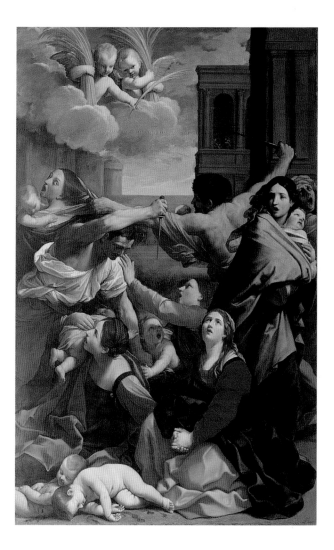

# The Baptism of Jesus

> And Jesus, when he was baptized, went up straightway out of the water: and, lo, the heavens were opened unto him, and he saw the Spirit of God descending like a dove, and lighting upon him: And lo a voice from heaven, saying, This is my beloved Son, in whom I am well pleased.

This panel by Piero della Francesca, now held in the National Gallery in London, was originally part of a triptych of Matteo di Giovanni in Sansepolcro, Florence. Its direct reference is the above text from Matthew; the crystal-clear sky, with the dove in the center, has all the evocative power of the Gospel verse. The presence of the angels, although derived from the apocryphal tradition in which they take Christ's garments, takes on a deeper meaning in this painting: They suggest the angels that appeared to Abraham under the oak trees in the plain of Mamre (Genesis 18:2), which the exegetes consider an Old Testament pre-figuration of Christian Trinity. In this case, the angel on the left is the Father, the one in the center the Holy Spirit, and the one on the right the Son. Indeed, one baptizes in the name of the Father, the Son, and the Holy Spirit—that is, in the name of the most holy Trinity, which is the kernel of the sacrament of baptism.

BAPTISM OF CHRIST
Piero della Francesca
*c.* 1450
National Gallery, London

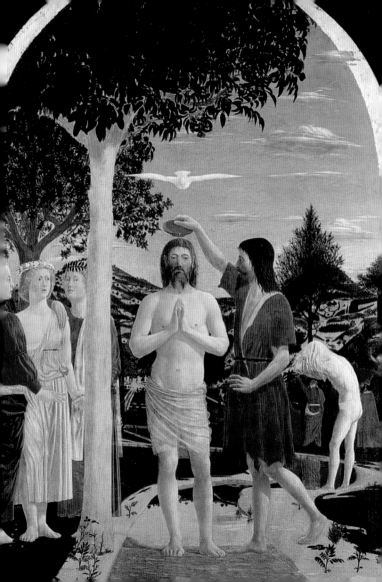

# *The Baptism of Jesus*

This painting, created by Verrocchio with the assistance of the young Leonardo (he painted the head of the angel in the foreground) when he was still apprenticing in Verrocchio's shop, was inspired by the above passage from Matthew. The presence of the angels, however, is only linked to their role as "servants" who hold the garments of Christ, who had disrobed himself in order to be baptized. The ancient ritual called for almost-total immersion in water, and Jesus immersed himself naked in the River Jordan. The legend says that angels appeared, offering to hold his garments. There is no other meaning implied in the two angelic figures, and certainly no hint of the Trinity, but the latter is clearly visible in the vertical axis at the center of the panel, starting from the bottom, with Christ, the dove of the Holy Spirit, and the hands of the Father.

THE BAPTISM OF CHRIST
Andrea del Verrocchio and Leonardo da Vinci
1472–75
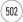
Galleria degli Uffizi, Florence

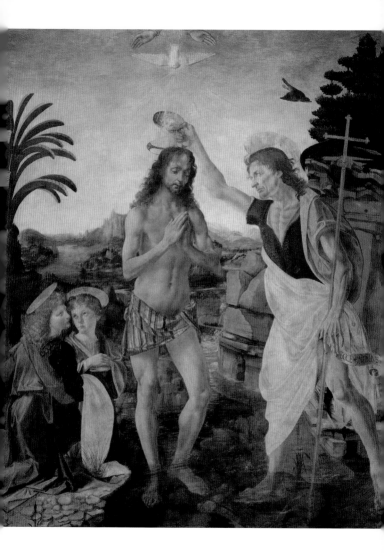

# Jesus Is Tempted by the Devil

> Then was Jesus led up of the Spirit into the wilderness to be tempted of the devil. And when he had fasted forty days and forty nights, he was afterward an hungred. [. . .] Again, the devil taketh him up into an exceeding high mountain, and sheweth him all the kingdoms of the world, and the glory of them; And saith unto him, All these things will I give thee, if thou wilt fall down and worship me. Then saith Jesus unto him, Get thee hence, Satan: for it is written, Thou shalt worship the Lord thy God, and him only shalt thou serve. Then the devil leaveth him, and, behold, angels came and ministered unto him.

This is the passage where Duccio di Buoninsegna found inspiration to create the *Majesty* panel, of which this is the predella. In fact, the cities are easily identifiable as the kingdoms of the world, and the angels are the divine envoys who came and ministered to the Lord after he had driven away the devil. Earlier, the tempter had provoked the Son of God in other ways; for example, he had asked him to turn stones into bread to prove his divinity, and Jesus had replied: "It is written, Man shall not live by bread alone, but by every word that proceedeth out of the mouth of God." Then the devil had asked him to cast himself from a pinnacle of the temple so that the angels could catch him, but Jesus had replied, "Thou shalt not tempt the Lord thy God."

TEMPTATION ON THE MOUNT
Duccio di Buoninsegna
1308–11
Frick Collection, New York

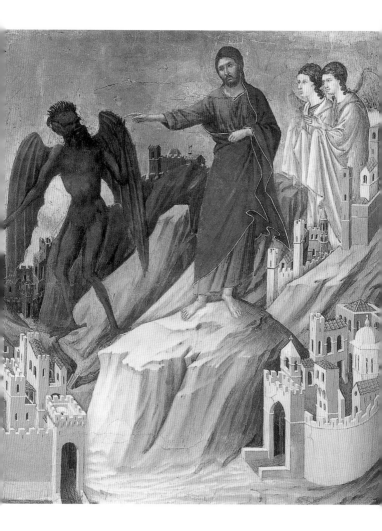

# Multiplication of the Loaves and the Fishes

> And he commanded the multitude to sit down on the grass, and took the five loaves, and the two fishes, and looking up to heaven, he blessed, and brake, and gave the loaves to his disciples, and the disciples to the multitude. And they did all eat, and were filled: and they took up of the fragments that remained twelve baskets full. And they that had eaten were about five thousand men, beside women and children.

This is a rare instance in which the angels appear in the episode of the multiplication of the loaves and the fishes. Not just any angels, they are here an iconographic metaphor for the Trinity. The evangelical exegesis sees in this episode an anticipation of the Eucharist and the Eucharistic assembly, where Jesus breaks the bread—which is his own body—and divides it among the apostles. Somehow, he multiplies it so as to appease everyone's hungering soul. For believers, the phenomenon of transubstantiation occurs when the bread becomes the Eucharist, and hereby the bread and the wine are truly transformed into the body and blood of Christ (Lateran IV). This means that in the Eucharist is the full essence of Christ, who is also the Father and the Holy Spirit—the Trinity, here evoked by the three child angels.

MULTIPLICATION OF THE LOAVES
AND THE FISHES
Guglielmo Caccia, known as il Moncalvo
late 16th century
Padri Domenicani, Chieri

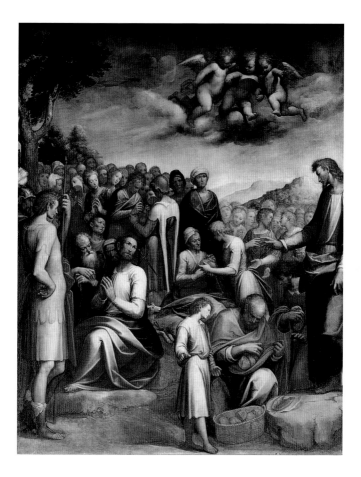

# *The Guardian Angel*

> Take heed that ye despise not one of these little ones; for I say unto you, That in heaven their angels do always behold the face of my Father which is in heaven.

This important passage from Matthew contributed to shaping Christian conception and image of the guardian angel, which is unique and finds no correspondence or equivalent with the many conceptions of intermediary or guardian beings of other religions. The idea of a protection coming from the beyond is common to humankind, and this task is often assigned to the souls of the dead, such as, for example, the ancient Roman Penates, who watched over the household. But this passage from Matthew moves the view to a sort of correspondence between the heavenly and the earthly world, where children have a priority relationship with God. However, the guardian angel also has the function of protecting, of being a bulwark, a shield for the soul against evil, and this is the meaning aptly expressed by this painting of Domenichino. The crouching devil in the bottom right of the canvas is trying to ensnare the little protagonist, contending between good and evil. But the devil with the pitchfork has no power before the angel's shield, for the strength of the child's defense comes from God, to whom the angel points with his hand.

GUARDIAN ANGEL
Domenico Zampieri, known as Domenichino
1615
Museo di Capodimonte, Naples

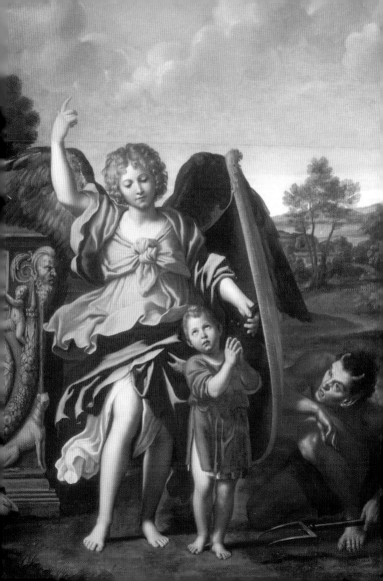

◀◀◀

# *The Guardian Angel*

This celebrated canvas by Guercino, which became famous through the verses of English literati and poets such as Robert Browning, was commissioned by a notable Fano family, the Nolfi, around 1641. The work seems to have been inspired directly by the passage in Matthew, first because a child is protected, and also because the cherubs floating in the air—angels who have the privilege of being near the face of God—resemble the child in the center. To the figure of the divine messenger, inspired by the classical Cinquecento models, the painter added more plasticity and flavor with fabrics such as satin and velvet. In spite of the apparently simple, pleasant composition, this painting also includes symbolic references such as the cube made of stone, which stands for solidity and safety, the divine messenger's role. Particular attention should be paid to the gesture that the guardian angel is coaxing his protégé to make: joining the hands. It is an invitation to prayer, the sole weapon that can defeat evil, and a "direct line" to God and his angels.

THE GUARDIAN ANGEL
Giovanni Francesco Barbieri,
known as Guercino
1642
Pinacoteca Malatestiana, Fano

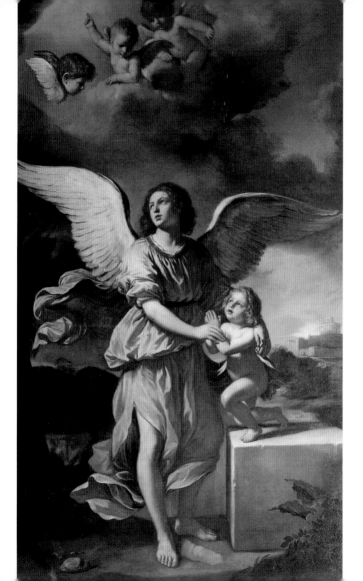

# The Last Judgment: Trumpet-Playing Angels

> Immediately after the tribulation of those days shall the sun be darkened, and the moon shall not give her light, and the stars shall fall from heaven, and the powers of the heavens shall be shaken: And then shall appear the sign of the Son of man in heaven: and then shall all the tribes of the earth mourn, and they shall see the Son of man coming in the clouds of heaven with power and great glory. And he shall send his angels with a great sound of a trumpet, and they shall gather together his elect from the four winds, from one end of heaven to the other.

This passage from the Gospel of Matthew takes into account a number of passages from the Old Testament, from Isaiah (13:10), Jeremiah (4:23–26), and Ezekiel (22:3–4), that will eventually flow into John's apocalyptic narrative. The latter will have more iconographic success; still, the roots of the Last Judgment images are to be found in this Gospel passage. The relief above the portal of the Ferrara cathedral, probably carved by craftsmen from north of the Alps, reflects this text and places the two trumpet-playing angels mentioned by Matthew underneath the tympanum at the same level as Christ in the mandorla.

THE LAST JUDGMENT
1427
Cathedral, Ferrara

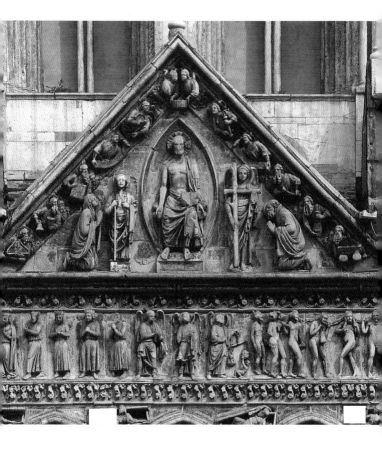

◄◄

# The Last Judgment:
# Trumpet-Playing Angels

This celebrated group of angels blowing on their trumpets in Michelangelo's *Last Judgment* was the subject of some criticism. Already, in his *Dialogue* of 1654, Don Giovanni Andrea Gilio had objected because the master had not represented the angels with wings. This author, a clergyman of the Counter-Reformation, saw in this anomaly the risk that the faithful might confuse the angels with demons. Actually, this is what Michelangelo was hoping for, as recent studies have established that most likely one of the literary sources for the Sistine Chapel fresco was *De judicium Dei* [*God's Judgment*] published in 1505 by Giovanni Sulpizio, a well-known rhetorician and grammarian and the Latin teacher of Pope Paul III, who was the second pope to commission the fresco. The book by Sulpizio contains a definition of angels and demons as *uterque genius*—that is, in the same class as the ancient Roman *daemones*. With this attribution, Sulpizio was reverting to the theology of Saint Augustine, according to whom there was no difference in the role of the angels, who could be either good or evil (see pages 516–17). Michelangelo rendered this theological concept by omitting wings for both angels and demons. As in the poetic vision of Sulpizio (as well as Pico della Mirandola and a good number of the Renaissance Neoplatonists), men were halfway between angels and demons and had the faculty of choosing whether to become one or the other.

THE LAST JUDGMENT
(detail)
Michelangelo Buonarroti
1534–41
Sistine Chapel, Vatican Palace, Vatican City

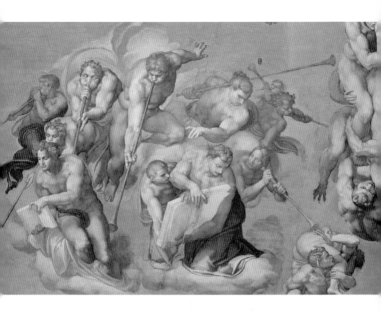

# The Lord Separates the Sheep from the Goats

> When the Son of man shall come in his glory, and all the holy angels with him, then shall he sit upon the throne of his glory: And before him shall be gathered all nations: and he shall separate them one from another, as a shepherd divideth his sheep from the goats: And he shall set the sheep on his right hand, but the goats on the left.

This Ravenna mosaic, illustrating the above passage from Matthew, is highly educational, for it clarifies how the nature and function of the angel was conceived at the time, a conception derived from the teachings of Saint Augustine: "The name angel pertains to the office, not to the nature [of the divine envoy]." Since their looks are identical, only the correspondence of the sheep and the goats allows us to understand who is the angel and who is the devil. The only distinction is the color: The red figure is the angel, because red is the subtle fire of the empyrean and of divine light, while the blue figure is the devil, because blue is the color of wind and air, which is considered a substance continuous with light. The bluer and darker the air, the less light it lets through; the thinner and clearer the air, the more light it filters through to transform it first into fire, then into light, and finally into ether. In this logic of the elements, derived from the cosmology of Stoic philosophers, angels and demons found their places as, respectively, beings of light and dark air. Below them were humans, who are beings of earth.

JESUS SEPARATES THE SHEEP
FROM THE GOATS
6th century
Sant'Apollinare Nuovo, Ravenna

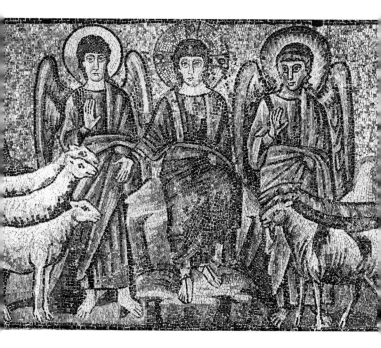

# *The Last Supper*

66 Now when the even was come, [Jesus] sat down with the twelve. And as they did eat, he said, Verily I say unto you, that one of you shall betray me. And they were exceeding sorrowful, and began every one of them to say unto him, Lord, is it I? [. . .] And as they were eating, Jesus took bread, and blessed it, and brake it, and gave it to the disciples, and said, Take, eat; this is my body. 99

The scene illustrated in this painting by Tintoretto refers to two Gospel passages: In the first, everyone starts asking who will betray Jesus; in the other, Christ breaks the bread and offers it to the twelve apostles. However, the artist was not satisfied with simply depicting a dinner, even an exceptional one. To confer to the event its rightfully prodigious dimension, the Venetian artist surrounded the heads of all the apostles (except for Judas, who is sitting at an outside corner of the table) with a luminous aura, and Christ's own head shines like a sun. But the novelty lies in the impalpable presence of the angels who appear made of the same flame burning in the oil lamp: It is no longer a lamp, but the light of faith spreading into the world.

THE LAST SUPPER
Jacopo Robusti, known as Tintoretto
1592–94
San Giorgio Maggiore, Venice

# Jesus Prays in the Garden of Gethsemane

> And [Jesus] went a little further, and fell on his face, and prayed, saying, O my Father, if it be possible, let this cup pass from me: nevertheless not as I will, but as thou wilt.

This lovely panel by Mantegna illustrates the above passage from Matthew, with some additions and amplifications that belong to the iconographic tradition and others attributable to the sensitivity and culture of this great artist. To the first belong the angels; although they are never mentioned in the text, they are always part of any work of art offering to Christ (and this is an interpretation of Mantegna) not the cup, but its figured translation—that is, the tools of his martyrdom (the cross). To the second belongs the silhouette of the city of Jerusalem, from whence a squad of soldiers advances, led by the betraying apostle. Thus Mantegna painted the capital of the Kingdom of Judah like Rome, a clear reference to the heavenly Jerusalem.

AGONY IN THE GARDEN
Andrea Mantegna
*c.* 1460
National Gallery, London

◄◄ ─────────────────────────────────────────

# *Jesus Prays in the Garden of Gethsemane*

───────────────────────────────────────── ►►

In *Agony in the Garden* by Botticelli, the two principal figures are painted in profile, as if in an icon, and stand out starkly against the background, almost creating a teaching diagram in which all the elements are arranged for the visual reader's maximum benefit. At the bottom of the painting are the sleeping apostles Peter, James, and John, symbolizing the weakness of humankind, easily tempted by sin and its own frailty. For this reason, Botticelli has chosen a foreshortened perspective: While Christ, seen in profile, is the certain and the eternal, the apostles are the ephemeral, the contingent. Between them and Christ is, literally, a fence—the garden fence that stands for man's inability to fully understand God's message. High above them, as if on an altar, Christ is lost in prayer, a silent dialogue with the angel who offers Jesus the cup that he would like to push away, the symbol of the future Eucharist, which is the only path of salvation for humanity. For the plan of redemption to be accomplished, Jesus offers himself and drinks to the end the cup that will become the nectar of eternal life for the human race.

AGONY IN THE GARDEN
Alessandro di Mariano Filipepi, known as Sandro Botticelli
1499
De los Reyes Chapel, Granada

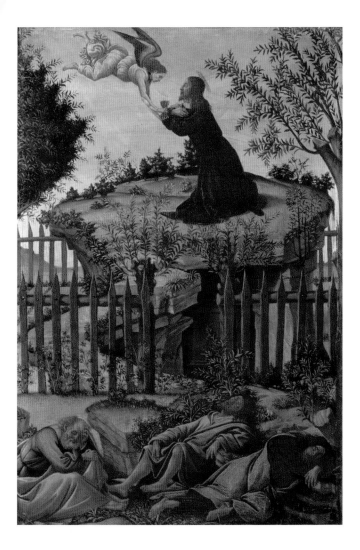

# Jesus Prays in the Garden of Gethsemane

This painting seems to show traces of Mantegna's and Bellini's compositions; in the foreground are the sleeping apostles, proof of the smallness of the human spirit. On the embankment, the kneeling Jesus is on higher ground, both physically and morally. His attitude is one of concentration, of someone who is aware of the drama that is unfolding but unaware of his surroundings.

He is only interested in the cup, which an angel who has come down at breakneck speed seems to offer to him with such persistence. This is the only prodigious note in a scene that would otherwise just portray a man praying. In the background, a bleak, harsh landscape dotted with turreted cities and buildings hints at the suffering that Christ is about to endure.

THE PRAYER IN THE GARDEN OF GETHSEMANE
Veronese school
16th century

Pinacoteca dell'Accademia dei Concordi, Rovigo

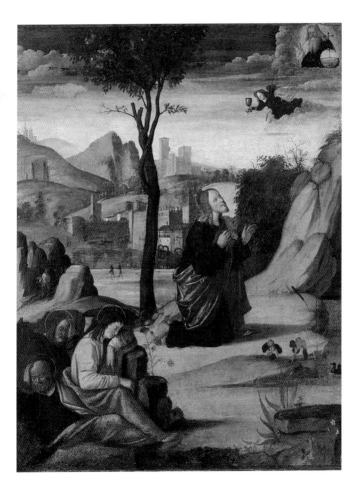

# *Jesus Prays in the Garden of Gethsemane*

The stagelike setting of this canvas by Sebastiano Conca shows traces of the grand theatrical elements typical of Baroque art. In particular, the angels play an important role in this painting: Next to the divine herald, who offers the cup to Christ in the manner of the traditional image, is a cloud of cherubim as soft as the large, solid cloud on which they lean. To this tragic moment, the cherubim add a touch of joy and triumph that illuminates Christ, who is fulfilling his plan of salvation. Above all, this light reflects on men, the poor creatures who will benefit from God's immense love. Christ's gesture is a consenting embrace of the inevitable moment, not a sign of surrender; his open arms are the gesture of someone who embraces a beloved creature, even at the cost of his own total sacrifice.

CHRIST IN THE GARDEN OF GETHSEMANE
Sebastiano Conca
18th century
Musei Vaticani, Vatican City

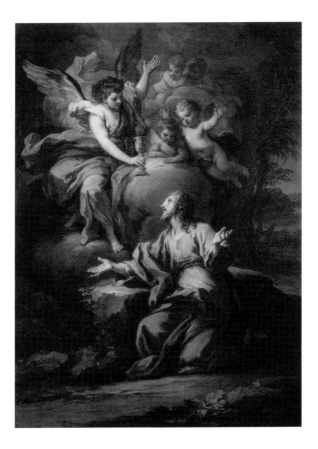

# *The Crucifixion*

> And they crucified him, and parted his garments, casting lots
> [. . .] And sitting down they watched him there; And set up
> over his head his accusation written, THIS IS JESUS THE
> KING OF THE JEWS. Then were there two thieves crucified
> with him, one on the right hand, and another on the left.
> [. . .] And about the ninth hour Jesus cried with a loud voice,
> saying, Eli, Eli, lama sabachthani? that is to say, My God, my
> God, why hast thou forsaken me? [. . .] Jesus, when he had
> cried again with a loud voice, yielded up the ghost.

This cross, which was originally kept in the church of Santa Maria degli Angeli in Lucca, is the earliest cross painted by Berlinghieri, a Tuscan master and founder of a family of painters who were active at the end of the thirteenth century. The unusual quality of this work resides not only in the presence of Mary and John on the two central panels and the Evangelists at the tips of the arms of the cross, but also the rare scene of the assumption of the Virgin, here supported by two angels, as if to signify that Mother and Son would meet again in heaven.

CRUCIFIX
Berlinghiero Berlinghieri
early 13th century
Museo Nazionale di Villa Guinigi, Lucca

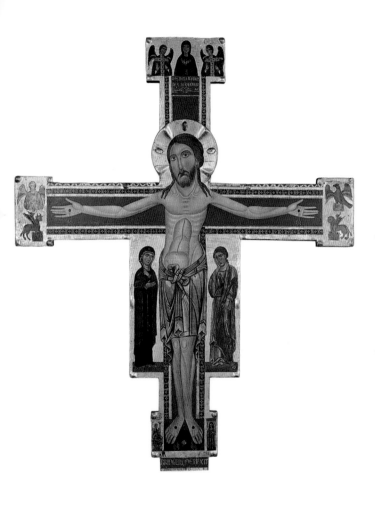

# The Deposition

“When the even was come, there came a rich man of Arimathaea, named Joseph, who also himself was Jesus' disciple: he went to Pilate, and begged the body of Jesus. Then Pilate commanded the body to be delivered.”

This splendid miniature from the *Heures de Rohan* [*Hours of Rohan*] may be seen as a reinterpretation and at the same time a symbolic synthesis of the deposition of Christ, for Joseph of Arimathaea does not even appear here. The protagonists are the martyred body of Jesus, heartrending to look upon, and Mary's immense suffering as she desperately tries to embrace him one last time and is held back by John,

"the disciple whom he loved," as the same Evangelist wrote when Jesus entrusted her to him (John 19:26–27). On the right is the Father; moved by pity, he blesses the scene, his figure supported by a choir of angels, who blend and become one with the sky. This is one of the clearest images illustrating how the angels were considered spiritual beings made of air, whose bodies become one with the stars and the darkness of the sky.

THE DEPOSITION
*c.* 1420–27
Bibliothèque Nationale de France, Paris

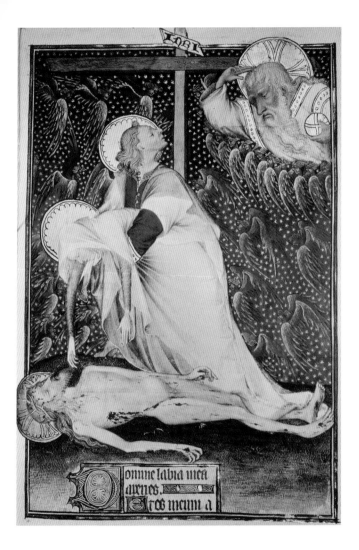

# The Angel Outside the Tomb

> In the end of the sabbath, as it began to dawn toward the first day of the week, came Mary Magdalene and the other Mary to see the sepulchre. And, behold, there was a great earthquake: for the angel of the Lord descended from heaven, and came and rolled back the stone from the door, and sat upon it. His countenance was like lightning, and his raiment white as snow: And for fear of him the keepers did shake, and became as dead men. And the angel answered and said unto the women, Fear not ye: for I know that ye seek Jesus, which was crucified. He is not here: for he is risen, as he said. Come, see the place where the Lord lay. And go quickly, and tell his disciples that he is risen from the dead; and, behold, he goeth before you into Galilee; there shall ye see him: lo, I have told you.

This Giotto fresco blends into one scene different episodes that all converge on the angel as the compositional focus. The Tuscan artist not only depicted the episode of the Resurrection with the sleeping soldiers, but also the scene where

Christ meets Mary Magdalene, who wants to embrace him, and he replies, *"Noli me tangere"* (Latin for "Do not touch me"). Giotto further strains his interpretation by painting two angels seated on the now empty tomb.

NOLI ME TANGERE
Giotto di Bondone, known as Giotto
*c.* 1309
Cappella degli Scrovegni, Padua

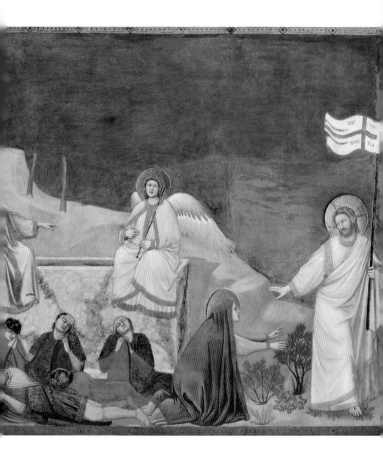

# *The Baptism of Jesus*

> And there went out unto [John] all the land of Judaea, and they of Jerusalem, and were all baptized of him in the river of Jordan, confessing their sins. [. . .] And it came to pass in those days, that Jesus came from Nazareth of Galilee, and was baptized of John in Jordan. And straightway coming up out of the water, he saw the heavens opened, and the Spirit like a dove descending upon him: And there came a voice from heaven, saying, Thou art my beloved Son, in whom I am well pleased.

Created using the calligraphic style typical of miniatures of the late French Gothic style, this scene showing Jesus' baptism, taken from *Très Belles Heures de Notre-Dame du Duc de Berry,* broadly reflects the narrative of Gospel of Mark. However, some elements of the narrative, such as the Holy Spirit, were not included, while others, such as the image of the Father or the group of angels holding Christ's immense robe, are not in the text. The angels have bodies that taper off into a sort of "tail" made of cloth, reinforcing the sense of impalpability of the angelic figure.

THE BAPTISM OF CHRIST
1404–1409
Bibliothèque Nationale de France, Paris

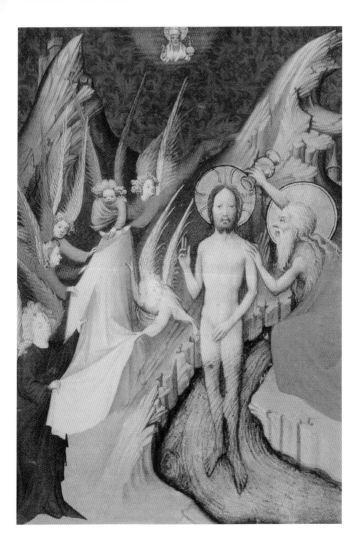

# Jesus in the Wilderness; the Angels Minister to Him

▶▶

> And immediately the Spirit driveth him into the wilderness. And he was there in the wilderness forty days, tempted of Satan; and was with the wild beasts; and the angels ministered unto him.

Mark sets this episode right after the baptism, when the Holy Spirit drives Jesus into the desert and exposes him to the temptations of Satan to strengthen his spirit, as Matthew also narrates (4:1–11). In his version, Mark also describes how the angels ministered to the Savior in the desert to show their faithfulness and support after he had overcome the trials of the devil.

For this reason, the artist has arranged the scene under a palm tree, a symbol of reward after a trial and of abundance because of its fruit, the date nut. The angels serving Christ are a tangible sign of his superiority, something that will be intensely debated in later ages; therefore, Mark's words seem to anticipate the reply to the many questions that theologians will pose.

CHRIST SERVED BY THE ANGELS
Jacques Stella
*c.* 1650
Galleria degli Uffizi, Florence

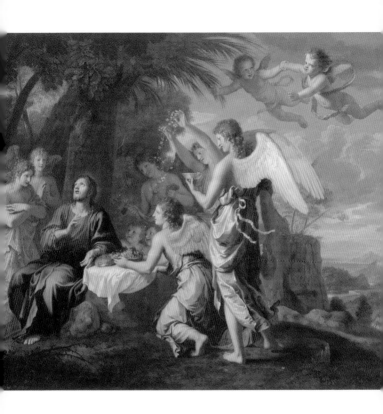

# *Jesus in the Wilderness; the Angels Minister to Him*

This work by Pietro Giarre, a painter of great delicacy of the Tuscan Settecento, was created with a very gentle touch and stands out for its unusual naturalness. After unmasking Satan as a conceited, evil creature and driving him away forever, Jesus withdraws to meditate and is immediately surrounded by angels, anxious to show him their infinite devotion. The divine messengers are more than happy to be waiters, innkeepers, and even cooks, since we see that two of them in flight are carrying choice dishes. These visual reflections are due to the artist's sensitivity in simply, yet masterfully, creating this extraordinary banquet in which the only diner is the Son of Man.

THE ANGELS' TABLE
Pietro Giarre
18th century
Charterhouse Refectory, Calci (Pisa)

# *The Last Judgment*

> ❝And then shall they see the Son of man coming in the clouds with great power and glory. And then shall he send his angels, and shall gather together his elect from the four winds, from the uttermost part of the earth to the uttermost part of heaven.❞

The text from the Gospel of Mark is almost identical to that of Matthew (13:24–31), and this *Last Judgment* is a monumental interpretation of it: Blinding and apocalyptic in appearance, the Son of Man is depicted high in the clouds, with the glory of his court of saints and blessed, as well as the presence of the Virgin Mary. Rubens seems to have followed Michelangelo's model, though with a different intent, for the Flemish painter has caught the compositional essence of the Sistine Chapel fresco by focusing on the rising of the blessed and the ruinous fall of the damned. The angels here play a central role, Michael in particular; weapons and shining shield in hand, he hurls himself against demons and damned souls and throws them into the infernal pits. The effect is one of intense visual impact that stirs the emotions of the faithful, leading them to fear God and accept the mysteries of faith.

THE FALL OF THE DAMNED
Pieter Paul Rubens
*c.* 1620
Alte Pinakothek, Munich

540

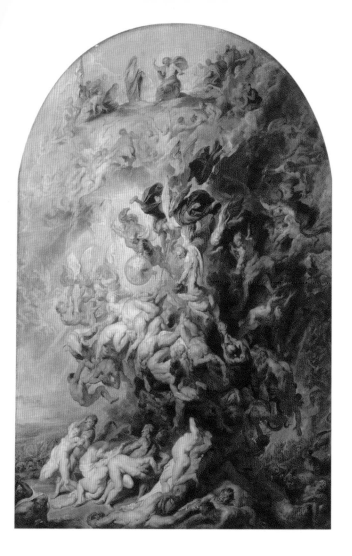

# *The Last Supper*

> ❝And as they sat and did eat, Jesus said, Verily I say unto you, One of you which eateth with me shall betray me. And they began to be sorrowful, and to say unto him one by one, Is it I? and another said, Is it I? And he answered and said unto them, It is one of the twelve, that dippeth with me in the dish. [. . .] And as they did eat, Jesus took bread, and blessed, and brake it, and gave to them, and said, Take, eat: this is my body. And he took the cup, and when he had given thanks, he gave it to them: and they all drank of it. And he said unto them, This is my blood of the new testament, which is shed for many.❞

The presence of angels at the Last Supper, which takes place in the house of Simon the Leper in Bethany, is rare. This episode is set in a unique space; the spiral columns are those of the temple of Solomon, where he kept the Ark of the Covenant. With the coming of Christianity, the Ark was replaced first by Jesus himself, and later, in memory of him, by the sacrament of the Eucharist, instituted precisely at this supper when Christ says: "This is my blood of the new testament, which is shed for many." For this reason, the temple columns have been added. In this light, the little angels fluttering above in the center of the room take on a new meaning: They are the cherubim who watch over the new ark, the immortal one built upon faith in Christ.

THE LAST SUPPER
Vincent Malo
17th century
Private collection, Genoa

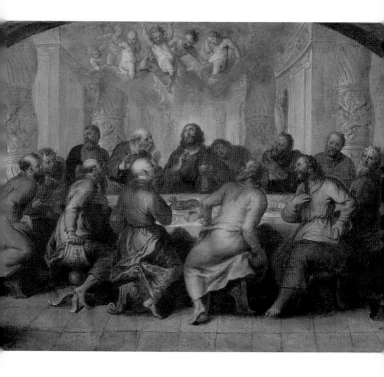

# *The Crucifixion*

"And it was the third hour, and they crucified him. [. . .] And with him they crucify two thieves; the one on his right hand, and the other on his left. [. . .] And when the sixth hour was come, there was darkness over the whole land until the ninth hour. And at the ninth hour Jesus cried with a loud voice, saying, Eloi, Eloi, lama sabachthani? which is, being interpreted, My God, my God, why hast thou forsaken me? [. . .] And one ran and filled a spunge full of vinegar, and put it on a reed, and gave him to drink, saying, Let alone; let us see whether Elias will come to take him down. And Jesus cried with a loud voice, and gave up the ghost."

This fresco by Pietro Lorenzetti is a masterpiece of medieval art. Next to Christ on the Cross, following an iconography that will become diffuse, the angels despair; some open their arms resignedly, others press their hands together, still others pull their hair. Their bodies, dressed in blue, take on the form of the clouds' vapors, exactly as Isidore of Seville (570–636), Father of the Church and encyclopedist, had explained; he wrote that the divine envoys derive their bodies from the highest air and that they wear them as solid forms made up of sky so that they can be identified more clearly by man's gaze.

CRUCIFIXION
Pietro Lorenzetti
*c.* 1320
Basilica inferiore di San Francesco, Assisi

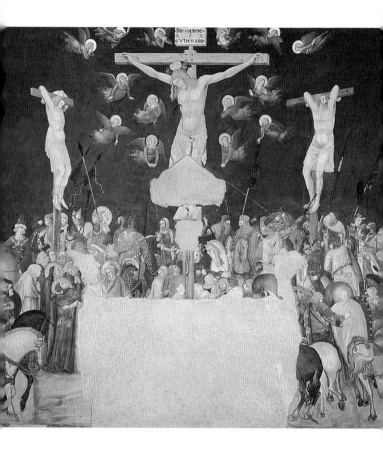

◄◄ ───────────────────────────────

# *The Crucifixion*

This great tempera canvas, created by Gaudenzio Ferrari, who also painted the angels in the fresco of the cupola of the Saronno cathedral (see pages 370–71), attributes to the angels the task of collecting the blood that flows copiously from the wounds on Jesus' hands and ribs. Therefore, the divine messengers will guard in these chalices (as with the Holy Grail) what will become the life-giving drink for the souls of all Christians. Below, underneath the cross that divides the composition in half, soldiers on horseback and people on foot experience the Crucifixion of Christ on a human level. Mary faints, held up by the devout women; Mary Magdalene kneels at the feet of the Cross; John looks up toward Christ; and the mob of soldiers, passersby, priests, and scribes mock him, as Mark tells us (14:29–32): "And they that passed by railed on him, wagging their heads, and saying, Ah, thou that destroyest the temple, and buildest it in three days, Save thyself, and come down from the cross. The chief priests and the scribes likewise mocked him, saying: He saved others; himself he cannot save. Let Christ the King of Israel descend now from the cross, that we may see and believe. And they that were crucified with him reviled him as well."

CRUCIFIXION
Gaudenzio Ferrari
*c.* 1535
Galleria Sabauda, Turin

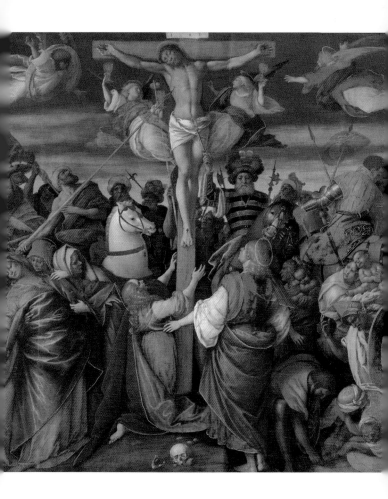

# The Angel Outside the Tomb

> And when the sabbath was past, Mary Magdalene, and Mary the mother of James, and Salome, had bought sweet spices, that they might come and anoint him. [. . .] And when they looked, they saw that the stone was rolled away: for it was very great. And entering into the sepulchre, they saw a young man sitting on the right side, clothed in a long white garment; and they were affrighted. And he saith unto them, Be not affrighted: Ye seek Jesus of Nazareth, which was crucified: he is risen; he is not here: behold the place where they laid him.

Duccio di Buoninsegna is certainly referring to this passage from Mark because, unlike Matthew (on whose text Giotto relied), he does not recall the episode of the guards. In both cases, however, the monumental tomb, with the great stone to be rolled aside, has been replaced with a sarcophagus, which was easier to identify for the faithful of the time. As the Gospel narrates, the angel depicted by the Sienese painter is wearing a luminous, white garment and points with his hand to the empty tomb, while the devout women barely conceal a gesture of fear or, perhaps, diffidence. In the background, a bleak landscape is a stark backdrop for this scene.

THE THREE MARYS AT THE TOMB
Duccio di Buoninsegna
1308–11
Museo dell'Opera del Duomo, Siena

# The Angel Outside the Tomb

Fra Angelico composed this scene with balance and monumentality, grouping together the Resurrection and the visit of the three Marys to the sepulcher on the Monday after Easter (known as "Angel Monday" because of the presence of the divine herald who reassures the women). In the bottom left, Saint Dominick, his head covered, witnesses the event as he prays. In the fresco, the artist introduces a new angelic image, which he will use in later works: the flame above the head. The reason is explained by a number of texts that specify that the angel is a bright, shining being, much brighter than the white robe he is wearing. Already Saint Augustine had described angels as being made of an extremely bright and ethereal substance (*lucidissima atque aetherea*). Sedulius, a fifth-century poet, priest, and composer of hymns, understood angels to be "of a flaming appearance, and wearing garments as blinding white as snow" (*flammeus aspectu, niveo praeclaro amictu*), exactly like Fra Angelico's angel.

RESURRECTION OF CHRIST
AND WOMEN AT THE TOMB
Fra Angelico and assistants
*c.* 1440
Convento di San Marco, Florence

550

◄◄

# *The Angel Outside the Tomb*

This splendid canvas by Bartolomeo Schedoni is made richer by the skimming, almost metaphysical light (in a de Chirico style) that pervades the scene and confers great seduction to the entire composition. The three Marys are not afraid; rather, they are shocked and cannot believe what is before their eyes. The tomb in the rocks described in the Gospel has been replaced by a sarcophagus that the angel keeps open, leaning on the cover. The bare-chested angel dressed in white points to the place where Jesus can be found while a cloud rises in the background— possibly the one out of which the angel took form.

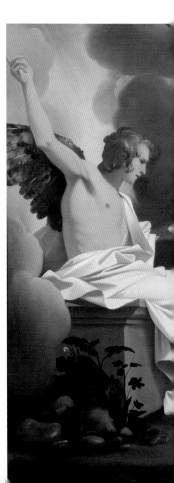

THE TWO MARYS AT THE TOMB
Bartolomeo Schedoni
1613
Galleria Nazionale, Parma

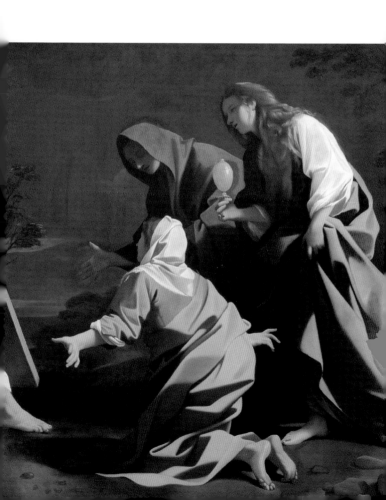

# *The Announcement to Zacharias*

▶▶

"There was in the days of Herod, the king of Judaea, a certain priest named Zacharias, of the course of Abia: and his wife [. . .] was Elisabeth. [. . .] And it came to pass, that while he executed the priest's office before God [. . .] there appeared unto him an angel of the Lord standing on the right side of the altar of incense. And when Zacharias saw him, he was troubled, and fear fell upon him. But the angel said unto him, Fear not, Zacharias: for thy prayer is heard; and thy wife Elisabeth shall bear thee a son, and thou shalt call his name John. [. . .] I am Gabriel, that stand in the presence of God; and am sent to speak unto thee, and to shew thee these glad tidings."

This twelfth-century fresco illustrates synthetically the extended narrative from the Gospel of Luke: on one hand, Zacharias, depicted as white-haired according to tradition, and on the other, the angel, who introduces himself to the priest with a scroll, which tells him that he should not fear, but be glad. Indeed, we read:

*Ne timeas Zacharia quoniam exaudita ets* [sic] ("Fear not, Zacharias, for [thy prayer] has been heard"). So as to leave not even a shred of doubt, above the divine messenger the artist wrote *Angelus Domini* ("the angel of the Lord"). Finally, next to the priest he inscribed his name, Zacharia, with the "Z" upturned.

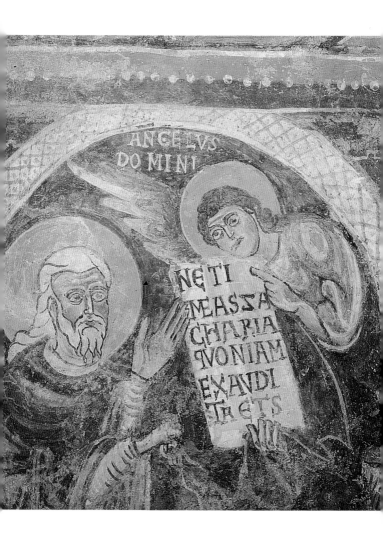

# The Announcement to Zacharias

This fresco covers the entire Zacharias episode. We see him kneeling at the incense altar, about to officiate, as Luke describes. Here the angel of the Lord appears to him in a burst of light, holding in his hand the scroll announcing the future event. On the right, Zacharias, temporarily mute for having doubted the angel's words, writes on a scroll his future son's name; next to him, Elisabeth lovingly assists him.

SCENES FROM THE LIFE OF SAINT JOHN THE BAPTIST: THE ANNOUNCEMENT OF THE ANGEL TO ZACHARIAS
Lorenzo Salimbeni and Jacopo Salimbeni
c. 1416
San Giovanni Battista, Urbino

# The Announcement to Zacharias

This lovely drawing by Bramantino is a preparatory study that focuses its attention on the two protagonists of the Gospel episode, offering a monumental interpretation of it. The perspective from below allows the viewer to almost take Zacharias's place and experience with him the emotion of the angel's sudden appearance. The angel is positioned higher because, as Luke writes, he appeared "standing on the right side of the altar of incense," therefore above the altar. His gesture is of someone speaking; the Gospel, in fact, explains that the angel spoke to the priest, who at first could not utter a word and then could only to express doubt, which cost him the use of speech until John was born (Luke 1:20).

THE ANNOUNCEMENT TO ZACHARIAS
Bartolomeo Suardi, known as Bramantino
1485–90
Gallerie dell'Accademia, Venice

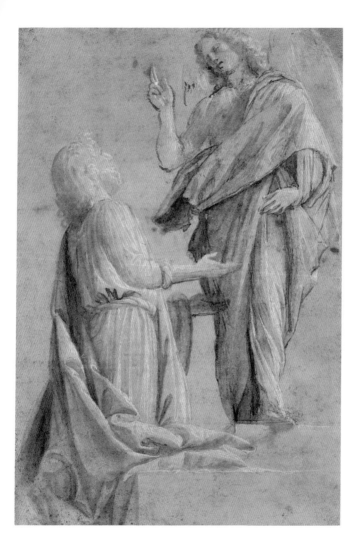

# *The Annunciation*

> And in the sixth month the angel Gabriel was sent from God [. . .] to a virgin espoused to a man whose name was Joseph, of the house of David; and the virgin's name was Mary. And the angel came in unto her, and said, Hail, thou that art highly favoured, the Lord is with thee: blessed art thou among women. And when she saw him, she was troubled at his saying [. . .]. And the angel said unto her, Fear not, Mary: for thou hast found favour with God. And, behold, thou shalt conceive in thy womb, and bring forth a son, and shalt call his name JESUS. [. . .] And Mary said, Behold the handmaid of the Lord; be it unto me according to thy word. And the angel departed from her.

This mural is the most ancient surviving depiction of the Annunciation, undoubtedly very unlike the iconography that we are used to seeing. Like all Paleochristian angels, the angel here is a man, without wings, dressed in a dalmatic and a pallium. Mary, on the other hand, is a Roman matron; seated, she waits to hear what her interlocutor will tell her. Indeed, the angel is moving his arm in the *adlocutio* gesture typical of orators—that is, he raises the right arm before speaking. Notwithstanding its generic quality, this is a highly suggestive scene, almost shrouded in a rarefied, timeless atmosphere.

THE ANNUNCIATION
2nd–3rd century
Catacomba di Priscilla, Rome

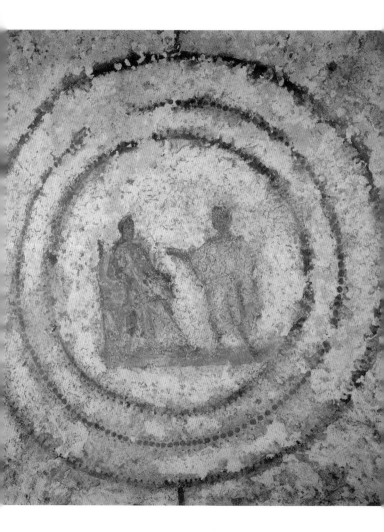

# The Annunciation

Enclosed in the elegant garland of this round design, this *Annunciation*, embroidered on a silk and wool tapestry by Byzantine weavers, displays a consolidated iconography, at least in its general traits. Specifically, the archangel Gabriel is recognizable by the wings and the halo that surrounds his head, decorated with a ribbon. His gesture is oratorical; it will blend with the benediction gesture. Mary is seated on a throne and has been endowed with all the traits that will make her immediately recognizable. For example, the mantle is now dark, and will become sky blue. On the red background of the tapestry, the angel's robe stands out; it is white, in keeping with early Christian tradition, and also because fifth-century hymn composers described it as being "bright white like snow."

◀◀

# *The Annunciation*

▶▶

This scene from a mosaic in Saint Mark's Basilica follows the apocryphal Gospels in narrating the moment of Annunciation, set next to a well. The bare, essential setting shows the future mother of Christ just outside her house as she walks toward a well, near which grows a tree, symbol of rebirth and of life; the well is Christ, who will quench with his own blood the thirst of all of mankind. To the left we see the small figure of the archangel Gabriel, almost rising from the gold background like foam on a wave; here as well his gesture is that of the rhetor. Above Mary's head the following is inscribed in Greek: *m[ether=]r th[eo]u* ("Mother of God"). Always according to the apocryphal texts, the following day, Gabriel was to return to Mary's house and greet her as "full of grace."

SCENES FROM THE LIFE OF THE VIRGIN: ANNUNCIATION
12th century
Basilica di San Marco, Venice

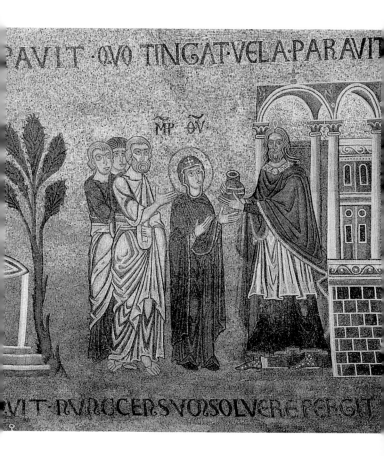

·PAVIT ·QVO TINGAT VELA·PARAVIT

ṀP ΘV

·VIT·RVRGGERSVOSOLVEREPERGIT

# The Annunciation

This precious *Annunciation* by Simone Martini and Lippo Memmi is filled with important details that help us understand this work more fully. First of all, the gold represents the divine light (which also bathes the archangel Gabriel); the cloud of seraphim holds the dove of the Holy Spirit, the artificer of the incarnation of Christ; and the angelic choir is formed by seraphim because they are the angels closest to God. The artists chose to represent the Holy Spirit, but not the figure of God the Father: In this they carefully followed the text in Luke, the only Evangelist to narrate the Annunciation. Gabriel's wings are also worthy of note: They are peacock wings, at once a symbol of eternal life and the naturalistic translation of the cherubim's wings. Gabriel symbolically benefits from this, since they give him a higher rank. He is dressed as a deacon, complete with dalmatic, mantle, and stole—an important choice not only because it takes into account the correspondence, present since the beginning, between the Church hierarchy and the heavenly one, but also because it suggests a comparison between Mary and the Church, one that over the centuries will become increasingly filled with meaning.

THE ANNUNCIATION AND THE TWO SAINTS
Simone Martini and Lippo Memmi
1333
Galleria degli Uffizi, Florence

# The Annunciation

*The Annunciation* by Donatello is a masterpiece of balance between beauty and meaning. Indeed, the true protagonist of this scene is the door, which stands out in the background with its richly decorated panels. The door is a symbol of Christ, as he himself explains in the Gospel of John (10:9) when he says, "I am the door." But the Virgin Mary also is the door through which Jesus comes into the world for the salvation of humankind. Thus, rightly so, Donatello made the door into a monumental presence inside this *Annunciation*. The other elements are also steeped in the iconographic tradition: Mary rises from her seat, a book in her hands that signifies wisdom, whose seat she is. The archangel enters the scene from the left and kneels before the future mother of God. He wears a deacon's tunic with the typical sleeve embroidery (the Byzantine-style *tablion*), because the Church is the door as well, and at the time of this work, one still heard the echo of the 1423 Jubilee, whose celebrations had begun precisely with the opening of the door.

THE ANNUNCIATION
Donato di Niccolò di Betto Bardi,
known as Donatello
1433–40
Santa Croce, Florence

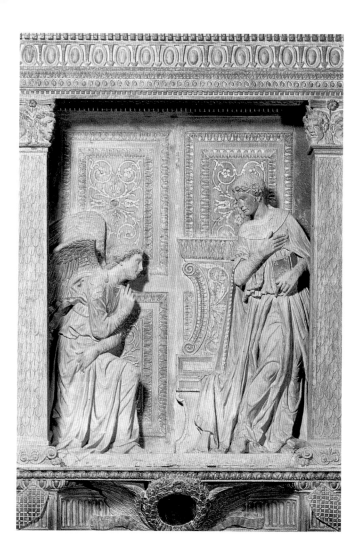

# The Annunciation

The iconography of the Annunciation in fifteenth-century Flemish art has now become set with recurring elements such as the domestic setting; in this work, for example, we find a fireplace, a chandelier, a canopy bed, and everything to make a Quattrocento bedroom comfortable. The angel Gabriel is wearing ecclesiastical clothes; he is dressed like a deacon, or more precisely an archdeacon with cope, stole, and *tunica alba* (white tunic) girded at the waist. If the domestic setting makes the Gospel scene appear closer to the artist's time, the presence of the angel in clerical robes instead evokes the relationship between the ecclesiastical hierarchy and the angelic one, in addition to the relationship between Mary and the Church. This symbolism is also expressed in seemingly secondary details such as the clear water cruet on the fireplace mantel and the prayer book. The latter is clearly anachronistic, since Mary could not pray Christian prayers (the painter and the tradition he represents only allude to those), which obviously did not yet exist. In any case, the book is a reminder of the Virgin's purity and of her role as the seat of wisdom.

ANNUNCIATION TRIPTYCH
(detail)
Rogier van der Weyden
1435
Musée du Louvre, Paris

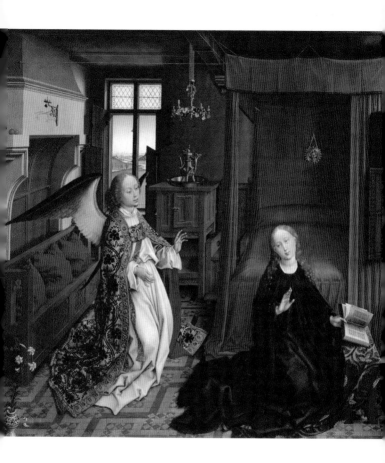

# *The Annunciation*

This true masterpiece of Flemish art, *The Annunciation* by Jan van Eyck, carries to the extreme the elements that make the setting contemporaneous to the artist's time and milieu, and the angel's role as a member of the Church hierarchy (analogous to the angelic one). It also clearly introduces an important element that had been hinted at in previous art: the relationship between Mary and the Church. Here the artist has set the scene inside a cathedral, an obvious anachronism with an equally obvious significance: Mary is the Church, and the angel wearing the rich cope is the priest, who officiates the annunciation ritual that will save humankind.

We are looking at a cosmic, universal ritual, as evidenced by the floor decorated with zodiacal signs and episodes from King David's life, and by the stained glass window in the background (see pages 334–35 for a description of this detail) that shows Christ in glory with the cherubim. Also interesting is the fact that the angel wears a crown, a sign of royalty, and is equipped with splendid peacock wings, a symbol of eternal life, resurrection, and powerful intellect (since they are linked to the cherubim). Finally, the angel's gesture is just as important; neither blessing nor signifying speech, he merely points upward to the entrance of the Holy Spirit.

THE ANNUNCIATION
Jan van Eyck
*c.* 1435
 National Gallery of Art, Washington

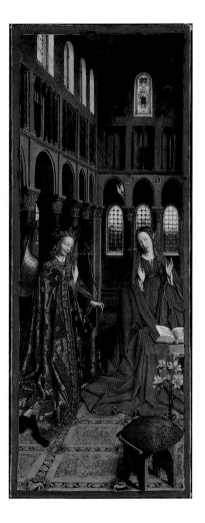

◄◄

# *The Annunciation*

►►

This masterly interpretation of the Annunciation by Fra Angelico takes its cue from the *exultet*, medieval scrolls that narrated the story of salvation through images, unrolled in the church pulpit for the purpose of educating the faithful. Their story began with the sin of Adam and Eve, referred to as *felix culpa* ("happy sin") because without their disobedience Jesus would not have become incarnated for our salvation. For this reason, the artist has included in his *Annunciation* the scene of the expulsion from the Garden of Eden. What is more, there seems to be almost an exchange of witnesses between the cherub, who drives our progenitors from earthly paradise, and the archangel Gabriel, who brings the good news to Mary, for they are linked together by the light ray of the Holy Spirit.

THE ANNUNCIATION
Fra Angelico
1430–32
(574) Museo del Prado, Madrid

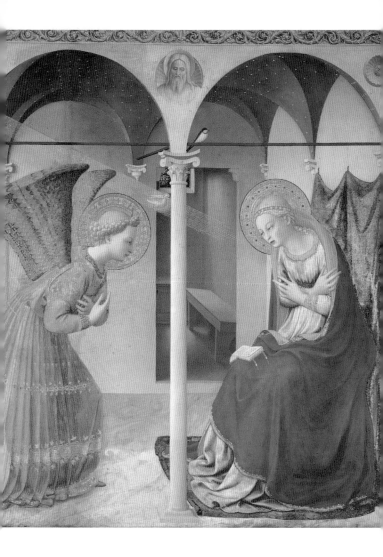

◄◄ ◄

# *The Annunciation*

►►

One of the loveliest panels of Quattrocento art, this work was painted by the Master of the Aix-en-Provence Annunciation, recently identified as Barthélemy d'Eyck. Here the theme introduced by Jan van Eyck, the relationship between the Madonna and the Church—which the culture of the time posited as an identity—is reintroduced. For this reason, the scene is set in a cathedral, where the essential architectural elements are clearly visible: the atrium where the angel kneels, the rose window, the naves, the mullioned windows. On the upper left is God the Father, which is almost a forcing of Luke's text, though one that will become widespread in later art. The angel is wearing a sumptuous cope with a wide stole decorated with embroidered images, which identifies him more as a bishop or a cardinal than a simple priest. Finally, the angel's naturalistic wings, according to scholars, reproduce those of the dove.

THE ANNUNCIATION
Barthélemy d'Eyck
*c.* 1445
Sainte Marie Madeleine,
Aix-en-Provence

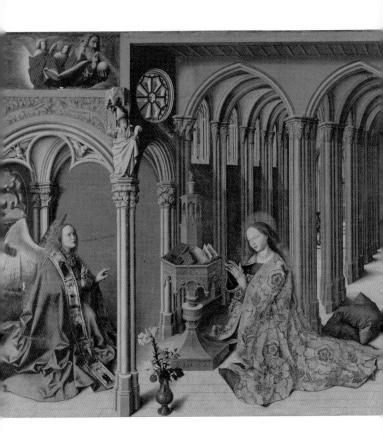

◄◄

# *The Annunciation*

►►

Set inside the clean lines of a Renaissance atrium, *The Annunciation* by Domenico Veneziano, though simple in setting, exhibits an unusual detail that will be revived by Piero della Francesca (see pages 584–85): Although the angel and the Virgin are arranged facing each other, they cannot see each other completely because of the cloister column, for the straight line from Gabriel to Mary along the floor set with rectangular tiles ends at the column, one of Mary's symbols. Finally, the image of the angel is innovative for its blending of tradition (the mantle) and fifteenth-century fashion (the waist-girded tunic and the stockings).

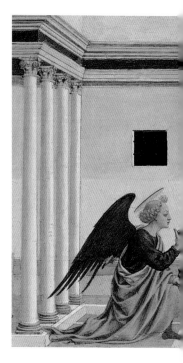

THE ANNUNCIATION
Domenico di Bartolomeo,
known as Domenico Veneziano
*c.* 1445
Fitzwilliam Museum, Cambridge

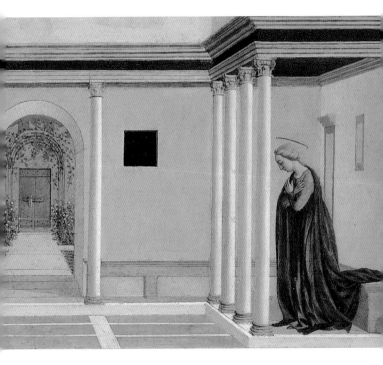

◄◄ ◄ ──────────────────────────────────

# *The Annunciation*

──────────────────────────────── ► ►►

"And the angel came in unto her": This sentence from the Gospel of Luke alludes to the fact that the archangel Gabriel went to visit Mary in her home. Artists and patrons paid attention to this detail and used it to set the Annunciation scene in homes that might look like those of their contemporaries. Given this practice of making history relevant and bringing the episode to life, even the home of the patron, artist, or other notable could resemble the one where the angel had come to make his announcement to Mary. This became a common phenomenon starting in the fifteenth century. In this panel by Dierick Bouts, for example, Mary welcomes the angel into an aristocratic Dutch home of the time—specifically into her bedroom, where a rich canopy bed, with a red curtain folded up in the typical fashion of the time, is boldly displayed. The angel wears the *tunica alba*, a white tunic that deacons and subdeacons wore at the time. Around his neck is the *amitto*, a square kerchief that completes the church vestments.

THE ANNUNCIATION
Dierick Bouts
*c.* 1450–55

The J. Paul Getty Museum, Los Angeles

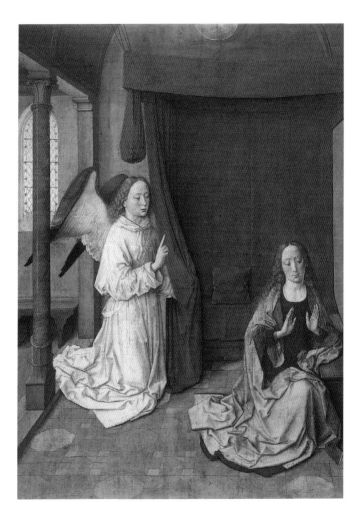

# *The Annunciation*

This Annunciation scene by Piero della Francesca shares some elements with Donatello's (see pages 568–69); in this case as well, the protagonist is the door that stands out from the background with its intarsio panels. The symbolic reference is to Christ and the Virgin, both "doors," in two different meanings of the word. In this case, however, the angel's garments have become more modern in the Quattrocento style; the divine envoy is wearing a sort of doublet with the sleeves fastened by small bows that end in small metal tips, the so-called *aguelli* that made it easier to thread the ribbons in the sleeve and jacket eyelets. Even the angels are catching up with fashion.

ANNUNCIATION
(detail)
Piero della Francesca
1455–56
Maggiore Chapel,
San Francesco, Arezzo

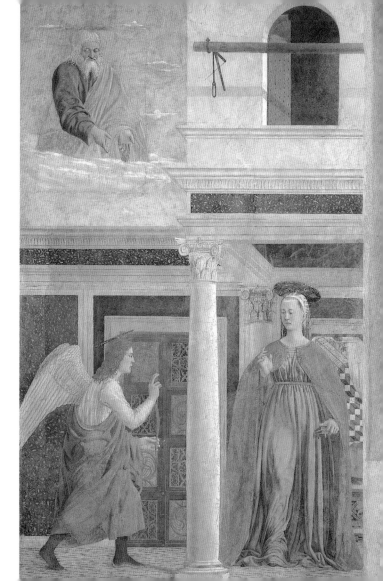

# *The Annunciation*

In this cyma that tops the Polyptych of Saint Anthony, the Annunciation scene created by Piero della Francesca revives the solution adopted earlier by Domenico Veneziano (see pages 578–79), even though he has toned down the effect, making it less immediately perceivable. Some recent studies have drawn diagrams of the floor tiles, noting that in this case also the Virgin Mary and Gabriel cannot see each other face-to-face. As in the panel of the Venetian artist, who worked often with Piero della Francesca, a portico column comes between Mary and the angel.

Here the Madonna is exhibited as the column in the plan of salvation that God has willed for humankind, in addition to being the very image of wisdom; comparison between her neck and the impregnable "ivory tower" of wisdom had become codified by this point. Compared to Veneziano's panel, Piero has moved the figures toward the middle; using the lower frame of the polyptych results in a more subtle perspectival effect, so much so that it took over five hundred years to uncover it. Additionally, the angel wears the classical *guarnello*.

POLYPTYCH OF SAINT ANTHONY
(detail)
Piero della Francesca
1478–85
Galleria Nazionale dell'Umbria, Perugia

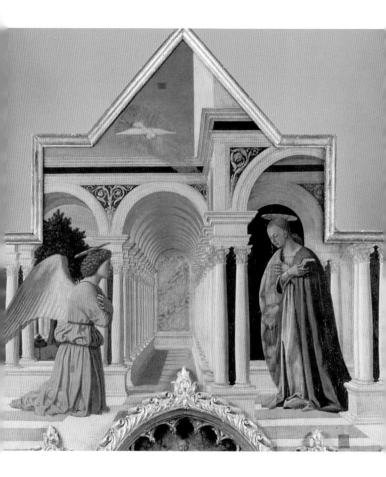

◀◀

# *The Annunciation*

▶▶

Even in this dazzling panel by Francesco del Cossa, the protagonist is the column, made obvious not only by its central position but also by the choice of the type of marble used for it. As with Piero della Francesca's second *Annunciation* (see pages 584–85), and that of Domenico Veneziano (see pages 578–79), the angel cannot see the Virgin's face. The symbolic reason is always the same, but with the addition that Gabriel is now equipped with two splendid peacock wings that, apart from representing everlasting life, allude specifically to the idea of wisdom amplified by the eyes of the cherubim. In the logic of this symbol, the more eyes one has, the more one sees, and therefore the more wisdom one has, just like the cherubim.

ANNUNCIATION AND NATIVITY
(ALTARPIECE OF OBSERVATION)
(detail)
Francesco del Cossa
1470
Gemäldegalerie, Dresden

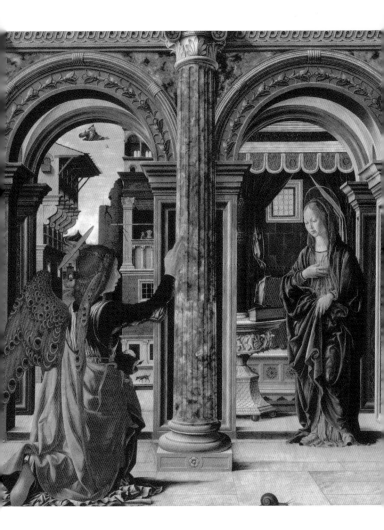

# The Annunciation

The *Annunciation* attributed to Carlo Braccesco is one of the more original fifteenth-century works on the theme. The setting recalls a church, for the theologians of the time were wont to identify Mary with that institution. But the artist has added new details: The roses behind the wall, for instance, are homage to the Virgin, since this flower is dedicated to her (as is the month of May), but they also evoke the *hortus conclusus* ("enclosed garden"), one of Mary's metaphors. Like the Virgin, the enclosed garden is pure and lovely, protected from the evils of the world. Mary's initial attitude, as Luke narrates, is one of fear, but in this gesture she is leaning on a column that in turn refers to the symbolism we have already illustrated. The vase of carnations on the right of the composition is a metaphor for Christ and his future Passion, as also hinted at by the presence of the coral grains hanging from the vase; they will become drops of blood. Finally, the angel is dressed in deacon's vestments, white as a dove, and matching the lily he carries in his hand. He is angled toward Mary on a golden disk that hints at his divine nature; the feather on his head is a naturalistic transposition of the flame, and here stands for the impalpability of the angelic nature.

ANNUNCIATION
Carlo Braccesco (attr.)
*c.* 1480
Musée du Louvre, Paris

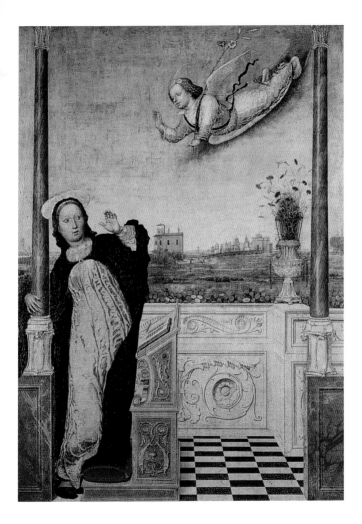

# The Annunciation

The Annunciation theme stimulated the creativity of many artists who strove to present different and always interesting interpretations. In this work by the Flemish painter Hans Memling, for example, the presence of the two angels holding up the Virgin, though they are a unique case in the history of the iconography on the subject, recalls the figure of Christ in Mercy supported by the angels, which is traditional in Venetian art. With this choice, the artist wanted to prefigure the grief that the Madonna would experience with the death of her son. Furthermore, the two angels are dressed in simple sub-deacon robes (the *tunica alba*, "white tunic") while Gabriel wears those of a deacon, complete with cope.

THE ANNUNCIATION
Hans Memling
1480–89
The Metropolitan Museum of Art, New York

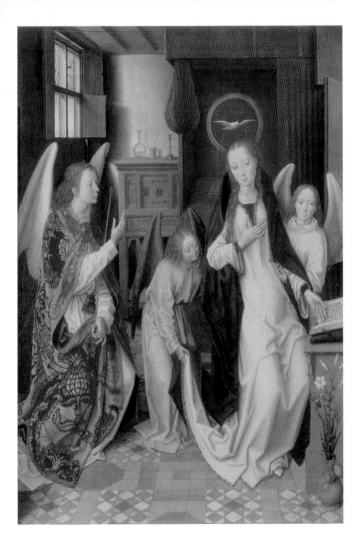

# The Annunciation

Sometimes, sacred images are interwoven with events from the historical environment that produced them. This *Annunciation* panel by Carlo Crivelli was created to celebrate the 1482 decision by Pope Sixtus IV to grant ecclesiastical freedom to the city of Ascoli Piceno, a status that also implied sizeable tax relief (as the Latin inscription at the base of the panel confirms). For this reason, next to the angel is an idealized portrait of Bishop Prospero Caffarelli, whose coat of arms is visible below, offering the city to the Virgin Mary. This decision to illustrate the Gospel episode as a corollary to a historical event was prompted by the fact that news of the decision first reached the city on the day of the Annunciation, March 25, 1482. Thus, Gabriel's role was renewed in the expectations of the contemporaries, and became a reason for more celebrations. The role of angels, in any case, is stressed in this work, since the Holy Spirit enters the house of Mary from a mass of clouds mixed with the golden heads of the seraphim. For the symbolism of the feather that decorates Gabriel's head, see pages 588–89.

ANNUNCIATION WITH SAINT EMIDIUS
Carlo Crivelli
1486
National Gallery, London

LIBERTAS · ECCLESIASTICA

◄◄

# *The Annunciation*

►►

Botticelli tones down the symbolic themes that we saw in the previous works of art, barely hinting at them, thereby achieving a generally pleasing simplification of the narrative of the Gospel passage. The room where Mary receives the announcement is both house and church (as the lectern suggests) and it has been pared down to the essential, while the floor shows continuity with the Quattrocento tradition of Domenico Veneziano and Piero della Francesca (see pages 578–79 and 584–85).

In the background, the door theme blends in with the landscape. The angel, just alighted, wears the traditional *guarnello*, softened by veils and a double yellow tunic, which adds a further classical touch. The Holy Spirit is not in the painting, and neither is God the Father, because the attention must be focused on this private dialogue. In the background, the genealogical tree is a reference to Christ, and the low wall enclosing the lawn alludes to the *hortus conclusus*, a metaphor for Mary.

CESTELLO ANNUNCIATION
Alessandro di Mariano Filipepi,
known as Sandro Botticelli
1489–90
Galleria degli Uffizi, Florence

# The Annunciation

Andrea del Sarto has painted not one but three announcing angels; it is easy to gather that their presence recalls the Trinity, even if the protagonist is only Gabriel, who arrives kneeling on a cloud and addresses Mary with an oratorical gesture to give her the good news. The angel's dress, which has evolved through the centuries, blends different fifteenth-century traditional elements; hence, the divine messengers are dressed sometimes in ecclesiastical vestments (with the white tunic and little chains holding the slits of the dalmatic), sometimes in classical clothes (puffy around the hips and draped with large fabric folds). Another classical touch in this painting is the temple that is visible in the background; its balanced, harmonious lines were revived and appropriated from the architecture of the time.

THE ANNUNCIATION
Andrea del Sarto
1512–13
Galleria Palatina,
Palazzo Pitti, Florence

# *The Annunciation*

Lorenzo Lotto's angel resembles a winged Victory forcefully entering this painting after deserting a Greek or Roman bas-relief, one that perhaps the artist had seen during his sojourn in Rome at the court of Pope Julius II. His hair and his *chiton* rumpled by the wind, the divine herald rushes in to announce the good news to the Virgin, who, from her very frightened look, already seems to know everything. In the angel's excitement, even a cat scampers away, while God the Father leans out from a cloud with arms extended, as if he had just thrown Gabriel down from the vault of heaven. Still, the artist's great visionary gifts fill the scene with deep meanings, which it is worth our while to examine: The cat symbolizes the devil; Mary (the Church) prays on a prie-dieu, and the entire room is a sacristy, but also a bedroom; on the stool is an hourglass, and immediately above that, an unlit candle, symbols of transience and death (though above them is the light coming from the window). Gabriel has entered the room through the door, whose meaning has already been explained (see pages 568–69), and in the enclosed garden we see roses and an arbor with grapevines, symbols of Mary and Christ, respectively.

ANNUNCIATION
Lorenzo Lotto
*c.* 1527
Pinacoteca Comunale, Recanati

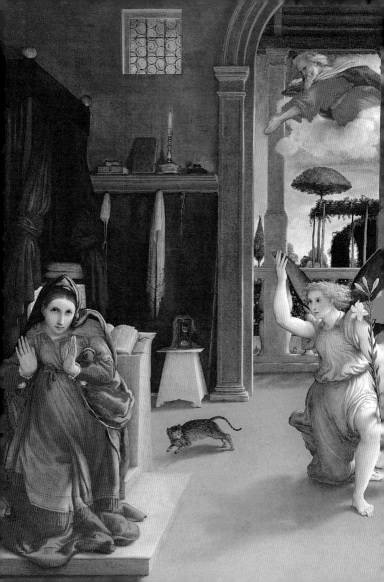

# The Annunciation

The image of Gabriel in deacon's robes is a common feature not only of Quattrocento iconography, but also of the Cinquecento, up until the end of the Seicento, albeit with adaptations and novelties. Were we to remove the wings, we would be left with a devout cleric kneeling before the Holy of Holies, given the red stole and *tunica alba* with which the artist has dressed him. Mary prays on a prie-dieu, and the atmosphere is churchlike. In this painting as well, the floor is patterned like those of the Quattrocento tradition, but the scene is set in Bologna instead of Nazareth, for behind the light emanating from the dove of the Holy Spirit, we glimpse the city's skyline. According to Carracci, there is no specific time or place for the Annunciation, which belongs to eternity. Finally, we find an additional reference to everyday life in the basket of freshly washed laundry, which makes Mary a good housewife.

THE ANNUNCIATION
Ludovico Carracci
1583–84
Pinacoteca Nazionale, Bologna

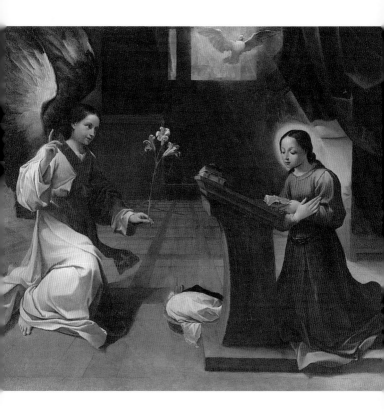

# The Annunciation

This *Annunciation*, painted on two canvases by Annibale Carracci, the cousin of Ludovico, was inspired by the guidelines set down by the theoretician Gabriele Paleotti, who had recently published his *Discorso intorno alle immagini sacre e profane* [*Discourse on Sacred and Profane Images*], in which he urged artists to be as faithful as possible to the descriptions in the Scriptures, that the images might be their true mirror. However, paradoxically, the guidelines that Paleotti suggested for paintings and sculptures were derived only from a long artistic tradition. Indeed, no sacred text states that Gabriel was a deacon or that Mary was praying when she received the announcement. Not only that, but the Virgin's house was neither a church nor a home with a prie-dieu. Still, Paleotti wanted to include these elements, which the iconographic tradition and the commentaries to the Scriptures had developed over the centuries.

THE ARCHANGEL GABRIEL
AND THE ANNOUNCED VIRGIN
Annibale Carracci
*c.* 1588
Pinacoteca Nazionale, Bologna

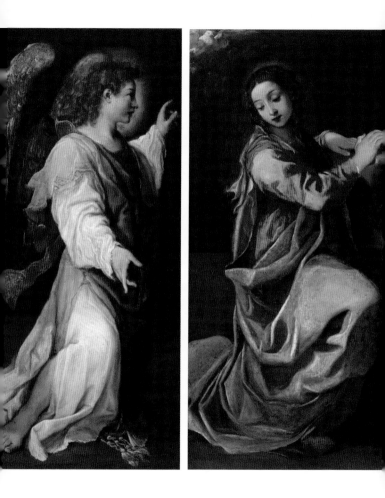

◄◄

# The Annunciation

►►

A painter and sculptor with a keen scientific bent (we may recall, for example, his fresco in the Pauline Chapel cupola in the Church of Santa Maria Maggiore in Rome, an *Immaculate Conception* that overlooks a moon with characteristics derived from Galileo's research), here Cigoli has created a meditation on light. Indeed, when the light of grace lights them up, the figures rise from the shadow as if from mystery. Contrary to the traditional arrangement of the Annunciation characters, here Mary appears on the left and the archangel Gabriel on the right, which is the visual equivalent of changing a hypothetical sentence such as "the archangel Gabriel announced God's will to Mary," to

"Mary received the announcement of God's will from the archangel," where the receiver of the announcement has become its active subject. Similarly, the artist has focused on Mary, making Gabriel an agent of the efficient cause par excellence— that is, God. Some small details in the scene confirm the central role of the Virgin Mary. She is about to pray, Gabriel wears deacon's vestments and carries a crown, cherubim are glimpsed in the shadow, and the sudden rending of light with the Holy Spirit—everything identifies Mary with the Church. The small "Copernican" revolution of the positions of the two leading characters thus has becomes enriched with another layer of meaning.

THE ANNUNCIATION
Ludovico Cardi, known as Cigoli
1595–1601
Convento dei Cappuccini di Montughi,
Florence

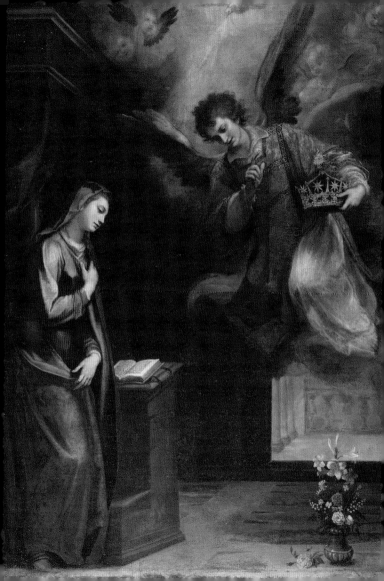

# The Annunciation

Created from two monumental blocks of white marble, the *Annunciation* by Francesco Mochi, one of the greatest Baroque sculptors, finely captures two opposite but complementary attitudes between Mary and the angel. The former is more frightened and wrapped in herself, and the latter is more daring, throwing himself forward to give her the incredible news. The angel's gesture is theatrical, as befits a Baroque actor; he points to the One who sent him, and who decided to save humanity. Gabriel's beauty and sensuality are those of a pagan divinity, though in harmony with Christian aesthetic ideal that prevailed in the Seicento. The delicateness of the angel is even more extraordinary if we think about the weight of the marble and Mochi's success in rendering the lightness of flight.

OUR LADY OF THE ANNUNCIATION AND
THE ANGEL OF THE ANNUNCIATION
Francesco Mochi
*c.* 1605, *c.* 1609
Museo dell'Opera del Duomo, Orvieto

# The Annunciation

Over the centuries, Gospel episodes such as the Annunciation have been set in different historical contexts, according to the tastes of the time. In this painting by Gentileschi, Mary's home is a seventeenth-century Italian house with tall windows, double shutters, and a canopy bed with red curtains and white sheets. Meanwhile, the angel is dressed in accordance with the canons of Renaissance tradition, the robe pulled up and fastened at the waist and a pose that, seen from the back, recalls Botticelli's *Annunciation* (see pages 594–95). His gesture, with the index finger pointed upward to remind, justify, but also admonish, evokes the theater of the time and will be used in many works on this theme throughout the seventeenth century. In this case as well, the position of the two protagonists is not traditional (see pages 604–605), so that Mary's role is highlighted. Note how the dove of the Holy Spirit, entering the room from the window, takes on an intentionally ambiguous role, both naturalistic and symbolic.

ANNUNCIATION
Orazio Gentileschi
1623
Galleria Sabauda, Turin

# The Annunciation

This large canvas by Guido Reni, which originally hung in the Alvitreti Chapel in the Church of Santa Maria della Carità in Ascoli Piceno, has a padded, dreamlike atmosphere. More than the episode of the Annunciation, it seems a vision of it, as in the mystical ecstasy of a saint. Mary is praying at home, before a window, when suddenly the clouds of the sky come into the room and the sunlight illuminates the walls until they disappear. Only the Renaissance-style floor seems solid.

Above, the clouds take on a golden hue, and between them one glimpses cherubim and the Holy Spirit, shining on Mary like the dawning sun. Before her, appearing as a youth, is an angel whose wings are lost in the sky. The angel's features are sweet like a girl's, but his resolute gesture is that of a man. In this case again, his dress is that of a Greek deity, even if the fabric is heavy and realistic, decorated like the fabrics of Guido Reni's time.

ANNUNCIATION
Guido Reni
1628–29
Pinacoteca Civica, Ascoli Piceno

# The Annunciation

The nineteenth century witnessed both the revival of Raphaelesque stylistic solutions, updated in technique and composition, and a reinterpretation of traditional religious themes. This large painting by Dante Gabriel Rossetti belongs to this second revival. The Virgin, huddling on the bed, stops her embroidery work (she was embroidering a lily, just like the one that Gabriel is carrying) when an unknown man dressed in white enters the room. He is an angel, albeit without the wings that a long tradition would demand. He greets her with one hand and offers her a snow-white lily. It is not easy to verify whether the artist had read the textual sources, but the solution of depicting the angel barefoot and with flames does not at all contrast with the orthodox texts on the subject. For one, Federico Borromeo (1564–1631) had recommended that the feet of angels be left naked because it was a sign of generosity; Pseudo-Dionysius had written that the "holy intelligences" have wings at their feet. Finally, many commentators believed that the angelic nature was a fiery one. All these elements justify the daring iconographic choice of Dante Gabriel Rossetti, whose middle name, we should not forget, is that of the angel.

ECCE ANCILLA DOMINI
Dante Gabriel Rossetti
1850
Tate Gallery, London

# *The Annunciation*

In this highly refined watercolor by James Tissot, in addition to the care the artist took in the ethnographic reconstruction of the environment and of Mary's figure—the result of specific studies and the artist's complex spiritual journey—the innovative representation of the archangel Gabriel stands out. He has depicted God's messenger as a cherub (in blue), and this is perfectly in keeping with the this angelic choir; it also appears to be consistent with the evolution of the image of the archangel with peacock wings, which we have met often.

THE ANNUNCIATION
James Tissot
1886–94
The Brooklyn Museum, New York

# The Nativity and the Announcement to the Shepherds

▶▶

" And it came to pass in those days, that there went out a decree from Caesar Augustus, that all the world should be taxed. [. . .] And so it was, that, while [Joseph and Mary] were there [in Bethlehem], the days were accomplished that she should be delivered. And she brought forth her firstborn son, and wrapped him in swaddling clothes, and laid him in a manger; because there was no room for them in the inn. And there were in the same country shepherds abiding in the field, keeping watch over their flock by night. And, lo, the angel of the Lord came upon them, and the glory of the Lord shone round about them [. . .]. And the angel said unto them, Fear not: for, behold, I bring you good tidings of great joy [. . .]. For unto you is born this day [. . .] a Saviour, which is Christ the Lord. [. . .] And suddenly there was with the angel a multitude of the heavenly host praising God, and saying, glory to God in the highest, and on earth peace, good will toward men. "

The intense luminance of this work is extraordinary, and truly innovative for the time. First of all, the angel is the source of light: He appears in a nimbus, a cloud that opens and magnifies the luminosity; his dress is a bright white tunic girded at the waist; he holds a scepter in his hand. Behind him, the halo around his head contrasts with the darker background.

ANNUNCIATION TO THE SHEPHERDS
Taddeo Gaddi
1327–30
Santa Croce, Florence

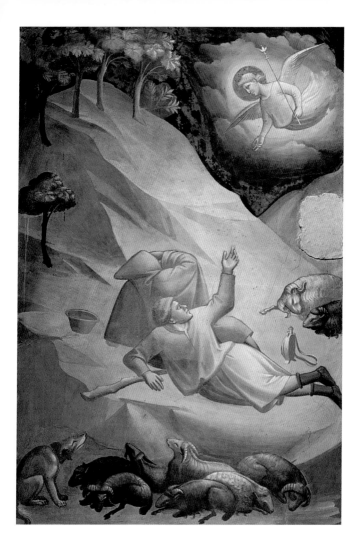

# The Nativity and the Announcement to the Shepherds

This is probably Piero della Francesca's last work, left incomplete because of the progressive blindness that he suffered. This particular panel is a contrast of joy and sorrow: joy for the Child's birth, sorrow for his fate. The magpie (a symbol of the devil) signifies sorrow, as does the braying donkey (a dissonant sound in the harmony of the cosmos, therefore another diabolical sign). The thistles in the foreground, with thorns prefiguring the Passion, are highlighted by the goldfinch on the lower left. Signs of joy are the gesture of the shepherd pointing to the invisible presence of the angelic herald and, above all, the group of adoring angels dressed with the typical *guarnello*, playing the lute and the *vihuela* (or *viella*), a thirteenth-century Spanish stringed instrument related to the lute. The angels' task is to sing the glory of the cosmos.

NATIVITY
Piero della Francesca
1470–75
National Gallery, London

# The Nativity and the Announcement to the Shepherds

Inspired by this passage from the Gospel of Luke, in which angels appear over and around the hut, this work by the Flemish artist Hugo van der Goes is much more complex than the text, since he depicts different groups of angels witnessing the divinity of the Child. We are struck by the sumptuousness of their ecclesiastical vestments: The blue angels are dressed like subdeacons, the white ones as deacons, and the stupendous copes embroidered in purple and gold are those worn by priests and bishops. But the decision to portray them in these clothes has an even deeper significance, for the wide stoles worn by the angels kneeling at bottom right have the words *Sanctus, Sanctus, Sanctus* ("Holy, Holy, Holy"—the seraphim's motto) embroidered on them.

We have commented often on the continuous superimposition of seraphim and cherubim—the peacock wings, for example, were to be a naturalistic interpretation of the cherubim's wings—and we have already illustrated the iconography of the two-winged cherubim.

It is therefore likely that the artist intended to depict cherubim, while the crowns on their heads would tend to support the idea that they belong to the highest of the three upper hierarchies.

PORTINARI TRIPTYCH
(detail)
Hugo van der Goes
1475–77
(620) Galleria degli Uffizi, Florence

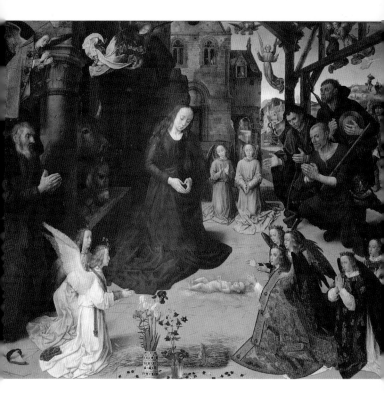

# The Nativity and the Announcement to the Shepherds

This fresco by Pinturicchio, which serves as altarpiece in the Della Rovere Chapel of the Church of Santa Maria del Popolo in Rome, has an unusual detail: The herald angel who appeared to the shepherds, as reported by Luke, shines high in the sky, and is at the same time the star of the Magi. It is not by coincidence that below the rock from whence a shepherd (one only, representing all of them) looks at the angel while tending his flock, we see a band of elegantly dressed horsemen riding down the slope;

they are the Magi. Therefore, since there is no star and the angel shines brightly with golden rays shooting from his side, we conclude that the angel plays the role of divine star. This episode is explained thoroughly by the philosopher and theologian Thomas Aquinas (*c.* 1225–74) in a passage of his *Summa Theologiae*, where he writes of the nature of the star: "Indeed, others say that the angel that appeared in human form to the shepherds, appeared as a star to the Magi." Pinturicchio has translated this concept into an image.

ADORATION OF THE SHEPHERDS
Bernardino di Betto, known as Pinturicchio
1488–90
Santa Maria del Popolo, Rome

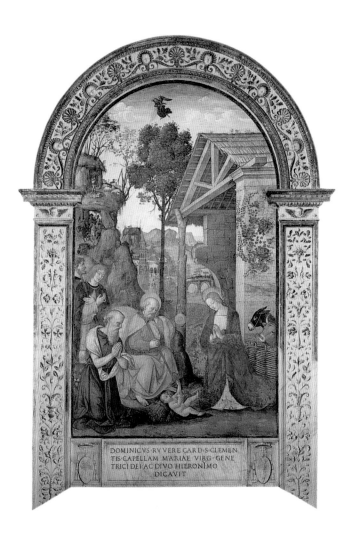

DOMINICVS·RVVERE·CARD·S·CLEMEN
TIS·CAPELLAM·MARIAE·VIRG·GENE
TRICI·DEI·AC·DIVO·HIERONIMO
DICAVIT

# The Nativity and the Announcement to the Shepherds

This panel by Botticelli interprets the Nativity as a propitious sign for renewed harmony between men and God. This work was influenced by the thought of Girolamo Savonarola as an impassioned reflection on the dark days of Florence after the death in 1492 of Lorenzo il Magnifico, the 1494 French invasion of Naples, and Cesare Borgia's Faenza siege of 1501, which imperiled all of Tuscany.

Above the angels, a Greek sentence conceived and inscribed by the artist explicates these feelings that run through the entire composition. Indeed, monstrous demons hide in the ravines that dot the meadow, while men and angels embrace each other, and the fluttering scrolls allude to the melody of Luke's angels, who sing: "Glory to God in the highest and on earth peace, good will toward men."

THE MYSTICAL NATIVITY
Alessandro di Mariano Filipepi, known as Sandro Botticelli
1500
National Gallery, London

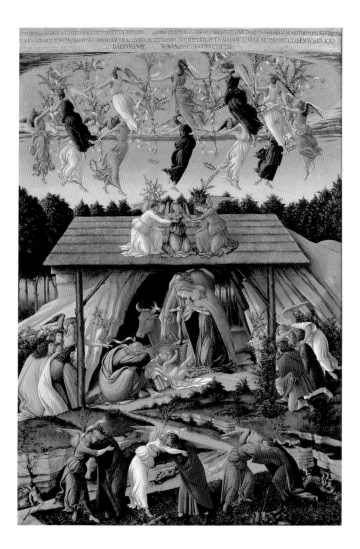

# The Nativity and the Announcement to the Shepherds

In this painting by Piero di Cosimo, the figure of Joseph is confined to the background; he is driving to pasture the ox and the donkey that are to warm Jesus with their breath. In the foreground are the Madonna and Child, John the Baptist, and two musical angels. The angels' dress does not conform to the contemporary tradition, since the artist has mixed details from clerical garb proper (the stole across the chest) and modern layman's wear (the *guarnello* and the yellow cape). The presence of wind instruments, instead of the traditional lute and *viella* that evoke the harmony of the spheres, suggests the rustic milieu and the future adoration of the shepherds. Elegant and sinuous, the two angels have feminine features, which by this time had become an established metaphor for divine beauty.

THE ADORATION OF THE CHRIST CHILD
Piero di Lorenzo, known as Piero di Cosimo
1505
Galleria Borghese, Rome

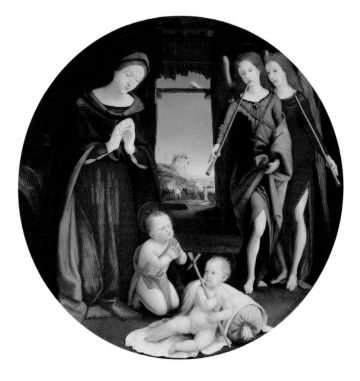

# The Nativity and the Announcement to the Shepherds

This suggestive *Nativity* from the Grimani Breviary presents unusual and noteworthy details, such as the decision to make the figure of the Child the only source of light of the entire scene, endowing him with momentous symbolism. The dresses of the flying angels end in spirals, as if suddenly emptying themselves of the creatures they are clothing. The artist's intention was to suggest the immateriality of the angel's body, which becomes pure impalpability due to its spiritual, ethereal, or fiery nature, depending on the different theological opinions. Once again, we note that the angels are dressed as subdeacons, deacons, and priests. Note also that the hut has columns and draws on the theme, by then consolidated, of a (pagan) temple in ruins, which the presence of Christ has transformed into a new church.

THE NATIVITY
16th century
Biblioteca Nazionale Marciana, Venice

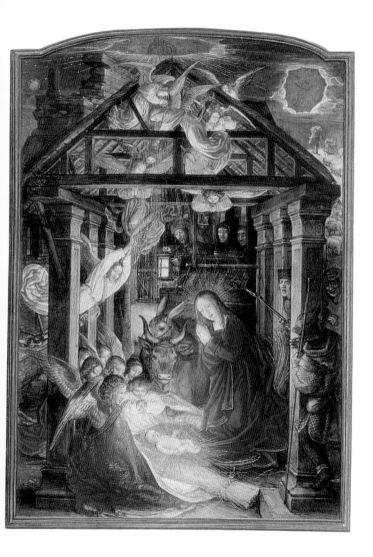

# The Nativity and the Announcement to the Shepherds

Created for the priorate of the community of Saint Anthony in Hildesheim, this altar was a complex structure consisting of an architectural part, a sculptural one (partially lost or destroyed), and a pictorial one, all skillfully executed by Mathias Grünewald with deep artistic sensitivity. The two panels of *Concert of Angels and Nativity* truly form an iconographic whole, where the presence of the angels is underscored. The panel on the left has angels meeting together to play inside a temple that features vinelike columns; it is the Temple of Solomon, drawn in the exuberant Gothic style that was still prevalent in Germany at the time. In the foreground, outside the temple, a musical angel plays the *lira da gamba*, while inside more angels play the *lira da braccio* and sing. In the first row on the left, a feathered angel, depicted following a popular fifteenth- and sixteenth-century English and German iconography, may be identified as a cherub. Its presence is justified by the traditional comparison of musical angels to birds (see pages 356–57). The panel on the right shows the Nativity; there, the diaphanous angelic figures have clearly issued from that forge of divine heralds that is the bright rend in the sky, where God the Father appears in glory, surrounded by myriads of blazing angels.

CONCERT OF ANGELS AND NATIVITY
Mathias Grünewald
*c.* 1515

Musée d'Unterlinden, Colmar

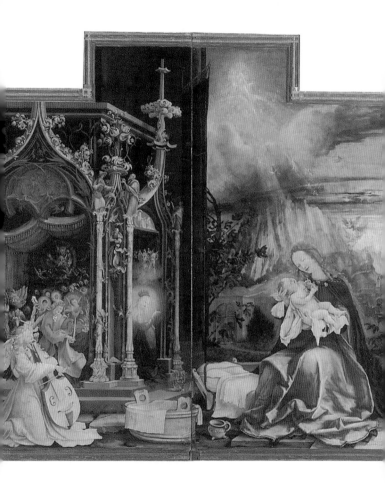

# The Nativity and the Announcement to the Shepherds

The presence of Joseph discreetly in the background, where we have often seen him, makes of this *Adoration* by Pellegrino Tibaldi a Nativity. Clearly influenced by Michelangelo's *Last Judgment*, which had been completed just a few years earlier, the artist here has highlighted the presence of the angels by placing them in the upper part of the composition, as if leaning out to guide the worshippers. In particular, the angel in the center holds a scroll that evokes the melody of which Luke wrote (1:14): "Glory to God in the highest and on earth peace, good will toward men." Although the scene is indoors, it is lit by the presence of the angels, who are like a vision to the worshippers, most likely shepherds, who have come to render homage to the Child.

ADORATION OF THE CHRIST CHILD
Pellegrino Tibaldi, known as il Pellegrini
1548
Galleria Borghese, Rome

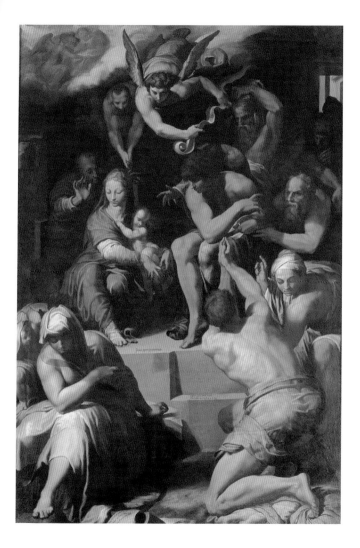

# The Nativity and the Announcement to the Shepherds

In the Quattrocento, a lighting solution developed that was increasingly adopted, in part due to its deep symbolism. The artists began to consider the infant Jesus as the sole source of light, an interpretation adopted by Vasari in this painting. The artist from Arezzo has taken pleasure in displaying his virtuosity in rendering the lighting effects on the worshipping shepherds, whose bodies emerge gradually from darkness, just as they are slowly moved from the darkness of ignorance to the light of the true faith. The principal novelty of this work, however, lies in the fact that, although they are bright, the cherubim singing in the clouds and dropping rose garlands below are still less luminous than the Child, as if, now that Jesus has come down to Earth, the heavens are less luminous for it.

THE NATIVITY
Giorgio Vasari
*c.* 1546
Galleria Borghese, Rome

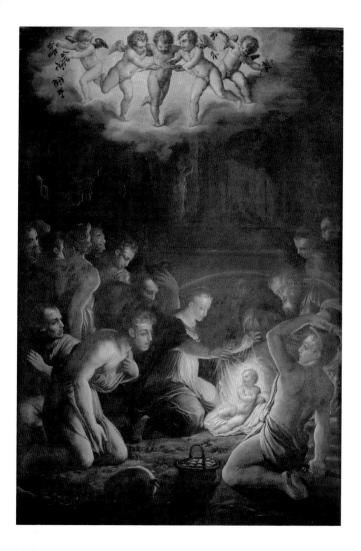

◄◄ ◄

# The Nativity and the Announcement to the Shepherds

This large painting by El Greco, arranged vertically, divides the scene into two parts, a solution adopted by the artist in other works as well. The Nativity and the adoration of the shepherds are in the lower part of the composition (illustrated on the opposite page). The shepherds approach and kneel before the Child, the central source of light that illuminates them. In the upper part of the painting are the angels holding scrolls and singing God's glory.

The artist here has prefigured the changes in angelic images that will develop in the seventeenth century; we see it in the adoring angel, the only one in this scene. From this point forward, the garment of the divine heralds—whose features will become increasingly more feminine—will become simpler, until it is a shapeless dress, a mere piece of fabric, more or less decorated, that follows the body almost as if blown by a divine wind.

ADORATION OF THE SHEPHERDS
(detail)
Doménikos Theotokópoulos,
known as El Greco
1596–1600
National Museum of Romanian Art, Bucharest

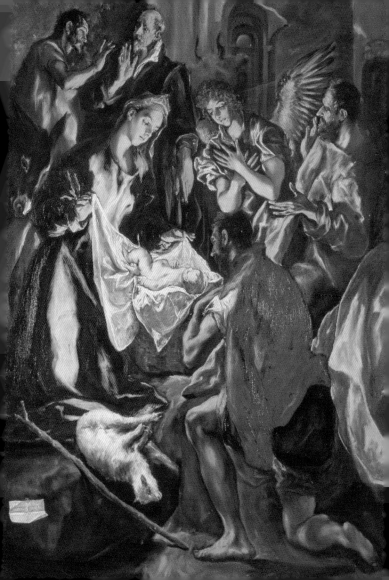

# Presentation of Jesus to the Temple and Circumcision

" And when eight days were accomplished for the circumcising of the child, his name was called JESUS, which was so named of the angel before he was conceived in the womb. And when the days of her purification according to the law of Moses were accomplished, they brought him to Jerusalem, to present him to the Lord; (As it is written in the law of the Lord, Every male that openeth the womb shall be called holy to the Lord;). And to offer a sacrifice according to that which is said in the law of the Lord, A pair of turtledoves, or two young pigeons. "

The quotation from the Scriptures mentioned by Luke at the end of this passage is from Leviticus (5:7, 12:8), the book that contains all the precepts to be followed by those faithful to God. In the case of circumcision, the sacrifice of a lamb was required only of the wealthy, and those who were not rich, like Mary and Joseph, could sacrifice turtledoves or pigeons instead. This scene created by Giotto for the Scrovegni Chapel marks the prodigious nature of the event with the presence of the angel. The divine herald suddenly comes down from heaven and seems to approach the priest, to guide his hand during the circumcision ritual.

NO. 19 SCENES FROM THE LIFE OF CHRIST:
3. THE PRESENTATION OF CHRIST AT THE TEMPLE
Giotto di Bondone, known as Giotto
1303–1305

Cappella degli Scrovegni, Padua

# The Baptism of Jesus

> Now when all the people were baptized, it came to pass, that Jesus also being baptized, and praying, the heaven was opened, And the Holy Ghost descended in a bodily shape like a dove upon him, and a voice came from heaven, which said, Thou art my beloved Son; in thee I am well pleased.

This fresco by Masolino da Panicale renders faithfully the passage from Luke. On the right is the crowd of people who have just come to John to be baptized. The artist has taken pleasure in displaying his skill, depicting the neophytes in different, even unconventional poses. On the opposite bank of the Jordan River, Masolino painted the three angels holding the garments while Jesus wades into the river. High in the sky, the dove of the Holy Spirit appears as the Baptist baptizes him.

BAPTISM OF CHRIST
Masolino da Panicale
1435
Battistero della Collegiata, Castiglione Olona

# The Baptism of Jesus

This *Baptism* by Veronese, painted toward the end of an exceptional artistic career, almost prefigures the luministic contrasts of Caravaggio. The unusual setting is a favorite of the artist, one he used in other works as well. The episode takes place in a wooded area along the banks of a river that the light can barely penetrate, a solution with clear symbolic implications. Thus, the blindingly white dove of the Holy Spirit shines with its own light, as do the halos surrounding the heads of Christ and the Baptist. The angels receive the light and are depicted as humble servants, praying or holding garments for Christ, who has just undressed himself to receive the baptism. The feminine beauty and chaste sensuality of the angels contribute to the bucolic quality of the entire scene. Nevertheless, the fact that the woodland is an oak grove and the angels are three in number is symbolic of the Trinity, since one of the Old Testament episodes that prefigures the Trinity is the apparition to Abraham of the three angels under the Mamre oak trees (Genesis 18:1–8; see pages 124–42).

BAPTISM OF CHRIST
Paolo Veronese
*c.* 1575

Palazzo Pitti, Florence

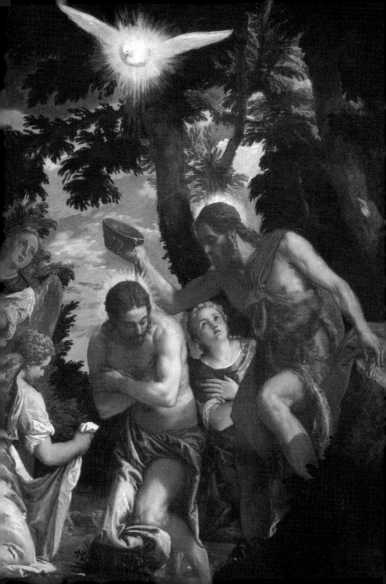

# The Last Supper

> And he took the cup, and gave thanks, and said, Take this, and divide it among yourselves: For I say unto you, I will not drink of the fruit of the vine, until the kingdom of God shall come. And he took bread, and gave thanks, and brake it, and gave unto them, saying, This is my body which is given for you: this do in remembrance of me. Likewise also the cup after supper, saying, This cup is the new testament in my blood, which is shed for you.

The *Last Supper* by Francesco Fontebasso revives an idea from Tintoretto (see pages 518–19), translated into eighteenth-century forms. The smoke from the lamp becomes impalpable angels, while the flames shed a light that is supernatural. Jesus is the figure who receives most of the light, and in turn a new light radiates from him into the room. The other figures become animated and the scene comes alive. The artist has painted the crucial moment of the blessing of the bread, just before the Eucharistic synapsis.

THE LAST SUPPER
Francesco Fontebasso
18th century
The Hermitage, Saint Petersburg

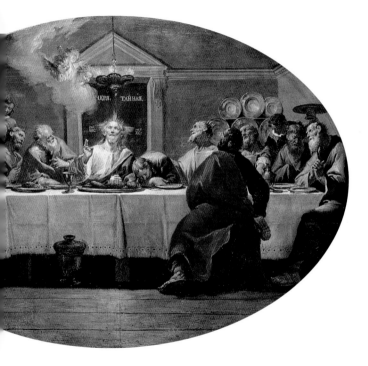

## *Jesus Prays on the Mount of Olives*

▸▸

"And he came out, and went, as he was wont, to the mount of Olives; and his disciples also followed him. And when he was at the place, he said unto them, Pray that ye enter not into temptation. And he was withdrawn from them about a stone's cast, and kneeled down, and prayed, Saying, Father, if thou be willing, remove this cup from me: nevertheless not my will, but thine, be done. And there appeared an angel unto him from heaven, strengthening him. And being in an agony he prayed more earnestly: and his sweat was as it were great drops of blood falling down to the ground. And when he rose up from prayer, and was come to his disciples, he found them sleeping for sorrow, And said unto them, Why sleep ye? rise and pray, lest ye enter into temptation."

This imaginary vision of the prayer in the Mount of Olives by Bernardino Cicogni, filled with gold and stars, has the figure of the angel at the end point of an upward path that begins from human weakness and rises up to the supreme sacrifice of Christ. All gold and dressed with the usual *guarnello*, the angel offers the cup to Jesus. The position of the angel's legs is in keeping with a specific iconographic trend intended to find the most appropriate visual solution to impart a sense of lightness and the spiritual nature of this figure.

PRAYER IN THE MOUNT OF OLIVES
(detail)
Bernardino Cicogni
1481
Biblioteca Piccolomini, Siena

646

# Jesus Prays on the Mount of Olives

Very close to Andrea Mantegna's *Agony in the Garden* (see pages 520–21), Bellini's work varies from it in some details. For one, it is more faithful to the Gospel text than Mantegna's. Indeed, here the angel that appears before Christ, anguished and tormented like the creases on his robe, offers him the cup. God's herald is a seraph fully immersed in light (and, therefore, made of fire), so that his body and garments are the same color as the sky, which is flooded with the dying, golden rays of the sun. Thus the cup becomes a metaphor for the Eucharist, and the vinegar that Christ will drink on the cross will become honey to humanity, which has been redeemed.

AGONY IN THE GARDEN
Giovanni Bellini
1465–70
National Gallery, London

648

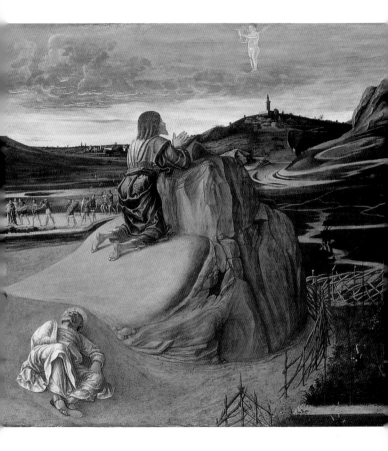

# *Jesus Prays on the Mount of Olives*

This artist painted several works on this subject, which today are preserved in several Italian museums, including Turin's Galleria Sabauda, the Castello Sforzesco, and the Pinacoteca di Brera in Milan. This painting is at Brera, and it is a particularly powerful version, especially the figure of the angel who, with uncommon force, approaches the meditating Christ and almost embraces him, exhibiting his powerful arm muscles. His immense wings are spread out, and the angel, like a divine heron, comes to Christ to tell him that the Father's will be done. It is a prodigious, intensely tragic night scene; in the foreground, barely gleaming, are the tools of his Passion: the cup, a nail, and the purse with the thirty coins.

CHRIST IN THE GARDEN
Francesco del Cairo
1633–35

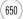

Pinacoteca di Brera, Milan

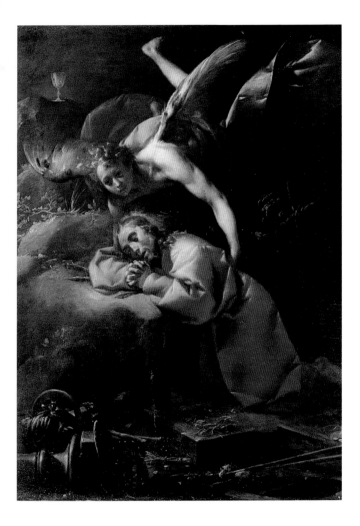

# Jesus Prays on the Mount of Olives

The great Spanish painter Goya dedicated two canvases to this theme, one preserved in Madrid, and this one at the Louvre. Both were created during the same period of religious reflection. Here also Christ is surrounded by the darkness of the night; he is inconsolably alone, a loneliness very similar to that of so many human beings. The traditional iconography has been totally discarded, except for the figure of the angel, who approaches, offering the cup. The scene is reduced to a sort of dialogue, the conclusion already prefigured in Jesus' gesture, his open arms in the form of the cross. The angel's light shines upon him, drawing him away from the darkness and lighting up his incomparable humanity, equal only to his divinity; the artist, however, has totally ignored the latter, halo notwithstanding. The angel has appeared suddenly, like a shooting star in the night that barely lights up Jesus' immense sadness.

CHRIST IN GETHSEMANE
Francisco Goya
1810–19
Musée du Louvre, Paris

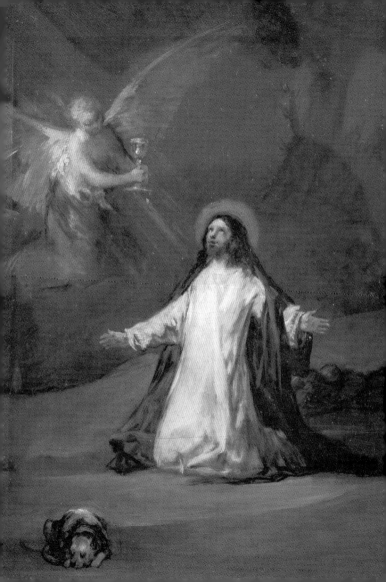

# The Crucifixion

>> 

" And when they were come to the place, which is called Calvary, there they crucified him, and the malefactors, one on the right hand, and the other on the left. [. . .] And the people stood beholding. And the rulers also with them derided him, saying, he saved others; let him save himself, if he be Christ, the chosen of God. And the soldiers also mocked him [. . .]. And a superscription also was written over him in letters of Greek, and Latin, and Hebrew, THIS IS THE KING OF THE JEWS. And one of the malefactors which were hanged [. . .] said unto Jesus, Lord, remember me when thou comest into thy kingdom. And Jesus said unto him, Verily I say unto thee, To day shalt thou be with me in paradise. [. . .] And the sun was darkened, and the veil of the temple was rent in the midst. And when Jesus had cried with a loud voice, he said, Father, into thy hands I commend my spirit: and having said thus, he gave up the ghost. "

This work by a budding genius, now preserved at the National Gallery in London, translates in Renaissance terms a still medieval composition; the two angels are modern, however, and they wear the *guarnello* and ribbons derived from deacon's stoles. They are carefully collecting the blood of Christ in golden goblets, which follows a medieval tradition that depicted them either busy at this task or weeping.

CRUCIFIXION (CITTÀ DI CASTELLO ALTARPIECE)
Raffaello Sanzio, known as Raphael
1502–1503
National Gallery, London

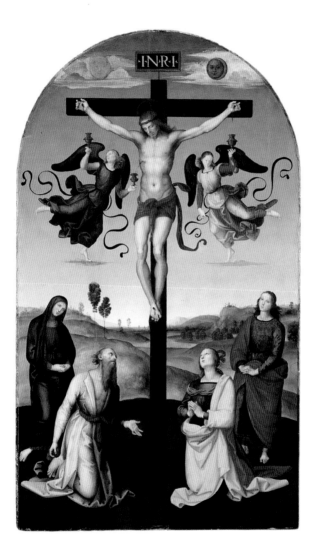

# The Crucifixion

This canvas by Bramantino stands out on account of an intentional moral connotation expressed in a number of symmetrical associations between the various elements of the composition. Like the other Gospels, that of Luke is extremely clear about the position of the two thieves who were crucified along with Jesus. The artist has highlighted this aspect, adding the dark figure of a devil with bat wings kneeling in midair to Christ's left, in line with the moon and the bad thief. On the opposite side, in line with the sun, an angel dressed in deacon's robes is positioned next to the good thief. Below the three crosses is the world of men, where this clear distinction becomes nuanced and uncertain; here are only Gospel characters, including the Madonna, John, and Mary Magdalene.

CRUCIFIXION
Bartolomeo Suardi, known as Bramantino
c. 1515
Pinacoteca di Brera, Milan

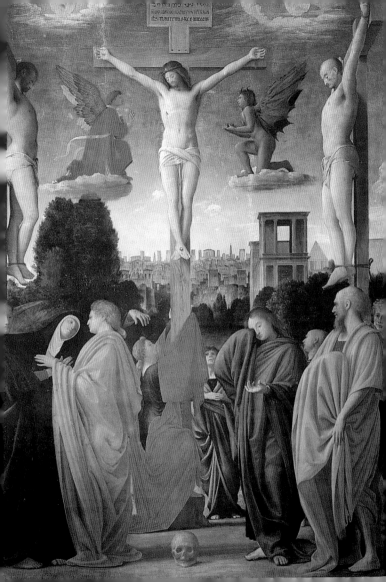

# The Angel Outside the Tomb

"Now upon the first day of the week, very early in the morning, they came unto the sepulchre, bringing the spices which they had prepared, and certain others with them. And they found the stone rolled away from the sepulchre. And they entered in, and found not the body of the Lord Jesus. And it came to pass, as they were much perplexed thereabout, behold, two men stood by them in shining garments: And as they were afraid, and bowed down their faces to the earth, they said unto them, Why seek ye the living among the dead? he is not here, but is risen: remember how he spake unto you when he was yet in Galilee, Saying, The Son of man must be delivered into the hands of sinful men, and be crucified, and the third day rise again. And they remembered his words."

This ivory carving in the collection of the Bargello Museum in Florence is a synthesis of several Gospel episodes that follow one another. From the left, as if coming out from the frame, the women come to the tomb to anoint the body of Christ with ointments, but, according to Matthew (28:2–7) and Mark (16:4–7), they find a white-robed young man seated on the tomb. The guards are still asleep, and the women look afraid, despite the angel's reassuring words.

THE DEVOUT WOMEN AT THE TOMB
AND THE SLEEPING GUARDS
5th century
Museo Nazionale del Bargello, Florence

658

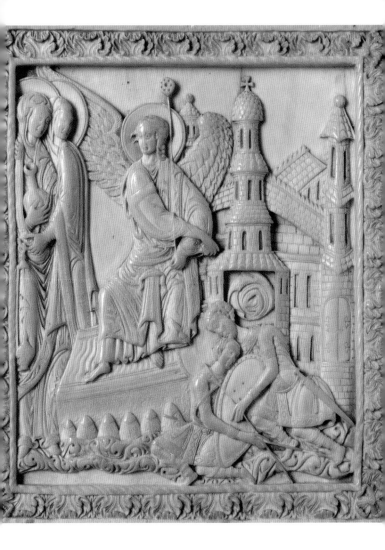

# The Ascension of Jesus

> And he led them out as far as to Bethany, and he lifted up his hands, and blessed them. And it came to pass, while he blessed them, he was parted from them, and carried up into heaven. And they worshipped him, and returned to Jerusalem with great joy: And were continually in the temple, praising and blessing God.

Andrea Mantegna has visually translated Luke's words ("he was carried up into heaven") by creating a flaming garland of red seraphim who, alternating with blue clouds, raise Jesus triumphant toward the Father. A glory of angels is the narrative core of the event, and is a clear demonstration of its prodigious nature. Below the sky streaked with snow-white clouds unraveling like cotton wool, on a barren, inhospitable earth that aptly translates the "out as far as to Bethany" of Luke's verse, Mantegna expansively portrays the feeling of wonder and admiration manifested by Jesus' disciples.

THE ASCENSION OF CHRIST
Andrea Mantegna
1460
Galleria degli Uffizi, Florence

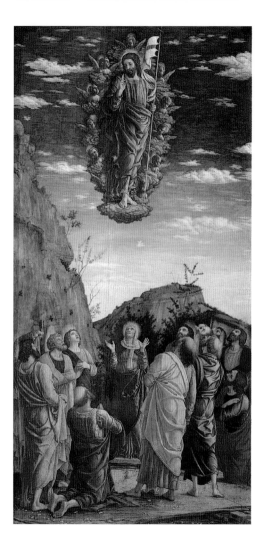

# The Ascension of Jesus

On the ceiling of the Ducal Chapel of Milan's Castello Sforzesco, restored at the behest of Galeazzo Maria Visconti by the architect Benedetto Ferrini during its renovation, a group of Lombard masters created this fresco of the Ascension. Unlike the narrative of the Gospels and Acts (1:1–14), this fresco fuses the moment of the Resurrection with that of the Ascension. Indeed, we see in the pendentives of the elegant pavilion a barren landscape with the Roman soldiers frightened and disoriented, trying to shield their faces from the unbearable light issuing from Christ. In the center of the scene is the sarcophagus that projects from a rocky cave, the artist's effort to reconcile the need to recognize the image with faithfulness to the text. Above the sarcophagus, surrounded by a garland of seraphim, is the figure of Christ, moving toward the Father between an array of acclaiming angels. Their robes moved by the wind, they form an elegant wreath, the decorative function of which is reinforced by the ribbons dancing in the wind.

THE ASCENSION OF JESUS
Lombard Masters
mid-5th century
Ducal Chapel,
Castello Sforzesco, Milan

# The Ascension of Jesus

The figures of the three angels next to the tomb in this visionary work by Albrecht Altdorfer put it in the context of the Gospel episode, for while the Scriptures do not mention the presence of the angels at the Resurrection, they are mentioned when the women go to the sepulcher. They are also implicit in the description of the Ascension, when Luke explains that Jesus "was carried up into heaven." Therefore, the German artist has blended the phases of the narrative: He has left the soldiers, since they refer directly to the Resurrection episode, and has added these three angels, who will carry Christ "up into heaven." Altdorfer has entrusted the prodigious nature of the event to a sky set on fire by a setting sun, a natural transposition of the theophany that some astonished soldiers are witnessing.

THE RESURRECTION OF CHRIST
Albrecht Altdorfer
c. 1516
Kunsthistorisches Museum, Vienna

# The Ascension of Jesus

This canvas was part of the series dedicated to the Passion of Christ that Rembrandt created for Prince Henry of Nassau. Here the purpose of the angels seems almost pure labor, because the group of cherubim placed beneath the brightly shining Christ seems to be straining to push the Savior upward. On this play of double meanings the artist builds the scene: A cloud pushed upward with such force by the cherubim seems light as a feather, and on it Jesus, whose figure is interwoven with light, seems even lighter. Other angels circle around in the luminous cone that leaves everything else in shadow, including the apostles, who watch in shock and admiration.

ASCENSION
Rembrandt von Rijn
1636
Alte Pinakothek, Munich

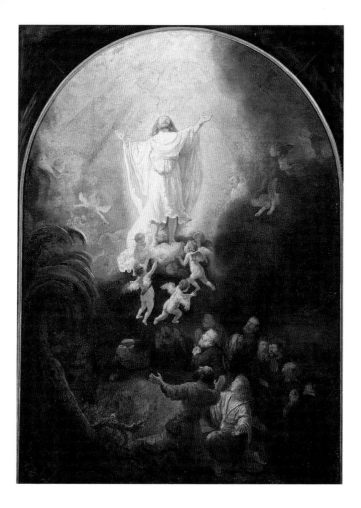

# *The Miracle at the Pool of Bethesda*

After this there was a feast of the Jews; and Jesus went up to Jerusalem. Now there is at Jerusalem by the sheep market a pool, which is called in the Hebrew tongue Bethesda, having five porches. In these lay a great multitude of impotent folk, of blind, halt, withered, waiting for the moving of the water. For an angel went down at a certain season into the pool, and troubled the water: whosoever then first after the troubling of the water stepped in was made whole of whatsoever disease he had. And a certain man was there, which had an infirmity thirty and eight years. When Jesus saw him lie, [. . .] he saith unto him, Wilt thou be made whole? The impotent man answered him, Sir, I have no man, when the water is troubled, to put me into the pool: but while I am coming, another steppeth down before me. Jesus saith unto him, Rise, take up thy bed, and walk. And immediately the man was made whole, and took up his mat, and walked.

The great Spanish painter Murillo illustrates this Gospel episode with a high degree of precision: There are the porticos, the paralytic man, and, in the background, shrouded in a halo of light that almost hides him, the impassive angel. Indeed, to heal, Jesus does not even need the man to step into the pool; he needs only word and the man's faith.

CHRIST HEALING THE PARALYTIC AT THE POOL OF BETHESDA
Bartolomé Esteban Murillo
1667–70
National Gallery, London

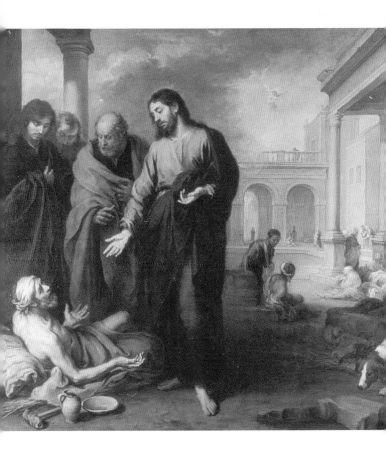

# The Crucifixion

> Then delivered he him therefore unto them to be crucified.
> And they took Jesus, and led him away. And he bearing his
> cross went forth into a place called the place of a skull, which
> is called in the Hebrew Golgotha: Where they crucified him,
> and two other with him, on either side one, and Jesus in the
> midst. And Pilate wrote a title, and put it on the cross. And
> the writing was, JESUS OF NAZARETH THE KING OF
> THE JEWS. [. . .] When Jesus therefore saw his mother, and
> the disciple standing by, whom he loved, he saith unto his
> mother, Woman, behold thy son! Then saith he to the disciple,
> Behold thy mother! And from that hour that disciple took
> her unto his own home. After this, Jesus [. . .], that the scrip-
> ture might be fulfilled, saith, I thirst. Now there was set a
> vessel full of vinegar: and they filled a spunge with vinegar,
> and put it upon hyssop, and put it to his mouth. When Jesus
> therefore had received the vinegar, he said, It is finished: and
> he bowed his head, and gave up the ghost.

Composed in the Gothic style, this elegant *Crucifixion* by Giovanni di Paolo uses the gold background to transform the moment of Christ's extreme sacrifice into a triumphant theophany. Small figures of weeping angels come and go in the precious sky, saturated with the same material of which they are made: the light. They tear their clothes and weep, but their sorrow turns into joy for man's salvation. Unaware, the figures at the feet of the cross cry inconsolably.

THE CRUCIFIXION
Giovanni di Paolo
*c.* 1440
Pinacoteca Nazionale, Siena

# *The Angel Outside the Tomb*

> The first day of the week cometh Mary Magdalene early, when it was yet dark, unto the sepulchre, and seeth the stone taken away from the sepulchre. Then she runneth, and cometh to Simon Peter, and to the other disciple, whom Jesus loved, and saith unto them, They have taken away the Lord out of the sepulchre [. . .]. Peter therefore went forth, and that other disciple, and came to the sepulchre. [. . .] Then cometh Simon Peter following him, and went into the sepulchre, and seeth the linen clothes lie, And the napkin, that was about his head, not lying with the linen clothes, but wrapped together in a place by itself. Then went in also that other disciple, which came first to the sepulchre, and he saw, and believed. For as yet they knew not the scripture, that he must rise again from the dead.

In contrast with the Gospel of John, which does not mention the angel, the iconographic tradition includes an angel in Resurrection scenes, such as this highly refined ivory piece, which depicts an angel standing guard at the open entrance to the sepulchre, with the resurrection of Lazarus carved on its doors. Represented without wings, as was the custom at the time, the divine herald is speaking, perhaps uttering Mark's very words (16:6): "He is risen; he is not here!"

THE DEVOUT WOMEN AT THE TOMB
AND THE SLEEPING SOLDIERS
5th century
Museo d'Arte Antica,
Castello Sforzesco, Milan

## *Noli me tangere*

➤➤

"Jesus saith unto her, Woman, why weepest thou? whom seekest thou? She, supposing him to be the gardener, saith unto him, Sir, if thou have borne him hence, tell me where thou hast laid him, and I will take him away. Jesus saith unto her, Mary. She turned herself, and saith unto him, Rabboni; which is to say, Master. Jesus saith unto her, Touch me not; for I am not yet ascended to my Father: but go to my brethren, and say unto them, I ascend unto my Father, and your Father; and to my God, and your God. Mary Magdalene came and told the disciples that she had seen the Lord, and that he had spoken these things unto her."

The Latin phrase *Noli me tangere*, which literally means "Touch me not," has been translated by modern scholarship by placing the accent not on the ban on touching, but on Jesus' admonition to not cling to him. Giotto has enriched this episode with two angels standing guard outside the tomb and has added two flying angels to underscore the prodigious nature of the event; they appear in the blue sky as if they had just materialized.

NOLI ME TANGERE
Giotto di Bondone, known as Giotto
*c.* 1309
Maddalena Chapel,
Basilica Inferiore di San Francesco, Assisi

# *Noli me tangere*

In composing this scene, the artist—who frequented, along with Philippe de Champaigne (see pages 248–49) the circle of intellectuals close to the Port-Royal Monastery—made simple but meaningful choices. The first was to portray the angel outside the tomb: Although it had not been a novelty since at least the time of Giotto, here it appears as a necessary premise and the very reason for the meeting between Jesus and Mary Magdalene. The perspective of the composition, in any case, places the two episodes in a cause-and-effect relationship—hence the diffuse, ethereal light radiating from the angel becomes transfused in the figure of Christ, who appears totally renewed, resurrected with no more traces of suffering, as the absence of the stigmata demonstrates. Indeed, his gesture undoubtedly is meant to prevent Mary Magdalene from looking at the Savior, whose "Glory body" can no longer be gazed at by human eyes.

NOLI ME TANGERE
Laurent de La Hire
1656
Musée des Beaux Arts, Grenoble

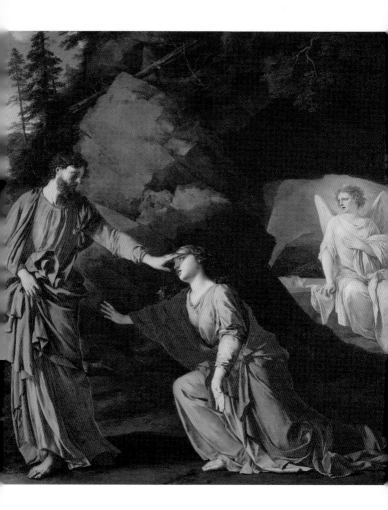

# The Ascension of Jesus

" To whom also he shewed himself alive after his passion by many infallible proofs, being seen of them forty days, and speaking of the things pertaining to the kingdom of God: And, being assembled together with them, commanded them that they should not depart from Jerusalem, but wait for the promise of the Father [. . .]. And when he had spoken these things, while they beheld, he was taken up; and a cloud received him out of their sight. And while they looked stedfastly toward heaven as he went up, behold, two men stood by them in white apparel; Which also said, Ye men of Galilee, why stand ye gazing up into heaven? this same Jesus, which is taken up from you into heaven, shall so come in like manner as ye have seen him go into heaven. "

This scene by Giotto—part of the Scrovegni Chapel cycle of frescoes—takes its cue from the above passage in Acts, marked by the presence of the two angels in the center below, asking the men who have gathered why they are looking at the sky. Completely faithful to the Scriptures,

Giotto has depicted eleven apostles, one fewer after Judas's betrayal. The presence of the Madonna, however, is not in line with a literal reading of the text, but perhaps Giotto found it impossible to believe that the Savior would ascend to heaven without taking leave from his mother as well.

NO. 38 SCENES FROM THE LIFE OF CHRIST:
22. ASCENSION
Giotto di Bondone, known as Giotto
1303–1305
Cappella degli Scrovegni, Padua

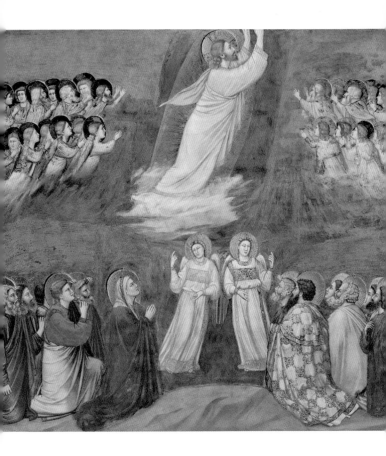

# Deliverance of Saint Peter

▶▶

"And when Herod would have brought him forth, the same night Peter was sleeping between two soldiers, bound with two chains: and the keepers before the door kept the prison. And, behold, the angel of the Lord came upon him, and a light shined in the prison: and he smote Peter on the side, and raised him up, saying, Arise up quickly. And his chains fell off from his hands. And the angel said unto him, Gird thyself, and bind on thy sandals. And so he did. And he saith unto him, Cast thy garment about thee, and follow me. [. . .] When they were past the first and the second ward, they came unto the iron gate that leadeth unto the city; which opened to them of his own accord: and they went out, and passed on through one street; and forthwith the angel departed from him."

This delicate panel, painted in a gentle, late Gothic style by Giacomo Jaquerio, transports this New Testament episode almost into a fairy-tale world while at the same time modernizing it. Indeed, the prison where Peter has been jailed is a medieval castle with corner turrets, embrasure, arrow slits, and double-mullioned windows. The angel who frees him, however, is a cleric wearing the dalmatic, which by then had become ecclesiastical garb; he is a deacon-angel coming to the aid of the first pope-apostle.

SAINT PETER DELIVERED BY THE ANGEL
Giacomo Jaquerio
15th century
Museo Civico d'Arte Antica, Turin

◄◄

# *Deliverance of Saint Peter*

►►

To understand the significance of this splendid illumination from the Graduale di San Pietro, which is fruit of the collaboration between Francesco Rosselli, who decorated the initial letter, and Liberale da Verona, who painted the scene inside it, we recall that this gradual was used specifically to celebrate Saint Peter's feast day. The apostle represents the Church, and the episode of his liberation has been interpreted as proof that God would ensure to the Church protection from its enemies. In this sense, the artist labored to superimpose Victory's classical figure on that of the angel; the latter, a torch in his hands, alludes to this further auspicious meaning.

SAINT PETER DELIVERED BY THE ANGEL
Francesco Rosselli and Liberale da Verona
*c.* 1475

Biblioteca Piccolomini, Siena

◄◄

# *Deliverance of Saint Peter*

This fresco by Raphael, one of the more celebrated renderings of Saint Peter's liberation, is a play on the symbology of light and lighting effects that seems to prefigure artistic solutions adopted in the Seicento. This scene, where the artist used to full advantage the clutter of the central door, receives light from many sources: first of all, the moon that feebly lights up the city sky; the live flame from the torch carried by a soldier making a tardy, useless round; and finally, the blinding light radiating from the angel. This last one is the true light, God's light, the light of faith that never dies out and that Peter is fated to bring to the world. Indeed, the inside of the jail is lit up like day, and provides the compositional and symbolic center of gravity to the entire fresco.

THE LIBERATION OF SAINT PETER
Raffaello Sanzio, known as Raphael
1513–14

Vatican Palace, Vatican City

# The Angelic Hierarchies: Powers, Principalities, and Dominions

> Far above all principality, and power, and might, and dominion, and every name that is named, not only in this world, but also in that which is to come.

Passages such as this contribute, on one hand, to formulate a concept of angelic hierarchy—a ladder that allows God's light to come down toward men without blinding them—and on the other, since the understood subject is Christ, to the affirmation of the superiority of the Messiah over the angels. From an iconographic point of view, there is no single representation, since there could be myriad solutions.

On this and the following pages, we compare the most important cycles, which provided parameters for artists of several eras. The Florentine mosaic on the facing page shows the Powers in armor with shields and spears, the Principalities carrying the standards of Christ's resurrection, and the Dominions wearing the Byzantine *loros* (an embroidered and jewel-encrusted strip of cloth) and carrying scepters.

PROCESSION OF ANGELS:
POWERS, PRINCIPALITIES, AND DOMINIONS
(details)
12th–14th century
Baptistery, Florence

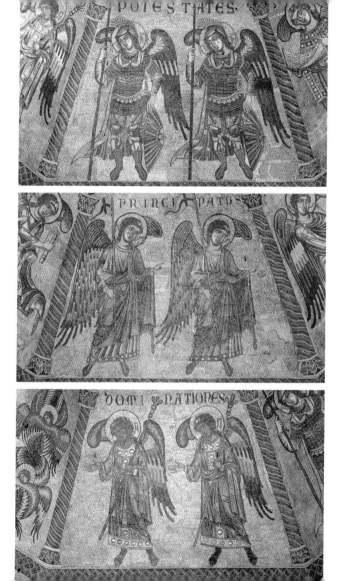

# The Angelic Hierarchies: Powers, Principalities, and Dominions

The codification of the angelic hierarchy as a theological concept and as a succession of angelic choirs was developed in the fifth century in the writings of Pseudo-Dionysius, who had a major influence on medieval Christian thought because he introduced the philosophical reasonings of Neoplatonism. The hierarchical sequence, set by Pseudo-Dionysius and revived by Dante in his poetic construction of paradise, moved from the bottom to the top as follows: Angels, Archangels, Virtues, Powers, Principalities, Dominions, Thrones, Cherubim, and Seraphim. This Venetian mosaic exhibits major variations compared to the Florentine one (see pages 686–87). For one, the Powers are represented wearing the traditional angelic dress—the dalmatic and the pallium—as they chain a demon. The Principalities are in armor with drawn swords, albeit in a seated position; they hold scrolls that identify them. The Dominions also are wearing armor and carrying spears in one hand and scales in the other hand as they strike a demon on the ground.

ANGELIC HIERARCHIES:
POWERS, PRINCIPALITIES, AND DOMINIONS
(details)
14th century
Baptistery,
Basilica di San Marco, Venice

# The Angelic Hierarchies: Powers, Principalities, and Dominions

The angel portraits by Guariento di Arpo, originally created for the Princes' Chapel in the Carraresi Royal Palace of Padua, are surely the most celebrated works of art illustrating the angelic hierarchies. The Powers are depicted holding the devil tied by a rope; the Principalities cut very elegant figures in their armor, a lovely "P" embroidered on their shields. Finally, the Dominions wear a cassock and are depicted as they weigh the souls and pierce the devil with a spear. This division of labor among the hierarchies was derived from the theological writings of both the Latin and Greek Fathers of the Church, starting from Saint Jerome, who, drawing on Origen, justified the differentiation of the angels into various classes by their individual merit. Still, according to Saint Hilary of Poitiers, their different status is a result of how God distributes roles and functions. Finally, according to Gregory of Nyssa, the difference lies in the specific activities that the angels perform.

ANGEL
Guariento di Arpo
1349–54
Musei Civici, Padua

# The Angelic Hierarchies: Powers, Principalities, Dominions, and Thrones

> For by him were all things created, that are in heaven, and that are in earth, visible and invisible, whether they be thrones, or dominions, or principalities, or powers: all things were created by him, and for him.

In Colossians, Saint Paul revisits the hierarchies and the angelic choirs by adding another class, the Thrones, which Pseudo-Dionysius placed in the first, and highest, hierarchy. In the mosaic that decorates the cupola of the Florence Baptistery, the Thrones are distinguishable by the mandorlas they hold in their hands, in blue fading to white. In this image, the mandorla probably stands for a mirror, as Dante explains through the words of Cunizza da Romano, the daughter of Ezzelino II, lord of the Marca Trevigiana: "Mirrors, ye call them thrones, from which to us / Reflected shine the judgments of our God" (*Paradiso*, IX, 60–63).

PROCESSION OF ANGELS: THRONES
(detail)
12th–14th century

Baptistery, Florence

# *The Angelic Hierarchies: Powers, Principalities, Dominions, and Thrones*

This Venetian image of the Thrones differs from that of the Florentine mosaic (see pages 692–93): Here the Throne angel is depicted wearing a crown, scepter in hand, seated on a starry, spherical sky that supports him like a wondrous pillow. Indeed, the artist's intention was to bind the Thrones choir to the starry sky, but the stars are none other than the mirrors of God's light, as amply documented in Christian literature.

Thus, the firmament is God's footstool, and, therefore, these angels are tied to the starry sky. In any case, Gregory the Great, writing about the Thrones, noted that they have this name because they are seated, and also because they possess absolute calm and peace, as God is enthroned on them. According to his vision, their "spiritual form" is that of welcoming God and enjoying his peace.

ANGELIC HIERARCHIES: THE THRONES
14th century
Baptistery,
Basilica di San Marco, Venice

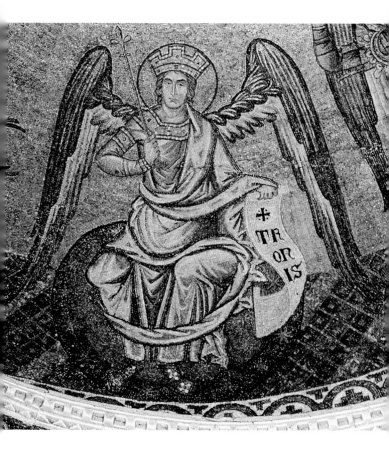

# The Angelic Hierarchies: Powers, Principalities, Dominions, and Thrones

Guariento di Arpo offers a suggestive image of the Thrones: He represents them seated inside a series of concentric circles marked by the rainbow (which, at the time of the artist, consisted of yellow, red, and black), traveling away from the viewer in the black space behind. Dressed in clerical garb, they each hold a lily and a dark globe. Most likely, these Thrones are seated on heavens that rotate concentrically and mirror God's will. On this point, we note that Gregory the Great, who would become pope, established a correspondence between the angelic hierarchies and Christian human virtues for, according to him, anyone who contemplates the Lord and accepts him in his or her soul as on a throne is assimilated to this angelic choir (see pages 694–95).

THRONES
Guariento di Arpo
1349–54
Musei Civici, Padua

696

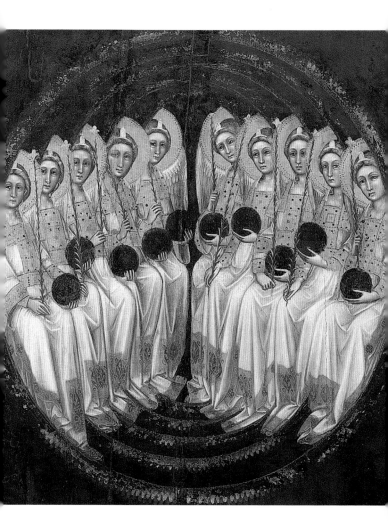

# The Descent into Limbo

> By which also he went and preached unto the spirits in prison; Which sometime were disobedient, when once the longsuffering of God waited in the days of Noah, while the ark was a preparing, wherein few, that is, eight souls were saved by water.

This work created by Jaime Serra for the altar of the Holy Sepulchre, at one time located in the Cathedral of Zaragoza, underscores the presence of angels who escort a pure, ethereal Christ. Their dark red robes and their golden wings, strewn with black dots suggesting the peacock's eyes, are visual details that identify these divine heralds as cherubim, or at least as high-ranking angels, as befits their role as escorts.

In any case, their majestic beauty is enhanced by the contrast with the hideous black demons balancing themselves atop the mount of hell. Gaping open like the door of a castle with a lowered drawbridge, or like the jaws of a monster fish, the mouth of hell lets through the holy patriarchs who could not be baptized, having been born before Jesus. Christ leads their long formation into paradise.

THE DESCENT INTO LIMBO
(detail)
Jaime Serra
1381–82
Museo de Zaragoza, Zaragoza

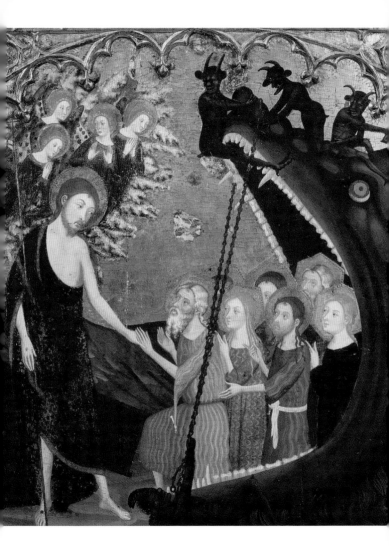

# The Punishment of the Rebel Angels

➤➤

"But there were false prophets also among the people, even as there shall be false teachers among you, who privily shall bring in damnable heresies, even denying the Lord that bought them, and bring upon themselves swift destruction. And many shall follow their pernicious ways; by reason of whom the way of truth shall be evil spoken of. And through covetousness shall they with feigned words make merchandise of you: whose judgment now of a long time lingereth not, and their damnation slumbereth not. For [. . .] God spared not the angels that sinned, but cast them down to hell, and delivered them into chains of darkness, to be reserved unto judgment."

Saint Peter's long speech ends with the example of the punishment meted out to the rebel angels. Though this episode does not appear explicitly in the Scriptures (except for Revelation), it is narrated clearly in the Enoch apocryphal text in Genesis (1:2 ff.) and also in the story of the children of Elohim (probably the angels) who lie with the daughters of men. Therefore, this passage from 2 Peter is the only explicit reference that contributed these scenes to the official iconography; one example is this masterpiece by the Master of the Rebel Angels, which portrays the angels being cast from the golden light down to the black of the bistre.

THE FALL OF THE REBELLIOUS ANGELS
Master of the Rebel Angels
14th century
Musée du Louvre, Paris

700

# The Punishment of the Rebel Angels

This celebrated scene, masterfully illuminated by the Limbourg brothers in the *Trè Riches Heures du Duc de Berry*, blends an extreme elegance of composition with an unexpected violence that aptly illustrates the crucial moment of the divine punishment. Satan falls headfirst, still wearing a deacon's tunic and stole that mark his previous status as preferred angel. Around God in papal bearing, supported by myriad blue cherubim and red seraphim, are three arrays of Thrones arranged in a semicircle: They are the third choir of the first angelic hierarchy. From here, the angels who rebelled against God are cast down. In the center is the militia proper, the Principalities or Powers, dressed in fifteenth-century military attire with iron shoes, shoulder straps, leather *lorica*, and helmets on their heads.

FALL OF THE REBEL ANGELS
Limbourg brothers
1415
Musée Condé, Chantilly

# The Punishment of the Rebel Angels

Frans Floris, an artist who matured by studying the paintings in the Sistine Chapel in Italy and those of the Italian Mannerists in France, chooses to depict the terrifying aspects of the scene in order to shock and awe the viewer. His interpretation is closer to that of Bosch, albeit revisited by new Italian experiences. Thus, the heads of the fallen angels have become heads of boars, felines, and monsters with tentacle hair. The angels who remained faithful to God have a tense yet serene expression and are dressed in light armor decorated with gold and precious stones. In the center, mortally wounded, the seven-headed dragon writhes and plunges headlong amid a wailing chorus.

THE FALL OF THE REBELLIOUS ANGELS
Frans Floris
1544
Koninklijk Museum voor Schone Kunsten, Antwerp

# The Punishment of the Rebel Angels

This famous panel by Bruegel is in the same visionary style as Floris's, and innovatively revives the style of Hieronymus Bosch. God's militia and the rebel angels pursue each other chaotically like a swarm of insects. The evil angels have already taken on the absurd shapes of flying fishes and fantastic hybrids, half-toad and half-bird; coleoptera with improbable *ghironda*-shaped bodies and formidable claws; huge fishes with delicate butterfly wings; or rats devouring one another. The angels, on the other hand, are deacons dressed in bright white tunics with red stoles blown about by the wind. A gaunt archangel Michael leads them, proudly dressed in a shining gold cuirass and a blue mantle, striking about him with his sword, but without any effort, as angels are wont to do.

THE FALL OF THE REBEL ANGELS
Pieter Bruegel the Elder
1562
Musées Royaux des Beaux-Arts, Brussels

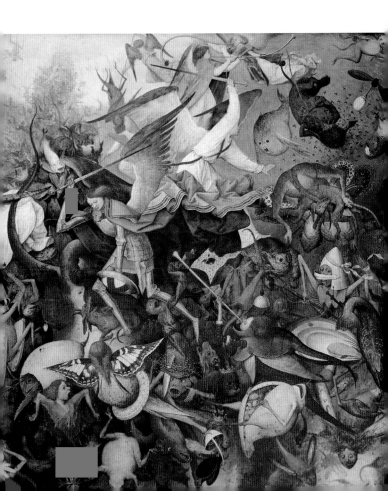

# The Punishment of the Rebel Angels

The undisputed hero of this painting is the archangel Michael: Shining shield in hand, he almost fills the center of the composition, while God is far in the background, seated on a throne of clouds. Holding his hand over the sphere of the earth, God notes what transpires and verifies that his will is being carried out by his militia. Statuesque angels make up the heavenly army. Only Michael is dressed like a Roman soldier, his fiery-red mantle flickering like a flame. The rest of the angels are practically naked, simply girded in rustling fabric stirred by the wind. The angels fall suddenly, thrown into the abyss together with the dragon, and we are reminded of the following passage: "And there was war in heaven: Michael and his angels fought against the dragon; and the dragon fought and his angels" (Revelation 12:7).

THE FALL OF THE ANGELS
Pieter Paul Rubens
*c.* 1619
Alte Pinakothek, Munich

# The Punishment of the Rebel Angels

The immense heavenly battle has been reduced by Giambattista Tiepolo to little more than a duel, an artistic choice that makes the scene even sharper. The foreshortened perspective, a favorite of this Venetian artist, fits beautifully with the subject matter and creates a daring, spectacular fall of the demons. The archangel Michael faces a band of demons alone, and does not even need to join a duel. All he has to do is open his arms to see his enemies plunge down, now differentiated from their former, resplendent status as angels by the bat wings, reptilian tails, black hair, and awkward, clumsy shapes. They plunge headlong like rocks into a precipice and leave behind them the memory of heaven.

THE FALL OF THE REBEL ANGELS
(detail)
Giambattista Tiepolo
1726
Palazzo Arcivescovile, Udine

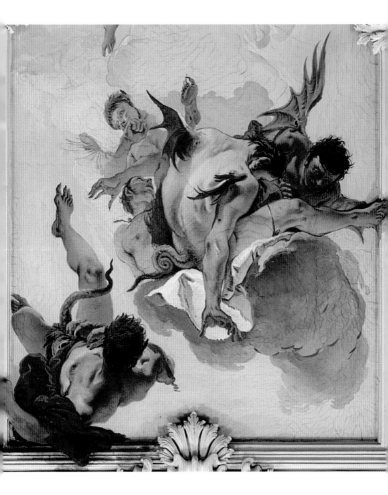

# John's Vision on the Island of Patmos

> I John [. . .] was in the isle that is called Patmos, for the word of God, and for the testimony of Jesus Christ. I was in the Spirit on the Lord's day, and heard behind me a great voice, as of a trumpet [. . .]. And I turned to see the voice that spake with me. And being turned, I saw seven golden candlesticks; And in the midst of the seven candlesticks one like unto the Son of man, clothed with a garment down to the foot, and girt about the paps with a golden girdle. His head and his hairs were white like wool, as white as snow; and his eyes were as a flame of fire; [. . .] and his voice as the sound of many waters. And he had in his right hand seven stars: and out of his mouth went a sharp twoedged sword: and his countenance was as the sun shineth in his strength.

John the Evangelist sits midway on a slope that symbolically links a monstrous-looking demon below to an air-colored angel above. This signifies man's position in creation, between angels and demons, who are the points of arrival of man's freely chosen actions—good and evil. Bosch enriches the illustration of this episode from Revelation with further meanings. John is on an island and turns around in the direction of a cone of light, where instead of a man, a woman "clothed with the sun" appears, as she does in other passages from Revelation (12:1–6).

SAINT JOHN THE EVANGELIST ON PATMOS
Hieronymus Bosch
*c.* 1500
Gemäldegalerie, Berlin

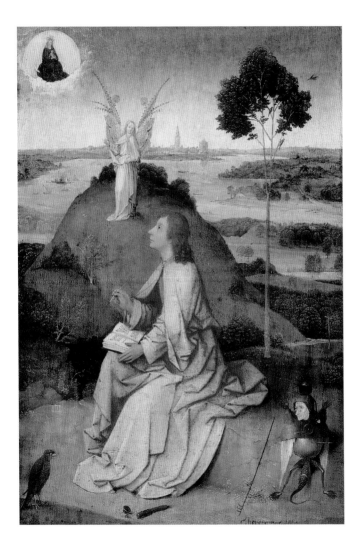

# *The Vision of the Seven Churches and the Seven Angels*

> The mystery of the seven stars which thou sawest in my right hand, and the seven golden candlesticks. The seven stars are the angels of the seven churches: and the seven candlesticks which thou sawest are the seven churches.

The churches of which John speaks are, in order, those of Ephesus (Revelation 2:1–6), Smyrna (2:8–11), Pergamus (2:12–17), Tiatira (2:18–29), Sardis (3:1–6), Philadelphia (3:7–13), and Laodycea (3:14–22), all major cities in Asia Minor, the peoples of which John addresses in his visions, that they may learn from them. The term "apocalypse" is derived from the Greek *apokalypto*, literally meaning "I discover, I reveal." The vehicles of this revelation are the angels sent to each church to explain the hidden meanings of John's vision, which has its roots in both the Old and the New Testament traditions. This large tapestry (more than three hundred feet long) was created by Robert Poinçon from cartoons by Jean Bondol.

THE APOCALYPSE OF ANGERS:
THE SEVEN CHURCHES OF ASIA
Robert Poinçon and Jean Bondol
1373–80
Castle, Angers

# The Vision of the Throne

> And immediately I was in the spirit: and, behold, a throne was set in heaven, and one sat on the throne. And he that sat was to look upon like a jasper and a sardine stone: and there was a rainbow round about the throne, in sight like unto an emerald. And round about the throne were four and twenty seats: and upon the seats I saw four and twenty elders sitting, clothed in white raiment; and they had on their heads crowns of gold. [. . .] And before the throne there was a sea of glass like unto crystal: and in the midst of the throne, and round about the throne, were four beasts full of eyes before and behind. And the first beast was like a lion, and the second beast like a calf, and the third beast had a face as a man, and the fourth beast was like a flying eagle. And the four beasts had each of them six wings about him; and they were full of eyes within: and they rest not day and night, saying, Holy, holy, holy, Lord God Almighty, which was, and is, and is to come.

This glowing panel by Jacobello Alberegno, with its resplendent golden background, is a literal rendition of Saint John's vision, which in turn recalls that of Ezekiel (1:1–28). This is clear from the multiplication of the eyes and wings of the four "beasts," which are also the symbols of the Evangelists.

VISION OF SAINT JOHN THE EVANGELIST
Jacobello Alberegno
1360–90
Gallerie dell'Accademia, Venice

# The Vision of the Throne

The Apocalypse Tapestry preserved at the Castle of Angers was already reputed to be an extraordinary artistic achievement by its contemporaries, who could admire its original colors, much more vivid than they are now. Commissioned by Louis I—duke of Anjou and brother of Charles V, king of France—it is still among the longest tapestries in existence, even if some scenes have been lost. The tapestry unfolds along the narrative from Revelation. Here John the Evangelist, on the right, contemplates the vision of what scholars refer to as the "Ancient of Days" or "he who is *ab aeterno*" ("since forever"), seated on a throne in a polylobate frame and surrounded by the Tetramorph beings, symbols of the four Evangelists. In his hands he holds the Lamb and the Book. High above are the angels; in the central registers we see crowned kings, hatted prelates, and tiaraed popes; below, the blessed carrying palm fronds. It is an adaptation of the established iconography of the time, which shows contamination by the iconography of the Last Judgment.

THE APOCALYPSE OF ANGERS:
THE CAMP OF THE SAINTS
Robert Poinçon and Jean Bondol
1373–80
Castle, Angers

# The Vision of the Throne

Another extraordinary series of episodes from Revelation was created by Albrecht Dürer in two editions, in 1498 and 1511. He also created a good number of the molds with highly refined engraving. The grandiose quality of the work is immediately apparent from the complex vision that appears as the doors open on heaven. Below is the outline of the wooded island of Patmos and the sea. Although Dürer remained completely faithful to the text, he added significantly to it. First of all, he added the figure of an angel with vigorous arms holding the throne of the Ancient of Days. In the Tetramorph vision, the winged man has the specific features of a cherub, placing Dürer in the unusual role of iconologist *ante litteram*, capable of visually underlining the textual links to Ezekiel (1:1–28). Second, John the Evangelist described the expression of the Elders as follows (4:10–11): "The four and twenty elders fall down before him that sat on the throne, and worship him that liveth for ever and ever, and cast their crowns before the throne, saying, Thou art worthy, O Lord, to receive glory and honour and power: for thou hast created all things, and for thy pleasure they are and were created."

THE REVELATION OF SAINT JOHN:
3. SAINT JOHN AND THE TWENTY-FOUR
ELDERS IN HEAVEN
Albrecht Dürer
1497–98
Staatliche Kunsthalle, Karlsruhe

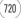

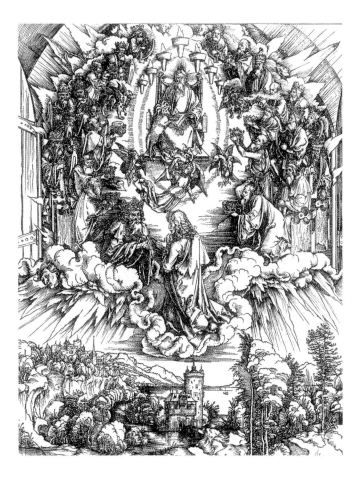

# *The Four Horsemen*

> And I saw, and behold a white horse: and he that sat on him had a bow; and a crown was given unto him [. . .]. And when [the Lamb] had opened the second seal, I heard the second beast say, Come and see. And there went out another horse that was red: and power was given to him that sat thereon to take peace from the earth, and that they should kill one another: and there was given unto him a great sword. And when he had opened the third seal, I heard the third beast say, Come and see. And I beheld, and lo a black horse; and he that sat on him had a pair of balances in his hand. And I heard a voice [. . .] say, A measure of wheat for a penny, and three measures of barley for a penny; and see thou hurt not the oil and the wine. And when he had opened the fourth seal, I heard the voice of the fourth beast say, Come and see. And I looked, and behold a pale horse: and his name that sat on him was Death, and hell followed with him.

In this famous woodcut, Dürer adds to the text the figure of the flying angel above the scene. The four horsemen are literal reproductions of John's vision, and the figure of the divine herald is the final justification for the scene; his presence explains how all that evil and all those atrocities are part of the divine plan.

THE REVELATION OF SAINT JOHN:
4. THE FOUR RIDERS OF THE APOCALYPSE
Albrecht Dürer
1497–98

Staatliche Kunsthalle, Karlsruhe

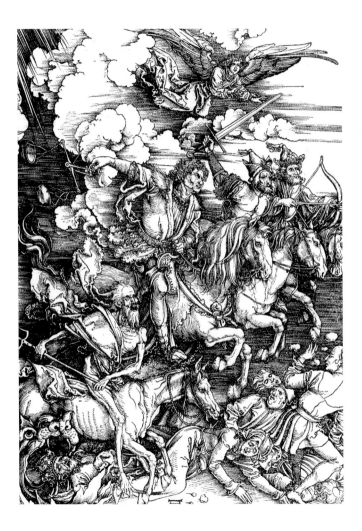

# The Angels Hold Back the Winds

And after these things I saw four angels standing on the four corners of the earth, holding the four winds of the earth, that the wind should not blow on the earth, nor on the sea, nor on any tree. And I saw another angel ascending from the east, having the seal of the living God: and he cried with a loud voice to the four angels, to whom it was given to hurt the earth and the sea, Saying, Hurt not the earth, neither the sea, nor the trees, till we have sealed the servants of our God in their foreheads.

The commentary to Revelation by the Spaniard Beatus (d. *c.* 800), a monk in the convent of Liébana in Asturias, was one of the most frequently reproduced texts of the Middle Ages, with understandable effects on later iconography. In this illumination from Beatus's *Commentary on the Apocalypse*, already the winds have the appearance of angels and are differentiated from the angel in the top center only by the breath coming out of their mouths. This passage in the Scriptures contributed to identifying winds with angels—an indispensable requirement for the attribution of wings to the angel that started in the fifth century.

ANGELS RESTRAINING THE WINDS
Pierpont Morgan Library, New York

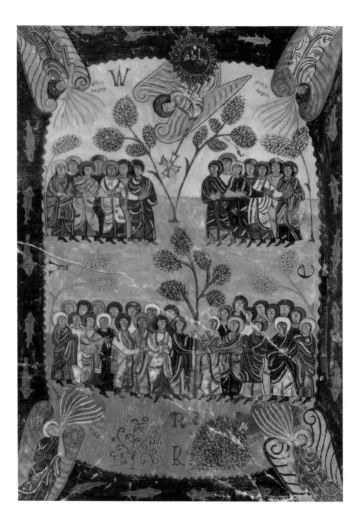

# The Angels Hold Back the Winds

The image of the episode that Dürer has created in this woodcut falls outside the cultural parameters that tended to superimpose angels and winds. In Dürer's time, the angels had an established, precise iconography and were represented as winged beings, because from the fifth century on they were identified with the winds (see pages 348–49). Here the artist differentiates by a mere look between angels and winds, placing the former on earth to rule over the latter, who are in the clouds. According to novel imagery that would start to prevail in the Renaissance, partially thanks to Dürer, the winds are visualized as faces blown up with air. The angels, on the other hand, are knights with large wings, swords, and mantles, and they have been given power to destroy the world. Finally, in the center above we see the angel with "the seal of the living God," which is the cross that he is carrying on his shoulder.

THE REVELATION OF SAINT JOHN:
6. FOUR ANGELS STAYING THE WINDS
AND SIGNING THE CHOSEN
Albrecht Dürer
1497–98
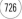
Staatliche Kunsthalle, Karlsruhe

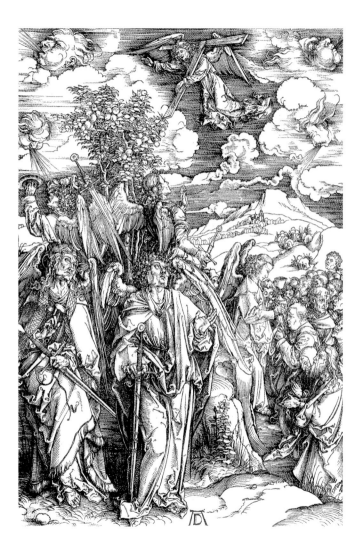

# The Angels Blowing the Trumpet and the Angel with the Censer

> And when he had opened the seventh seal, [. . .] I saw the seven angels which stood before God; and to them were given seven trumpets. And another angel came and stood at the altar, having a golden censer; and there was given unto him much incense, that he should offer it with the prayers of all saints upon the golden altar which was before the throne. [. . .] And the angel took the censer, and filled it with fire of the altar, and cast it into the earth: and there were voices, and thunderings, and lightnings, and an earthquake. [. . .] The first angel sounded [the trumpet], and there followed hail and fire mingled with blood, and they were cast upon the earth: and the third part of trees was burnt up, and all green grass was burnt up.

The figures of the seven angels with their trumpets, four to the left and three to the right, stand out starkly against the alarming red background, lining the way to the central mandorla that encloses the Ancient of Days, who holds both the book of the seven seals and the lamb in his hand. John the Evangelist timidly looks on from a side door, as witness and guarantor of the truth of the event: Everything stops in the presence of God, who reveals himself.

THE APOCALYPSE OF ANGERS: SEVENTH SEAL.
THE SEVEN TRUMPETS
Robert Poinçon and Jean Bondol
1373–80
Castle, Angers

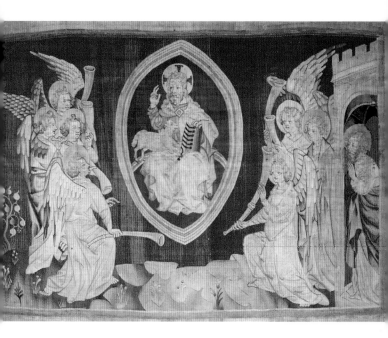

# The Angels Blowing the Trumpet and the Angel with the Censer

The iconographic design of the Apocalypse Tapestry breaks up the various Revelation scenes, with the same degree of attention paid to each detail. Here, for example, we see the angel with the golden censer; after spraying scents on the altar of God, the angel fills it with fire and hurls it into the earth as if it were a sling. The effects of this gesture are expressed in the faces of the winds that blow fire from an overhanging cloud—a fascinating (if arbitrary) addition to the text of Revelation. With a frightened expression, John the Evangelist understands the ill omen as he watches the other angel playing the second apocalyptic trumpet.

THE APOCALYPSE OF ANGERS:
THE ANGEL CASTING THE FIRE
OF THE CENSER UPON THE EARTH
Robert Poinçon and Jean Bondol
1373–80
Castle, Angers

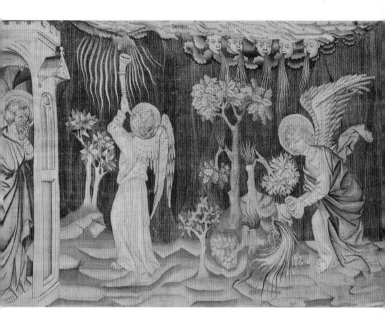

# The Angels Blowing the Trumpet and the Angel with the Censer

Dürer's elaborate woodcut unfolds the vision of John the Evangelist almost frame by frame, giving life to a busy and dynamic scene. The artist took pains to illustrate the effects of the sound of the trumpets, seeing what will transpire. In the upper part of the woodcut the angels are not yet playing, while the angel with the censer opens it before God to release the aromas and then hurls the fire into the earth. However, to the right and below the altar, the angels sound the clarion trumpets and immediately produce hail, fire, and blood. To the left below the altar, the star Wormwood falls, and, a little to the center, two powerful hands tear a mountain from the ground and hurl it into the sea. The ships sink and men despair.

THE REVELATION OF SAINT JOHN:
7. THE SEVEN TRUMPETS ARE GIVEN
TO THE ANGELS
Albrecht Dürer
1497–98
Staatliche Kunsthalle, Karlsruhe

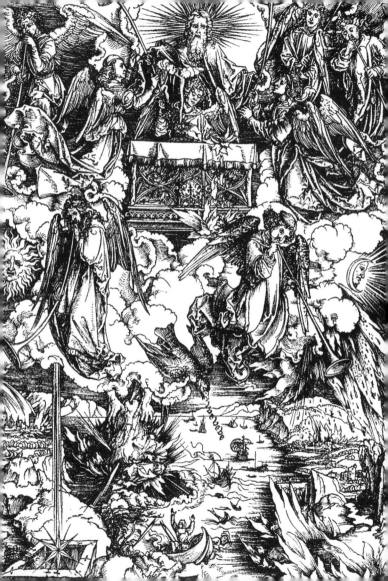

◄◄

# The Angels Blowing the Trumpet and the Angel with the Censer

This icon may be considered a summary of the main episodes of the Revelation of John the Evangelist, who, incidentally, has always been referred to as "Theologian" in Christian Orthodox milieu. In this icon, the figure of Christ on the top left is dressed as a priest (wearing the *podir*, the vestment of the high priests) and has white hair, following the text of Revelation (1:14). With his left hand, Christ holds a sphere with a multipointed star surrounded by seven trumpet-sounding angels, the same ones that we find in the lower part of the painting dressed in clerical robes, and each angel is standing near his church, as explained in Revelation (1:1–20, see pages 714–15). As we know, "they are the angels of the seven Churches"; but from each angel's mouth, only a trumpet comes out, which will bring the voice of the Lord to John.

THE VISION OF JOHN THE THEOLOGIAN
early 17th century
Tretyakov Gallery, Moscow

# The Second Angel Blows the Trumpet

> And the second angel sounded, and as it were a great mountain burning with fire was cast into the sea: and the third part of the sea became blood; And the third part of the creatures which were in the sea, and had life, died; and the third part of the ships were destroyed.

The bloodred background of this panel is the same frightening color as the mass of fire that is cast onto the earth and into the sea. The angel stays calm and impassive, and is as still as a tower. His instrument, more a horn than a trumpet, sends forth a gloomy sound that corresponds to the voice of God. He wears a snow-white robe with red lapels, red as the fire and the blood that has been shed. Behind him, John the Evangelist watches, disbelieving, and weeps. People despair in the sea, they flounder about and swim hopelessly, clinging to wreckage and pulling out their hair. Meanwhile, with each sound, fire, ashes, and stones are cast down from the sky like rain.

THE APOCALYPSE OF ANGERS:
SECOND TRUMPET. THE GREAT MOUNTAIN
BURNING WITH FIRE CAST INTO THE SEA
Robert Ponçon and Jean Bondol
1373–80
Castle, Angers

736

# The Wind-Angels Above the Euphrates

> And the sixth angel sounded, and I heard a voice from the four horns of the golden altar which is before God, Saying to the sixth angel which had the trumpet, Loose the four angels which are bound in the great river Euphrates. And the four angels were loosed, which were prepared for an hour, and a day, and a month, and a year, for to slay the third part of men.

Beatus of Liébana wrote an interesting comment on this specific passage from Revelation, which influenced angelic iconography, confirming the idea that the angels and the winds are the same thing. He wrote: "Babylon [. . .] must be interpreted as a symbol of confusion. Therefore, we may look at it as an image of this world, where the devil is kept bound. For which reason, [God] said: 'Loose the four winds which are bound in the Euphrates,' and it is as if he had said: 'Preach to the four corners of the world.' For at first he had said that they were four winds, now he states that they are four angels. Therefore, even here [God] shows that angels and winds are the same thing."

THE WIND-ANGELS ABOVE THE EUPHRATES
10th century
Biblioteca Nacional, Madrid

# The Angel with the Face as the Sun

▶▶

> And I saw another mighty angel come down from heaven, clothed with a cloud: and a rainbow was upon his head, and his face was as it were the sun, and his feet as pillars of fire: And he had in his hand a little book open: and he set his right foot upon the sea, and his left foot on the earth, And cried with a loud voice, as when a lion roareth: and when he had cried, seven thunders uttered their voices. [. . .] And I went unto the angel, and said unto him, Give me the little book. And he said unto me, Take it, and eat it up; and it shall make thy belly bitter, but it shall be in thy mouth sweet as honey.

As if creating a surrealist painting before its time, Albrecht Dürer illustrates John's visionary image with great, even brilliant effectiveness; he has depicted the angel's legs, described in the text as "pillars of fire," like architectural pillars lapped at the summit by fire. The body of the divine herald is impalpable, like a cloud, and the rainbow encircles his face like a halo. The exaggerated gesture of feeding the book of Wisdom into John's mouth highlights the incompatibility of the human and the divine—a gap that can be bridged only by God's will. Above, more angelic presences heighten the prodigious nature of the event.

THE REVELATION OF SAINT JOHN:
9. SAINT JOHN DEVOURS THE BOOK
Albrecht Dürer
1497–98
Staatliche Kunsthalle, Karlsruhe

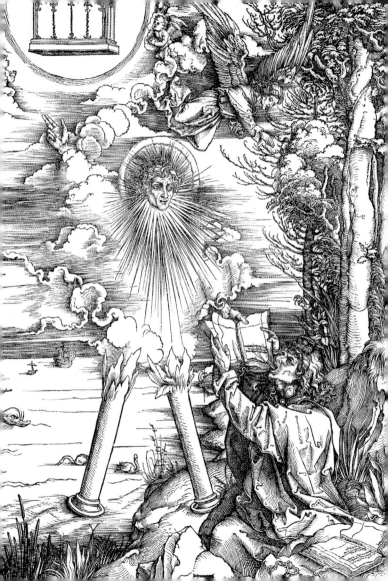

◄◄ ◄

# *The Angel with the Face as the Sun*

Artists such as Jean Duvet were inspired by the woodcut that Dürer had created at least fifty years earlier (see pages 740–41), adapting it and renewing its language. Duvet's copper engraving is smokier and less systematic than Dürer's woodcut, although just as monumental. The influence of the German artist is visible on top with the presence of the angel and the change in direction, as well as in the various positions of the characters—evidence that the French engraver took the fifteenth-century work as a model. Indeed, by copying Dürer's print on a mold and putting the plate through the printing press, the left and right of the original work are inverted once more. Duvet added some details, such as the numerical reference to the passage from Revelation. The scene, intentionally compressed into a restricted space, with the altar crammed in at the edge of the sheet, takes on a visionary, chaotic atmosphere in which the white spaces highlight the presence of the book, the apocalyptic angel, and the fantasy of the artist.

THE ANGEL WITH FEET LIKE
PILLARS OF FIRE
Jean Duvet
16th century
Musée du Louvre, Paris

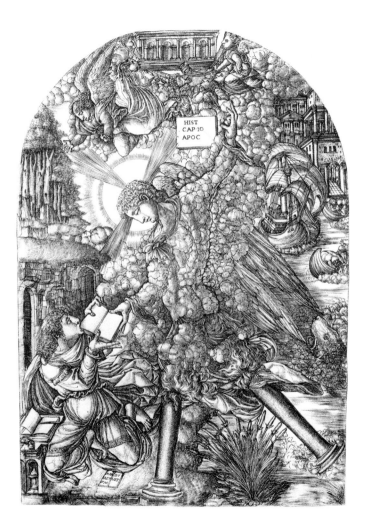

HIST
CAP·10
APOC

# *The Woman Clothed with the Sun*

> And there appeared a great wonder in heaven; a woman clothed with the sun, and the moon under her feet, and upon her head a crown of twelve stars: And she being with child cried, travailing in birth, and pained to be delivered. And there appeared another wonder in heaven; and behold a great red dragon, having seven heads and ten horns, and seven crowns upon his heads. And his tail drew the third part of the stars of heaven, and did cast them to the earth: and the dragon stood before the woman which was ready to be delivered, for to devour her child as soon as it was born. And she brought forth a man child, who was to rule all nations with a rod of iron: and her child was caught up unto God, and to his throne. And the woman fled into the wilderness, where she hath a place prepared of God, that they should feed her there a thousand two hundred and threescore days.

This scene from the Apocalypse Tapestry illustrates the assumption up to God, the or "catching" of the "man child who was to rule all nations with a rod of iron." Prefiguring what will be Quattrocento angelic fashion, the angels' garments seem to vanish at the edges, suggesting lightness and impalpability. Finally, the dragon is separated from the woman by a crown of clouds that encircle her in a blue space, a symbolic contrast with the red background.

THE APOCALYPSE OF ANGERS:
THE WOMAN CLOTHED WITH THE SUN
Robert Poinçon and Jean Bondol
1373–80
Castle, Angers

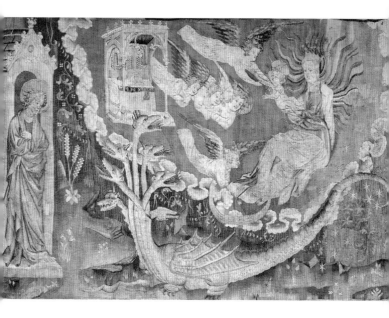

◄◄ ———————————————————————————————

# The Woman Clothed with the Sun

———————————————————————————————————

The image of the "woman clothed with the sun, with the moon under her feet, and upon her head a crown of twelve stars" is the source of the iconography of the Immaculate Conception. Although recognized as dogma only in the nineteenth century, it had become widely diffused in popular devotion and as a subject for artists. In this woodcut, the figure of the woman is by and large a prefiguration of the Virgin Mary, except for the wings. Here, as in the Apocalypse Tapestry (see pages 744-45), Dürer has chosen to highlight the presence of the angels who "catch" the child born of this woman, to avoid his being devoured by the dragon. Two child-like cherubim take him and carry him up to God the Father, who is waiting in a blessing pose. Here also the presence of the angels is arbitrary, since the text makes no mention of them. Their presence is thoroughly justified, however, since they are the only beings who could carry out such a task without altering the logic of the narrative.

THE REVELATION OF SAINT JOHN:
10. THE WOMAN CLOTHED WITH THE SUN
AND THE SEVEN-HEADED DRAGON
Albrecht Dürer
1497–98
Staatliche Kunsthalle, Karlsruhe

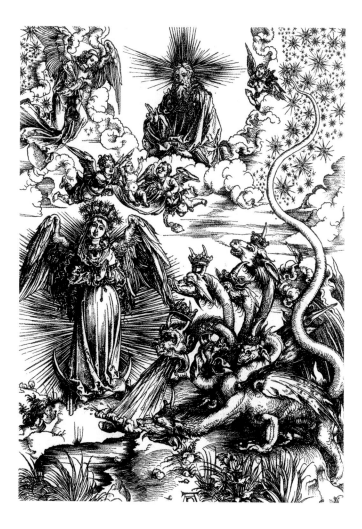

# Michael and His Angels Attack the Dragon

> And there was war in heaven: Michael and his angels fought against the dragon; and the dragon fought and his angels.

This is undoubtedly one of the most well-known images from Revelation, one with a truly monumental dimension, like sculptures in the tympani and on the doors of great cathedrals. Unlike sculpture, however, this fresco adds incisive colors that become multifaceted on the dragon's scales. Saint Michael is the only angel in military dress; he is on the left, striking the dragon's central snout (the other six heads are arranged around its neck). The other angels wear the traditional dalmatic and pallium, though they also carry spears. In the central mandorla, Christ is enthroned, while around him the "sky war" takes place, with angels and demons battling one another; the diaphanous slain demons fall under the large dragon and its concentric spirals.

MICHAEL AND HIS ANGELS
ATTACK THE DRAGON
11th century
San Pietro al Monte, Civate

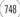

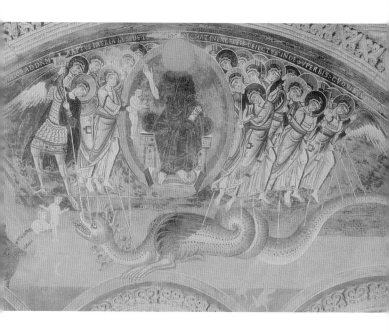

# Michael and His Angels Attack the Dragon

Exploiting the symbolism of colors and the wreaths of ribbon clouds that separate the good from the wicked, the Apocalypse Tapestry at the Castle of Angers displays the heraldic battle between God's angels and the dragon, by now in agony on the ground. The text from Revelation continues thus: "And the great dragon was cast out, that old serpent, called the devil, and Satan, which deceiveth the whole world: he was cast out into the earth, and his angels were cast out with him."(12:8–9). Thus, the huge, red, seven-headed dragon, which here, prodigiously, has a son, is hurled down to earth while the angels lean out from a blue window bordered with clouds and strike the ancient enemy that introduced discord between man and God at the dawn of Time, now defeated forever. The angels are armed with swords and spears but they have no armor, only wide cloaks, for their strength comes from the cross that Michael holds: That is the true sword.

THE APOCALYPSE OF ANGERS:
SAINT MICHAEL ARCHANGEL FIGHTING
AGAINST THE DRAGON
Robert Poinçon and Jean Bondol
1373–80
Castle, Angers

◀◀◀

# Michael and His Angels Attack the Dragon

Dürer has envisioned a true battle, hand-to-hand combat between the good angels and the wicked ones. The apocalyptic seven-headed dragon has disappeared, replaced by hideous, scaly, horned demons with skeletal wings—almost caricatures, for besides being ugly and frightening, evil is also grotesque and ridiculous. The angels, by contrast, are majestic and soar in the sky with their large wings. Even though they carry spears, swords, shields, and even bows, they also wear the cassock—as if to show that the most effective weapon is prayer. The battle unfolds in the sky, with the clouds coming between the combatants. Below, an indifferent landscape is isolated from the momentous tragedy unfolding above and the impending change in man's destiny.

THE REVELATION OF SAINT JOHN:
11. SAINT MICHAEL FIGHTING THE DRAGON
Albrecht Dürer
1497–98
Staatliche Kunsthalle, Karlsruhe

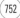

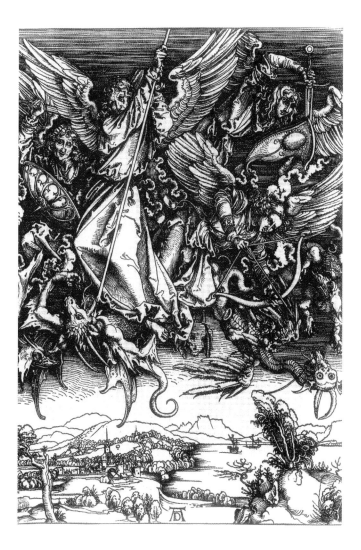

# The Son of Man Arrives with His Angels

"And another angel came out of the temple which is in heaven, he also having a sharp sickle. And another angel came out from the altar, which had power over fire; and cried with a loud cry to him that had the sharp sickle, saying, Thrust in thy sharp sickle, and gather the clusters of the vine of the earth; for her grapes are fully ripe. And the angel thrust in his sickle into the earth, and gathered the vine of the earth, and cast it into the great winepress of the wrath of God. And the winepress was trodden without the city, and blood came out of the winepress, even unto the horse bridles, by the space of a thousand and six hundred furlongs."

The dreadful scene described in the above passage is illustrated with great elegance by Jacobello da Alberegno, who has positioned the two angels each under aedicules— little shrines from which the angels lean out. Wearing deacon's clothes, the angel with the sickle is about to throw it on the ground, following advice of the other angel, who is dressed like a subdeacon with his slim tunic and seems to be coming out of the altar. The ambiguity of the text and the mention of a grape harvest, which is an important reference to the Gospel, make this scene, with the grapevines in the foreground, a disturbing prelude to the next one, when the winepress oozes blood that will cover all the surrounding lands.

THE HARVEST OF THE WORLD
Jacobello Alberegno
1360–90
Gallerie dell'Accademia, Venice

754

# *Babylon the Prostitute*

> So he carried me away in the spirit into the wilderness: and I saw a woman sit upon a scarlet coloured beast, full of names of blasphemy, having seven heads and ten horns. And the woman was arrayed in purple and scarlet colour, and decked with gold and precious stones and pearls, having a golden cup in her hand full of abominations and filthiness of her fornication: And upon her forehead was a name written, MYSTERY, BABYLON THE GREAT, THE MOTHER OF HARLOTS AND ABOMINATIONS OF THE EARTH. And I saw the woman drunken with the blood of the saints, and with the blood of the martyrs of Jesus.

This illumination, conserved at Toulouse, has a simple yet effective design. To the left is John, squeezing his hands, a sign of deep anxiety. A terrifying sight is before him, and only the angel who brought him in spirit into the wilderness so that he might witness these things can comfort him. The beast on which the woman sits, a cup in her hand, is Babylon, the very image of abomination. However, in creating this scene the artist has taken into account another passage from Revelation (13:2), where it is written: "And the beast which I saw was like unto a leopard, and his feet were as the feet of a bear, and his mouth as the mouth of a lion: and the dragon gave him his power, and his seat, and great authority."

THE WOMAN ON THE BEAST
14th century
Musée des Augustins, Toulouse

# The Angel Standing in the Sun

> And I saw an angel standing in the sun; and he cried with a loud voice, saying to all the fowls that fly in the midst of heaven, Come and gather yourselves together unto the supper of the great God; That ye may eat the flesh of kings, and the flesh of captains, and the flesh of mighty men, and the flesh of horses, and of them that sit on them, and the flesh of all men, both free and bond, both small and great.

This canvas by William Turner was inspired by the above passage from Revelation; he added to it other biblical figures, such as Adam and Eve in the bottom right corner, caught as they weep over Abel's dead body. Created in the last period of the artist's life, this canvas is an example of Turner's powerful visionary skill, for he has suggested with great effectiveness the status of the apocalyptic angel, who is not only "standing in the sun" but is "made of sun"—that is, of light. The scenes on the left are apparently linked to passages from Revelation that suggest cannibalism. The atmosphere is filled with a subtle feeling of death that contrasts with the colors, though it is made clear by the presence of the skeleton.

THE ANGEL STANDING IN THE SUN
William Turner
1840

Tate Gallery, London

# *The Angel Chains the Dragon*

> And I saw an angel come down from heaven, having the key of the bottomless pit and a great chain in his hand. And he laid hold on the dragon, that old serpent, which is the devil, and Satan, and bound him a thousand years.

This illumination from the Winchester Psalter is deeply suggestive, in addition to creating a strong visual impact. Hell is visualized as a huge beast with its jaws always wide open, as medieval tradition suggested, and is transformed into a horrible casket with a lock shut with a double turn by an angel of the Lord. The angel also carries out the task of chaining hell, its lord, and the souls of the damned. This image projects a strong apocalyptic feeling, even though the text it decorated was only a psalter. The angel of God cuts an elegant figure with its lines in the Gothic style and confirms with just one gesture the difference between good and evil, which confronted each other in the battle of the Apocalypse, and decrees the victory of the former and the defeat of the latter.

THE ANGEL LOCKS AWAY HELL
*c.* 1171
British Library, London

◀◀

# *The Angel Chains the Dragon*

With this woodcut we end the extraordinary series of illustrations by Albrecht Dürer. Here the artist has blended two conclusive passages from the apocalyptic text. In fact, in the forefront we see the angel binding the eternal enemy with a chain, a key, and a huge lock, in keeping with the previously cited passage. In the middle and the back, he added a scene that draws from a later event, when the angel shows to John the new Jerusalem. On top of the hillock, we see the apostle and the divine messenger, with large, open wings, pointing to a faraway spot in the valley, to a city renewed in spirit and "having the glory of God" (Revelation 21:10).

THE REVELATION OF SAINT JOHN:
15. THE ANGEL WITH THE KEY
TO THE BOTTOMLESS PIT
Albrecht Dürer
1497–98
Staatliche Kunsthalle, Karlsruhe

# The Vision of John the Evangelist

> And there came unto me one of the seven angels [. . .] and talked with me, saying, Come hither, I will shew thee the bride, the Lamb's wife. And he carried me away in the spirit to a great and high mountain, and shewed me that great city, the holy Jerusalem, descending out of heaven from God, Having the glory of God [. . .] [with] a wall great and high, and [. . .] twelve gates, and at the gates twelve angels, and names written thereon, which are the names of the twelve tribes of the children of Israel [. . .]. And the wall of the city had twelve foundations, and in them the names of the twelve apostles of the Lamb.

In this painting, characterized by strong lighting contrasts, Alonso Cano has depicted the heavenly Jerusalem, bathed in a golden atmosphere behind the angel and the Evangelist. This is an urbanistic translation of Mary, the Church, and Israel. He has drawn an Oriental architectural model and kept the number of gates—twelve, like the tribes of Israel and the apostles. While supporting John, the angel brings his hand to his chest as if to say, "Trust me . . . I will show you an extraordinary sight!" With this image we end our long journey among the angels on the tracks of the Scriptures—a path that brought together faith, history, and art.

SAINT JOHN THE EVANGELIST'S VISION OF JERUSALEM
Alonso Cano
1636–37
Wallace Collection, London

# ANGELS: DEFINITIONS AND CATEGORIES

According to a widely held religious belief not limited to Christianity, angels have a purely spiritual, incorporeal nature; they are God's perfect heralds and servants. The word "angel" comes from the Latin *angelus*, in turn derived from the Greek *ángelos*, which translates literally the Hebrew *malak*, meaning "he who announces." It is important to note that angelic figures are an integral part of Islamic as well as Hebrew theology: It is the archangel Gabriel who appears to Mohammed to apprise him of his mission the world (Surah II, 97–98).

Hence, angels not only protect human beings and ensure that their prayers reach God, but also supervise the functioning of the world; they move the stars and watch over all the elements of the universe, as well as over man's nations and cities. Finally, they are God's army, act as his messengers, and intervene to ensure that the will of the creator is enforced over all of creation.

In the Scriptures, angels appear often, but their types and classifications are not clearly defined; this took place later, in the first Christian centuries, under the Fathers of the Church—the leading Christian scholars—Pseudo-Dionysius in particular, who wrote *De coelesti hierarchia* [*On the Heavenly Hierarchy*]. This author had in antiquity been identified, mistakenly, with Dionysius the Areopagite, who was the first bishop of Athens and a disciple of Saint Paul. Recent scholarship has been able to date the texts of Pseudo-Dionysius to the fifth or sixth century CE, a discovery that undermines neither the importance nor the influence that this treatise had on the development of the theology of angels. Pseudo-Dionysius codified the structure of the angelic ranks into nine orders, organized in three triads whose rank depends on the degree of spiritual participation to God's mysteries. These concepts were later revived by Dante in his *Divine Comedy*.

## FIRST HIERARCHY
### Seraphim, Cherubim, Thrones

**Seraphim.** These are the angels closest to God and the only ones who can look at him directly. Their name means "the burning ones," because God's heat sets them on fire. For this reason, painters color them red and give them six wings—still, their iconography often becomes confused with that of the cherubim.

**Cherubim.** The role of this angelic choir, whose name means "fullness of knowledge," is to contemplate God. Based on a description by the prophet Ezekiel, artists color the cherubim blue and give them four wings, strewn all over with eyes. Alongside the iconographic tradition adapted from Ezekiel's vision, another trend developed based on passages from Exodus that speak of transporting the Ark of the Covenant and building the temple of Solomon (1 Kings); as a result, the cherubim were portrayed with just two wings and were identical to simple angels. The presence of eyes in the description of Ezekiel later suggested to artists a wing consisting of feathers from a peacock's tail.

**Thrones**. Pseudo-Dionysius explains that their name "refers to their perfect detachment from every earthly subjection." For this reason, painters depict them next to a throne, holding a mirror, seated on a globe or throne, or among the celestial spheres.

## SECOND HIERARCHY
### Dominations or Dominions, Potencies or Virtues, and Powers

**Dominations or Dominions**. This is the first choir of the second hierarchy. About their name, Pseudo-Dionysius states: "I believe that their name means a nonservile elevation free of any other desire of what is below [. . .], free [. . .] above all humiliating bondage, incapable of decay." Iconography portrays them as they weigh the souls, pierce the devil, or carry a leader's staff.

**Potencies or Virtues**. The second choir of the second hierarchy has two names, the roots of which are in the meaning of the Greek word *dynamis*. This word has been translated both as "potency" (physical strength) and as "virtue" (strength, especially moral strength), which explains the meaning of this second word in expressions such as "he flew by virtue of the wind," i.e., by the power of the wind. Additionally, the term "virtue" is derived from the Latin *virtus*, which designates the set of physical and moral qualities pertaining to man (*vir*). Not coincidentally, Pseudo-Dionysius states that "the name of the holy potencies points to a certain virile, unadulterated force in all divine operations proper to it." From this originates the custom of portraying them as they work miracles, save people, or conduct exorcisms.

**Powers**. Pseudo-Dionysius explains that "the name of the holy powers refers [. . .] to their being disposed [. . .] to receive divine things; it means that there is a level of super-worldly, intellectual power and that it [. . .] does not abuse [. . .] its power with respect to inferior things, but continuously elevates itself in orderly fashion toward what is divine." For this reason, artists depict the Powers armed or in the act of chaining the devil.

## THIRD HIERARCHY
### Principalities or Princedoms, Archangels, Angels

**Principalities or Princedoms**. According to Pseudo-Dionysius, "The name of the heavenly principalities means their divine strength to command and lead . . ." They are always portrayed armed with a shield, a sword, or a spear.

**Archangels**. Archangels also protect and safeguard, but, as Pseudo-Dionysius explains, because they occupy an intermediate position between the Principalities and the Angels, they take on the characteristics of both; therefore, they are oriented toward the sole Principle, but they also have the role of calibrating God's light so that it may be received also by the lower choir, the Angels. In sacred iconography they are portrayed as they escort souls or hold scrolls. Among the archangels are Gabriel, Michael, and Raphael-all associated with key episodes in the Old and the New Testament, and widely portrayed by artists of all periods.

**Angels**. The simple messengers of God, angels have the duty of transfusing into the created world God's will, revealed to them by the upper hierarchical levels. For this reason, it is usually angels (and not the higher orders) who appear in men's visions. In sacred images they usually wear clerical garments and act as psychopomps (guides of the souls of the dead) or carry in their hands the *rotulo*. They are dressed in many different fashions, as shown by the many examples reproduced in this book.

# FURTHER READING

Several works on angels have been published in recent years, most of them in the wake of the New Age fashion of searching for one's own guardian angel, or a certain type of esotericism that associates angels with paranormal phenomena.

This book, on the other hand, aims to better understand man's view of the sacred and its representations, so rich with highly complex cultural and artistic aspects, by analyzing how man looks at angels.

For this reason, this book would be incomplete without a brief bibliographical section to help the reader with selections that range from religion to art history. The works we are suggesting are useful tools of knowledge, in-depth study, or updates on the theme, starting from the fundamental texts, which are the biblical sources.

In writing this book, first of all, the Old and New Testament were consulted, using the dated but still sound edition of F. (Fulcran) Vigouroux's *La Sainte Bible Polyglotte* [*The Polyglot Holy Bible*] (Paris, 1900–1908), which offers a comparison of the Hebrew, Greek, and Latin versions. For the bible excerpts that appear in this book, the text of the King James Version was used, in the public domain and available in print and online. In turn, the Vulgate version used is from the *Biblia Sacra: iuxta Vulgatam versionem* [*The Holy Bible and Its Vulgate Version*] edited by R. (Robert) Weber (Stuttgart, 1975).

For the apocryphal texts, we mostly consulted *Apocrifi dell'antico Testamento* [*Old Testament Apocrypha*] edited by Paolo Sacchi (Turin, 1981) and *I Vangeli apocrifi* [*The Apocryphal Gospels*] edited by Marcello Craveri (Turin, 1969). Concerning patristic texts, we consulted for the most part the great collections edited by J.-P. (Jacques-Paul) Migne, *Patrologiae Cursus Completus, series greca* [*Complete Patrology Texts: Greek Series*] (Parisiis, 1857–76) and *Patrologiae Cursus Completus, series latina* [*Complete Patrology Texts: Latin series*] (Parisiis, 1841–64) which are fundamental.

For the texts of Pseudo-Dionysius, we consulted *Tutte le opere* [*Complete Works*], translated into Italian by Piero Scazzoso (Milan, 1981). Renzo Lavatori, *Gli angeli* [*Angels*] (Genoa, 1991) offers a solid theological body of work. Although the author does not discuss the subject of art, it is still today an irreplaceable reference work. Similarly, though open to cultural contamination, is Bernard Teyssèdre's *Anges, asters, et cieux: figures de la destinée et du salut* [*Angels, Stars, and Heavens: Figures of Destiny and of Salvation*] (Paris, 1986), in which the author rediscovers the Persian, Hebrew, Christian, and Islamic traditions that equate the angels with stars and with God's heavenly army, introducing an argument that is treated in this volume, namely the relationship between angels and the winds, which several artists dealt with in different periods.

For anyone interested in the history of the representation of angelic figures, the initial step is to consult the great reper-

tories—that is, entries in encyclopedias such as the dated but still very rich and interesting *Realenzyklopadie der klassischen Altertumswissenschaft* [*Encyclopedia of Classical Antiquity*] edited by Pauly-Wissowa, which analyzes the aspects linked to classical culture (such as the Erotes and Nike or winged Victory). For information about angels in the early Christian age, Henri Leclercq's entry "Ange" in *Dictionnaire d'Archaeologie Chrétienne et de Liturgie* I, 2 [*Dictionary of Christian archeology and liturgy*] (Paris, 1909) is very useful; for the medieval period, we recommend Theodor Klauser's entry "Engel" in *Reallexikon für Antike und Christentum*, V [*Dictionary of Antiquity and Christianity*] (Stuttgart, 1962) and the author's entry "Angelo" in *Enciclopedia dell'Arte Medievale* [*Encyclopedia of Medieval Art*], published by the Istituto dell'Enciclopedia Italiana, I (Rome, 1991).

For anyone interested specifically in the iconographic development of this subject up to the Baroque age, we suggest the author's *Storia degli Angeli: Racconto d'immagini e di idee* [*History of Angels:*

*A Tale of Images and Ideas*] (Milan, 1991 and 2003), which is one of the more extensive treatments of the subject, where the link between angels and winds is analyzed iconographically.

Deserving of a separate mention is Massimo Cacciari's *Necessary Angel* (New York, 1994), which, in sophisticated language, reviews the theological and philosophical arguments for the idea of the angel.

Among more recent illustrated books we should mention Nancy Grubb's *Angels in Art* (New York, 1997) and James Underhill's *Angels* (New York, 1994). Also, Giulietta Bandiera's *Guida insolita ai misteri, ai segreti, alle leggende, alle curiosità e ai luoghi dell'Italia degli Angeli* [*Unusual Guide to the Mysteries, Secrets, Legends, Little-known Facts, and Places of the Italy of the Angels*] (Rome, 2000) is a partially illustrated work. Finally, we found the right balance of information and images, with space for collateral subjects as well, in Rosa Giorgi's *Angels and Demons in Art* in the Guide to Imagery series (Los Angeles, 2005).

# INDEX OF EPISODES

# INDEX OF NAMES

# PHOTOGRAPHIC CREDITS